American Printmakers
1946–1996

An Index to Reproductions and Biocritical Information

Betty Kelly Bryce

The Scarecrow Press, Inc.
Lanham, Maryland, and London
1999

SCARECROW PRESS, INC.

Published in the United States of America
by Scarecrow Press, Inc.
4720 Boston Way
Lanham, Maryland 20706

4 Pleydell Gardens, Folkestone
Kent CT20 2DN, England

British Library Cataloguing in Publication Information Available

Library of Congress Cataloging-in-Publication Data

Bryce, Betty Kelly, 1942–
 American printmakers, 1946–1996 : an index to reproductions and
biocritical information / Betty Kelly Bryce.
 p. cm.
 Includes bibliographical references and indexes.
 ISBN 0-8108-3586-X (alk. paper)
 1. Prints, American—Indexes. 2. Prints—20th century—United
States—Indexes. 3. Printmakers—United States—Indexes.
I. Title.
NE508.B76 1999
016.76992'273—dc21 98-43773

♾™ The paper used in this publication meets the minimum requirements of American National Standard for Information Sciences—Permanence of Paper for Printed Library Materials, ANSI/NISO Z39.48–1992.
Manufactured in the United States of America.

DEDICATED TO MY DAUGHTERS
SARAH KELLY BRYCE AND ALISON CAIRNS BRYCE
AND TO MY SON
JAMES ANDREW BRYCE

CONTENTS

INTRODUCTION

PURPOSE

The period of post-World War II American printmaking is unique in the history of printmaking, as the volume and variety of prints proliferated and artists experimented with modern motifs and abstract forms. This printmaking explosion in America that began in the late 1940s and early 1950s carried the medium into prominence and acceptance: As a result of this rapid and fantastic growth, printmaking has come into its own as a respected art medium. Alongside printmaking's growing prestige, the print market flourished, and newly founded printmaking workshops and presses emerged as places providing for and encouraging creativity and experimentation. As new techniques emerged and evolved in these workshops, widening the possibilities and altering the appearances of the medium, universities and colleges began including printmaking in their art curricula. All of these factors contributed to a burgeoning interest in and production of original prints, making this period of American art an innovative and productive era in the history of printmaking.

There is currently no index of prints of this period, however, that brings together all the available biographical and critical material with the published reproductions of works in one place. The indexes that have been published are too general to be of value for scholarly research on prints.

In order to increase access to these prints and to information about their creators, and to augment study and research in this field, this index brings together all the information on published visual images of American prints from 1946 to 1996 and the critical and biographical information on printmakers working during this period. It is hoped that the study, collection, and preservation of American prints of the second half of the 20th-century will be furthered by the intellectual access provided by this index.

CHRONOLOGICAL SCOPE

The chronological scope of this index covers the time period after World War II to the present day, during which time there was a new

era of modernism. This fifty-year period is unified by the widespread break from traditional forms and search for new approaches to printmaking. Artists during this era experimented with new ideas in every area of printmaking—from medium to size to form.

PUBLICATIONS LISTED

The primary section of this index, the Printmaker Index, lists three general categories of publication under the names of individual artists. The first is standard reference sources on American art that give biographical information about artists.

The second group of books is general art books and catalogs that have been indexed for reproductions of prints, for critical information about the artist, or for biographical information about the artist. These books include works ranging from major art books to slim exhibition catalogs. Also included are major works, such as catalogues raisonnés of major print workshops and presses, because these workshops contributed so much to the quantity and innovative quality of printmaking of this post-World War II period.[1] Sales catalogs, periodical articles, and technique books have been excluded. Books and catalogs included are only those available in several major libraries or through interlibrary loan. Though the majority of the books are no longer in print, the ones listed here are held by enough United States libraries to be reasonably accessible.

The third group of books listed is that of monographs or other works solely about one artist. I have limited these books to include catalogues raisonnés except in cases of very obscure artists about whom nothing else is known or whose work is rarely represented in standard collections. All books, with the exception of the monographs

1. While the index attempts to include all inclusive works for this period, some works absent from this index are worthy of note. *Catalogue Raisonné: Tamarind Lithography Workshop, Inc., 1960-1970* documents the prints produced at the Tamarind Lithography Workshop in Los Angeles between 1960 and 1970. While the artists and prints included in this work are extensive, the reproductions themselves, being very small, make this book less useful within this index. Karen Beall's *American Prints in the Library of Congress: A Catalog of the Collection* is another useful resource; however, as with the *Tamarind Lithography Workshop*, the reproductions are not of high enough quality to be considered useful to this index.

and other works solely about one artist, are given a three-letter code that is included in the printmaker index.

PRINTMAKER INDEX

The printmaker index provides access to reproductions, critical information, and biographical information. This information may be in any of the three types of publications included in the index. To qualify for inclusion, the printmaker has to be either an American—having been born in America or naturalized—or have produced prints in America between 1946 and 1996. Printmakers are included if they are represented in an art book or catalog, or if they are subjects of a monograph. It is possible that an artist is listed in *Who's Who in American Art* or a similar index and yet is not included in this index because no reproductions of the artist's work are published in any form.

Listing of the printmakers is alphabetical. Name variations are indicated. Birth and death dates follow the artist's name.

INDIVIDUAL PRINTMAKER ENTRY

Three types of sources are included in each entry:
1. Biographical dictionaries are indicated by abbreviations that refer to entries in the bibliography in the first part of the volume.
2. General art books and catalogs are also listed by abbreviations given in the bibliography. Biographical and critical information about an artist is listed first in this category, indicated by the three-letter code. Some of the biographical and critical information is complete, while other sources give merely an overview of the artist's biography or critical information. Following this entry is the listing of reproductions of prints. These reproduction listings include the following:
 a) The title of the work is listed first. If there are various titles for the same print, and this fact is known, it is indicated in brackets. Information regarding states, proofs, plate numbers, and so on, is italicized and also written in brackets. If the print is part of a larger series, this fact is noted in parentheses, along with any other information that might help

distinguish a print from other works of the same title.[2]

b) The medium of the print is then listed.[3] A list of print mediums and codes for each type is listed after the bibliography. If two sources list a different medium for the same print, then the most specific description is cited.

c) The date of the print is listed after the medium. Occasionally different dates for the same print are listed by different sources. This fact is indicated in parentheses.

d) The source is listed after the date according to the three-letter code listed in the bibliography. The source is followed by a colon, and page numbers in that source follow. In the event that a work is not paginated, page numbering is assumed, beginning with the title page; these approximated page numbers are put in brackets (i.e., [6]). Works that prove too long and unwieldy for such numbering, or which order prints alphabetically, have been marked with "*abc*" following the colon, indicating that the work has no page numbers, but that prints may be located alphabetically by artist. The code "clp" designates reproductions listed by colorplates instead of page numbers (i.e., clp213). Figure numbers are italicized. A slash (/) following a page number indicates that information on the print is more than two pages removed from the print

2. Due to the fact that a great number of the prints indexed in this volume are untitled and many of those prints share the same media and production techniques, dates of creation, and so on, the author has chosen to include specific information in brackets after "Untitled" that might help to distinguish seemingly identical prints. In most cases, the bracketed information only appears in the subject index, as this is where such identically titled works are most likely to cause confusion. In the event there is not enough written information available to distinguish between clearly separate prints, asterisks (*) are used to set them apart.

3. Because of the experimental nature of much of the work of this period, some of the art produced by prominent printmakers does not fall comfortably within the area of printmaking and therefore has been omitted from this index. Molded and pressed paperworks, paper collages, and any paper constructions that do not involve some form of the printing process have been excluded from this index. However, some less traditional mediums, such as vacuum-formed plastics, are included, provided that printmaking has played a part in the creation and/or final appearance of the work.

reproduction itself; in such instances, the first number marks the location of the print, the second, the location of the descriptive information. Page or colorplate numbers in bold typeface designate reproductions that offer a particularly accurate, realistic representation of the original work (i.e., color reproduction, higher resolution of image, greater size, and so on).

3. The "See also:" section of the printmaker entry contains any catalogue raisonné of the artist. Because there are so many books and catalogs devoted to individual artists of this period, only those that contain the complete works of an artist during a given time period are included. If there are published catalogs or books about very obscure artists about whom little else is known, these have been included.

SUBJECT INDEX

The subject index includes subjects of all types, from abysses to zoos. Because there are so many abstract prints created during this period, at times it has been difficult to list subjects for some prints. In most of these cases, a subject has not been designated. In some cases, works may be listed according to predominant shapes or colors.

ACKNOWLEDGMENTS

I would like to thank The University of Alabama for granting me sabbatical leave for the fall of 1997. I would also like to thank The University of Alabama Research Grants Committee for a grant that provided funding for a research assistant and for travel. I wish to express appreciation to Lynn Barstis Williams of Auburn University for her help in preparing this volume, which is a companion to her own work *American Printmakers 1880-1945: An Index to Reproductions and Biocritical Information*. I would also like to thank Elizabeth Milewicz for her diligent work as my research assistant.

BIBLIOGRAPHY

AAP Walker, Barry. *American Artist as Printmaker.* Brooklyn, N.Y.: Brooklyn Museum, Division of Publications and Marketing Services, 1983. A catalog of one hundred prints from an exhibit at the Brooklyn Museum, which includes the major printmakers of post-war America. An accompanying essay details the developments of printmaking and describes how each print added to that development.

ACW *American Color Woodcuts: Bounty from the Block, 1890s-1990s.* Madison, Wis.: Elvehjem Museum of Art, University of Wisconsin, Madison, 1993. A beautifully illustrated, full-color catalog of an exhibition at the Elvehjem Museum of Art at the University of Wisconsin, Madison. James Watrous's essay, "A Century of Color Woodcuts," details the influence of Japanese woodcuts on the early American printmakers. Helpful footnotes.

AGM Field, Richard S., and Ruth E. Fine. *A Graphic Muse: Prints by Contemporary American Women.* New York: Hudson Hills Press, 1987. Includes lengthy introductory essay on history of women's contribution to the contemporary print. Contains biographical essay on each artist. Also includes bibliographical notes.

AKG *Amerikanische Graphik seit 1960 [American Graphics since 1960].* Zurich: Kunstmuseum Basel, 1972. Concentrates on American graphic art of the 1960s. Introductory essay refers to earlier art movements that influenced the art of this period and discusses the art movements that emerged during the 1960s. Text in German.

AMI Castleman, Riva. *American Impressions: Prints Since Pollock.* New York: Alfred A. Knopf, 1985. Well illustrated with many colorplates, this text gives a detailed history of printmaking in post-war America. It includes the major printmakers and their most significant works. Selected bibliography.

AML Adams, Clinton. *American Lithographers 1900-1960: The Artists and the Printers.* Albuquerque: University of New Mexico Press, 1983. This text traces lithography in America from early stages to 1960. Includes historical information about prints and printmakers. Includes extensive bibliography.

AMP *American Printmakers, 1900-1989: Edward Hopper to Jasper Johns.* Chicago, Ill.: R. S. Johnson Fine Art, 1989. An exhibition catalog that accompanied an exhibit of works by major artists from 1900 to 1989. Most major artists of this period are represented. Selected bibliography.

APB *American Prints 1879-1979: Catalogue of an Exhibition at the Department of Prints and Drawings in the British Museum, 1980.* London: British Museum, 1980. An exhibition catalog from the British Museum containing works by some forty-eight printmakers. Includes essay that gives general history of printmaking in America. Includes selected bibliography and some biographical information about each artist.

APM *American Prints 1960-1980.* Milwaukee: Milwaukee Art Museum, 1982. A catalog from an exhibition of graphic works from the Milwaukee Art Museum's permanent collection. No bibliography.

APP Johnson, Una E. *American Prints and Printmakers: A Chronicle of Over 400 Artists and Their Prints from 1900 to the Present.* Garden City, N.Y.: Doubleday, 1980. A good basic text covering a large number of printmakers. Selected bibliography.

APR *American Print Renaissance, 1958-1988.* New York: Whitney Museum of American Art, 1988. An exhibition catalog that accompanied an exhibit at the Whitney Museum of American Art branch in Fairfield County. A lengthy introductory essay provides a look at the history of printmaking in America and tells why this period represents a renaissance.

APS Sheehan, Susan. *American Prints From the Sixties.* New York: Susan Sheehan Gallery, 1989. An exhibition catalog of 1960s prints from the collection of the Susan Sheehan Gallery.

Most prints are color, and each comes with a brief discussion of style, technique, and history. Index and bibliography included.

AWP *American Women Printmakers.* University of Missouri— Saint Louis, 1975. A catalog of an exhibit at Gallery 210. Does not contain introductory essay. Gives detailed biographical information on the artists.

BAG *Impressions/Expressions: Black American Graphics.* New York: Studio Museum in Harlem, 1979. An exhibition catalog of two centuries of Black American artists' prints—over one hundred prints dating from 1773 to 1979. Includes brief biographies for most artists represented and a selective bibliography of books, periodicals, and catalogs. An introduction by Richard Powell discusses the history of Black American printmaking.

BWS Williams, Reba, and Dave Williams. *Black and White Since 1960.* Raleigh, N.C.: City Gallery of Contemporary Art, 1989. Exhibition catalog devoted exclusively to black-and-white prints.

CAM *Contemporary American Monotypes.* Norfolk, Va.: The Chrysler Museum, 1985. An exhibition catalog with an introductory essay that offers a historical perspective and an explanation of the print medium. The styles of the artists in the exhibition are discussed.

CHI Adrian, Dennis, and Richard A. Born. *The Chicago Imagist Print: Ten Artists' Works, 1958-1987: A Catalogue Raisonné.* Chicago: The David and Alfred Smart Gallery, in association with the University of Chicago, 1987. Representations of works by ten leading Chicago Imagist artists, with the most comprehensive coverage possible of the history of each print. Extensive essay on the Chicago Imagists, by Dennis Adrian, with selected bibliography and brief biographies of the artists.

CIP *Collaboration in Print: Stewart & Stewart Prints: 1980-1990.* Ann Arbor: Washtenaw Community College Foundation, 1990. Includes mostly Michigan artists with other nationwide artists who worked with Stewart & Stewart printers. Brief introduction

summarizes the history of Stewart & Stewart and screenprinting in the United States. Includes index of prints by title.

CMZ Boyle, Jane M. *Contemporary Mezzotints.* Williamstown, Mass.: Williams College Museum of Art, 1978. An exhibition catalog from the Williams College Museum of Art. An introduction discusses this type of print and traces its development. The style of each artist is discussed.

CUN Cunningham, Eldon L. (E. C.). *Printmaking: A Primary Form of Expression.* Niwot, Colo.: University of Colorado, 1992. Many less well-known printmakers are included in this text. Interviews detail the life and particular interests in printmaking of each artist.

EIE *Eight in Eighty: An Invitational Exhibition of Eight American Printmakers.* DeKalb, Ill.: Northern Illinois University, 1980. Catalog from an invitational exhibition. No bibliography.

ENP *Eighteenth National Print Exhibition.* New York: The Brooklyn Museum Press, in cooperation with Sanders Printing Corporation, 1972. Exhibition catalog of prints from the late 1960s and early 1970s exhibited at The Brooklyn Museum and the California Palace of the Legion of Honor. No bibliography. (Book is not page numbered, but works appear in alphabetical order.)

ESS *Eleven in Seventy Seven: An Invitation Exhibition of Eleven American Printmakers.* DeKalb, Ill.: Northern Illinois University, 1977. Catalog from an invitational exhibition. No bibliography.

FIM *First Impressions: Early Prints by Forty-six Contemporary Artists.* New York: Hudson Hills Press, 1989. Numerous colored reproductions are included in this well-illustrated catalog of early graphic work of a large number of contemporary American artists. An introduction, by Elizabeth Armstrong, provides a good overview of contemporary printmaking. No bibliography.

FTP *Forty Texas Printmakers.* Fort Worth, Tex.: Modern Art Museum of Fort Worth, 1990. Many lesser-known artists are included in this exhibition catalog. An essay chronicles the history

of printmaking in Texas. No bibliography.

FWC *Prints of the Fort Worth Circle 1940-1960.* Austin, Tex.:
Archer M. Huntington Art Gallery, College of Fine Arts, the
University of Texas, 1992. This is the first work to introduce the
art of the Fort Worth Circle to a larger audience. The unique
innovations and contributions of this little-known group of artists
are revealed in a biographical essay by Stephen Pinson. Includes
a selected bibliography.

GAP *Georgia Printmakers: March 4-May 11, 1986, High Museum
of Art, Atlanta.* Atlanta: The Museum, 1986. Exhibition catalog
including some lesser-known printmakers. No bibliography.

GAR Bober, Jonathan, ed. *Guest Artists in Printmaking.* Austin,
Tex.: Archer M. Huntington Art Gallery, in association with The
University of Texas, 1989. Selections from works produced by
residents in the Guest Artist in Printmaking Program at the
University of Texas in Austin, from 1979 to 1987. Includes brief
descriptions of individual styles and techniques involved in
producing each print.

GMC *Prints from the Guggenheim Museum Collection.* New York:
The Solomon R. Guggenheim Foundation, 1978. A selection of
the finest prints housed in the Guggenheim Museum, with an
introductory essay on the history of printmaking, by Linda
Konheim. Also includes a brief glossary of major printmaking
techniques, and a one-page bibliography of other works
containing prints by the represented artists.

GRE *Graphic Excursions: American Prints in Black and White,
1900-1950. Selections from the Collection of Reba and Dave
Williams.* Boston: David R. Godine, 1991. Exhibition catalog with
reproductions and biographies that give critical assessment of the
artists' work as well as biographical information. Introductory
essay discusses Americans' unique images. Selected bibliography.

IAI Armstrong, Elizabeth, and Marge Goldwater. *Images and
Impressions: Painters Who Print.* Minneapolis, Minn.: Walker
Art Center, 1984. As the title suggests, this exhibition catalog

focuses on painters who also work in the print medium. All works are accompanied by biographical and analytical essays on the artist and the print. Introduction by Elizabeth Armstrong.

INN Lovell, Charles, ed. *Into the Nineties: Prints from the Tamarind Institute.* Greensboro, N.C.: Weatherspoon Art Gallery, in association with The University of North Carolina at Greensboro, 1995. A look at lithography as it continues to develop and flourish at the Tamarind Institute. Essay by Diana Gaston.

INP Hansen, Trudy V. *Intaglio Printing in the 1980s: Prints, Plates, and Proofs from the Rutgers Archives for Printmaking Studios.* New Brunswick, N.J.: The Jane Voorhees Zimmerli Art Museum, in association with Rutgers, The State University of New Jersey, 1990. Third in a series of exhibition catalogs, this work focuses on the current trends in intaglio printmaking and relationships between the artists and the printers. Includes an interview with Sylvia Roth, Mary Seibert, and John Beerman, as well as a glossary of printing terms and a select bibliography.

KSP *Kansas Printmakers.* Lawrence, Kans.: Helen Foresman Spencer Museum of Art, University of Kansas, Lawrence, 1981. Exhibition catalog that includes lesser-known Kansas printmakers. Includes bibliographies.

LAP Feinblatt, Ebria, and Bruce Davis. *Los Angeles Prints: 1883-1980.* Los Angeles: Los Angeles County Museum of Art, 1980. Created in celebration of the Los Angeles bicentennial, the Los Angeles Prints exhibition covers over a century of art produced by artists in the area, reflecting not only the growth of the art community but also the changing character of the city. Essays address two separate time periods (1883-1959 and 1960-1980) and the major printing techniques used during these eras (etching, woodcut and wood engraving, lithography, silkscreen, and relief prints). Includes selected bibliography.

MCN Phagan, Patricia. *Myth, Culture, Narrative: Current Prints by Six Georgia Artists.* Athens, Ga.: Georgia Museum of Art, in association with the University of Georgia, 1989. Highlights a small group of Georgia artists whose work analyzes/criticizes

contemporary society and culture. Includes timelines, brief biographies, exhibitions, and selected bibliographies for each artist.

NAP *New American Paperworks.* World Print Council. San Francisco: World Print Council, 1982. A catalog that accompanied an exhibit organized by the World Print Council and held at the University of Houston and at various other museums. Good color illustrations. Includes bibliography.

NCP MacNaughton, Mary Davis. *New California Printmaking: Selections from Northern and Southern California* Claremont, Calif.: The Galleries of the Claremont Colleges, 1987. Introduced by MacNaughton as an exhibition of the works of a new generation of young California printmakers. All works fall between the years 1984 and 1987, and each appears with a brief commentary by the artist as well as a synopsis of the artist's schooling and experience.

NPE Baro, Gene. *Twenty-First National Print Exhibition.* Philadelphia: Falcon Press, in association with The Brooklyn Museum, 1978. Part of an annual series that takes a look at contemporary printmaking and the issues and innovations that shaped it in the year before the exhibition. Includes statements by the artists and indexing by medium.

PAC Goldman, Judith. *Print Acquisitions, 1974-1984.* New York: Whitney Museum of American Art, 1984. Exhibition catalog of all works purchased since the publication of the 1974 catalog—works that represent the museum's commitment to diversity and quality. Prints included represent the expanse of printmaking techniques, many of which were developed since the 1960s.

PAP Walker, Barry. *Public and Private: American Prints Today. The 24th National Print Exhibition.* New York: The Brooklyn Museum, 1986. Presents the range of printmaking styles practiced during the mid-1980s. Walker's essay traces the history of printmaking from the beginnings of the National Print Exhibition, and highlights the trends over the years. Includes a glossary, an index to lenders, and an index to printers.

PFB *Prints from Blocks, 1900-1985: Twentieth Century American Woodcuts, Wood Engravings, and Linocuts.* New York: Associated American Artists, 1985. An exhibition catalog of relief prints from over ninety artists, a continuation of the previous work, *A Century of American Woodcuts, 1850-1950* (1980). Begins with a brief introduction to the history of woodcuts, by Carol Evans.

PIA Hansen, Trudy V., et al. *Printmaking in America: Collaborative Prints and Presses, 1960-1990.* New York: H.N. Abrams, Inc., in association with Mary and Leigh Block Gallery, Northwestern University, 1995. Catalog to accompany an exhibition at Northwestern University. Includes bibliographical references and index. Contains good color illustrations.

PNM Adams, Clinton. *Printmaking in New Mexico, 1880-1990.* Albuquerque: University of New Mexico Press, 1991. Text details the development of printmaking in the southwest, especially at the Tamarind Lithography Workshop. Includes little-known printmakers. Selected bibliography.

PNW Allan, Lois. *Contemporary Printmaking in the Northwest.* Sydney, NSW: Craftsman House, in association with G + B Arts International, 1997. A collection of work currently done by artists residing or working in the Northwest United States. These works demonstrate the variety of techniques and mediums used in printmaking today, as well as the various themes that concern these artists, who range widely in age and ethnicity.

POR Reaves, Wendy Wick, ed. *American Portrait Prints: Proceedings of the Tenth Annual American Print Conference.* Charlottesville, Va.: University Press of Virginia, in association with the National Portrait Gallery, Smithsonian Institution, 1979. A sampling of the holdings of the National Portrait Gallery, replete with histories of the American portrait print, focused mainly on the time period from the late 18th to the late 19th centuries, but offering some views into portrait prints of the 20th century. Essay by Alan Fern.

PPP Goldman, Judith. *American Prints: Process & Proofs.* New York: Whitney Museum of American Art, 1981. Excellent introductory essay traces the development of American prints from 1670. Strong critical essays accompany each artist's prints.

PRO Walker, Barry. *Projects & Portfolios: The 25th National Print Exhibition.* New York: The Brooklyn Museum, with Hine Editions, 1989. Showcases American printmaking styles of the late 1980s, particularly the practice of printing related images, separately or within portfolios, suites, and the like. Includes brief glossary of terms and index to printers.

PWP *Presswork: The Art of Women Printmakers.* Lang Communications Corporate Collection, 1991. Exhibition catalog. Focuses on women printmakers from the 1980s to the early 1990s, particularly those who have made significant contributions in the field of printmaking. Also includes an essay on the impact women have made in the world of art and, in recent years, increasing recognition of this contribution and the unique qualities of women's art.

RBW *Through a Master Printer: Robert Blackburn and the Printmaking Workshop.* Columbia, S.C.: The Columbia Museum, 1985. Short catalog for an exhibit at the Columbia Museum of Art. Contains bibliography.

SIM Moser, Joann. *Singular Impressions: The Monotype in America.* Washington and London: Smithsonian Institution Press, for the National Museum of American Art, 1997. Focuses on the long-obscured history of the monotype in America—its use for professional as well as private projects. Uses prints from across the centuries to illustrate the various techniques, and details individual contributions to the medium. Selected bibliography.

SMP Castleman, Riva. *Seven Master Printmakers: Innovations in the Eighties.* New York: The Museum of Modern Art, 1991. Catalog of an exhibition held at the Museum of Modern Art. Includes bibliographical references.

TCA Goldman, Judith. *Twentieth-Century American Printmakers:*

Selections from the Permanent Collection of the Whitney Museum of American Art. New York: Whitney Museum of American Art, 1984. A survey of 20th-century American printmaking, with an introductory essay by Goldman.

TCR Tyler, Kenneth E. *Tyler Graphics: Catalogue Raisonné, 1974-1985*. Minneapolis, Minn.: Walker Art Center; New York: Abbeville Press, 1987. Focuses on the contributions of the printer to the printmaking process, specifically Kenneth Tyler and his studio's affect on the American print world. Lengthy essay by Dorothy Gilmour opens the book; diagrams and explanations of printing presses and the printing process follow the catalog, along with a glossary of terms.

TGX *Tyler Graphics: The Extended Image*. New York: Abbeville Press, in association with Walker Art Center, 1987. With in-depth essays on Kenneth Tyler, paper and the printmaking process, and the artists themselves, this work offers a broad and insightful look at the printer and his practice through the artists and the works that have passed through his studio. Includes a selected bibliography broken down into general works and those that deal with particular artists.

THL *Tamarind: Homage to Lithography*. New York: Museum of Modern Art, in association with The New York Graphic Society, 1969. An exhibition catalog honoring the Tamarind workshop and the lithography medium. Its introduction chronicles the history of the workshop and its influence on the medium in America and on artists worldwide.

TPI Goldman, Judith. *The Pop Image: Prints and Multiples*. New York: Marlborough Graphics, 1994. Accompanied an exhibit held at Marlborough Gallery. Several informative, critical essays accompany numerous plates.

TWO Castleman, Riva. *Printed Art: A View of Two Decades*. New York: The Museum of Modern Art, 1980. Collection of prints by European and American Artists, demonstrating the range of printmaking styles and techniques that emerged in the twenty years following World War II. Includes an essay on the history of

printmaking from the 1940s to the 1960s.

TYA Baro, Gene. *Thirty Years of American Printmaking.* Brooklyn, N.Y.: The Brooklyn Museum, 1977. This catalog describes the physical creation of each print in some detail. Brief biographical information is included. A short introductory essay gives a brief history of American printmaking from 1947 to 1977. No bibliography.

WAA *Who's Who in American Art.* New York: R.R. Bowker, 1936-. Irregular serial biographical dictionary listing living artists. Includes education, exhibitions, publications, awards, and current mailing address.

WAT Watrous, James. *American Printmaking: A Century of American Printmaking 1880-1980.* Madison: University of Wisconsin Press, 1984. Chronicles major figures and events in the history of American printmaking. Concentrates on major figures. Includes bibliography.[4]

4. When the final manuscript of this index had been completed, the compiler became aware of a new exhibition catalog relevant to the scope covered here: *Second Sight: Printmaking in Chicago, 1935-1995*, published by the Mary and Leigh Block Gallery of Northwestern University.

ABBREVIATIONS

ab	abaca
ac	acrylic
ad	acid
ag	assemblegraph or assemblage
ai	photo aid
al	aluminum
am	enamel
an	air stencil
aq	aquatint
ar	airbrushed
as	acrylic sheeting
at	acetate
ba	ballpoint pen
bd	bleached
be	blind embossing
bf	bisque fired (porcelain)
bg	chemical boil ground (etching)
bk	book
bl	block print
bn	burnishing
bp	blueprint
br	bronzing powder
brl	bronze leaf
bs	blind stamp
bsf	bas relief
bu	burin
bx	box
by	body print
bz	bronze leaf
ca	canvas
cb	carborundum
cc	cello cut
cd	cardboard
ce	collage
cf	chronaflex film
cg	collograph
ch	chine collé

chp	papier collé
ci	chiaroscuro
ck	chalk (or conté)
cl	collotype
cm	chamois
cn	construction (or constructed)
co	color
cp	copper (or copperplate)
cq	chine appliqué
cr	charcoal
cs	cast paper (en tout cas papier)
ct	carborundum tint
cu	cut
cv	cliché verre
cx	color xerox
cy	crayon
db	deep-bite (etching)
dc	direct
dd	diamond dust
de	debossing
dg	Day-Glo
di	diazo
dl	double
dm	dry pigment
dp	diptych
dr	drypoint
ds	double-sided
dt	dye transfer
du	Du Pont chromolin
dv	direct gravure
dw	computer drawing
dy	dyed
eb	embedded
ek	ektachrome print
el	electric stippler
em	embossing or embosure
en	engraving
ep	embossed print
er	erasure
es	esthetograph (monotype)

et	etching
ex	experimental
fa	fabric or cloth
fb	foul-bite (etching)
fc	steel-faced (etching or engraving)
fd	folded
fk	flocking
fl	foil
fm	frame
fo	form
fp	fish print
fr	fiber (i.e., plant)
ft	felt
gb	gum bichromate
gd	gilded
ge	gesso
gg	gold ground
gl	gold leaf
gn	glassine
go	gouache
gp	gelatin silverprint
gr	graphite
gs	gunshot
gt	glitter
gu	glue
ha	hand-pressed
hb	hand-burnishing
hc	hand-coloring
hd	hand-drawing (or pencil)
hf	photo halftone plate
hg	hard-ground (etching)
hh	human hair
hi	hanga shi
hl	hand-pulled lithograph
hm	handmade paper
hn	hand-printed
hp	hand-painted
hr	hand reduction
hs	hand stenciling
hw	handwork or hand additions

ic	inclusions
ig	ink-ground (etching)
ij	ink-jet print
ik	ink
iky	spray inking
il	inkless
in	intaglio
ip	iris print (digital computer print)
is	installation
kn	knotting
ku	sosaku hanga
kz	katazome
la	lacquer
lc	linocut (or linoleum cut)
ld	lead
le	line-etching
lf	lifted
lg	lift ground (etching)
li	lithograph (or lithogravure)
ll	Letra-Line tape
lm	laminated
ln	linoleum
lp	(hand-set) letterpress
lq	liquid ground (aquatint)
lr	lead relief
ls	litho sticks
lt	lithotint
lu	lucite engraving
lv	line-engraving
lx	Liquitex
ly	multilayered (relief)
mc	multicolored
md	molded
me	metal
mg	Magnacolor
mi	mixed intaglio
ml	module
mm	mold-made paper
mn	montage
mo	monotype

mp	monoprint
mr	microcomputer
mt	multiple
mu	multiplate
mx	mixed media
my	mylar
mz	mezzotint
na	saltlift ground (etching)
ng	string
nl	negative lithograph
ob	open bite (etching)
oc	oil crayon
of	offset
oi	oil paint
ok	oil stick
op	overprint
or	organic coloring
os	open screen
ou	à la poupée
ov	overlay
pa	paper
pb	pop-up book
pc	pochoir
pd	pressed
pe	photo etching
pf	photo offset
pg	planograph
ph	photolithograph
pi	photo intaglio
pin	polymer intaglio
pk	Paintstik
pl	plaster
pm	photoemulsion
pn	photoengraving
po	poster
pp	polyptych
ppy	polypropylene
pr	paper relief
ps	photo silkscreen
pt	plastic

pu	paper pulp
pv	photogravure
pw	power tool
px	Plexiglas
py	polystyrene
rb	rubber
rc	porcelain
rd	retouched
re	relief (or relief cut)
rf	perforations or perforated
rg	reversed (etching)
ri	rubbing ink
rl	roulette
rm	ready-made
rn	resin
ro	blended roll
rp	relief print
rr	reproduction
rs	rubberstamp or stamping
rt	relief etching
ru	rubbings
rv	reductive
sa	sanding
sb	spit bite (etching)
sc	screenprint
sd	sandblasting
sf	soft ground (etching)
sg	spray ground (etching)
sh	shaped
shl	shellacked
si	silk
sk	silkscreen (serigraph)
sl	sugarlift
sm	simultaneous
sn	stencil or stenciling
so	soap-ground
sp	scraping
spg	sandpaper ground
sq	sequins
sr	styrene

ss	stones
st	stipple
su	sumi
sv	subtractive
sw	sewing or stitching
sy	spray paint
tc	trace (monotype)
td	three-dimensional
te	tempera
tf	transfer (print)
th	thread
tl	pastels
tn	tin
to	photo
tp	triptych
tr	transparencies
ts	tissue
tt	tinted
tu	tusche (wash)
ty	typography
ur	cast polyurethane
ut	cut out
ve	veneer
vf	vacuum-formed
vg	vitreograph
vl	vinylcut
vm	vellum
vn	solvent (transfer)
vp	vegetable print
vr	silver leaf
vt	vermiculite
vy	vinyl or polyvinyl
wb	woodblock
wc	watercolor
wd	wood
we	welded
wg	white-ground (etching)
wi	wire
wl	white-line woodcut
wn	wood engraving

wo	woodcut (or wood relief)
wp	wallpaper
wt	water-based
wv	wood veneer
wx	wax
xd	mixed
xg	xerography
xm	x-ray monoprint
xt	xerox transfer or photocopy transfer
xx	xerox or photocopy
ze	zinc etching
zn	zinc (or zinc plate)

Special Locations

bcv	back cover
clp	colorplate
fcv	front cover
fpc	frontispiece
tlp	title page
end	endpapers

Other Symbols

(co) denotes works originally produced in color (i.e., works not simply black-and-white)

/ when used between medium and technique codes, designates work printed in either one or the other of the two codes (i.e., ac/wc = colored in either acrylic or watercolor)

- indicates technique was a combination of two separate elements or was performed in direct conjunction with another element (i.e., co-li = color lithograph; hc-wc = hand-colored using watercolor)

PRINTMAKER INDEX

ABDALLA, NICK 1939-
Biographical dictionaries: WAA 73, 76, 78, 80, 82, 84, 86, 89-90
Art books and catalogs: PNM
Nude in Red Kimono co-li (co) 1979 PNM: 95

ABRAMOWICZ, JANET 1930-
Biographical dictionaries: WAA 76, 78, 80, 82, 84, 86, 89-90, 91-92, 93-94, 95-96, 97-98
Art books and catalogs: PAP
Metropolis/Rome hg aq sb dr bn 1984-85 PAP: 28

ABRAMS, JANE ELDORA 1940-
Biographical dictionaries: WAA 76, 78, 80, 82, 84, 86, 89-90, 91-92, 93-94, 95-96, 97-98
Art books and catalogs: GAR, PNM
Fumbling at the Speed of Light co-in (co) 1983 PNM: 106
Snare for Wild Horns co-in (co) 1983 GAR: **37**

ABULARACH, RODOLFO MARCO 1933-
Biographical dictionaries: WAA 82, 84, 86, 89-90, 91-92, 93-94, 95-96, 97-98
Art books and catalogs: APP, THL
Untitled li 1967 APP: 223
Untitled li 1966 THL: 23

ACCONCI, VITO 1940-
Biographical dictionaries: WAA 73, 76, 78, 80, 82, 84, 86, 89-90, 91-92, 93-94, 95-96, 97-98
Art books and catalogs: AMI, FIM, PAP, PIA, TWO
Building Blocks for a Doorway pe hg sf aq (co) 1983-85 PAP: **16**, 29
Kiss-Off li (co) 1971 FIM: **73**
Stones for a Wall co-li (co) 1977 AMI: clp121
Think/Leap/Re-think/Fall of 1976 TWO: 76

Three Flags for One Space and Six Regions pe aq (co) 1979-81
PIA: **172**/117-18

ADAMS, CLINTON 1918-
Biographical dictionaries: WAA 53, 56, 59, 62, 66, 70, 73, 76,
78, 80, 82, 84, 86, 89-90, 91-92, 93-94, 95-96, 97-98
Art books and catalogs: AML, INN, LAP, PNM, THL, WAT
Extension li 1944 INN: **23**
Second Hand Store I li 1953 AML: 175
Silver Bottle li 1950 LAP: 60/102
Strata li 1970 PNM: 79
Venus in Cíbola I co-li (co) 1968 WAT: 150
Venus in Cibola IV co-li (co) 1967-69 LAP: 82/105
Window Series [*Plate III*] (*from portfolio*) co-li (co) 1960 THL:
27 WAT: 242
See also:
Adams, Clinton. *A Retrospective Exhibition of Lithographs.*
Albuquerque: University of New Mexico Art Museum, 1973.

ADAMS, KENNETH MILLER 1897-1966
Biographical dictionaries: WAA 40-41, 40-47, 53, 56, 62, 66
Artbooks and catalogs:

ADAMS, MARK 1925-
Biographical dictionaries: WAA 62, 66, 70, 73, 76, 78, 80, 82,
84, 86, 89-90, 91-92, 93-94, 95-96, 97-98
Artbooks and catalogs:
See also:
Adams, Mark. *Mark Adams: A Way with Color.* San Francisco:
Chronicle Books, in association with John Berggruen Gallery,
1995.

ADAMS, RON 1934-
Biographical dictionaries:
Art books and catalogs: PNM
Profile in Blue co-li (co) 1987 PNM: clp11

AFRICANO, NICHOLAS 1948-
Biographical dictionaries:
Art books and catalogs: FIM

Shadow (*set of four*) et aq sb em (co) 1979 FIM: **113**

ALBEE, GRACE THURSTON ARNOLD **1890-1985**
 Biographical dictionaries: WAA 36-37, 40-41, 40-47, 53, 56,
 59, 62, 66, 70, 73, 76
 Art books and catalogs: TYA
 Fly Agaric wn 1973 TYA: 15

ALBERS, ANNI **1899-1994**
 Biographical dictionaries: WAA 40-41, 40-47, 53, 56, 59, 62,
 66, 70, 73, 76, 78, 80, 82, 84, 86, 89-90, 91-92, 93-94
 Art books and catalogs: TCR, TGX, TYA
 Enmeshed I li 1963 TGX: **96**
 Mountainous [I-VI] em hm 1978 TCR: **40-41**
 Mountainous II em hm 1978 TCR: **40** TGX: 96
 Second Movement [I-VI] et aq (co) 1978 TCR: **42-43**
 Second Movement II et aq (co) 1978 TCR: **36**, **42**
 Triangulated Intaglio [I-VI] aq/et in (co) 1976 TCR: **38-39**
 Triangulated Intaglio II et aq 1976 TCR: **38** TGX: **95**
 Triangulated Intaglio V et in aq (co) 1976 TCR: **39** TYA: 15

ALBERS, JOSEF **1888-1976**
 Biographical dictionaries: WAA 40-41, 40-47, 53, 56, 59, 62,
 66, 70, 73, 76
 Art books and catalogs: AMI, AMP, APM, APP, GMC, PIA,
 TCR, TGX, THL, TWO, TYA, WAT
 Ascension (*from* Graphic Tectonic) of-li 1942 AMI: clp15
 Day and Night [*Plate I*] (*from portfolio*) co-li (co) 1963 THL: 35
 Embossed Linear Construction, 2-A (*from series of 8*) il em APP:
 156
 Never before d sc (co) 1976 TGX: **88**
 Gouache study for Mitered Squares go (co) 1976 TGX: **93**
 Gray Instrumentation I (*Ia-Il from portfolio*) sc (co) 1974 TCR:
 47-50
 Gray Instrumentation I, Plus I sc (co) 1974 TCR: **51**
 Gray Instrumentation Ib (*from portfolio* Gray Instrumentation) sc
 (co) 1974 TGX: **91**
 Gray Instrumentation Ie (*from portfolio* Gray Instrumentation) sk
 (co) 1974 TCR: **48** TYA: 15

Gray Instrumentation If (*from portfolio* Gray Instrumentation) sc
(co) 1974 TGX: **91**

Gray Instrumentation Ig (*from portfolio* Gray Instrumentation) sc
(co) 1974 TGX: **91**

Gray Instrumentation II (*IIa-III from portfolio*) sc (co) 1975 TCR:
51-55

Gray Instrumentation II, Plus II sc (co) 1975 TCR: **55**

Gray Instrumentation Ik sc (co) 1974 TGX: **91**

Homage to the Square (*four from portfolio*) sk (co) 1965 TWO: **53**

Homage to the Square: Midnight and Noon [*Plate V*] li (co) 1964
AMI: clp79

Mitered Squares (*a-l from portfolio*) sc (co) 1976 TCR: **56-60**

Mitered Squares f (*from portfolio* Mitered Squares) sc (co) 1976
TCR: **58** TGX: **92**

Mitered Squares, Plus II sc (co) 1976 TCR: **60**

Multiplex A wo 1947 AMI: clp16

Never Before (*a-l from portfolio*) sc (co) 1976 TCR: **61-64**

Never Before (Variation IX) co-sc (co) 1976 AMP: 81

Never Before e (*from portfolio* Never Before) sc (co) 1976 TCR:
44, 62

Never Before f (*from portfolio* Never Before) sk (co) 1976 TCR:
62 TYA: 16

Untitled [Midnight and Noon III] (*from suite* Midnight and
Noon/Homage to the Square) li (co) 1964 PIA: **133**/113

Untitled [Midnight and Noon V] (*from suite* Midnight and
Noon/Homage to the Square) li (co) 1964 PIA: **133**/113

Untitled [Midnight and Noon VI] (*from suite* Midnight and
Noon/Homage to the Square) li (co) 1964 PIA: **133**/113

Variant 4 sk 1969 GMC: 10

Variant IX (*from* Ten Variants) sc (co) 1967 APP: clp11

W.E.G.1 (*from portfolio of 10*) co-sk em (co) 1971 APM: 8/11
WAT: 259

See also:

Miller, Jo. *Josef Albers Prints, 1915-1970.* New York: The
Brooklyn Museum, 1973.

ALBERT, CALVIN 1918-

Biographical dictionaries: WAA 40-47, 53, 56, 62, 66, 70, 73,
76, 78, 80, 82, 84, 86, 89-90, 91-92, 93-94, 95-96, 97-98

Artbooks and catalogs: RBW
Sculpture li RBW: [6]

ALBRIGHT, IVAN LELORRAINE 1897-1983
Biographical dictionaries: WAA 36-37, 40-41, 40-47, 53, 56,
59, 62, 70, 73, 76, 78, 80, 82
Art books and catalogs: AMP, APP, GRE, TYA
Fleeting Time Thou Hast Left Me Old li 1945 AMP: 11
Into the World There Came a Soul Called Ida li vm 1940 AMP: 9
Self-Portrait at 55 Division Street [Self-Portrait: East Division
Street *or* Self-Portrait—55 East Division St.] li 1947-48
AMP: 11 APP: 111 TYA: 16
Show Case Doll li 1954 GRE: clp*110*

ALBRIGHT, RIPLEY F. 1951-
Biographical dictionaries:
Art books and catalogs: TYA
Coffee by the Pool li hc 1975 TYA: 17

ALECHINSKY, PIERRE 1927-
Biographical dictionaries:
Art books and catalogs: TWO
Around the falls hc-et (co) 1979 TWO: 114

ALEXANDER, JOHN E. 1945-
Biographical dictionaries: WAA 76, 78, 80, 82, 84, 86, 89-90,
91-92, 93-94, 95-96, 97-98
Art books and catalogs: FTP
Queen for a Day li 1986 FTP: **11**

ALEXANDER, PETER 1939-
Biographical dictionaries: WAA 78, 80, 82, 84, 86, 89-90, 91-
92, 93-94, 95-96, 97-98
Art books and catalogs: AAP, LAP
Anacin II of-li 1972 LAP: 88/107
Chula Vista Cirrus li hp 1982 AAP: 34

ALLEN, TERRY 1943-
Biographical dictionaries: WAA 93-94, 95-96, 97-98

Art books and catalogs: FTP, TYA
Palabras Malo co-li (co) 1989 FTP: **13**
Pinto to Paradise li 1970 TYA: 16

ALLISON, DAN 1953-
Biographical dictionaries:
Art books and catalogs: FTP
East of Eden/West of Eden cg ca dp (co) 1989 FTP: **15**

ALPS, GLEN EARL 1914-96
Biographical dictionaries: WAA 62, 66, 70, 73, 76, 78, 80, 82,
 84, 86, 89-90, 91-92, 93-94, 95-96, 97-98
Art books and catalogs: PNW
Moon Sequence cg (co) 1976 PNW: **19**
Three Chickens cg 1959 PNW: 20
White Square cg (co) 1968 PNW: 21

ALTMAN, HAROLD 1924-
Biographical dictionaries: WAA 66, 70, 73, 76, 78, 80, 82, 84,
 86, 89-90, 91-92, 93-94, 95-96, 97-98
Art books and catalogs: APP, WAT
Luxembourg November li 1965 APP: 209
Park with Seven Figures in 1969 WAT: 302

ALTOON, JOHN 1925-69
Biographical dictionaries:
Art books and catalogs: LAP
Untitled co-li (co) 1966 LAP: 72/104

AMAN, JANE 1943-
Biographical dictionaries:
Art books and catalogs: TYA
Untitled sk 1975 TYA: 17

AMEN, IRVING 1918-
Biographical dictionaries: WAA 53, 56, 62, 66, 70, 73, 76, 78,
 80, 82, 84, 86, 89-90, 91-92, 93-94, 95-96, 97-98
Art books and catalogs: ACW
Dreamer Amid Flowers co-wo (co) c.1958 ACW: **58**, 116

AMENOFF, GREGORY 1948-
Biographical dictionaries: WAA 91-92, 93-94, 95-96, 97-98
Art books and catalogs: PAP
Chamber wo 1985 PAP: 30

AMOS, EMMA 1938-
Biographical dictionaries: WAA 91-92, 93-94, 95-96, 97-98
Art books and catalogs: INP, PIA, PWP, RBW
Diver (*from series* The Aquarium) si-cg (co) 1987 INP: 12 PIA:
 204/121 PWP: clp2/111
Dream Girl co-et (co) 1975 RBW: [6]

ANAYA, STEPHEN RAUL 1946-
Biographical dictionaries: WAA 73, 76, 78
Art books and catalogs: ENP, LAP
Kuraje st-et 1971 ENP: *abc* LAP: 85/106

ANDELL, NANCY 1953-
Biographical dictionaries: WAA 89-90, 91-92, 93-94, 95-96, 97-
 98
Art books and catalogs: NPE
Around 4:00 P.M. in November 1977 mo 1977 NPE: 22
Picnic at Crane's Beach et dr sb (co) 1976 NPE: 21

ANDERSON, ADRIENNE 1949-
Biographical dictionaries:
Art books and catalogs: GAP
Trilogy: Ulysses and the Sirens, Apollo and Daphne, and Galatea
 mp tp 1985 GAP: 13/29

ANDERSON, CHRIS 1947-
Biographical dictionaries:
Artbooks and catalogs: PWP
History of the Square in the Landscape #89 mo mx (co) 1989
 PWP: clp76/111

ANDERSON, LARRY JENS 1947-
Biographical dictionaries:

Art books and catalogs: GAP
Ecce Homo et mi re (co) 1986 GAP: 10/29

ANDERSON, LAURIE 1947-
Biographical dictionaries: WAA 86, 89-90, 91-92, 93-94, 95-96,
97-98
Art books and catalogs: AAP
Mt. Daly/US IV li (co) 1982 AAP: **31**, 35

ANDERSON, MARK ROBERT 1948-
Biographical dictionaries: WAA 89-90, 91-92, 93-94, 95-96, 97-
98
Art books and catalogs: FTP
Garden wt-re-mp (co) 1987 FTP: **17**

ANDERSON, WILLIAM THOMAS 1936-
Biographical dictionaries: WAA 76, 78, 80, 82, 84, 86, 89-90,
91-92, 93-94, 95-96, 97-98
Artbooks and catalogs: ENP
Great Indian War Series, No. 26 sk et px 1970 ENP: *abc*

ANDRADE, EDNA WRIGHT 1917-
Biographical dictionaries: WAA 70, 73, 76, 78, 80, 82, 84, 86,
89-90, 91-92, 93-94, 95-96, 97-98
Artbooks and catalogs: ENP
Black Cisoide li 1971 ENP: *abc*

ANDRE, CARL 1935-
Biographical dictionaries: WAA 70, 73, 76, 78, 80, 82, 84, 86,
89-90, 91-92, 93-94, 95-96, 97-98
Art books and catalogs: TWO
Xerox Book (*by Carl Andre, Robert Barry, Douglas Huebler,
Joseph Kosuth, Sol LeWitt, Robert Morris, and Lawrence
Weiner*) xx 1968 TWO: 93

ANDREWS, BENNY 1930-
Biographical dictionaries: WAA 70, 73, 76, 78, 80, 82, 84, 86,
89-90, 91-92, 93-94, 95-96, 97-98
Art books and catalogs: RBW

Pusher et 1972 RBW: [6]

ANTONAKOS, STEPHEN 1926-
Biographical dictionaries: WAA 70, 73, 76, 78, 80, 82, 84, 86,
 89-90, 91-92, 93-94, 95-96, 97-98
Art books and catalogs: PAP
Book sc ut ce 1980-85 PAP: 31

ANTREASIAN, GARO ZAREH 1922-
Biographical dictionaries: WAA 40-47, 53, 56, 59, 62, 66, 70,
 73, 76, 78, 80, 82, 84, 86, 89-90, 91-92, 93-94, 95-96, 97-98
Art books and catalogs: AML, APP, GAR, PNM, THL, TYA,
 WAT
Bebek II co-sk po (co) 1984 PNM: clp13
Fragments (*suite of 12 plus title page and colophon*) co-li (co)
 1960-61 WAT: 199
Limes, Leaves and Flowers co-li (co) 1959 AML: 177
Plums co-li (co) 1954 PNM: 104
Quantum Suite [*Plate VII*] (*from portfolio*) co-li (co) 1966 THL:
 37
Untitled co-li em (co) 1980 GAR: 21
Untitled (78.2—I a & b) li (co) 1978 APP: clp22
Untitled 72-121 co-li (co) 1972 PNM: 105
View li 1959 TYA: 17
See also:
Krause, Martin F. *Garo Antreasian: Written on Stone.*
 Indianapolis: Indianapolis Museum of Art, 1996.

ANUSZKIEWICZ, RICHARD JOSEPH 1930-
Biographical dictionaries: WAA 66, 70, 73, 76, 78, 80, 82, 84,
 86, 89-90, 91-92, 93-94, 95-96, 97-98
Art books and catalogs: AMI, PIA, TWO, TYA, WAT
Diamond Chroma (*from portfolio* New York 10) sc (co) 1965
 PIA: **135**/113
Eternity (*from suite* Inward Eye) co-sk (co) 1970 WAT: **213**
Inward Eye [*Plate 3*] sk 1970 TWO: 52
Inward Eye [*Plate 6*] sk (co) 1970 AMI: clp85
Largo li 1973 TYA: 18
Soft Lime ps 1976 TYA: 18

APP, TIMOTHY 1947-
Biographical dictionaries: WAA 84, 86, 89-90, 91-92, 93-94,
95-96, 97-98
Art books and catalogs: PNM
Untitled co-li (co) 1988 PNM: 135

APPLEBROOG, IDA H. 1929-
Biographical dictionaries: WAA 78, 80, 82, 84, 86, 89-90, 91-
92, 93-94, 95-96, 97-98
Art books and catalogs: AAP, PIA, PWP
Executive Tower, West Plaza aq sf tp 1982 AAP: 36
"I will go before thee, And make the crooked places straight."
Isaiah 45: 2 li 1989 PWP: clp37/111
Just Watch and See li hp dp 1985 PIA: **193**/120

ARAKAWA, SHUSAKU 1936-
Biographical dictionaries: WAA 70, 73, 76, 78, 80, 82, 84, 86,
89-90, 91-92, 93-94, 95-96, 97-98
Art books and catalogs: AMI, APP, PIA, TWO, TYA
and/or in profile li sk em 1975 TYA: 18
Degrees of Meaning sk li 1973 TWO: 79
signified or if (No. 2) et aq (co) 1975-76 AMI: clp**106**
Signified or IF et aq 1975-76 APP: 249
Untitled 1 (*from* No! Says the Signified) li ce (co) 1973-74 PIA:
157/116
Untitled 5 (*from* No! Says the Signified) li sc (co) 1973-74 PIA:
157/116

ARMAN, (ARMAND PIERRE) 1928-
Biographical dictionaries: WAA 73, 76, 78, 80, 82, 84, 86, 89-
90, 91-92, 93-94, 95-96, 97-98
Art books and catalogs: TWO
Cachets rs 1956 TWO:18

ARNESON, ROBERT CARSTON 1930-92
Biographical dictionaries: WAA 73, 76, 78, 80, 82, 84, 86, 89-
90, 91-92
Art books and catalogs: AAP, APM

Hollow Gesture co-li (co) 1980 APM: 23/11
Nuclear War Head wo 1983 AAP: 37

ARNOLDI, CHUCK (CHARLES ARTHUR) 1946-
Biographical dictionaries: WAA 84, 86, 89-90, 91-92, 93-94,
95-96, 97-98
Art books and catalogs: AAP, INP, LAP, PAP
Rahway mp wo mo (co) 1985 PAP: **14**, 32
Untitled co-et (co) 1979 LAP: 93/108
Untitled hg sf aq 1983 INP: 18
Untitled, #3 wo dp 1983 AAP: 38

ARTSCHWAGER, RICHARD ERNST 1924-
Biographical dictionaries: WAA 70, 73, 76, 78, 80, 82, 84, 86,
89-90, 91-92, 93-94, 95-96, 97-98
Art books and catalogs: AMI, FIM, PAC
Interior sc dp 1972 PAC: [6]/65
Interior (Woodgrain) #2 dr 1977 AMI: clp117
Locations sc mx (co) 1969 FIM: **65**

ASH, RICHARD 1943-
Biographical dictionaries:
Art books and catalogs: FTP
Pinocchio Series, The Financier (2D) mo (co) 1988 FTP: **19**

ASKIN, WALTER MILLER 1929-
Biographical dictionaries: WAA 76, 78, 80, 82, 84, 86, 89-90,
91-92, 93-94, 95-96, 97-98
Art books and catalogs: ENP, LAP
Bruegel-Britannia sk 1969 ENP: *abc*
Transitory Passions sk 1971 LAP: 73/106

ATKINSON, TERRY 1939-
Biographical dictionaries:
Art books and catalogs: TWO
Map of Thirty-Six Square Mile Area of Pacific Ocean West of
Oahu lp 1967 TWO: 92

ATTIE, DOTTY 1938-
> **Biographical dictionaries:** WAA 76, 78, 80, 82, 84, 86, 89-90,
> 91-92, 93-94, 95-96, 97-98
> **Artbooks and catalogs:** INN, PWP
> Exile co-li (co) 1992 INN: **11**
> No Teeth li pp 1989 PWP: clp84/111

AUSBY, ELLSWORTH AUGUSTUS 1942-
> **Biographical dictionaries:** WAA 80, 82, 84, 86, 89-90, 91-92,
> 93-94, 95-96, 97-98
> **Art books and catalogs:** RBW
> Space Odyssey #5 mp 1984 RBW: [7]

AUTRY, CAROLYN (ELLOIAN) 1940-
> **Biographical dictionaries:** WAA 76, 78, 80, 82, 84, 86, 89-90,
> 91-92, 93-94, 95-96, 97-98
> **Art books and catalogs:** AWP
> Relationship of Things (Belief XV) in le aq cp 1974 AWP: [4]

AVEDISIAN, EDWARD 1936-
> **Biographical dictionaries:** WAA 66, 70, 73, 76, 78, 80, 82, 84,
> 86, 89-90, 91-92, 93-94, 95-96, 97-98
> **Art books and catalogs:**

AVERY, ERIC 1948-
> **Biographical dictionaries:**
> **Art books and catalogs:** FTP, INN, PAP, PRO
> Blue Bath (*from suite of four* Damn It) co-li wo-op (co) 1987
> PRO: clp**4**
> False Bacchus ph sc lc ce gd 1985 PAP: 33
> Massacre of Innocents lc (co) 1985 FTP: **21**
> Summer Boogie Woogie (*from suite of four* Damn It) co-li wo-op
> (co) 1987 PRO: clp**3**
> Watson and the Shark co-li lc (co) 1990 INN: **18**

AVERY, MARCH 1932-
> **Biographical dictionaries:**
> **Art books and catalogs:** CAM
> Striped Cat oi-mo hn 1978 CAM: 20/43

AVERY, MILTON CLARK 1893-1965
Biographical dictionaries: WAA 36-37, 40-41, 40-47, 53, 56, 59, 62
Art books and catalogs: ACW, AMI, APP, CAM, GRE, PAC, PFB, SIM, TCA, TYA
Birds and Sea wo co-ik (co) 1955 ACW: **46**, 109 PAC: [7]/65
Dancer wo 1954 AMI: clp21
Fish in Dappled Sea co-mo mx (co) 1950 SIM: **134**
Head of a Man et 1935 APP: 64
Nude Recumbent (Nude Asleep) co-mo (co) 1950 SIM: **134**
Nude with Long Torso dr 1948 APP: 117 TYA: 19
Sailboat wo 1954 TYA: 19
Self-Portrait mo hn 1951 CAM: 6/43
Three Birds wo 1952 GRE: clp*108* TCA: [30]
Two Birds co-wo (co) 1952 PFB: **fcv**, 5
See also:
Owens, Carlotta J. *Milton Avery: Works on Paper.* Washington, D.C.: National Gallery of Art, 1994.

AY-O 1931-
Biographical dictionaries: WAA 73, 76
Artbooks and catalogs: ENP
Rainbow Night B sk 1970 ENP: *abc*

AZUMA, NORIO 1928-
Biographical dictionaries: WAA 70, 73, 76, 78, 80, 82, 84, 86, 89-90, 91-92, 93-94, 95-96, 97-98
Art books and catalogs: APP
Image of a City sc 1962 APP: 196

BACZEK, PETER GERARD 1945-
Biographical dictionaries: WAA 84, 86, 89-90, 91-92, 93-94, 95-96, 97-98
Art books and catalogs: NPE
Duboce Street aq 1978 NPE: 24
Lombard Street Triptych aq em tp 1977 NPE: 23

BAEDER, JOHN ALAN 1938-
Biographical dictionaries: WAA 76, 78, 80, 82, 84, 86, 89-90, 91-92, 93-94, 95-96, 97-98
Art books and catalogs: CMZ
Empire Diner mz 1976 CMZ: [57]/26

BALDESSARI, JOHN ANTHONY 1931-
Biographical dictionaries: WAA 76, 78, 80, 82, 84, 86, 89-90, 91-92, 93-94, 95-96, 97-98
Art books and catalogs: FIM, PIA, PRO
I Will Not Make Any More Boring Art li 1971 FIM: 15
Object (with Flaw) co-li px (co) 1988 PRO: clp6
Fallen Easel co-li sk me (co) 1988 PIA: **207**/122 PRO: clp5

BALDWIN, MICHAEL 1945-
Biographical dictionaries:
Art books and catalogs: TWO
Map of Thirty-Six Square Mile Area of Pacific Ocean West of Oahu lp 1967 TWO: 92

BALKIN, ANDREW G. 1947-
Biographical dictionaries:
Art books and catalogs: NPE
Future Memories I aq en mz sf dr 1977 NPE: 26
Life's Flight into Water: Harmony aq en mz sf dr 1976 NPE: 25

BANERJEE, (BIMAL) 1939-
Biographical dictionaries: WAA 76, 78, 80, 82, 84, 86, 89-90, 91-92, 93-94, 95-96, 97-98
Artbooks and catalogs: ENP
Her Handkerchief Lost in a Spiritual Nature ce mx 1971 ENP: *abc*

BARNET, WILL 1911-
Biographical dictionaries: WAA 40-41, 40-47, 53, 56, 59, 62, 66, 70, 73, 76, 78, 80, 82, 84, 86, 89-90, 91-92, 93-94, 95-96, 97-98
Art books and catalogs: APP, RBW, TYA, WAT
Child Among Thorns li RBW: [7]
Singular Image co-wo (co) 1964 APP: clp**18** TYA: 19 WAT: 291

Waiting li sc 1976 APP: 198
See also:
Cole, Sylvan, Jr. *Will Barnet: Etchings, Lithographs, Woodcuts, Serigraphs, 1932-1972.* (catalogue raisonné). New York: Associated American Artists, 1972.
Cole, Sylvan, Jr. *Will Barnet: Lithographs, Serigraphs, 1973-1979: Supplement to the Catalogue Raisonné.*, addendum to *Will Barnet: Etchings, Lithographs, Woodcuts, Serigraphs, 1932-1972, Catalogue Raisonné.* New York: Associated American Artists, 1979.

BARRERA, ALBERTO
Biographical dictionaries:
Art books and catalogs: RBW
Untitled et RBW: [7]

BARRETT, LAWRENCE LORAS 1897-1973
Biographical dictionaries: WAA 40-47, 53
Art books and catalogs: AML
Untitled [Horses in Winter] li AML: 172

BARROW, THOMAS FRANCIS 1938-
Biographical dictionaries: WAA 76, 78, 80, 82, 84, 86, 89-90, 91-92, 93-94, 95-96, 97-98
Art books and catalogs: PNM
Task Mask co-pg (co) 1989 PNM: clp15

BARTLETT, JENNIFER LOSCH 1941-
Biographical dictionaries: WAA 73, 76, 78, 80, 82, 84, 86, 89-90, 91-92, 93-94, 95-96, 97-98
Art books and catalogs: AAP, AGM, AMI, FIM, PAC, PAP, PIA, PWP, TWO
Day and Night et dr (co) 1978 AGM: **50** AMI: clp99 FIM: **107** PAC: [8]/66
Graceland Mansions sk li et dr wo aq pp (co) 1978-79 AGM: **51-52** PIA: **168-69**/117 TWO: **126-27**
In the Garden #116 sc 1982-83 AAP: 39
Rhapsody: House, Mountain, Ocean pe in aq sl tp 1987 PWP: clp6/111

Shadow sf aq sb dr bn pp (co) 1984 AGM: **53-54** PAP: 34

BASELITZ, GEORG 1938-
Biographical dictionaries:
Art books and catalogs: TWO
Eagle lc dp 1977 TWO: 71

BASKIN, LEONARD 1922-
Biographical dictionaries: WAA 56, 59, 62, 66, 70, 73, 76, 78, 80, 82, 84, 86, 89-90, 91-92, 93-94, 95-96, 97-98
Art books and catalogs: ACW, AMI, APP, PFB, POR, TYA, WAT
Angel of Death wo 1959 APP: 107
Crazy Horse 1974 li TYA: 20
Eve li 1926 TYA: 20
Every Man wo 1960 PFB: 6
Frightened Boy and His Dog co-wo (co) 1955 ACW: **50**, 112
Hydrogen Man wo 1954 WAT: 189
Icarus co-wo (co) c.1966 ACW: **51**, 112
Jean-Louis-André Théodore Géricault et 1969 POR: 264
Man of Peace wo 1952 APP: 106 WAT: 188
Mantegna at Eremitani wo 1952 WAT: 187
Torment wo 1958 AMI: clp25
See also:
Fern, Alan, and Judith O'Sullivan. *The Complete Prints of Leonard Baskin: A Catalogue Raisonné, 1948-1983.* Boston: New York Graphic Society Book, in association with Little, Brown and Co., 1984.

BASQUIAT, JEAN-MICHEL 1960-88
Biographical dictionaries:
Art books and catalogs: AAP, PIA
Back of the Neck sc hp (co) 1983 AAP: 40 PIA: **181**/118-19

BASS, JOEL LEONARD 1942-
Biographical dictionaries: WAA 78, 80, 82, 84, 86, 89-90, 91-92, 93-94, 95-96, 97-98
Art books and catalogs: LAP
Horizontals—C et ld-ce 1974 LAP: 96/107

BATES, DAVID 1952-
 Biographical dictionaries: WAA 89-90, 91-92, 93-94, 95-96, 97-98
 Art books and catalogs: FTP
 Bar-B-Q [Friday Catfish] hc-li (co) 1983 FTP: **23**

BAYER, HERBERT 1900-85
 Biographical dictionaries: WAA 59, 62, 66, 70, 73, 76, 78, 80, 82, 84
 Art books and catalogs: AML
 Convolution co-li (co) 1948 AML: 161

BAYNARD, ED 1940-
 Biographical dictionaries: WAA 78, 80, 82, 84, 86, 89-90, 91-92, 93-94, 95-96, 97-98
 Art books and catalogs: ACW, TCR
 Blue Tulips co-wo hm (co) 1980 ACW: **69**, 121 TCR: **72**
 China Pot wo hm (co) 1980 TCR: **70**
 Dark Pot with Roses wo hm (co) 1980 TCR: **72**
 Diptych 5 (*from* Monotype Series) mo hm dp (co) 1981 TCR: **74**
 Dragonfly Vase wo hm (co) 1980 TCR: **69**
 E-6 (*from* Monotype Series) mo hm (co) 1981 TCR: **75**
 H-1 (*from* Monotype Series) mo hm (co) 1981 TCR: **75**
 I-1 (*from* Monotype Series) mo hm (co) 1981 TCR: **76**
 J-7 (*from* Monotype Series) mo hm (co) 1981 TCR: **76**
 K-4 (*from* Monotype Series) mo hm (co) 1981 TCR: **76**
 Lilies li hc (co) 1980 TCR: **73**
 M-1 (*from* Monotype Series) mo hm (co) 1981 TCR: 77
 N-2 (*from* Monotype Series) mo hm (co) 1981 TCR: 77
 Print Scarf wo hm (co) 1980 TCR: **66**, **71**
 Quarter Moon wo hm (co) 1980 TCR: **70**
 Roses li hc (co) 1980 TCR: **74**
 Still Life with Orchid wo hm (co) 1980 TCR: **68**
 Sunflower li hc (co) 1980 TCR: **73**
 Tulip Pitcher wo hm (co) 1980 TCR: **69**

BEAL, JACK 1931-
 Biographical dictionaries: WAA 66, 73, 76, 78, 80, 82, 84, 86, 89-90, 91-92, 93-94, 95-96, 97-98

Art books and catalogs: ACW, BWS, PAC, TYA, WAT
Brook Trout li 1976 BWS: 7/30
Oysters with White Wine and Lemon co-li (co) 1974 WAT: **263**
Self-Portrait li 1974-75 PAC: [9]/66 TYA: 20
Trillium co-lc (co) 1977 ACW: **67**, 120

BEARDEN, ROMARE HOWARD **1914-88**
 Biographical dictionaries: WAA 53, 56, 59, 70, 73, 76, 78, 80,
 82, 84, 86
 Art books and catalogs: AMI, APP, PIA, SIM, TWO
 Prevalence of Ritual sc 1974-75 APP: 207
 Train pe aq sn (co) 1975 AMI: clp**130** PIA: **162**/116 TWO: 104
 Vampin' [Piney Brown Blues] mo wc c.1976 SIM: **150**
 See also:
 Bearden, Romare. *A Graphic Odyssey: Romare Bearden as*
 Printmaker. Edited by. Gail Gelburd. Philadelphia:
 Distributed by University of Pennsylvania, 1992.

BECK, EUGENE C., JR. **1937-**
 Biographical dictionaries:
 Artbooks and catalogs: ENP
 Geek's Picnic et 1972 ENP: *abc*

BECK, HELEN **1943-**
 Biographical dictionaries:
 Artbooks and catalogs: PWP
 St. Francis mo 1989 PWP: clp**28**/111

BECKER, DAVID **1937-**
 Biographical dictionaries: WAA 80, 82, 84, 86, 89-90, 91-92,
 93-94, 95-96, 97-98
 Art books and catalogs: TYA, WAT
 In a Dark Time et en in 1973 TYA: 21 WAT: 300
 Tremble in the Air et en 1971 TYA: 21
 Union Grove Picnic et en 1975 TYA: 21

BECKER, FRED **1913-**
 Biographical dictionaries: WAA 62
 Art books and catalogs: TYA, WAT

Cage co-in pe (co) 1946 WAT: 156
Inferno et en 1946 TYA: 22

BECKMANN, MAX 1884-1950
Biographical dictionaries:
Art books and catalogs: AMI
King and Demagogue (*from portfolio* Day and Dream) tf-li 1946
AMI: clp9

BEERMAN, JOHN 1958-
Biographical dicationaries:
Art books and catalogs: INN, INP, PAP, PIA
Stones Silent Witness et aq (co) 1986 INP: 25 PIA: **198**/120-21
Two Bushes at Twilight co-li gl (co) 1990 INN: **15**
Untitled (#3) mo 1985 PAP: 35

BELL, CHARLES S. 1935-95
Biographical dictionaries: WAA 76, 78, 80, 82, 84, 86, 89-90,
91-92, 93-94, 95-96
Art books and catalogs: INP
Thunder Smash aq 1988 INP: vi

BENGLIS, LYNDA 1941-
Biographical dictionaries: WAA 73, 76, 78, 80, 82, 84, 86, 89-
90, 91-92, 93-94, 95-96, 97-98
Art books and catalogs: FIM, PWP
Lagniappe I cs ac (co) 1978 FIM: **105**
Lagniappe II cs ac gt gl ppy (co) 1979 FIM: **105**
Tandem Series, #18 mp hw (co) 1988 PWP: clp20/111

BENGSTON, BILLY AL 1934-
Biographical dictionaries: WAA 66, 70, 73, 76, 78, 80, 82, 84,
86, 89-90, 91-92, 93-94, 95-96, 97-98
Art books and catalogs: LAP
Mecca Dracula co-li (co) 1968 LAP: 77/105

BENNEY, PAUL 1959-
Biographical dictionaries:
Art books and catalogs: INP

Untitled et aq 1987 INP: 15

BENY, W. ROLOFF 1924-84
Biographical dictionaries: WAA 73, 76, 78, 80, 82, 84
Art books and catalogs: TYA
Time of War and a Time of Peace et aq li en 1947 TYA: 22

BEN-ZION 1897-1987
Biographical dictionaries: WAA 40-41, 40-47, 53, 56, 59, 62, 66, 70, 76, 78, 80, 82, 84, 86
Art books and catalogs: APP
In the Grip of the Five Senses (*from* In Search of Oneself) et 1967 APP: 113

BERDICH, VERA (VERONICA) 1915-
Biographical dictionaries: WAA 59, 73, 76, 78, 80
Art books and catalogs: APP, CHI
Fabricated Mirror aq dr mz 1957 APP: 226
Silent Eclectic Fish Tattoo (*exquisite corpse by Vera Berdich, Art Green, Suellen Rocca, and William Schwedler*) et 1964 CHI: 191

BERG, TOM (THOMAS) 1943-
Biographical dictionaries: WAA 78, 80, 82, 84, 86, 89-90, 91-92, 93-94, 95-96, 97-98
Art books and catalogs: PNM
Dark Adirondack co-li (co) 1988 PNM: 134

BERGER, PAUL ERIC 1948-
Biographical dictionaries: WAA 80, 82, 84, 86, 89-90, 91-92, 93-94, 95-96, 97-98
Art books and catalogs: PNW
Mathematics #57 (*from series* Mathematics) gp 1977 PNW: 24
Mathguy (*from series* Cards) ij 1989 PNW: 25
Treroll₃ (*from series* World Info) ip (co) 1995 PNW: **23**

BERMAN, ELEANORE (LAZAROF) 1928-
Biographical dictionaries: WAA 80, 82, 84, 86, 89-90, 91-92, 93-94, 95-96, 97-98

Art books and catalogs: LAP
Dos Lados de la Mañana co-in (co) 1979 LAP: 96/108

BERMAN, EUGENE 1899-1972
Biographical dictionaries: WAA 40-41, 40-47, 53, 56, 59, 62, 66, 70
Art books and catalogs: AML, LAP
Nocturnal Cathedral co-li (co) 1951 AML: **186**
Pisan Fantasy li 1951 LAP: 61/102

BERMAN, VIVIAN 1928-
Biographical dictionaries: WAA 76, 78, 80, 82, 84, 86, 89-90, 91-92, 93-94, 95-96, 97-98
Artbooks and catalogs: ENP
This Spaceship Earth cg-in 1972 ENP: *abc*

BERNAY, LYNN 1941-
Biographical dictionaries:
Artbooks and catalogs: PWP
Departure #7 mo 1989 PWP: clp70/111

BEUYS, JOSEPH 1921-86
Biographical dictionaries:
Art books and catalogs: TWO
Minneapolis Fragments li pp 1977 TWO: 77

BIDDLE, MICHAEL 1934-
Biographical dictionaries:
Artbooks and catalogs: ENP
Untitled et 1971 ENP: *abc*

BIGELOW, ROBERT CLAYTON 1940-
Biographical dictionaries: WAA 84, 86, 89-90, 91-92, 93-94, 95-96
Artbooks and catalogs:

BIGGERS, JOHN THOMAS 1924-
Biographical dictionaries: WAA 40-47, 53, 56, 62, 76, 78, 80, 82, 84, 86, 89-90, 91-92, 93-94, 95-96, 97-98

Art books and catalogs: RBW
Untitled li 1983 RBW: [8]
See also:
Wardlaw, Alvia J. *The Art of John Biggers: View from the Upper Room*. Houston: Harry N. Abrams, Inc., in association with the Museum of Fine Arts, 1995.

BILLOPS, CAMILLE J. 1933-
Biographical dictionaries:
Art books and catalogs: RBW
I am Black, I am Black, I am Dangerously Black et 1974 RBW: [8]

BISHOP, ISABEL 1902-88
Biographical dictionaries: WAA 36-37, 40-41, 40-47, 53, 56, 59, 62, 66, 70, 73, 76, 78, 80, 82, 84, 86
Art books and catalogs: APP
Encounter et 1939 APP: 49
Little Nude et aq 1964 APP: 215
See also:
Teller, Susan. *Isabel Bishop: Etchings and Aquatints (A Catalogue Raisonné)*. New York: Associated American Artists, 1981.

BJORKLUND, MARC R. 1949-
Biographical dictionaries:
Art books and catalogs: TYA
Void V/VI et sk hc 1975 TYA: 22

BLACK, FREDERICK EDWARD 1924-
Biographical dictionaries: WAA 56, 59, 62, 66, 73, 76, 78, 80, 82, 84
Art books and catalogs: PNM
Regatta: The Start co-wo (co) 1953 PNM: 68

BLACKBURN, LINDA Z. 1941-
Biographical dictionaries: WAA 91-92, 93-94, 95-96, 97-98
Art books and catalogs: FTP
Escape mo (co) 1989 FTP: **25**

BLACKBURN, ROBERT 1920-
Biographical dictionaries: WAA 95-96, 97-98
Art books and catalogs: RBW, TYA
Germination et 1983 RBW: [5]
Girl in Red li 1950 TYA: 23
Jus Jazz Set li 1983 RBW: [4]
Sunburst wb 1969 RBW: [3]
Windowed Shapes li 1963 RBW: fcv

BLAEDEL, JOAN STUART ROSS 1942-
Biographical dictionaries: WAA 93-94, 95-96, 97-98
Art books and catalogs: PNW
Arabesque III mo gl (co) 1995 PNW: **27**
Head, Cell + Soul I mo 1991 PNW: 29
Portrait mo 1988 PNW: 28

BLAINE, NELL WALDEN 1922-96
Biographical dictionaries: WAA 40-47, 53, 56, 66, 70, 73, 76,
 78, 80, 82, 84, 86, 89-90, 91-92, 93-94, 95-96, 97-98
Art books and catalogs: RBW
Sleeping Girl et 1984 RBW: [9]

BLAIR, MALCOLM 1950-
Biographical dictionaries:
Art books and catalogs: INP
Torso [*1st State*] aq xt 1989 INP: 19

BLUMENSCHEIN, HELEN GREENE 1909-89
Biographical dictionaries: WAA 40-41, 40-47, 53, 56, 62
Art books and catalogs: PNM
Untitled [Ranchos de Taos] li 1945 PNM: 65

BOCHNER, MEL 1940-
Biographical dictionaries: WAA 78, 80, 82, 84, 86, 89-90, 91-
 92, 93-94, 95-96, 97-98
Art books and catalogs: AMI, PIA, PRO, TWO
First Quartet aq 1988 PIA: **208**/122 PRO: clp7
Fourth Quartet aq 1988 PIA: **208**/122 PRO: clp10
Rules of Inference aq 1974 AMI: clp105 TWO: 80

Second Quartet aq 1988 PIA: **208**/122 PRO: clp8
Third Quartet aq 1988 PIA: **208**/122 PRO: clp9

BODGER, LORRAINE 1946-
Biographical dictionaries:
Artbooks and catalogs: PAP, PWP
English Summer Night mo (co) 1989 PWP: clp3/111
Family at Home (*from portfolio* Eldindean Press XVII by XVII) et
aq 1985 PAP: 53

BOLOTOWSKY, ILYA 1907-81
Biographical dictionaries: WAA 40-41, 40-47, 56, 59, 62, 66,
70, 73, 76, 78, 80
Art books and catalogs: APM, APP
Rectangle Red, Yellow sc (co) 1974 APP: clp7
Red Tondo co-sk (co) 1979 APM: 8/11

BOLT, SUSAN HAMILTON 1949-
Biographical dictionaries: WAA 82, 84
Art books and catalogs: NPE
Box Making sk (co) 1978 NPE: 28
Declination Reparation sk (co) 1977 NPE: 27

BOLTON, JAMES 1938-
Biographical dictionaries: WAA 76, 78, 80, 82
Artbooks and catalogs: ENP
Two Girls li 1971 ENP: *abc*

BOLTON, RANDY C. 1956-
Biographical dictionaries:
Art books and catalogs: AAP, CUN
Berry Pickers sc tp (co) 1990 CUN: **77**
Boat of Holes sc 1988 CUN: 4
Run and Hide pb (co) 1989 CUN: **78**
Strong Arm sc dd tp 1983 AAP: 41
Winter Storm sc wd dp 1990 CUN: 2

BOMAR, BILL 1919-91
Biographical dictionaries: WAA 62, 66, 73, 70

Art books and catalogs: FWC
Altar aq sf c.1945 FWC: 18

BONIOR, NANCY ANNA 1947-
Biographical dictionaries:
Art books and catalogs: TYA
Effacement in et 1974 TYA: 23

BONTECOU, LEE 1931-
Biographical dictionaries: WAA 66, 70, 78
Art books and catalogs: AAP, AMI, ENP, PIA, WAT
Etching One et aq 1967 WAT: 259
First Stone li 1962 APP: 147
Fourth Stone co-li (co) 1963 AMI: clp67
Seventh Stone li hm 1965-68 PIA: **137**/113
Twelfth Stone li 1966-70 ENP: *abc*
Untitled Print li 1982 AAP: 42

BOROFSKY, JON(ATHAN) E. 1942-
Biographical dictionaries: WAA 78, 80, 82, 84, 86, 89-90, 91-
 92, 93-94, 95-96, 97-98
Art books and catalogs: AAP, AMI
People Running li 1982 AAP: 43
Stick Man li (co) 1983 AMI: clp**148**

BOSHIER, DEREK 1937-
Biographical dictionaries:
Art books and catalogs: FTP
Watch li (co) 1990 FTP: 27

BOSMAN, RICHARD 1944-
Biographical dictionaries: WAA 86, 89-90, 91-92, 93-94, 95-96,
 97-98
Art books and catalogs: AAP, ACW, AGM, AMI, CAM, FIM,
 IAI, INP, PAC, PAP, PFB, PIA
Backdoor 82-003 mo 1982 CAM: 13/43
Double Trouble wo dp 1983 AAP: 44
Drowning Man I wo 1981 IAI: 7
Drowning Man II wo (co) 1981 AMI: clp**144**

Forced Entry et aq 1983 INP: 10
Man Overboard wo (co) 1981 FIM: **119** IAI: **11** PIA: **176**/118
Meteor Man li 1985 PAP: 36
Mutiny wo (co) 1981 IAI: **12**
Rescue wo 1983-84 AGM: 32
Snowman lc 1983 PFB: 8
Suicide co-wo co-pa (co) 1980-81 ACW: **86**, 130
Survivor wo 1982-83 IAI: **14** PAC: [13]/69

BOTHWELL, DORR 1902-
Biographical dictionaries: WAA 40-47, 53, 56, 59, 62, 66, 70,
73, 76, 78, 80, 82, 84, 86, 89-90
Art books and catalogs: TYA, WAT
Memory Machine co-sk (co) 1947 TYA: 23 WAT: 221

BOURGEOIS, LOUISE 1911-
Biographical dictionaries: WAA 40-47, 53, 56, 59, 62, 66, 70,
73, 76, 78, 80, 82, 84, 86, 89-90, 91-92, 93-94, 95-96, 97-98
Art books and catalogs: AMI, APP
"In the mountains of central France forty years ago, sugar was a
rare product" [*Plate No. 4*] (*from series* He Disappeared into
Complete Silence) en 1947 APP: 132
Plate No. 6 (*from series* He Disappeared into Complete Silence)
en 1947 AMI: clp13
See also:
Wye, Deborah, and Carol Smith. *The Prints of Louise Bourgeois.*
New York: Museum of Modern Art, 1995.

BOWMAN, DOROTHY LOUISE 1927-
Biographical dictionaries: WAA 62, 66, 70, 73, 76, 78, 80, 82,
84
Art books and catalogs: LAP
Sleeping City sk c.1957-58 LAP: 66/103

BOXER, STANLEY ROBERT 1926-
Biographical dictionaries: WAA 73, 76, 78, 80, 82, 84, 86, 89-
90, 91-92, 93-94, 95-96, 97-98
Artbooks and catalogs: TCR
Amissinamist (*from portfolio* Ring of Dust in Bloom) et aq hc hm

Oddconversationatnoon (*from portfolio* Ring of Dust in Bloom) et aq hc hm (co) 1976 TCR: **83**

Pauseofnoconcern (*from portfolio* Ring of Dust in Bloom) et aq hc hm (co) 1976 TCR: **82**

Personages with Long Ears (*from portfolio* Carnival of Animals) et aq en hc hm (co) 1979 TCR: **91, 102**

Pianist (*from portfolio* Carnival of Animals) et aq en dr hc hm (co) 1979 TCR: **93, 103**

Ring of Dust in Bloom [Title Page] et li hm (co) 1976 TCR: **80**

Softwinterseekingwhiteness li 1976 TCR: **84**

Spawnofcloverwithcuriousoccupants et aq hm (co) 1977 TCR: **85**

Strangetalkwithfriend (*from portfolio* Ring of Dust in Bloom) et aq hc hm (co) 1976 TCR: **82**

Swan (*from portfolio* Carnival of Animals) et aq en hc hm (co) 1979 TCR: **94, 104-5**

Turtle (*from portfolio* Carnival of Animals) et aq en dr hc hm (co) 1979 TCR: **88, 98-99**

BOYD, FISKE 1895-1975
Biographical dictionaries: WAA 36-37, 40-41, 56, 59, 62
Art books and catalogs: APP
American Cotton wo 1950 APP: 32

BOYD, JOHN DAVID 1939-
Biographical dictionaries: WAA 76, 78, 80, 82, 84, 86, 89-90, 91-92, 93-94, 95-96, 97-98
Art books and catalogs: CUN
Homage to Picasso cs in (co) 1989 CUN: **79**
Homage to Rembrandt cs in 1988 CUN: 7
Portrait of Magritte cs in 1989 CUN: 7
Portrait of van Gogh cs in (co) 1985 CUN: **78**

BOYLE, MARTIN 1952-
Biographical dictionaries:
Art books and catalogs: NPE
Triptych: Conundrum I, Omnidirectional Translator, Conundrum I et tp (co) 1977 NPE: 30
Wan Was Wax ob et (co) 1977 NPE: 29

BOYNTON, JACK (JAMES W.) 1928-
 Biographical dictionaries: WAA 62, 66, 70, 73, 76, 78, 80, 82,
 84, 86, 89-90, 91-92, 93-94, 95-96, 97-98
 Art books and catalogs: THL
 Plate VIII (*from portfolio* Packaged Horizon or a Guided Tour of
 Oblivion) co-li (co) 1967 THL: 42

BRACH, PAUL HENRY 1924-
 Biographical dictionaries: WAA 70, 73, 76, 78, 80, 82, 84, 86,
 89-90, 91-92, 93-94, 95-96, 97-98
 Art books and catalogs: PNM, THL
 Sandia co-li (co) 1980 PNM: 101
 Silver Series co-li (co) 1965 THL: 34

BRADFORD, HOWARD 1919-
 Biographical dictionaries: WAA 62, 66, 70, 73, 76, 78, 80, 82,
 84, 86, 89-90, 91-92, 93-94, 95-96, 97-98
 Art books and catalogs: LAP
 Suspended Seawave sk 1956 LAP: 66/103

BRADY, RICHARD 1947-
 Biographical dictionaries:
 Art books and catalogs: RBW
 Tiger Lilies li 1981 RBW: [9]

BRANTS, CYNTHIA 1924-
 Biographical dictionaries:
 Art books and catalogs: FWC
 Deserted House et sf sp bn c.1947 FWC: 19
 Family Group aq bn et c.1951 FWC: 20

BRATT, BYRON H. 1952-
 Biographical dictionaries: WAA 97-98
 Art books and catalogs: PNW
 Gaia and Uranus hc-mz (co) 1989 PNW: **31**
 Random Order hc-mz (co) 1989 PNW: 32
 Three Graces hc-mz (co) 1989 PNW: 33

BRAVO, CLAUDIO 1936-
 Biographical dictionaries:
 Art books and catalogs: TWO
 Fur Coat Front and Back li dp 1976 TWO: 102

BREIGER, ELAINE 1938-
 Biographical dictionaries: WAA 73, 76, 78, 80, 82, 84, 86, 89-
 90, 91-92, 93-94, 95-96, 97-98
 Art books and catalogs: TYA
 Homage to Ben Cunningham VII et (co) 1975 TYA: **25**

BREKKE, MICHAEL 1943-
 Biographical dictionaries:
 Art books and catalogs: GAP
 Passage VII mp 1985 GAP: 18/29

BRICE, WILLIAM JULES 1921-
 Biographical dictionaries: WAA 53, 56, 62, 66, 70, 73, 76, 78,
 80, 82, 84, 86, 89-90, 91-92, 93-94, 95-96, 97-98
 Art books and catalogs: INN, LAP
 Striped Robe li 1961 LAP: 68/104
 Untitled #2 co-li (co) 1989 INN: **14**

BRILL, GLENN F. 1949-
 Biographical dictionaries: WAA 89-90, 91-92, 93-94, 95-96, 97-
 98
 Art books and catalogs: NPE
 Cranbrook Series, Black Hanging #1 li ce 1978 NPE: 31
 Cranbrook Series, Collage #5 li ce hc hd (co) 1978 NPE: 32

BRIMBERRY, KATHERINE 1949-
 Biographical dictionaries:
 Art books and catalogs: FTP
 Haiku at Our Feet in sl sf wg aq wo (co) FTP: **29**

BROKL, ROBERT
 Biographical dictionaries:
 Art books and catalogs: NCP
 Weeping Willow wb 1986 NCP: 18

BRONER, ROBERT 1922-
Biographical dictionaries: WAA 59, 62, 66, 70, 73, 76, 78, 80,
 82, 84, 86, 89-90, 91-92, 93-94, 95-96, 97-98
Art books and catalogs: TYA
Quarry et aq 1962 TYA: 24

BROODTHAERS, MARCEL 1924-76
Biographical dictionaries:
Art books and catalogs: TWO
Museum sk 1972 TWO: 75

BROOKS, JAMES 1906-92
Biographical dictionaries: WAA 40-41, 53, 56, 59, 62, 66, 70,
 73, 76, 78, 80, 82, 84, 86, 89-90, 91-92
Art books and catalogs: TYA
Springs li 1971 TYA: 24

BROWN, JAMES 1951-
Biographical dictionaries: WAA 80, 82, 84, 86, 89-90, 91-92,
 93-94, 95-96, 97-98
Art books and catalogs: PRO
Japanese Room Drawings (*four from suite of 10*) li ch hm 1988
 PRO: clp11

BROWN, JOAN 1938-90
Biographical dictionaries: WAA 66
Artbooks and catalogs: PWP
Donald li 1983 PWP: clp**13**/111

BROWN, RAY 1933-
Biographical dictionaries:
Art books and catalogs: LAP, TYA
Alice N.S. co-et (co) 1975 LAP: 93/108
Figure in the Art et aq en 1955 TYA: 26

BROWN, ROGER 1941
Biographical dictionaries: WAA 76, 86, 89-90, 91-92, 93-94,
 95-96, 97-98

Art books and catalogs: CHI, PIA

1986 Navy Pier co-li sk (co) 1986 CHI: 53

Airplane xx hd ce 1968 CHI: 44

Cathedrals of Space co-li sk (co) 1983 CHI: 53

Colorado Condos li 1981 CHI: 52

Così Fan Tutte co-li (co) 1979 CHI: 50

Disasters co-of-li (co) 1972 CHI: 55

False Image (*poster/invitation for 1*[st] *"False Image" group exhibition*) of-li ds 1968 CHI: 204

False Image (*price list for 1*[st] *"False Image" group exhibition*) of-li 1968 CHI: 206

False Image (*price list for 2*[nd] *"False Image" group exhibition*) of-li 1969 CHI: 207

False Image Decals (*created by Roger Brown, Eleanor Dube, Philip Hanson, and Christina Ramberg*) co-sk pp (co) 1969 CHI: **36**, 207

False Image II (*based on exquisite corpse by Roger Brown, Eleanor Dube, Philip Hanson, and Christina Ramberg*) co-of-li (co) 1969 CHI: 206

False Image Postcards (*created by Roger Brown, Eleanor Dube, Philip Hanson, and Christina Ramberg*) co-of-li (co) 1968 CHI: 204-5

Family Tree Mourning Print co-wo (co) 1987 CHI: 54

Famous Artists from Chicago co-of-li (co) 1970 CHI: 54

Female Legs xx hd ce 1968 CHI: 44

Giotto in Chicago co-li ph (co) 1981 CHI: 51

i of the storm li 1979 CHI: 49

Indian Hands et 1968 CHI: 45

Indian Lightning co-sk (co) 1967 CHI: 42

Introduction to an out-of-town girl et aq pp 1968 CHI: 47

Liberty inviting artists to take part in an exhibition against international leftist terrorists et 1983 CHI: 52

Little Nimbus co-li (co) 1979 CHI: 49

Magic co-sk (co) 1967 CHI: 43

Male Legs xx hd ce 1968 CHI: 44

Mother and Child li 1986 CHI: 54

Obelisk co-li (co) c.1971 CHI: 45

Pre-View co-of-li (co) 1970 CHI: 54

Purple Passion in the South Sea et 1968 CHI: 45

Rain Print co-sk (co) 1967 CHI: 43

Roads co-sk (co) 1967 CHI: 42

Roger Brown/Art Green (*based on exquisite corpse by Roger Brown and Art Green*) of-li 1973 CHI: 208

Rolling Meadows li 1979 CHI: 49

Shit to Gold tf-pa-li 1986 CHI: 52

Shoelaces sk (co) 1967 CHI: 42

short introduction et aq 1968 CHI: 47

short Introduction to a lady in a red dress et aq hc-wc dp (co) 1968 CHI: **22**

Sinking et aq hb 1977 CHI: 48

Sketchbook li ce 1982-83 CHI: 52

Splashes sk (co) 1967 CHI: 43

Standing While All Around Are Sinking et aq hb 1977 CHI: 48 PIA: **167**/117

Theater Row et aq pp 1968 CHI: 46

Three Lightning Bolts co-sk (co) 1967 CHI: 42

Tree in Sunderland co-sk (co) 1980 CHI: **23**, 50

Untitled et 1968 CHI: 45

Untitled sk 1968-69 CHI: 43

Visions/Painting and Sculpture: Distinguished Alumni of the School of the Art Institute of Chicago co-of-li (co) 1976 CHI: 55

Which Way Is Up? li 1979 CHI: 49

BROWNE, VIVIAN E. 1929-93
Biographical dictionaries: WAA 78, 80, 82, 84, 86, 89-90, 91-92, 93-94
Art books and catalogs: RBW
Ti-Tan li dp 1973 RBW: [9]

BUCK, JOHN E. 1946-
Biographical dictionaries: WAA 91-92, 93-94, 95-96, 97-98
Art books and catalogs: AAP, ACW, FIM, PAP, PIA
Beirut wo 1983 AAP: 45
Father & Son wo hm (co) 1985 PAP: 37 PIA: **189**/119
Les Grande Eclipse co-wo (co) 1982 FIM: **121** ACW: **84**, 129

BUENO, JOSE *see* GOODE, JOE

BUMBECK, DAVID ANTHONY 1940-
 Biographical dictionaries: WAA 73, 76, 78, 80, 82, 84, 86, 89-
 90, 91-92, 93-94, 97-98
 Art books and catalogs: NPE
 Actress pe aq en et sp bn 1977 NPE: 33
 Moods of Miss J pe aq en et ob sp bn (co) 1978 NPE: 34

BURCHFIELD, CHARLES EPHRAIM 1893-1967
 Biographical dictionaries: WAA 36-37, 40-41, 40-47, 53, 56,
 59, 62, 66
 Art books and catalogs: AML, GRE
 Autumn Wind li 1951 GRE: clp*107*
 Summer Benediction li 1951-52 AML: 151

BURGESS, CHERYL 1955-
 Biographical dictionaries:
 Art books and catalogs: GAP, MCN
 Beast Series: Untitled mp pp 1984 GAP: 16-17/29
 Temptations mo pp (co) 1989 MCN: **[5]**

BURKERT, ROBERT RANDALL 1930-
 Biographical dictionaries: WAA 73, 76, 78, 80, 82, 84, 86, 89-
 90, 91-92, 93-94, 95-96, 97-98
 Art books and catalogs: WAT
 December Woods co-sk (co) 1962 WAT: **274**

BURKHARDT, HANS GUSTAV 1904-94
 Biographical dictionaries: WAA 59, 62, 66, 70, 73, 76, 78, 80,
 82, 84, 86, 89-90, 91-92, 93-94
 Art books and catalogs: AML, LAP
 Destruction li 1948 AML: 162
 Lovers li 1948 LAP: 57/102

BURY, POL 1922-
 Biographical dictionaries:
 Art books and catalogs: TWO
 Circle and Ten Triangles, Yellow-Black wo (co) 1976 TWO: **55**

BUSH, SUSAN 1946-
Biographical dictionaries:
Artbooks and catalogs: PWP
Memories—Cornucopia with Framed Bouquet mo-oi tf (co) 1989
PWP: clp78/112

BUTLER, JAMES D. 1945-
Biographical dictionaries: WAA 78, 80, 82, 84, 86, 89-90, 91-
92, 93-94, 95-96, 97-98
Art books and catalogs: ESS
Hydra li ESS: [8]

BYARD, CAROLE MARIE 1941-
Biographical dictionaries: WAA 76, 78, 80, 82, 84, 86, 89-90,
91-92, 93-94, 95-96, 97-98
Art books and catalogs: RBW
Thoughts: May Your Aspirations Unfold in Ascensions Ways li
1975 RBW: [10]

BYRON, MICHAEL 1954-
Biographical dictionaries: WAA 91-92, 93-94, 95-96, 97-98
Art books and catalogs: PRO
Untitled (*from series of 10*) co-mo ch hm (co) 1987 PRO: clp12-
13

CADMUS, PAUL 1904-
Biographical dictionaries: WAA 36-37, 40-41, 40-47, 53, 56,
62, 66, 70, 73, 76, 78, 80, 82, 84, 86, 89-90, 91-92, 93-94,
95-96, 97-98
Art books and catalogs: APP, INP
Going South [Bicycle Riders] et 1934 APP: 50
Rehearsal hg 1984 INP: 9

CAGE, JOHN 1912-92
Biographical dictionaries: WAA 78, 80, 82, 84, 86, 89-90, 91-
92
Art books and catalogs: AAP, AMI, APP, PAP, SIM
Fire #9 mo 1985 SIM: 156
Fire #10 mo 1985 PAP: 38

Not Wanting to Say Anything About Marcel co-li (co) 1969 AMI: clp104
Not Wanting to Say Anything about Marcel, Plexigram I sc pt 1969 APP: 164
When R=Ryoanji dr pp 1983 AAP: 46

CALDER, ALEXANDER 1898-1976
Biographical dictionaries: WAA 40-41, 40-47, 53, 56, 59, 62, 66, 70, 73, 76
Art books and catalogs: AMI, APP, WAT
Big I sf 1944 WAT: 152
Flying Saucers li 1968 APP: 129
Score for Ballet 0-100 (*from portfolio* VVV) en 1942 AMI: clp12

CAMBLIN, BOB BILYEU 1928-
Biographical dictionaries: WAA 78, 80, 82, 84
Art books and catalogs: FTP
Gone Fishing et 1989 FTP: **31**

CAMPBELL, NANCY B. 1952-
Biographical dictionaries: WAA 93-94, 95-96, 97-98
Artbooks and catalogs: AGM, CIP
Cremorne Lights li sc (co) 1980 AGM: **56**
Fitting li sc hc hm (co) 1984 AGM: **57**
Tsubasa co-sc (co) 1988 CIP: **13**

CAPOBIANCO, DOMENICK (DAVID) 1928-
Biographical dictionaries: WAA 82, 84, 86, 89-90, 91-92, 93-94, 95-96, 97-98
Art books and catalogs: TYA
B.A.L.L.& S. li sk 1976 TYA: 26

CAPOREAL, SUZANNE 1949-
Biographical dictionaries: WAA 93-94, 95-96, 97-98
Artbooks and catalogs: PWP
White Horse li 1990 PWP: clp17/112

CAPPS, CHARLES MERRICK 1898-1981
Biographical dictionaries: WAA 36-37, 40-41, 40-47, 53, 56, 62

Art books and catalogs: KSP
Into the Hills aq et 1949 KSP: 77/74
Mission at Trampas aq et 1949 KSP: 78/74
Taos aq et KSP: 76/74
Trees at Questa et KSP: 75

CARD, GREG S. 1945-
Biographical dictionaries: WAA 76, 78, 80, 82, 84, 86
Art books and catalogs: LAP
Untitled sk px 1972 LAP: 91/107

CARNWATH, SQUEAK 1947-
Biographical dictionaries: WAA 82, 84, 86, 89-90, 91-92, 93-94, 95-96, 97-98
Artbooks and catalogs: INN, INP, PWP
Unknown Quantities co-li (co) 1991 INN: **6**
We All Want to Believe hg sf aq 1989 INP: 17 PWP: clp16/112

CARSMAN, JON 1944-
Biographical dictionaries:
Art books and catalogs: TYA
Asbury Reflections sk 1976 TYA: 26

CARSON, DAVID 1956-
Biographical dictionaries:
Art books and catalogs:
See also:
Blackwell, Lewis, and David Carson. *The End of Print: The Graphic Design of David Carson.* San Francisco: Chronicle Books, 1995.

CARTER, NANETTE CAROLYN 1954-
Biographical dictionaries: WAA 86, 89-90, 91-92, 93-94, 95-96, 97-98
Artbooks and catalogs: PWP
Moonlight Shadow #2 mo (co) 1989 PWP: clp75/112

CASARELLA, EDMOND 1920-
Biographical dictionaries: WAA 66, 70, 73, 76, 78, 80, 82, 84,

86, 89-90, 91-92, 93-94, 95-96, 97-98
Art books and catalogs: ACW, APP, WAT
Moment of Panic pa-re (co) 1954 ACW: **49**, 111 WAT: **142**
Rock Cross cd 1955 APP: 136
Triggered cd-re (co) 1959 APP: clp6

CASTELLÓN, FEDERICO 1914-71
 Biographical dictionaries: WAA 40-41, 40-47, 53, 56, 59, 62,
 66, 70
 Art books and catalogs: APP, PAC, PNM, TYA
 China [Title Page] et c.1946 TYA: 27
 Memories li c.1940 PAC: [14]/71
 Mimi as a Florentine et 1965 APP: 225
 Roman Urchins et 1953 TYA: 27
 Spanish Landscape li 1938 APP: 80
 Taos Tryst et c.1942 PNM: 41
 See also:
 Freundlich, August L. *Federico Castellón: His Graphic Works,*
 1936-1971 (exhibition catalog). Syracuse, N.Y.: Syracuse
 University, 1978.

CASTRILLO, REBECCA 1954-
 Biographical dictionaries: WAA 95-96, 97-98
 Art books and catalogs: RBW
 Cancion Del Embryo et 1978 RBW: [10]

CATLETT, ELIZABETH (MORA) 1919-
 Biographical dictionaries: WAA 76, 78, 80, 82, 86, 89-90, 91-
 92, 93-94, 95-96, 97-98
 Art books and catalogs: BAG, RBW
 Lovey Twice li 1969 BAG: 48/23
 My Reward has been bars between me and the rest of the Land lc
 1946 BAG: 17/23
 Portrait in Black li 1978 RBW: [10]

CAULFIELD, PATRICK 1936-
 Biographical dictionaries:
 Art books and catalogs: TPI, TWO
 Café co-sc (co) 1968 TPI: 80

Lampshade co-sc (co) 1969 TPI: **28**
Letter co-sc (co) 1967 TPI: 80
Sweet Bowl sk 1967 TWO: 48

CELMINS, VIJA **1939-**
Biographical dictionaries:
Art books and catalogs: AAP, AGM, ENP, LAP, PAP, PIA,
TYA
Alliance aq dr mz 1983 AGM: **63**
Concentric Bearings B aq dr mz 1983 AGM: **62**
Concentric Bearings D dr aq pv mz bn 1984 PAP: 39
Drypoint-Ocean Surface dr 1983 AGM: **61**
Strata mz 1982 AAP: 47
Untitled li 1971 ENP: *abc* LAP: 84/106
Untitled li 1975 TYA: 27
Untitled Galaxy et 1986 AGM: **4**/60
View (*two of 4*) mz 1985 PIA: **190**/119-20

CHAFETZ, SIDNEY **1922-**
Biographical dictionaries: WAA 73, 76, 78, 80, 82, 84, 86, 89-
90, 91-92, 93-94, 95-96, 97-98
Art books and catalogs: ACW, WAT
Freud wo 1963 WAT: 292
Mio, Milhaud co-wo (co) 1955 ACW: **63**, 119

CHAGOYA, ENRIQUE **1953-**
Biographical dictionaries: WAA 95-96, 97-98
Art books and catalogs: SIM
Life Is a Dream, Then You Wake Up co-mo hm (co) 1995 SIM:
177

CHAN, JUDY
Biographical dictionaries:
Art books and catalogs: NCP
Time Series, No. 3 li tl 1986 NCP: 9

CHASE, LOUISA L. **1951-**
Biographical dictionaries: WAA 82, 84, 86, 89-90, 91-92, 93-
94, 95-96, 97-98

Art books and catalogs: AAP, ACW, AGM, AMI, IAI, PAP,
 PFB, PIA, PRO, PWP
Black Sea wo (co) 1983 PFB: 23/8
Cave wo 1981 IAI: **18**
Chasm wo (co) 1982-83 AAP: 48 AMI: clp**146** IAI: **17**
Portfolio of Six Untitled Etchings dr aq sb 1984 PAP: 40
Red Sea wo hc (co) 1983 ACW: **82**, 128 AGM: **67** PIA: **182**/119
Squall wo 1981 IAI: **18**
Thicket wo (co) 1983 AGM: **66**
Untitled co-et aq (co) 1988 PRO: clp15-17
Untitled li 1988 PWP: clp65/112
Untitled [Water] et sb dr (co) 1984 IAI: **20**

CHENG, AMY I. 1956-
 Biographical dictionaries:
 Artbooks and catalogs: PWP
 Untitled mo ch (co) 1989 PWP: clp**40**/112

CHENG, EMILY 1953-
 Biographical dictionaries: WAA 89-90, 91-92, 93-94, 95-96, 97-
 98
 Artbooks and catalogs: PWP
 Untitled mo 1987 PWP: clp**35**/112

CHERRY, HERMAN 1909-92
 Biographical dictionaries: WAA 40-47, 53, 56, 62, 73, 76, 82,
 84, 86, 89-90, 91-92
 Art books and catalogs: RBW
 Untitled mo 1982 RBW: [11]

CHESEBRO, ERIC 1971-
 Biographical dictionaries:
 Art books and catalogs: PNW
 Eight Generation Shape in a Successive Randomization of a Cubic
 Torus dr et aq (co) 1996 PNW: **35**
 Random Chair #4 et 1995 PNW: 37

CHESNEY, LEE R., JR. 1920-
 Biographical dictionaries: WAA 59, 62, 66, 70, 73, 76, 78, 80,

82, 84, 86, 89-90, 91-92, 93-94, 95-96, 97-98
Art books and catalogs: TYA, WAT
Engraving 1952 en 1952 TYA: 28
Pierced and Beset co-in (co) 1952 WAT: 218

CHEW, CARL T. 1948-
Biographical dictionaries:
Art books and catalogs: TYA
MN-O cg 1975 TYA: 28
(PS) cg 1975 TYA: 28

CHICAGO, JUDY 1939-
Biographical dictionaries: WAA 73, 76, 78, 80, 82, 84, 86, 89-
90, 91-92, 93-94, 95-96, 97-98
Art books and catalogs: AWP, PNM
Creation co-sk (co) 1985 PNM: clp35
Peeling Back li pf 1974 AWP: [5]

CHILDS, BERNARD 1910-
Biographical dictionaries:
Artbooks and catalogs: APP, ENP
Eyeball of the Sun (*from* Images from Hawaiian Legends) in-cg
(co) 1968 APP: clp24
Images from Hawaiian Legends—Puëo Alii, King of the Owls in
1971 ENP: *abc*

CHILLA, BENIGNA 1940-
Biographical dictionaries:
Artbooks and catalogs: ENP
Plan and Form et 1971 ENP: *abc*

CHILLIDA, EDUARDO 1924-
Biographical dictionaries:
Art books and catalogs: TWO
Aundi II aq 1970 TWO: 109

CHRISTO (JAVACHEFF) 1935-
Biographical dictionaries: WAA 73, 76, 78, 80, 82, 84, 86, 89-
90, 91-92, 93-94, 95-96, 97-98

Art books and catalogs: AKG, AMI, ENP, TWO, TYA

Allied Chemical Tower, Rear li 1971 ENP: *abc*

MOMA (Rear) (*from* (some) Not Realized Projects) li ce 1971 TWO: 73

Whitney Museum Wrapped [Wrapped Whitney] (*from portfolio* (Some) Not Realized Projects) co-li ce (co) 1971 AMI: clp116 TYA: 29

Wrapped Monument to Leonardo co-li (co) 1970 AKG: clp2

See also:

Christo. *Christo and Jeanne-Claude, Prints and Objects, 1963-1995: A Catalogue Raisonné.* 2nd ed. Munchen; New York: Edition Schellmann; Schirmer Mosel Verlag, 1995.

Hovdenakk, Per. *Christo: Complete Editions, 1964-1982.* New York: New York University Press, 1982.

CHRYSSA, (VARDEA) 1933-

Biographical dictionaries: WAA 66, 70, 73, 76, 78, 80, 82, 84, 86, 89-90, 91-92, 93-94, 95-96, 97-98

Art books and catalogs: AMI

Weather Map (*from* Newspaper Book) ph fb 1962 AMI: clp84

CHRZANOWSKI, ROMOLA 1946-

Biographical dictionaries:

Art books and catalogs: NPE

Untitled et aq sf (co) 1977 NPE: 36

CITRON, MINNA WRIGHT 1896-1991

Biographical dictionaries: WAA 36-37, 40-41, 40-47, 53, 56, 62, 66, 70, 73, 76, 78, 80, 82, 84, 86, 89-90, 91-92

Art books and catalogs: AWP

Urban-Mystique pe aq zn 1973 AWP: [6]

CLARK, CLAUDE 1915-

Biographical dictionaries: WAA 56, 62, 78, 80, 82, 84, 86, 89-90, 91-92, 93-94, 95-96, 97-98

Artbooks and catalogs: BAG

Boogie Woogie li 1935-42 BAG: 36/23

CLARKE, ALLAN HUGH 1920-

Biographical dictionaries:

Art books and catalogs: RBW
Untitled mo 1982 RBW: [11]

CLARKE, JOHN CLEM 1937-
Biographical dictionaries: WAA 73, 76, 78, 80, 82, 84, 86, 89-
90, 91-92, 93-94, 95-96, 97-98
Art books and catalogs: AMI
Color Abstract sk (co) 1972 AMI: clp112

CLEMENTE, FRANCESCO 1952-
Biographical dictionaries: WAA 86, 89-90, 91-92, 93-94, 95-96,
97-98
Art books and catalogs: AMI, IAI, PIA, PRO
I wo (co) 1982 IAI: **25**
Not St. Girolamo et dr (co) 1981 IAI: **23**
Self-Portrait #2 [Teeth] et 1981 IAI: **26**
Self-Portrait #3 [Pincers] et 1981 IAI: **26**
Tondo et aq (co) 1981 AMI: clp151
Untitled mo (co) 1983 IAI: **24**
Untitled (*portfolio of 5*) sf 1987 PIA: **203**/121 PRO: clp21

CLINE, CLINTON CLIFFORD 1934-
Biographical dictionaries: WAA 78, 80, 82, 84, 86, 89-90, 91-
92, 93-94, 95-96, 97-98
Art books and catalogs: CUN
Emerging Target mo (co) 1991 CUN: **81**
Hot and Cold Winds li 1982 CUN: 10
Shifting Target mo (co) 1991 CUN: **80**
Vergio in 1968 CUN: 11

CLINTON, PAUL ARTHUR 1942-
Biographical dictionaries: WAA 82, 84, 86, 89-90, 91-92, 93-
94, 95-96, 97-98
Art books and catalogs: NPE
Cave Painting li (co) 1976 NPE: **37**
Lithophyte [Blue II] li bp hc hd (co) 1977 NPE: 38

CLOSE, CHUCK 1940-
Biographical dictionaries: WAA 73, 76, 78, 80, 82, 84, 86, 89-

90, 91-92, 93-94, 95-96, 97-98

Art books and catalogs: ACW, AMI, APM, APP, BWS, CMZ, ENP, FIM, PAP, PIA, POR, PPP, TWO, WAT

Georgia hm-mt 1984 PAP: 41

Janet rv-lc (co) 1988 ACW: **87**, 130

Keith mz ce 1972 AMI: clp110 CMZ: [49]/28 ENP: *abc* FIM: **83** PIA: **151**/115 PPP: 64-67, 69 TWO: 101

Phil li 1981 BWS: 11/30

Self Portrait hg aq 1977-78 APM: 23/12 APP: 243 POR: 268 WAT: 258

See also:

Close, Chuck. *Chuck Close: Editions: A Catalog Raisonné and Exhibition: Youngstown, Ohio, September 17th - November 26th, 1989.* Youngstown, Oh.: The Butler Institute of American Art, 1989.

COBITZ, JOAN **1933-**
Biographical dictionaries:
Art books and catalogs: GAP
Couple et 1983 GAP: 19/29

COLANGELO, CARMON **1957-**
Biographical dictionaries:
Art books and catalogs: CUN
Hook and Ladder li 1990 CUN: 16
Rotation li (co) 1990 CUN: **82**
Trophies li 1990 CUN: 15
Upside Down Cake li (co) 1990 CUN: **81**

COLESCOTT, WARRINGTON WICKHAM **1921-**
Biographical dictionaries: WAA 53, 56, 59, 62, 66, 70, 73, 76, 78, 80, 82, 84, 86, 89-90, 91-92, 93-94, 95-96, 97-98
Art books and catalogs: CUN, EIE, PIA, TYA, WAT
Attack and Defense at Little Bohemia co-in (co) 1966 WAT: **272**
Birdbrain (*illustration for "Birdbrain," a poem by Allen Ginsberg*) et 1985 CUN: 20
History of Printmaking: Goya Studies War et 1976 TYA: 29
History of Printmaking: S.W. Hayter Discovers Viscosity Printing co-in co-et (co) 1976 PIA: 26 TYA: **bcv**/4 WAT: **273**

Judgment Day at NEA co-et (co) 1991 CUN: **83**
Life and Times of Prof. Dr. S. Freud et wo (co) 1989 CUN: **84**
Raft of the Titanic co-et (co) 1988 CUN: 19
Tremble Sin City (San Andreas Fault) et EIE: 9
Triumph of St. Valentine co-in (co) 1963 WAT: **271**

CONDESO, ORLANDO 1947-
Biographical dictionaries: WAA 78, 80, 82, 84, 86, 89-90, 91-
92, 93-94, 95-96, 97-98
Artbooks and catalogs: ENP
And Only the Wind... en em 1971 ENP: *abc*

CONN, DAVID EDWARD 1941-
Biographical dictionaries: WAA 78, 80, 82, 84, 86, 89-90, 91-
92, 93-94, 95-96, 97-98
Art books and catalogs: FTP
Hobo Signs Portfolio rg 1981 FTP: **33**

CONNER, ANN 1948-
Biographical dictionaries: WAA 86, 89-90, 91-92, 93-94, 95-96,
97-98
Art books and catalogs: ACW
Silverado co-wo (co) 1986 ACW: **81**, 127

CONNER, BRUCE 1933-
Biographical dictionaries: WAA 70, 73, 76, 78, 80, 82, 84, 86,
89-90, 91-92, 93-94, 95-96, 97-98
Art books and catalogs: FIM
Mandala li (co) 1965 FIM: **55**
Thumb Print li 1965 FIM: **56**

CONOVER, ROBERT FREMONT 1920-
Biographical dictionaries: WAA 70, 73, 76, 78, 80, 82, 84, 86,
89-90, 91-92, 93-94, 95-96, 97-98
Art books and catalogs: ACW, APP, PFB, TYA
Anger co-wo (co) 1965 PFB: 3/8
Collision wo 1958 APP: 94
Early Spring cd-re 1976 TYA: 30
Tree wo (co) 1959 ACW: **53**, 113

CONSUEGRA, HUGO 1929-
Biographical dictionaries: WAA 73, 76, 78, 80
Artbooks and catalogs: ENP
Quartet—Opus ii sk 1972 ENP: *abc*

COOK, GORDON SCOTT 1927-85
Biographical dictionaries:
Art books and catalogs: TYA
Headlands V et en 1965 TYA: 30

COOPER, RON(ALD) 1943-
Biographical dictionaries: WAA 76, 78, 80, 82, 84, 86, 89-90,
 91-92, 93-94, 95-96, 97-98
Art books and catalogs: LAP
Tri-axial Rotation of a Floating Volume of Light co-li (co) 1972
 LAP: 90/107

CORITA, SISTER MARY, IHM 1918-86
Biographical dictionaries: WAA 70, 73, 76
Art books and catalogs: LAP, WAT
This Beginning of Miracles co-sk (co) 1953 LAP: **65**/103 WAT:
 144

CORNELL, THOMAS BROWNE 1937-
Biographical dictionaries: WAA 80, 82, 84, 86, 89-90, 91-92,
 93-94, 95-96, 97-98
Art books and catalogs: TYA
Pig en 1975 TYA: 31
Resting Women et 1975 TYA: 31

CORRIGAN, DENNIS
Biographical dictionaries:
Art books and catalogs: ENP, TYA
President Nixon Hiding in a Small Town cf 1974 TYA: 31
Queen Victoria Troubled by Flies cf 1972 ENP: *abc*

CORTESE, DON F. 1934-
Biographical dictionaries: WAA 78, 80, 82, 84, 86, 89-90, 91-

92, 93-94, 95-96, 97-98
Art books and catalogs: CUN
Grigenti Scroll mp lp ce hm (co) 1990 CUN: **84-85**
Take-Hon mp hm fr 1988 CUN: 23
"Take-Mado" Bamboo Curtain et hm fa fr pp (co) 1988 CUN: **85**
Take-Rinmom mp et hm fr 1987 CUN: 24

CORTRIGHT, STEVEN M. **1942-**
Biographical dictionaries: WAA 76, 78, 80, 82, 84, 86, 89-90,
91-92, 93-94, 95-96, 97-98
Artbooks and catalogs: ENP
Insert Series VIII li re 1969 ENP: *abc*

COSTAN, CHRIS **1950-**
Biographical dictionaries: WAA 89-90, 91-92, 93-94, 95-96, 97-
98
Artbooks and catalogs: INP, PWP
Announcement sb sl hg aq ce 1989 INP: 14
Misappropriate mo ch 1990 PWP: clp25/112

COTTEN, WALTER **1946-**
Biographical dictionaries:
Art books and catalogs: TYA
Untitled sk dp 1975 TYA: 31

COTTINGHAM, ROBERT **1935-**
Biographical dictionaries: WAA 78, 80, 82, 84, 86, 89-90, 91-
92, 93-94, 95-96, 97-98
Art books and catalogs: PIA, TYA, WAT
Fox co-li (co) 1973 PIA: **153**/115 WAT: **214**
Hot li 1973 TYA: 32

CRABB, JAMES **1947-**
Biographical dictionaries:
Art books and catalogs: NPE
Departure #8 aq et dr en (co) 1977 NPE: 40
No Deposit, No Return aq et dr en NPE: 39

CRANE, GREGORY 1951-
Biographical dictionaries:
Art books and catalogs: INP
Clematis/Agave (*from* Crane's Botanicals) sf hg sb wc-hc (co)
 1989-90 INP: 13

CRANE, PAULA H.
Biographical dictionaries:
Art books and catalogs: CUN, GAR
Greetings from Green River sk (co) 1988 CUN: **87**
In the Eye of the Storm sk 1986 CUN: 29
Neo-Colorado sk 1988 CUN: 27
Outside In co-ps (co) 1981 GAR: 25
Strangers in a Strange Land sk (co) 1989 CUN: **86**

CRAWFORD, RALSTON 1906-78
Biographical dictionaries: WAA 36-37, 40-41, 40-47, 53, 56,
 59, 62, 66, 70, 73, 76, 78
Art books and catalogs: AMI, APP, TCA
Cologne Landscape, No.12 li 1951 APP: 97
Third Avenue El, No. 1 li (co) 1952 AMI: clp**26**
Third Avenue Elevated #1 li (co) 1951 TCA: [**38**]

CREMEAN, ROBERT 1932-
Biographical dictionaries: WAA 66, 70, 73, 76, 78
Art books and catalogs: LAP
Fourteen Stations of the Cross (*one from suite of 14*) co-li (co)
 1966-67 LAP: 73/105

CRILE, SUSAN 1942-
Biographical dictionaries: WAA 78, 80, 82, 84, 86, 89-90, 91-
 92, 93-94, 95-96, 97-98
Art books and catalogs: AAP, AGM, CIP, PWP
Buskirk Junction wo (co) 1982 AGM: **70**
Echo co-sc (co) 1989 CIP: **16**
Expansion li (co) 1981 AGM: **71**
Oculus co-sc (co) 1988 CIP: **15** PWP: clp33/112
Palio co-sc (co) 1989 CIP: **17**
Renvers on Two Tracks wo dp (co) 1982 AAP: 49 AGM: **69**

CROSSGROVE, ROGER LYNN 1917-
Biographical dictionaries: WAA 53, 56, 62, 66, 70, 73, 76, 78, 80, 82, 84, 86, 89-90, 91-92, 93-94, 95-96, 97-98
Art books and catalogs: SIM
Three Athletes [Vaulters VIII] wc-mo (co) 1979 SIM: **183**

CRULL, FORD 1952-
Biographical dictionaries:
Art books and catalogs: INP, PAP
Le Rêve aq sf sl go wc-hc (co) 1989 INP: 14
Prophet mo 1985 PAP: 42

CRUTCHFIELD, WILLIAM RICHARD 1932-
Biographical dictionaries: WAA 70, 73, 76, 78, 80, 82, 84, 86, 89-90, 91-92, 93-94, 95-96, 97-98
Art books and catalogs: LAP, TCR
Burial at Sea li (co) 1978 TCR: **110**, **115**
Cubie Smoke li (co) 1978 TCR: **115**
Diamond Express li (co) 1978 TCR: **115**
Elevated Smoke li (co) 1978 TCR: **114**
Tamarind-Tanic co-li (co) 1970 LAP: 83/106
Trestle Trains li (co) 1978 TCR: **114**
Zeppelin Island li wc (co) 1977 TCR: **114**

CUEVAS, JOSÉ LUIS 1934-
Biographical dictionaries: WAA 73, 76, 78, 80, 82, 84, 86, 89-90, 91-92, 93-94, 95-96, 97-98
Art books and catalogs: THL
"Music Is a Higher Relevation Than Philosophy" Beethoven co-li (co) 1966 THL: 51

CUILTY, LIA 1908-78
Biographical dictionaries:
Art books and catalogs: FWC
False Flags et sf aq c.1945 FWC: 22
Fruit et sf 1957 FWC: 23
Shells et sf aq 1950 FWC: 23
Untitled [Daphne] [*working proof*] et gr c.1943 FWC: 21

CUMMING, ROBERT H. 1943-
 Biographical dictionaries: WAA 76, 78, 80, 82, 84, 86, 89-90,
 91-92, 93-94, 95-96, 97-98
 Art books and catalogs: ACW, PIA, PAP, PRO, SIM
 Adirondack Chair I mo hm 1988 PRO: clp18
 Adirondack Chair V co-mo hm (co) 1988 PRO: clp19
 Adirondack Chair XI co-mo hm (co) 1988 PRO: clp20
 Alexandria wo hm (co) 1989 PIA: **211**/122
 Burning Box co-wo (co) 1989 ACW: **85**, 129
 Two Frame Arc li sc 1985 PAP: 43
 Untitled [Cup] co-mo (co) 1987 SIM: **157**

CUNNINGHAM, (CHARLES) BRUCE 1943-
 Biographical dictionaries: WAA 76, 78, 80, 82, 84, 86, 89-90,
 91-92, 93-94, 95-96, 97-98
 Art books and catalogs: GAR
 Texas High Line/Low Line co-li (co) 1980 GAR: 23

CUNNINGHAM, DENNIS 1949-
 Biographical dictionaries:
 Art books and catalogs: PNW
 N.W. Notgelt lc dp (co) 1992 PNW: **39**
 Pesca Cabeza #7 lc 1983 PNW: 41
 Trout Need Trees lc 1996 PNW: 40

CUNNINGHAM, E.C. (ELDON LLOYD) 1956-
 Biographical dictionaries: WAA 91-92, 93-94, 95-96, 97-98
 Art books and catalogs: CUN
 Beach House with Claw in re (co) 1990 CUN: **88**
 Fried Egg House in re 1990 CUN: 32
 From Poughkeepsie to Soho: A Train Ride mo mx (co) 1988
 CUN: **87**
 Road Work mo xx 1989 CUN: 31

DALLMAN, DANIEL FORBES 1942-
 Biographical dictionaries: WAA 80, 82, 84, 86, 89-90, 91-92,
 93-94, 95-96, 97-98
 Art books and catalogs: TYA

Bath li 1974 TYA: 32
Sunbather li 1973 TYA: 32

DAMER, JACK 1938-
Biographical dictionaries:
Art books and catalogs: NPE, WAT
Fog Mourn II li 1972 WAT: 294
Main Line li (co) 1977 NPE: 41
Xacto Facto li 1977 NPE: 42

DAMER, ROBERT WILLIAM 1948-
Biographical dictionaries:
Art books and catalogs: NPE
1973 Birdnest, Rose, and Capital sc (co) 1977 NPE: **45**
I Bombed the Taj Mahal with Art (What's Steven Got in His
 Hand) sk pp 1976 NPE: 43

DANNER, ROBERT W. 1948-
Biographical dictionaries:
Art books and catalogs: EIE
Airplanes, Bananas, Crayons, and Dragons [*developmental proof*]
 EIE: 11

DARBOVEN, HANNE 1941-
Biographical dictionaries: WAA 78, 80, 82, 84, 86, 89-90, 91-
 92, 93-94, 95-96, 97-98
Art books and catalogs: TWO
Diary NYC February 15 Until March 4, 1974 of 1974 TWO: 94

D'ARCANGELO, ALLAN MATTHEW 1930-
Biographical dictionaries: WAA 66, 70, 73, 76, 78, 80, 82, 84,
 86, 89-90, 91-92, 93-94, 95-96, 97-98
Art books and catalogs: AKG, TPI, WAT
Constellation II sk 1971 AKG: clp73
Landscape No. 3 co-sk (co) 1969 WAT: **210**
Side View Mirror co-sc px (co) 1966 TPI: **30**

DASBURG, ANDREW MICHAEL 1887-1979
Biographical dictionaries: WAA 36-37, 40-41, 40-47, 53, 56,

59, 62, 66, 70, 73, 76, 78
Art books and catalogs: PNM
Ranchos Valley I tf-li 1974 PNM: 85

DASH, ROBERT (WARREN) 1934-
Biographical dictionaries: WAA 62, 66, 70, 73, 76, 78, 80, 82, 84, 86, 89-90, 91-92, 93-94, 95-96, 97-98
Artbooks and catalogs: ENP
Air Is Like a Cryst-O-Mint li 1972 ENP: *abc*

DASS, DEAN ALLEN 1955-
Biographical dictionaries: WAA 84, 86, 89-90, 91-92, 93-94, 95-96, 97-98
Art books and catalogs: AAP, PAP, PRO
Beast in View dr ch ce hd 1983 AAP: 50
WICCE #6 (*from series* WICCE) co-li go tu dm ce hd (co) 1988 PRO: clp22
WICCE #11 (*from series* WICCE) co-li go tu dm (co) 1988 PRO: clp23
Within-Without mp et hc go dm (co) 1985 PAP: 44

DAUPERT, BARBARA 1949-
Biographical dictionaries:
Art books and catalogs: GAP, MCN
Metamorphosis et aq dr dp 1985 GAP: 14/29
Written in the Body [Lizards Ascending] et em 1989 MCN: [7]

DAVID, MICHAEL 1954-
Biographical dictionaries:
Art books and catalogs: PAP, PRO
Blue (*from suite* Invisible Cities) co-wo cg pc hc (co) 1988 PRO: clp24
Red (*from suite* Invisible Cities) co-wo cg pc hc (co) 1988 PRO: clp24
Untitled #8 mo hc oi (co) 1985 PAP: 15, 45
White (*from suite* Invisible Cities) co-wo cg pc hc (co) 1988 PRO: clp24

DAVIDSON, PAUL S. 1951-
Biographical dictionaries:

Art books and catalogs: NPE
Untitled li cy (co) 1977 NPE: 46-47

DAVIS, GENE 1920-85
Biographical dictionaries: WAA 66, 70, 73, 76, 78, 80, 82, 84
Art books and catalogs: AMI
Checkmate li (co) 1972 AMI: clp87

DAVIS, RICHARD THOMAS 1947-
Biographical dictionaries:
Art books and catalogs: NPE
Bottles sk (co) 1976 NPE: **fcv**
Outcrop sk to-sn 1978 NPE: 49

DAVIS, RON(ALD WENDEL) 1937-
Biographical dictionaries: WAA 70, 73, 76, 78, 80, 82, 84, 86,
 89-90, 91-92, 93-94, 95-96, 97-98
Art books and catalogs: ENP, FIM, LAP, TCR, TGX, TYA
Arc Arch sc li hc hm (co) 1979 TCR: **121** TGX: **101**
Arch aq et hc hm (co) 1975 TCR: **118**
Bent Beam aq et hc hm (co) 1975 TCR: **119** TGX: **207**
Big Open Box aq et dr hc hm (co) 1975 TCR: **119**
Cube I pf lm-my-ov pt (co) 1971 FIM: **75**
Cube II pf lm-my-ov pt (co) 1971 FIM: **14**
Four Circle co-li sk (co) 1972 LAP: 91/107
Invert Span sc li hc hm (co) 1979 TCR: **116, 120** TGX: **100**
Pinwheel, Diamond, and Stripe aq in et dr hc-mc-hm (co) 1975
 TCR: **119** TYA: 33
Single Divider li em 1971 ENP: *abc*
Twin Wave sc li hc hm (co) 1979 TCR: **123**
Upright Slab aq et dr en hc hm (co) 1975 TCR: **118**
Wide Wave sc li hc hm (co) 1979 TCR: **122**

DAVIS, STUART 1894-1964
Biographical dictionaries: WAA 36-37, 40-41, 40-47, 53, 56,
 59, 62
Art books and catalogs: AML, APP
Detail Study for Cliché co-li (co) 1957 AML: **183**
Sixth Avenue El li 1931-32 APP: 27

DAVISON, BILL 1941-
> **Biographical dictionaries:** WAA 82, 84, 86, 89-90, 91-92, 93-94, 95-96, 97-98
> **Art books and catalogs:** TYA
> Decoy—Providence Island sc 1976 TYA: 33

DAY, GARY LEWIS 1950-
> **Biographical dictionaries:** WAA 82, 84, 86, 89-90, 91-92, 93-94, 95-96, 97-98
> **Art books and catalogs:** TYA
> Fishing is Another 9-to-5 Job li 1974 TYA: 34

DAY, WORDEN 1916-86
> **Biographical dictionaries:** WAA 40-47, 53, 56, 59, 62, 66, 70, 73, 76, 78, 80, 82, 84, 86
> **Art books and catalogs:** ACW, APP, WAT
> Arcana III co-wo (co) 1954 ACW: **41**, 106 WAT: **140**
> Burning Bush wo 1954 APP: 88
> Mandala II wo (co) 1957 APP: clp**3**

DEHN, ADOLF ARTHUR 1895-1968
> **Biographical dictionaries:** WAA 36-37, 40-41, 40-47, 53, 56, 59, 62, 66
> **Art books and catalogs:** APP
> Mayan Queen li 1961 APP: 53
> **See also:**
> Lumsdaine, Joycelyn Pang. *The Prints of Adolf Dehn: A Catalogue Raisonné.* St. Paul: Minnesota Historical Society Press, 1987.

DEHNER, DOROTHY (MANN) 1901-94
> **Biographical dictionaries:** WAA 40-47, 53, 56, 59, 62, 66, 70, 73, 76, 78, 80, 82, 84, 86, 89-90, 91-92, 93-94
> **Art books and catalogs:** APP
> Lunar Series, No.6 li 1971 APP: 135

DEINES, ERNEST HUBERT 1894-1967
> **Biographical Dictionaries:** WAA 40-41, 40-47, 53, 56, 62, 66

Art books and catalogs: KSP
Joy on Kaw Valley Loam wd-en c.1947 KSP: 16

DE KOONING, ELAINE MARIE CATHERINE 1920-89
Biographical dictionaries: WAA 62, 66, 70, 73, 76, 78, 80, 82, 84, 86
Artbooks and catalogs: AGM, PAP, WAT
Jardin du Luxembourg I co-li (co) 1977 WAT: 252
Lascaux #3 li 1984 AGM: **102**
Lascaux #4 li 1984 AGM: **103**
Torchlight Cave Drawings (*one from portfolio of 8*) aq 1985 PAP: 46

DE KOONING, WILLEM 1904-97
Biographical dictionaries: WAA 66, 70, 73, 76, 78, 80, 82, 84, 86, 95-96
Art books and catalogs: AMI, AMP, APB, APM, APP, APS, ENP, PIA, PPP
Minnie Mouse li 1971-2 APB: clp*116*/43 APM: 4/12 ENP: *abc*
Untitled co-li (co) 1987 AMP: **87**
Untitled li 1960 AMI: clp36
Untitled li 1960 APP: 192
Untitled (*illustration for "Revenge" by Harold Rosenberg, from 21 Etchings and Poems*) et aq 1960 APS: clp2 PPP: 51
Untitled [Large Sumi Brush Strokes] li 1970 PIA: 84, **145**/114
Woman in Amagansett li 1970 AMI: clp37
See also:
Graham, Lanier. *Willem De Kooning. Catalogue Raisonné de l'Oeuvre Grave. Volume I, 1957-1971.* Paris: Baudoin Lebon, 1991.

DE LAMONICA, ROBERTO 1933-95
Biographical dictionaries: WAA 78, 80, 82, 84, 86, 89-90, 91-92, 93-94, 95-96
Art books and catalogs: PAP, RBW
Untitled mo (co) 1984 PAP: **24**, 47
Who co-et (co) 1969 RBW: [11]

DELANEY, BEAUFORD 1901-79
 Biographical dictionaries:
 Art books and catalogs: SIM
 Untitled [Istanbul, Turkey] co-mo (co) 1966 SIM: **149**

DELAP, TONY 1927-
 Biographical dictionaries: WAA 66, 70, 73, 76, 78, 80, 82, 84, 86, 89-90, 91-92, 93-94, 95-96, 97-98
 Art books and catalogs: LAP
 Karnak, I (*set of 4*) co-li em (co) 1972 LAP: 92/107

DELAWRENCE, NADINE (DELAWRENCE-MAINE)
 Biographical dictionaries:
 Art books and catalogs: RBW
 Untitled et 1982 RBW: [12]

DELOS, KATE 1945-
 Biographical dictionaries:
 Art books and catalogs: NCP
 Imago: State Three: VI li ch 1987 NCP: 19

DEMATTIES, NICK FRANK 1939-
 Biographical dictionaries: WAA 73, 76, 78, 80, 82, 84, 86, 89-90, 91-92, 93-94, 95-96, 97-98
 Art books and catalogs: EIE
 Conversation et ch EIE: 13

DE MAURO, DON 1936-
 Biographical dictionaries:
 Artbooks and catalogs: ENP
 Trapeze Figures li 1970 ENP: *abc*

DENES, AGNES CECILIA 1938-
 Biographical dictionaries: WAA 73, 76, 78, 80, 82, 84, 86, 89-90, 91-92, 93-94, 95-96, 97-98
 Art books and catalogs: AMI, APP, ENP, TYA
 Dialectic Triangulation: A Visual Philosophy es 1970 AMI: clp103
 Introspection IV. "The Kingdom" es xm 1971 ENP: *abc*

Map Projections (*one from suite*) li 1974 TYA: 34
Probability Pyramid li fk 1978 APP: 246

DENNIS, CRAIG 1950-
Biographical dictionaries:
Art books and catalogs: NPE
Cross-Reference pe dp 1977 NPE: 50
Stones/Bones cy tu li (co) 1978 NPE: 51

DENNIS, DONNA FRANCES 1942-
Biographical dictionaries: WAA 82, 84, 86, 89-90, 91-92, 93-
94, 95-96, 97-98
Art books and catalogs: AAP, PWP
Deep Station: View from the Track hc-li (co) 1987 PWP:
clp91/112
Two Towers li hc (co) 1982-83 AAP: 51

DE SAINT PHALLE, NIKI 1930-
Biographical dictionaries:
Art books and catalogs: ENP
Zoo with You li 1970 ENP: *abc*

DESHAIES, ARTHUR 1920-
Biographical dictionaries: WAA 66, 70, 73, 76, 78, 80
Art books and catalogs: APP, TYA, WAT
Cycle of a Large Sea: Night Sea Rider Virgin, Night Sea Rider
Love, and Night Sea Rider Death lu 1962 TYA: 35
Cycle of a Large Sea. Unbeing Myself, January 24, 1961 pl-re-en
1962 APP: 193
Death That Came for Albert Camus lu-en 1960 APP: 96 WAT:
191

DETAMORE, ROBERT CONRAD 1947-
Biographical dictionaries:
Art books and catalogs: GAP
Secret Letters and Private Numbers hc-mi (co) 1985 GAP: 7/29

DEWEY, LILIBET
Biographical dictionaries:
Art books and catalogs: NCP

I.S. Part 2: 86.62.4 (*from* The Irremeable Self) in mo ch 1986
NCP: 15

DEWOODY, JAMES 1945-
Biographical dictionaries:
Art books and catalogs: BWS
55th Street at Madison Avenue (*from portfolio* Ten Images of the
City) pc 1987 BWS: 6/30

DIAMOND, MARTHA 1944-
Biographical dictionaries:
Art books and catalogs: AAP, PAP
Manhattan Suite (*one from portfolio of 5*) sc 1985 PAP: 48
Untitled mo 1983 AAP: 52

DIAO, DAVID 1943-
Biographical dictionaries: WAA 73, 76, 78, 80, 82, 84, 86, 89-
90, 91-92, 93-94, 95-96, 97-98
Art books and catalogs: INP
Untitled [China in Russian] pe aq 1989 INP: 17

DI CERBO, MICHAEL 1947-
Biographical dictionaries: WAA 80, 82, 84, 86, 89-90, 91-92,
93-94, 95-96, 97-98
Art books and catalogs: NPE
Untitled [77A] aq et 1977 NPE: 52
Untitled [78C] aq et 1978 NPE: 53

DICKSON, JANE LEONE 1952-
Biographical dictionaries: WAA 86, 89-90, 91-92, 93-94, 95-96,
97-98
Artbooks and catalogs: AGM, PAP
Mother and Child aq 1984 PAP: 49
Stairwell aq (co) 1984 AGM: **75**
White Haired Girl aq (co) 1984 AGM: **bcv, 75**

DIEBENKORN, RICHARD CLIFFORD, JR. 1922-93
Biographical dictionaries: WAA 66, 70, 73, 76, 78, 80, 82, 84,
86, 89-90, 91-92, 93-94

Art books and catalogs: AAP, ACW, AMI, APM, AMP, APP, BWS, LAP, PAC, PAP, PIA, SIM, TWO, TYA, WAT

41 Etchings and Drypoints [*Plate No. 3*] sf 1965 APP: 206

Black Club et aq dr 1981 PAC: [18]/75

Blue co-wo (co) 1984 ACW: **76**, 125

Blue Surround sb-aq dr (co) 1982 AAP: **10**, 53

Cup and Saucer li 1965 TYA: 35

Green co-sb-aq so-aq dr (co) 1986 PIA: **199**/121

IV 4-13-75 mo 1975 SIM: 169

Large Bright Blue et aq (co) 1980 AMI: clp77

Ochre co-wb (co) 1983 AMP: **83** PAP: **22**, 50

Seated Woman Drinking from a Cup li 1965 BWS: fpc/30

Six Soft-ground Etchings [#*4*] sf 1978-80 APM: 7/12 WAT: 257

Untitled #5 aq dr 1978 LAP: 93/108

Untitled (*from* 5 Aquatints with Drypoint) aq dr 1978 TWO: 123

Untitled li 1961 LAP: 69/104

V 4-13-75 mo 1975 SIM: 169

See also:

Guillemin, Chantal. *Richard Diebenkorn: Etchings and Drypoints, 1949-1980*. Houston: Houston Fine Art Press, 1981.

DILL, LADDIE JOHN 1943-

Biographical dictionaries: WAA 78, 80, 82, 84, 86, 89-90, 91-92, 93-94, 95-96, 97-98

Art books and catalogs: CAM

LJD-MT-228 mo 1983 CAM: 36/43

DINE, JIM (JAMES) 1935-

Biographical dictionaries: WAA 66, 70, 73, 76, 78, 80, 82, 84, 86, 89-90, 91-92, 93-94, 95-96, 97-98

Art books and catalogs: AAP, ACW, AKG, AMI, AMP, APB, APM, APP, APR, APS, BWS, CAM, ENP, FIM, PAP, PIA, PPP, SMP, TCA, TPI, TWO, TYA, WAT

Bathrobe (*from* New York Ten) et 1965 TPI: 81

Black and White Blossom et sb-aq dv dr bn 1986 SMP: **20**

Black and White Cubist Venus dr aq SMP: **19**

Black and White Robe et li 1977 AMI: clp139

Braid, second state et ik 1973 APB: clp*123*/46-47

Car Crash I-V li 1960 FIM: 32

Colored Palette co-li (co) 1963 TPI: 81

Double Apple Palette with Gingham co-li ce (co) 1965 TPI: 81

Drag-Johnson and Mac co-et (co) 1967 TPI: **32**

Eleven Part Self Portrait [Red Pony] li 1965 TWO: 42

End of the Crash li (co) 1960 FIM: **33**

Five Layers of Metal Ties (*one of 5*) hc-dr (co) 1961 TPI: 80

Five Paint Brushes et dr rl 1972 APP: 185 WAT: 234

Five Paintbrushes [*states*] et dr sf 1972-73 APM: 14/12 APR: 7/[12] BWS: 8/30 PPP: 70-73

Flesh Palette in a Landscape li 1965 TYA: 36

Four C Clamps li 1962 AMI: clp**53**

Fourteen Color Woodcut Bathrobe wo (co) 1982 SMP: **18**

French Watercolor Venus sf en-pw hc (co) 1985 PAP: 51

Girl and Her Dog No. 11 et hc-wc (co) 1971 AKG: clp7a ENP: *abc* TYA: fcv/4

Heart 1983 li-mo hp 1983 CAM: 19/43

Heart and the Wall sf sb aq en dr pp (co) 1983 AAP: 54 PIA: **183**/119

Informal Tie dr hc (co) 1961 PIA: **127**/112

My Nights in Santa Monica et dv sb aq dr (co) 1986 SMP: **23**

Nine Views of Winter I co-wo hw (co) 1985 ACW: **79**, 126

Nurse et wc (co) 1976 APB: clp*125*/47

Painted Self-Portrait hc sn cr tl (co) 1970 TPI: **31**

Photographs and Etchings by Jim Dine and Lee Friedlander (*16 etchings with photographic collage*) et to-ce 1969 TPI: 82

Picture of Dorian Gray bk co-li (co) 1968 AKG: clp5 TPI: 81

Piranesi's 24 colored marks et wc (co) 1976 APB: clp*124*/47

Red Bathrobe co-li (co) 1969 APS: clp**54**

Scissors and Rainbow [Rainbow Scissors] co-li (co) 1969 AMP: 85 TCA: [**43**]

Self Portrait as a Negative et 1975 WAT: 235

Self-portrait in Zinc and Acid et 1964 APB: clp*121*/46

Self-Portrait: The Landscape co-li (co) 1969 TPI: **32**

Side View in Florida hc-et sf dr (co) 1986 SMP: **21**

Sovereign Nights et dp (co) 1986 SMP: **22**

Strelitzia [*states 1-3*] et mo ac (co) 1980 PPP: 75, **76-77**

Swimmer et hc (co) 1976 TYA: 36

Three Trees in the Shadow of Mount Zion dr sc tp (co) 1981

SMP: **17**

Throat (*from* 11 Pop Artists) sk 1965 AMI: clp**56**

Tie dr (co) 1961 FIM: **31**

Tomato and Pliers co-li et (co) 1973 WAT: **148**

Tool Box (*portfolio of 10*) co-sc ce (co) 1966 TPI: 80

Vegetables of-li to-ce 1969 TPI: 82

Youth and the Maiden hc-wo pv sf sb dr tp (co) 1987-88 SMP: **24-25**

See also:

D'Oench, Ellen, and Jean E. Feinberg. *Jim Dine Prints, 1977-1985* (exhibition catalog). New York: Harper & Row, 1986.

Krens, Thomas. *Jim Dine Prints: 1970-1977* (exhibition catalog). New York: Harper & Row, 1977.

Jim Dine, Complete Graphics. Berlin: Galerie Mikro, 1970.

DI SUERVO, MARK 1933-

Biographical dictionaries: WAA 70, 73, 76, 78, 80, 82, 84, 86, 89-90, 91-92, 93-94, 95-96, 97-98

Art books and catalogs: TCR, TYA

Afterstudy for Marianne Moore li (co) 1976 TCR: **126**

Centering li (co) 1976 TCR: **124**, **127**

For Rilke li 1976 TCR: **126**

Jak li sk (co) 1976 TCR: **126** TYA: 36

Tetra li (co) 1976 TCR: **127**

DIXON, KEN (KENNETH RAY) 1943-

Biographical dictionaries: WAA 78, 80, 82, 84, 86, 89-90, 91-92, 93-94, 95-96, 97-98

Art books and catalogs: FTP

Wildflowers of Texas: LBJ & Ladybird co-wb (co) 1989 FTP: **35**

DOLE, WILLIAM 1917-83`

Biographical dictionaries: WAA 53, 56, 62, 66, 70, 73, 76, 78, 80, 82, 84

Art books and catalogs: ENP

Rain Dance li 1971 ENP: *abc*

DOVE, TONI 1946-

Biographical dictionaries: WAA 86, 89-90, 91-92, 93-94, 95-96,

97-98
Art books and catalogs: AAP
Untitled 1983 wb dp 1983 AAP: 55

DOWELL, JOHN EDWARD, JR. 1941-
Biographical dictionaries: WAA 80, 82, 84, 86, 89-90, 91-92, 93-94, 95-96, 97-98
Art books and catalogs: APP, TYA
Free Form for Ten et 1973 APP: 222
Letter to My Betty I and II li dp 1970 TYA: 37
Sound Thoughts of Tomorrow et aq 1973 TYA: 37

DOWNES, VALIA 1930-
Biographical dictionaries:
Art books and catalogs: ENP
Diminuer re-em 1972 ENP: *abc*

DRASITES, ROY R. 1945-
Biographical dictionaries:
Art books and catalogs: TYA
Leaf-like Chessboard li 1976 TYA: 38

DREWES, WERNER 1899-1985
Biographical dictionaries: WAA 36-37, 40-41, 40-47, 53, 56, 59, 62, 66, 70, 73, 76, 78, 80, 82, 84
Art books and catalogs: ACW, APP, PFB, SIM, WAT
Calm Morning co-wo (co) 1954 ACW: **44**, 108
Cliffs on Monhegan Island wo (co) 1969 ACW: **45**, 108
Maine Sunset co-wo (co) 1949 WAT: 176
Nausikaa (no. 149) co-mo (co) 1951 SIM: **139**
Spectre [Two Monsters] co-wo lc (co) 1943 PFB: 11
Untitled (*from portfolio* It Can't Happen Here) wo 1934 APP: 70
See also:
Rose, Ingrid. *Drewes: A Catalogue Raisonné of His Prints.*
Munich and New York: Verlag Kunstgalerie Esslingen, 1984.

DRIESBACH, DAVID FRAISER 1922-
Biographical dictionaries: WAA 62, 66, 70, 73, 76, 78, 80, 82, 84, 86, 89-90, 91-92, 93-94, 95-96, 97-98

Art books and catalogs: WAT
St. Luke Paints the Madonna in 1958 WAT: 296

DU**BASKY, V**ALENTINA **1951-**
Biographical dictionaries: WAA 86, 89-90, 91-92, 93-94, 95-96, 97-98
Artbooks and catalogs: PWP
Heron Cove mo ch (co) 1990 PWP: clp50/112

D**UBE, E**LEANOR
Biographical dictionaries:
Artbooks and catalogs: CHI
False Image (*poster/invitation for 1st "False Image" group exhibition*) of-li ds 1968 CHI: 204
False Image (*price list for 1st "False Image" group exhibition*) of-li 1968 CHI: 206
False Image (*price list for 2nd "False Image" group exhibition*) of-li 1969 CHI: 207
False Image Decals (*created by Roger Brown, Eleanor Dube, Philip Hanson, and Christina Ramberg*) co-sk pp (co) 1969 CHI: **36**, 207
False Image II (*based on exquisite corpse by Roger Brown, Eleanor Dube, Philip Hanson, and Christina Ramberg*) co-of-li (co) 1969 CHI: 206
False Image Postcards (*created by Roger Brown, Eleanor Dube, Philip Hanson, and Christina Ramberg*) co-of-li (co) 1968 CHI: 204-5

D**UBUFFET, J**EAN**(-P**HILIPPE**-A**RTHUR**) 1901-85**
Biographical dictionaries:
Art books and catalogs: TWO
Parade funèbre pour Charles Estienne sk 1967 TWO: 112

D**UCHAMP, M**ARCEL **1887-1968**
Biographical dictionaries:
Art books and catalogs: TPI, TWO
L.H.O.O.Q. Shaved rm co-rr (co) 1965 TPI: **fpc**
Selected Details after Courbet [*State II*] (*from* The Large Glass and Related Words (Volume II) *by Arturo Schwarz*) et aq 1968 TWO: 116

See also:
Schwarz, Arturo. *The Complete Works of Marcel Duchamp*, 2nd
 ed.. New York: Harry N. Abrams, 1970.

DUNHAM, CARROLL 1949-
 Biographical dictionaries:
 Art books and catalogs: FIM, PAP, PRO
 Black [5th] (*from portfolio* Red Shift) co-li (co) 1987-88 PRO:
 clp25
 Blue [2nd] (*from portfolio* Red Shift) co-li (co) 1987-88 PRO:
 clp25
 Green [4th] (*from portfolio* Red Shift) co-li (co) 1987-88 PRO:
 clp25
 Purple [3rd] (*from portfolio* Red Shift) co-li (co) 1987-88 PRO:
 clp25
 Red [1st] (*from portfolio* Red Shift) co-li (co) 1987-88 PRO: clp25
 Untitled li 1984-85 FIM: **135**
 Untitled li 1985 PAP: 52

ECKART, CHRISTIAN 1959-
 Biographical dictionaries: WAA 89-90, 91-92, 93-94, 95-96, 97-
 98
 Art books and catalogs: PRO
 Cimabue Restoration Project (*pages from an exhibition catalog*)
 ce lm ll (co) 1988 PRO: clp27

EDMONDSON, LEONARD 1916-
 Biographical dictionaries: WAA 53, 56, 62, 66, 70, 73, 76, 78,
 80, 82, 84, 86, 89-90, 91-92, 93-94, 95-96, 97-98
 Art books and catalogs: LAP
 Escarpment co-et (co) 1956 LAP: 62/103
 Failing Light sk 1950 LAP: 66/103

EDMUNDS, ALLAN LOGAN 1949-
 Biographical dictionaries: WAA 76, 78, 80, 82, 84, 86, 89-90,
 91-92, 93-94, 95-96, 97-98
 Artbooks and catalogs: BAG
 Reflections on Silkscreen sk 1971 BAG: 24

EDWARDS, CAROLINE
Biographical dictionaries:
Art books and catalogs: RBW
Untitled sk RBW: [12]

EDWARDS, MEL(VIN) 1937-
Biographical dictionaries: WAA 97-98
Art books and catalogs: RBW
Mt. Vernon Plaza pe 1982 RBW: [12]

EHLBECK, MICHAEL W. 1948-
Biographial dictionaries:
Art books and catalogs: TYA
Untitled in 1976 TYA: 38

EICHENBERG, FRITZ 1901-90
Biographical dictionaries: WAA 40-41, 40-47, 53, 56, 59, 62, 66, 70, 73, 76, 78, 80, 82, 84, 86, 89-90, 91-92
Art books and catalogs: TYA, WAT
Bestiarium Juvenille co-wd-en (co) 1965 WAT: 254
Book of Jonah wn 1955 TYA: 38
Dame Folly Speaks wn 1972 TYA: 39

ELLIS, JONATHAN 1953-
Biographical dictionaries:
Art books and catalogs: PAP
Mook Woman mo 1985 PAP: 56

ELLIS, ROBERT M. 1922 -
Biographical dictionaries: WAA 66, 91-92, 93-94, 95-96, 97-98
Art books and catalogs: PNM
Rio Grande Gorge #16 co-li (co) 1982-83 PNM: 96

ELLIS, STEPHEN 1951-
Biographical dictionaries: WAA 93-94, 95-96, 97-98
Art books and catalogs: PRO
Japanese Gothic (*portfolio of 13*) dr et aq 1988 PRO: clp26

ELLISON, MICHAEL EDWARD 1952-
 Biographical dictionaries:
 Art books and catalogs: GAP
 International Boulevard sv-wo 1985 GAP: 21/29

ELOUL, KOSSA 1920-
 Biographical dictionaries: 70, 73, 76, 78, 80, 82, 84, 86, 89-90,
 91-92, 93-94, 95-96, 97-98
 Art books and catalogs: ENP
 Eluding I sk 1971 ENP: *abc*

ENGEL, JULES 1915-
 Biographical dictionaries:
 Art books and catalogs: LAP
 Curfew li 1960 LAP: 68/104

ERLEBACHER, MARTHA MAYER 1937-
 Biographical dictionaries: WAA 91-92, 93-94, 95-96, 97-98
 Art books and catalogs: NPE
 Homage to Bacchus li (co) 1978 NPE: 55
 New Potatoes li (co) 1978 NPE: 54

ERSKINE, ELEANOR H. 1959-
 Biographical dictionaries:
 Art books and catalogs: PNW
 Firebird (*from series* Residuals) cg (co) 1996 PNW: **47**
 Icarus (*from series* Findings) et br wi 1996 PNW: 48
 Vertical Edge (*from series* Findings) et br th 1996 PNW: 49

ESAKI, YASUHIRO 1941-
 Biographical dictionaries: WAA 80, 82, 84, 86, 89-90, 91-92,
 93-94, 95-96, 97-98
 Art books and catalogs: NPE
 Fourth Iris et aq hc-wc (co) 1977 NPE: 56
 Jacket et 1978 NPE: 57

ESCHER, FRED 1940-
 Biographical dictionaries:
 Art books and catalogs: AAP

Pissin' in the Wind li 1982 AAP: 56

ESPADA, IBSEN 1952-
Biographical dictionaries:
Art books and catalogs: FTP
Pesera II et (co) 1984 FTP: **37**

ESTES, RICHARD 1936-
Biographical dictionaries: WAA 76, 78, 80, 82, 84, 86, 89-90,
 91-92, 93-94, 95-96, 97-98
Art books and catalogs: APB, AGM, AMI, APM, APP, FIM,
 PAC, TCA, TWO, WAT
Grant's sc (co) 1972 FIM: **85**
Linoleum sc 1972 AGM: 18
Nass Linoleum sc 1972 APP: 237
Oriental Restaurant (*from* Urban Landscapes) sc (co) 1972 TCA:
 [**45**]
Seagram Building (*from* Urban Landscapes) co-sk (co) 1972
 APM: 22/12 WAT: 284
Untitled sc 1974-75 PAC: [19]/76 TCA: 12
Untitled, 40c (*from* Urban Landscapes II) sc 1979 APB: clp*134*/53
Urban Landscapes 3 [*plate*] sk (co) 1981 AMI: clp**108**
Urban Landscapes No. 2 [*plate 5*] sk 1979 TWO: 97

EVERGOOD, PHILIP (HOWARD FRANCIS) 1901-73
Biographical dictionaries: WAA 36-37, 40-41, 40-47, 53, 56,
 62, 66, 70, 73
Art books and catalogs: APP
Cool Doll in Pool li 1961 APP: 110

EVERTS, CONNOR 1926-
Biographical dictionaries: WAA 70, 78, 80, 82, 84, 86, 89-90,
 91-92, 93-94, 95-96
Art books and catalogs: CIP, LAP
Execution li 1960 LAP: 68/104
Romabrite co-sc (co) 1988 CIP: **19**

FAHLSTRÖM, OYVIND AXEL CHRISTIAN 1928-76
Biographical dictionaries: WAA 70, 73, 76

Art books and catalogs: TWO
Eddy (Sylvie's Brother) in the Desert (*from* New York
International) sk 1966 TWO: 47

FALCONER, JAMES
Biographical dictionaries:
Art books and catalogs: CHI
da Hairy Who Kamic Kamie Page (*comic strip page by James
Falconer, Art Green, Gladys Nilsson, Jim Nutt, Suellen
Rocca, and Karl Wirsum*) of-li 1967 CHI: 200
Dis is THE catalog (*catalog/checklist/price list by James
Falconer, Art Green, Gladys Nilsson, Jim Nutt, Suellen
Rocca, and Karl Wirsum*) of-li 1969 CHI: 203
Hairy Who (cat-a-log) (*comic book by James Falconer, Art
Green, Gladys Nilsson, Jim Nutt, Suellen Rocca, and Karl
Wirsum*) co-of-li (co) 1968 CHI: **35**, 201-2
Hairy Who (*comic book by James Falconer, Art Green, Gladys
Nilsson, Jim Nutt, Suellen Rocca, and Karl Wirsum*) co-of-li
(co) 1968 CHI: 199-200
Hairy Who (*poster for 1^{st} "Hairy Who" group exhibition*) of-li
1966 CHI: 194
Hairy Who (*poster for 2^{nd} "Hairy Who" group exhibition*) of-li
(co) 1967 CHI: **35**, 196
Hairy Who Sideshow (*comic book by James Falconer, Art Green,
Gladys Nilsson, Jim Nutt, Suellen Rocca, and Karl Wirsum*)
co-of-li (co) 1967 CHI: 196-98
Hateha (*from portfolio* Da Hairy Who) co-sk (co) 1967-68 CHI:
193
Portable Hairy Who! (*comic book by James Falconer, Art Green,
Gladys Nilsson, Jim Nutt, Suellen Rocca, and Karl Wirsum*)
bk co-of-li (co) 1966 CHI: 194-95

FALKENSTEIN, CLAIRE 1908-
Biographical dictionaries: WAA 40-47, 53, 66, 70, 73, 76, 78,
80, 82, 84, 86, 89-90, 91-92, 93-94, 95-96, 97-98
Art books and catalogs: LAP, WAT
From Point to Cone sl 1976 WAT: 308
Struttura Grafica ep 1972 LAP: 92/107

FARLEY, KEN 1947-
Biographical dictionaries:
Art books and catalogs: ENP
Rotary Circuit li 1971 ENP: *abc*

FARMER, MAURINE 1952-
Biographical dictionaries:
Art books and catalogs: NPE
Little Floaters to-tf sk 1978 NPE: 59
Summer Salads to-tf sk 1978 NPE: 58

FARNSWORTH, DONALD 1952-
Biographical dictionaries:
Art books and catalogs: PAP
Counterpoint Series/Quatrefoil ch li mo ic-hm gl vr hc hd (co)
 1985 PAP: 57

FEARING, (WILLIAM) KELLY 1918-
Biographical dictionaries: WAA 40-47, 53, 56, 62, 66, 70, 73,
 76, 78, 80, 82, 84, 86, 89-90, 91-92, 93-94, 95-96, 97-98
Art books and catalogs: FWC
Annunciation aq sf db 1946 FWC: 26
Birds en sp 1946 FWC: 26
Collector [*Fifth State of Five*] et sf 1945 FWC: 25
Fishermen et sf 1947 FWC: 27

FEDDERSEN, JOE 1953-
Biographical dictionaries:
Art books and catalogs: PNW
Changer II re 1992 PNW: 52
Plateau Geometric #71 aq dr re-sn ro (co) 1996 PNW: **51**
Veiled Memory et 1996 PNW: 53

FEIGIN, MARSHA 1946-
Biographical dictionaries: WAA 76, 78, 80, 82, 84, 86, 89-90,
 91-92, 93-94, 95-96, 97-98
Art books and catalogs: AWP, ENP, TYA
Farrier sg sd cp 1975 AWP: [7]
Tennis et 1974 TYA: 39

Woman, Child, Umbrella in 1970 ENP: *abc*

FEINBERG, ELEN 1955-
Biographical dictionaries: WAA 89-90, 91-92, 93-94, 95-96, 97-98
Art books and catalogs: PNM
Dawn co-li (co) 1988 PNM: 136

FEININGER, LYONEL CHARLES 1871-1956
Biographical dictionaries: WAA 40-41, 40-47, 53
Art books and catalogs: AML
Manhattan [Stone 2] li 1955 AML: 152

FEITELSON, LORSER 1898-1978
Biographical dictionaries: WAA 73, 76, 78
Art books and catalogs: LAP
Untitled sk 1971 LAP: **86**/106

FELDMAN, ALINE 1928-
Biographical dictionaries:
Artbooks and catalogs: AGM, PWP
Hawaiian Memory [Kauai] wo hc dp (co) 1985 AGM: **78**
Midday wl (co) 1989 PWP: clp**96**/112

FENTON, JOHN 1922-
Biographical dictionaries:
Art books and catalogs: ENP
Open Road in 1971 ENP: *abc*

FERRER, RAFAEL 1933-
Biographical dictionaries: WAA 78, 80, 82, 84, 86, 89-90, 91-92, 93-94, 95-96, 97-98
Art books and catalogs: ACW, INP
Amanecer Sobre el Cabo [Dawn over the Cape] co-wo (co) 1988 ACW: **70**, 122
azul cb 1989 INP: 11

FICHTER, ROBERT WHITTEN 1939-
Biographical dictionaries: WAA 78, 80, 82, 84, 86, 89-90, 91-

92, 93-94, 95-96, 97-98
Art books and catalogs: INN
Bones Alone Has Looked on Beauty Bare co-li hn (co) 1987 INN: **16**

FIDLER, SPENCER D. **1944-**
Biographical dictionaries: WAA 82, 84, 86, 89-90, 91-92, 93-94, 95-96, 97-98
Art books and catalogs: PNM
Madness co-in (co) 1989 PNM: 109

FINK, AARON **1955-**
Biographical dictionaries: WAA 89-90, 91-92, 93-94, 95-96, 97-98
Art books and catalogs: AAP, PAP
Blue Smoker li 1982 AAP: 57
Portrait I et sl aq hc-ik hc-ok (co) 1984 PAP: 58

FINKBEINER, DAVID **1936-**
Biographical dictionaries:
Art books and catalogs: PAP
Through the Glass rl dr 1985 PAP: 54

FISCHL, ERIC **1948-**
Biographical dictionaries: WAA 86, 89-90, 91-92, 93-94, 95-96, 97-98
Art books and catalogs: AGM, FIM, PAP, SIM
Digging Kids et aq 1982 FIM: **123**
Untitled (*from* Floating Islands) aq 1985 AGM: 37
Untitled [Group in Water] co-mo (co) 1992 SIM: **176**
Year of the Drowned Dog et aq dr tp 1983 PAP: 59

FISCUS, RICHARD **1926-**
Biographical dictionaries:
Art books and catalogs: TYA
Presidio sc 1975 TYA: 40

FISH, JANET I. **1938-**
Biographical dictionaries: WAA 78, 80, 82, 84, 86, 89-90, 91-

92, 93-94, 95-96, 97-98
Art books and catalogs: PAP, PWP, TYA
Pears and Autumn Leaves et dr (co) 1988 PWP: clp77/112
Pears and Mitten wo 1985 PAP: 60
Preserved Peaches li 1975 TYA: 40

FISHER, VERNON 1943-
Biographical dictionaries: WAA 76, 78, 80, 82, 89-90, 91-92, 93-94, 97-98
Art books and catalogs: FTP, GAR, PAP
Hanging Man co-ph sc (co) 1984 GAR: 41 PAP: 61
Perdido en el Mar li (co) 1989 FTP: **39**

FOLSOM, KARL LEROY 1938-
Biographical dictionaries: WAA 76, 78, 80, 82, 84, 86, 89-90
Art books and catalogs: TYA
K pi em 1975 TYA: 40

FONG, FREDDIE 1952-
Biographical dictionaries:
Art books and catalogs: NPE
Black and Newsprint Grey li ce dp (co) 1977 NPE: 60
Candy Wrappers IV li (co) 1977 NPE: 61

FONTANA, LUCIO 1899-1968
Biographical dictionaries:
Art books and catalogs: TWO
Untitled (*from* Six Original Etchings) et em 1964 TWO: 84

FONTECILLA, ERNESTO 1936-
Biographical dictionaries:
Art books and catalogs: CMZ
Belgium Interior co-mz (co) 1970 CMZ: [54]/31

FOOTE, HOWARD REED 1936-
Biographical dictionaries: WAA 78, 80, 82, 84, 86, 89-90, 91-92, 93-94, 95-96, 97-98
Art books and catalogs: ENP
In by Nine, Out by Five li 1970 ENP: *abc*

FORBIS, STEVE 1950-
Biographical dictionaries:
Art books and catalogs: PNM
Sharing Traditions li 1982 PNM: 123

FÖRG, GÜNTER
Biographical dictionaries:
Art books and catalogs: PIA
Reason Why I Work with Maurice. . . li 1990 PIA: 33

FORMICOLA, JOHN JOSEPH 1941-
Biographical dictionaries: WAA 82, 84, 86, 89-90, 91-92, 93-
94, 95-96, 97-98
Art books and catalogs: ENP
Meditation sk 1971 ENP: *abc*

FORRESTER, PATRICIA TOBACCO 1940-
Biographical dictionaries: WAA 84, 86, 89-90, 91-92, 93-94,
95-96, 97-98
Art books and catalogs: AWP, ENP, TYA
Daphne's Garden et 1970 TYA: 41
Daughters et cp 1975 AWP: [8]
Great Palm et 1974 TYA: 41
Won't You Come into My Parlor? et 1972 ENP: *abc*

FORTESS, KARL EUGENE 1907-
Biographical dictionaries: WAA 40-41, 40-47, 53, 56, 59, 62,
66, 70, 73, 76, 78, 80, 82, 84, 86, 89-90, 91-92, 93-94
Art books and catalogs: AML
Cityscape li 1953 AML: 164

FRANCIS, (MADISON) KE, JR. 1945-
Biographical dictionaries: WAA 78, 80, 82, 84, 86, 89-90, 91-
92, 93-94, 95-96, 97-98
Art books and catalogs: ACW
Shattered King (*from series* Tornado) wo (co) 1989 ACW: **80**,
127

FRANCIS, SAM(UEL) LEWIS 1923-94
 Biographical dictionaries: WAA 62, 66, 70, 73, 76, 78, 80, 82,
 84, 86, 89-90, 91-92, 93-94
 Art books and catalogs: AAP, AKG, AMI, AML, APM, APP,
 CAM, ENP, LAP, NAP, PAP, PIA, PPP, SIM, THL, TYA,
 WAT
 Coldest Stone co-li (co) 1960 APM: 2/12
 First Stone co-li (co) 1960 AKG: clp9
 Hurrah for the Red, White and Blue co-li (co) 1961 AKG: clp11
 Lover Loved Loved Lover li (co) 1960 PPP: **78**
 Red Again sk 1972 TYA: 42
 Serpent on the Stone li (co) 1960 PPP: **79**
 Slant [*detail*] co-mo (co) 1979 SIM: **146**
 Slant co-mo (co) 1979 SIM: **181**
 Untitled co-li (co) 1963 THL: **29** WAT: **200**
 Untitled co-mo hm (co) 1981 NAP: **27**
 Untitled li (co) 1978 APP: clp**23**
 Untitled li 1974-75 TYA: 42
 Untitled mo (co) 1982 AMI: clp**78**
 Untitled sk aq sb 1985 PAP: 62
 Untitled wo mo (co) 1983 AAP: **23**, 58
 Untitled [Metal Field] li (co) 1972 PPP: **80-81**, 83
 Untitled [SF-113I] li 1971 ENP: *abc*
 Untitled [SF-14-02-79] mo em (co) 1979 CAM: 24
 Untitled [SFM82-049] wo-mo hm (co) 1982 PIA: **178**/118
 Upper Yellow li (co) 1960 AMI: clp**40**
 White Line co-li (co) 1960 AML: **187** LAP: 67/103
 See also:
 Lembark, Connie W. *The Prints of Sam Francis: A Catalogue
 Raisonné, 1960-1990.* New York: Hudson Hills Press, 1992.

FRANK, MARY 1933-
 Biographical dictionaries: WAA 70, 73, 76, 78, 95-96, 97-98
 Art books and catalogs: AAP, AMI, APR, CAM, PAC, PAP,
 PWP, SIM
 Amaryllis mo dp (co) 1977 AMI: clp**141**
 Astronomy mo (co) 1985 PAP: 63
 Dinosaur co-mo (co) 1980 APR: 9/[14] PAC: [22]/77
 Man in the Water [*State II*] li 1987 PWP: clp**32**/112

Skeletal Figure mo ce (co) 1975 SIM: **185**
Untitled mo tp 1984 CAM: 34/43
Untitled [Head] mo (co) 1981 AAP: **25**, 59

FRANK, RICHARD 1939-
Biographical dictionaries:
Art books and catalogs: ENP
Black Juke sk 1971-72 ENP: *abc*

FRANKENTHALER, HELEN 1928-
Biographical dictionaries: WAA 59, 62, 66, 70, 73, 76, 78, 80,
 82, 84, 86, 89-90, 91-92, 93-94, 95-96, 97-98
Art books and catalogs: AAP, ACW, AGM, AMI, APM, APS,
 CAM, ENP, PAC, PIA, PPP, PRO, TCA, TCR, TGX, TWO,
 TYA, WAT
Barcelona li hm (co) 1977 TCR: **130**
Bay Area Sunday VI mo (co) 1982 AAP: **22**, 60
Bay Area Tuesday IV mo rb-fo-em (co) 1982 CAM: 28/44
Cameo wo hm (co) 1980 PPP: **90-1** TCR: **137** TGX: **71**
Cedar Hill wo tt-pa (co) 1983 ACW: **73**, 123 AGM: **fcv**, **83**
Deep Sun et aq dr en mz hm (co) 1983 TCR: **139**
Dream Walk li hm (co) 1977 TCR: **130**
Earth Slice et aq hm (co) 1978 TCR: **131** TGX: **68**
East and Beyond wo hm (co) 1973 AGM: **82**
Essence Mulberry—State I wo hm (co) 1977 PIA: **166**/117 TCR:
 128, 131
Essence Mulberry wo hm (co) 1977 AMI: clp74 TCR: **131** TGX:
 62 TWO: 106
Experimental Impression [*I-IX*] mp (co) 1978 TCR: **132-35**
Experimental Impression [*I, IV, and V*] mp (co) 1978 TCR: **132-
34** TGX: **68**
First Stone co-li (co) 1961 APS: clp3 WAT: 228
Ganymede et aq (co) 1978 TCR: **136** TGX: **68**
Harvest li hm (co) 1977 TCR: **130**
Lot's Wife li tp 1971 PAC: [23]/77
Monoprint [*I, III, VII, and IX*] (*from* Monoprint, Monotype Series)
 mp hm (co) 1981 TCR: **137-38**
Mountains and Sea oi ca (co) 1952 TGX: **64**
Napenthe li 1972 ENP: *abc*

Ochre Dust co-li aq mm (co) 1987 PRO: clp28
Orange Downpour co-pc (co) 1970 APM: 6/14
Persian Garden li (co) 1965-66 TCA: [39]
Red Sea li hm (co) 1982 TCR: 139
Savage Breeze co-wo (co) 1974 ACW: 72, 123 PPP: 87 TYA: 43
 WAT: 267
Savage Breeze [*trial proofs*] wo ce (co) 1974 PPP: 84-85
Savage Breeze [*working proof*] wo cy ik ce (co) 1974 PPP: 87
Slice of the Stone Itself li (co) 1969 AMI: clp73
Sure Violet [*color trial proofs 3/16, 6/16, and 9/16*] et aq dr hm
 (co) 1979 TGX: 72
Sure Violet sl aq dr hm (co) 1979 AGM: 81 TCR: 136 TGX: 73
Tribal sign co-li mi lm (co) 1987 PRO: clp29
Untitled [Cleveland Orchestra Print] sc (co) 1978 TCR: 136
Walking Rain co-li en et aq mm (co) PRO: clp30
See also:
Harrison, Pegram. *Frankenthaler: A Catalogue Raisonné: Prints,
 1961-1994.* New York: Abrams, 1996.
Krens, Thomas. *Helen Frankenthaler Prints: 1961-1979*
 (exhibition catalog). New York: Harper & Row, 1980.

FRASCONI, ANTONIO 1919-
 Biographical dictionaries: WAA 59, 62, 66, 70, 73, 76, 78, 80,
 82, 84, 89-90, 91-92, 93-94, 95-96, 97-98
 Art books and catalogs: ACW, AMI, APP, POR, THL, TYA,
 WAT
 Boy with Cock co-wo (co) 1947 ACW: 38, 104 WAT: 180
 Don Quixote and Rocinantes, No. 14 wo 1949 APP: 85
 Franco I (*from portfolio* Oda a Lorca) li 1962 THL: 55 WAT: 243
 Monterey Fisherman wo dp 1951 AMI: clp22
 Self-Portrait with Don Quixote wo 1949 APP: 84 TYA: 43
 Untitled [Self-Portrait] wo 1952 POR: 261

FRECKELTON, SONDRA 1936-
 Biographical dictionaries: WAA 80, 82, 84, 86, 89-90, 91-92,
 93-94, 95-96, 97-98
 Artbooks and catalogs: AGM, CIP, NPE, PWP
 All Over Red pc 1988 PWP: clp73/113
 Begonia with Quilt li 1978 NPE: 63

Blue Chenille co-sc (co) 1985 AGM: **87** CIP: **22**
Drawingroom Still Life co-sc (co) 1986 CIP: **23**
Openwork co-sc (co) 1986-87 AGM: **fpc**/85 CIP: **24**
Plums and Gloriosa Daisies of-li (co) 1980 AGM: **86**
Red Chair co-sc (co) 1984 CIP: **21**
Souvenir co-sc (co) 1989 CIP: **25**
Tulips li (co) 1977 NPE: 62

FREED, ERNEST BRADFIELD 1908-
Biographical dictionaries: WAA 40-41, 53, 56, 59, 62, 66, 70, 73
Art books and catalogs: TYA, WAT
Battle of the Sexes en 1946 TYA: 44 WAT: 160

FREEDMAN, DEBORAH S. 1947-
Biographical dictionaries: WAA 91-92, 93-94, 95-96, 97-98
Art books and catalogs: PRO
Waterfall #37 co-mo et (co) 1988 PRO: clp31
Waterfall #43 co-mo et (co) 1988 PRO: clp32

FREEMAN, DON 1908-78
Biographical dictionaries: WAA 40-41, 40-47, 53, 56, 62
Artbooks and catalogs:
See also:
McCulloch, Edith. *The Prints of Don Freeman: A Catalogue Raisonné*. Charlottesville: Published for the University of Virgina Art Museum by the University Press of Virginia, 1988.

FREILICHER, JANE 1924-
Biographical dictionaries: WAA 66, 70, 73, 76, 78, 80, 82, 84, 86, 89-90, 91-92, 93-94, 95-96, 97-98
Art books and catalogs: AAP, AGM, PWP, TYA
Flower Cherry pc (co) 1978 AGM: **90**
Peonies (Ten-Color) et aq (co) 1990 PWP: clp89/113
Poppies and Peonies et aq rl (co) 1983 AAP: 61 AGM: **91**
Still Life and Landscape li 1971 TYA: 44
Untitled li (co) 1975 TYA: **45**

FRICANO, TOM SALVATORE 1930-
 Biographical dictionaries: WAA 76, 78, 80, 82, 84, 86, 89-90,
 91-92, 93-94, 95-96, 97-98
 Art books and catalogs: CUN, GAR, LAP, TYA
 Drifting ag 1974 TYA: 46
 Erosion of Red Square cg 1962 TYA: 45
 Facade III hp-mo 1982 CUN: 36
 In a State of Transition I mo (co) 1983 CUN: **90**
 Steady Course I mo 1982 CUN: 35
 Street Wise mo ch (co) 1984 CUN: **89**
 Texas Adventure ag hc (co) 1982 GAR: **33**
 Umbria #1 cd-cu 1961 LAP: 70/104

FRIED, ROBERT SAMUEL 1937-
 Biographical dictionaries:
 Art books and catalogs: ENP
 Dylan's Drifter sk 1971 ENP: *abc*

FRIEDLANDER, ISAC 1890-1968
 Biographical dictionaries: WAA 40-47, 53, 56, 62
 Art books and catalogs: RBW
 East Side et 1931 RBW: [13]

FRIESE, NANCY MARLENE 1948-
 Biographical dictionaries: WAA 93-94, 95-96, 97-98
 Art books and catalogs: CAM
 Homage to Constable mo go 1984 CAM: 26/44

FRITZIUS, HARRY 1932-
 Biographical dictionaries:
 Art books and catalogs: PAP
 Untitled mp wo ce tp 1985 PAP: 64

FUENTES, MANUEL 1940-
 Biographical dictionaries:
 Art books and catalogs: ENP
 Solstsmoon aq 1971 ENP: *abc*

FURNBACK, DEBORAH GROBMAN 1944-
 Biographical dictionaries:
 Art books and catalogs: NPE
 Straight Strokes V li tu (co) 1976 NPE: 64
 Straight Strokes VI li tu (co) 1976 NPE: 64
 Strokes Given Linear Momentum by Hand (*from* Hayward
 Portfolio) rs hc hd (co) 1977 NPE: 65

FUSSELL, VALORI C. 1954-
 Biographical dictionaries:
 Art books and catalogs: GAP
 Memento Mori et 1986 GAP: 27/30

GABO, NAUM 1890-1977
 Biographical dictionaries: WAA 62, 66, 73, 76
 Art books and catalogs: AMI
 Opus 5 ["Constellations"] wd-en-mp 1951 AMI: clp14

GAFGEN, WOLFGANG 1936-
 Biographical dictionaries:
 Art books and catalogs: CMZ
 Mezzotint No. 4 (*from portfolio* Sept Manieres Noires) mz 1974
 CMZ: [56]/32

GANDOLFI, DIANA GONZALEZ 1951-
 Biographical dictionaries:
 Art books and catalogs: RBW
 Three Island Series VI mp 1984 RBW: [13]

GARABEDIAN, CHARLES 1923-
 Biographical dictionaries: WAA 93-94, 95-96, 97-98
 Art books and catalogs: PRO
 Behavior (*from* Cultural Escape) co-et aq (co) 1986-88 PRO:
 clp34
 China (*from* Cultural Escape) co-et aq (co) 1986-88 PRO: clp34
 Collective Logic (*from* Cultural Escape) co-et aq (co) 1986-88
 PRO: clp34
 Cultural Escape co-et aq (co) 1986-88 PRO: clp34
 Forest (*from* Cultural Escape) co-et aq (co) 1986-88 PRO: clp34

Inquisition (*from* Cultural Escape) co-et aq (co) 1986-88 PRO:
 clp**34**
Samurai (*from* Cultural Escape) co-et aq (co) 1986-88 PRO: clp**34**
Trumps (*from* Cultural Escape) co-et aq (co) 1986-88 PRO: clp**34**

GARDNER, ANDREW BRADFORD 1937-
Biographical dictionaries: WAA 73, 76, 78, 80, 82, 84, 86, 89-
 90, 91-92, 93-94, 95-96, 97-98
Art books and catalogs: ENP
American Air Tourist—1940's (Marifu) sk 1971 ENP: *abc*

GARDNER, SUSAN ROSS 1941-
Biographical dictionaries: WAA 76, 78, 80, 82, 84, 86, 89-90,
 91-92, 93-94, 95-96, 97-98
Art books and catalogs: ENP, RBW
Annunciation sk 1971 RBW: [13]
Missing Person's Reports sk 1971 ENP: *abc*

GARET, JEDD 1955-
Biographical dictionaries: WAA 93-94, 95-96, 97-98
Art books and catalogs: AAP
Night Boy li sc (co) 1983 AAP: **15**, 62

GARFINKEL, GLORIA 1929-
Biographical dictionaries:
Artbooks and catalogs: PWP
Ginko Kimono #1 sh-et ce-et aq sf sl dr (co) 1989 PWP:
 clp**21**/113

GASH, GAIL 1951-
Biographical dictionaries:
Art books and catalogs: PNM
Shin Hanga III co-li fd ng (co) 1983 PNM: 128

GELB, JAN 1906-78
Biographical dictionaries: WAA 40-41, 40-47, 53, 56, 62, 66,
 70, 73, 76, 78
Art books and catalogs: RBW
Oahu Sunrise co-et (co) 1974 RBW: [14]

GELLIS, SANDY L. 1946-
Biographical dictionaries: WAA 78, 80, 82, 84, 86, 89-90, 91-92, 93-94, 95-96, 97-98
Artbooks and catalogs: PRO, PWP
(Key) (*from portfolio* Spring 1987: In the Northern Hemisphere) co-pe (co) 1987-88 PRO: clp33
BB Verona, Wisconsin (*from portfolio* Spring 1987: In the Northern Hemisphere) co-pe (co) 1987-88 PRO: clp33
BJU Pine Plains, New York (*from portfolio* Spring 1987: In the Northern Hemisphere) co-pe (co) 1987-88 PRO: clp33
Dusk: Lake Rowland et pe 1987 PWP: clp41/113
GW Seattle, Washington (*from portfolio* Spring 1987: In the Northern Hemisphere) co-pe (co) 1987-88 PRO: clp33
JGR Kingston, Rhode Island (*from portfolio* Spring 1987: In the Northern Hemisphere) co-pe (co) 1987-88 PRO: clp33
KM Warwick, New York (*from portfolio* Spring 1987: In the Northern Hemisphere) co-pe (co) 1987-88 PRO: clp33
LZ Somerset, England (*from portfolio* Spring 1987: In the Northern Hemisphere) co-pe (co) 1987-88 PRO: clp33
MB Lyngby, Denmark (*from portfolio* Spring 1987: In the Northern Hemisphere) co-pe (co) 1987-88 PRO: clp33
MM Oldbridge, New Jersey (*from portfolio* Spring 1987: In the Northern Hemisphere) co-pe (co) 1987-88 PRO: clp33
NS Putney, Vermont (*from portfolio* Spring 1987: In the Northern Hemisphere) co-pe (co) 1987-88 PRO: clp33
RR Albuquerque, New Mexico (*from portfolio* Spring 1987: In the Northern Hemisphere) co-pe (co) 1987-88 PRO: clp33
SG New York, NY (*from portfolio* Spring 1987: In the Northern Hemisphere) co-pe (co) 1987-88 PRO: clp33
Spring 1987: In the Northern Hemisphere (*portfolio*) co-pe (co) 1987-88 PRO: clp33

GELMAN, ANITA 1952-
Biographical dictionaries:
Art books and catalogs: NPE
Self-Portrait II pe sf (co) 1977 NPE: **68**
Serpents pe aq et ou (co) 1976 NPE: 66

GEORGE, THOMAS R. 1918-
Biographical dictionaries: WAA 66, 70, 73, 76, 78, 80, 82, 84, 86, 89-90, 91-92, 93-94, 95-96, 97-98
Art books and catalogs: TYA
Tower, Scheme No. 3 wo 1954 TYA: 46

GERTSCH, FRANZ 1930-
Biographical dictionaries:
Art books and catalogs: TWO
Jean Frederic Schnyder (*from* Documenta: The Super Realists) li 1972 TWO: 103

GILBERT AND GEORGE
See PROERSCH, GILBERT *or* PASSMORE, GEORGE

GILBERT, HELEN ODELL 1922-
Biographical dictionaries: WAA 82, 84, 86, 89-90, 91-92, 93-94, 95-96, 97-98
Artbooks and catalogs: PWP
Paris Two li 1987 PWP: clp**23**/113

GILKEY, GORDON WAVERLY 1912-
Biographical dictionaries: WAA 62, 66, 70, 73, 76, 78, 80, 82, 84, 86, 89-90, 91-92, 93-94, 95-96, 97-98
Art books and catalogs: PNW
Fractured Earth: Landslide cg (co) 1985 PNW: **55**
Oregon Coast aq 1993 PNW: 57
Theme Center, New York World's Fair et aq 1938 PNW: 56

GILL, GENE 1933-
Biographical dictionaries: WAA 73, 76, 78, 80, 82, 84, 86, 89-90, 91-92, 93-94, 95-96, 97-98
Art books and catalogs: LAP
Untitled sk pt al 1972 LAP: 76/107

GILLIAM, SAM 1933-
Biographical dictionaries: WAA 70, 73, 76, 78, 80, 82, 84, 86, 89-90, 91-92, 93-94, 95-96, 97-98
Art books and catalogs: AAP, AMI, PIA, TYA

Lattice (II) et li 1982 AAP: 63
Nile li (co) 1972 AMI: clp127
Pink Horse Shoes sc fk gt (co) 1973 PIA: **154**/115
Wave li 1972 TYA: 46

GILOT, FRANÇOISE 1921-
Biographical dictionaries:
Artbooks and catalogs:
See also:
Yoakum, Mel. *Stone Echoes: Original Prints by Françoise Gilot: A Catalogue Raisonné.* Collegeville, Pa.: Philip and Muriel Berman Museum of Art at Ursinus College, c.1995.

GLARNER, FRITZ 1899-1972
Biographical dictionaries: WAA 40-47, 53, 56, 59, 62, 66, 70
Art books and catalogs: AMI, APS, PAC, RBW
Color Drawing for Relational Painting co-li (co) 1963 APS: clp6
Drawing for Tondo li 1959 AMI: clp28
Recollection (*from book* Recollection) li bk 1964-68 PAC: [24-5]/77
Untitled li 1959 RBW: [14]

GLICK, JOHN PARKER 1938-
Biographical dictionaries: WAA 91-92, 93-94, 95-96, 97-98
Artbooks and catalogs: CIP
Overflight co-sc (co) 1989 CIP: **27**

GLIER, MIKE (MICHAEL) 1953-
Biographical dictionaries: WAA 91-92, 93-94, 95-96, 97-98
Art books and catalogs: PAP
Entertaining (*from series* Men at Home) pv my et aq rl dr mz 1985 PAP: 65

GLOECKLER, RAYMOND 1928-
Biographical dictionaries:
Art books and catalogs: ACW, WAT
Big Biker wo-en 1971 WAT: 293
Eeny Meeny Miney Moe co-wo (co) 1968 ACW: **64**, 119
Hornblower ci-wo (co) 1980 ACW: **65**, 119 WAT: **269**

GOETZ, JAMES RUSSELL 1915-53
Biographical dictionaries: WAA 40-47, 53
Art books and catalogs: GRE
Untitled Abstract en 1946 GRE: clp*98*

GOLDMAN, JANE E. 1951-
Biographical dictionaries:
Artbooks and catalogs: CIP, NPE, PWP
Breezeway #7 co-sc (co) 1986 CIP: **32**
Castle Place Reflections #1 et aq rl ou 1978 NPE: 70
Dallas Reflections #15 co-sc (co) 1983 CIP: **30**
Ellen's Window co-sc (co) 1990 CIP: **29**
Grassmere Lane co-sc (co) 1983 CIP: **30**
Mid-Summer Light co-sc (co) 1987 CIP: **31**
Norris Court #4 pe aq (co) 1977 NPE: 69
November et (co) 1989 PWP: clp52/113
Summer Nights co-sc (co) 1984 CIP: **31**
Sun Porch co-sc (co) 1988 CIP: **32**
To the Garden co-sc (co) 1989 CIP: **33**

GOLDSTEIN, DANIEL JOSHUA 1950-
Biographical dictionaries: WAA 78, 80, 82, 84, 86, 89-90, 91-
92, 93-94, 95-96, 97-98
Art books and catalogs: TYA
Evening Iris wo dp 1976 TYA: 47

GOLDSTEIN, MILTON 1914-
Biographical dictionaries: WAA 53, 56, 59, 62, 66, 70, 73, 76,
78, 80, 82, 84, 86, 89-90, 91-92, 93-94, 95-96, 97-98
Art books and catalogs: TYA
Pompei 79 A.D. et aq 1969 TYA: 47

GOLDYNE, JOSEPH 1942-
Biographical dictionaries:
Art books and catalogs: CAM, SIM
Narcissus co-mo (co) 1978 SIM: **162**
One, Two, Three...All Gone co-mo pp (co) 1980 SIM: **174**
Untitled [Dark Floral] mo (co) 1979 CAM: 21/44

GOLUB, LEON ALBERT 1922-
Biographical dictionaries: WAA 66, 70, 73, 76, 78, 80, 82, 84, 86, 89-90, 91-92, 93-94, 95-96, 97-98
Art books and catalogs: AMI, FIM, GRE
Combat (I) to-sk 1972 AMI: clp143
Workers li 1949 GRE: clp*104*
Wounded Warrior (*from portfolio* Agon) li (co) 1965 FIM: **59**

GONGORA, LEONEL 1932-
Biographical dictionaries: WAA 73, 76, 78, 80, 82, 84, 86, 89-90, 91-92, 93-94, 95-96, 97-98
Art books and catalogs: ENP
Transformation of Samson & Delilah into Judith & Holofernes li 1970 ENP: *abc*

GONZALEZ-TORNERO, SERGIO 1927-
Biographical dictionaries: WAA 78, 80, 82, 84, 86, 89-90, 91-92, 93-94, 95-96, 97-98
Art books and catalogs: RBW
Stepladder et 1972 RBW: [14]

GOODALE, CHRISTINE 1959-
Biographical dictionaries:
Art books and catalogs: TYA
Untitled sk 1973 TYA: 47

GOODE, JOE 1937-
Biographical dictionaries: WAA 73, 76, 78, 80, 82, 84, 86, 89-90, 91-92, 93-94, 95-96, 97-98
Art books and catalogs: AAP, ENP, LAP, TPI, TYA
Glass Middle Left—Spoon Middle Right co-li (co) 1967 TPI: 83
Untitled co-li (co) 1978 LAP: 97/108
Untitled co-li sc (co) 1971 TPI: **35**
Untitled li 1969 ENP: *abc*
Untitled li 1974 TYA: 49
Untitled li sk 1971 TYA: 49
Untitled #301c-JG '81 li gs dp 1981 AAP: 64

GOODMAN, JEFF(REY) 1943-
Biographical dictionaries:
Art books and catalogs: AAP
Un Ange Passe mo 1983 AAP: 65

GOODMAN, KEN(NETH HUNT) 1950-95
Biographical dictionaries: WAA 86, 89-90, 91-92, 93-94, 95-96
Art books and catalogs: PAP
Untitled [*State II*] sc 1985 PAP: 66

GORDY, ROBERT P. 1933-86
Biographical dictionaries: WAA 73, 76, 78, 80, 82, 84
Art books and catalogs: AAP, CAM, NPE, PAP, SIM
Dog sc hn (co) 1976 NPE: 71
Figure in Landscape mo 1985 PAP: 67
Male Head mo 1984 CAM: 35/44
Sister Act sc hn (co) 1977 NPE: 72
Suspicious Head, First Version mo hc (co) 1983 AAP: 66
Wanderer co-mo (co) 1986 SIM: **148**

GORMAN, R(UDOLPH) C(ARL) 1932-
Biographical dictionaries: WAA 73, 76, 78, 80, 82, 84, 86, 89-
90, 91-92, 93-94, 95-96, 97-98
Art books and catalogs: PNM
Taos Man li 1972 PNM: 81

GORNIK, APRIL 1953-
Biographical dictionaries: WAA 82, 84, 86, 89-90, 91-92, 93-
94, 95-96, 97-98
Artbooks and catalogs: PAP, PWP
Equinox sf 1989 PWP: clp80/113
Rolling Clouds mo 1985 PAP: 68

GORNY, A-P (ANTHONY-PETER) 1950-
Biographical dictionaries: WAA 91-92, 93-94, 95-96, 97-98
Art books and catalogs: AAP, PAP, TYA
A-B-D-O-M-A-N li ds 1982 AAP: 67
H.T.A.D. aq 1974 TYA: 49
Queen's Autumn (a.k.a. A queer Fall) li ch 1985 PAP: 69

GOTTLIEB, ADOLPH 1903-74
 Biographical dictionaries: WAA 36-37, 40-41, 40-47, 53, 56,
 59, 62, 66, 70, 73
 Art books and catalogs: AMI, AMP, PPP, SIM, TPI, WAT
 Apparition aq dr c.1945 AMI: clp6
 Black and Gray co-sk (co) 1967 AMP: 89
 Germination II li 1969 AMI: **clp41**
 Untitled co-li (co) 1969 WAT: **146**
 Untitled co-mo (co) 1973 SIM: **135**
 Untitled co-wo (co) c.1945 AMI: clp20 PPP: 52 TPI: 15

GOULET, CIE 1940-
 Biographical dictionaries:
 Art books and catalogs: PNW
 Bales of Hay mo (co) 1994 PNW: **59**
 Rolling Fields mo 1994 PNW: 60
 Wide Cornfields #571 mo 1994 PNW: 61

GRACE, CONSTANCE 1929-
 Biographical dictionaries:
 Artbooks and catalogs: PWP
 Key Limes Marigot Harbour wl 1989 PWP: clp31/113

GRAVES, NANCY STEVENSON 1940-95
 Biographical dictionaries: WAA 73, 76, 78, 80, 82, 84, 86, 89-
 90, 91-92, 93-94, 95-96
 Art books and catalogs: AGM, AMI, FIM, PAP, PWP, TCR,
 TGX
 Alloca mo co-hm (co) 1981 AGM: **95**
 Approaches the Limit of I li (co) 1981 PWP: clp63/113 TCR: **144**
 Approaches the Limit of II li et (co) 1981 TCR: **144** TGX: **10**
 Calibrate et aq sf en li (co) 1981 AGM: **8**/93 TCR: **140**
 Ceive mp hm (co) 1981 TCR: **145**
 Chala mp hm (co) 1981 TGX: **85**
 Creant mp hm (co) 1981 TGX: **85**
 Fra Mauro Region of the Moon li (co) 1972 FIM: **81**
 Gling mp hm (co) 1981 TCR: **147**
 Merab mp hm (co) 1981 TCR: **146**

Mosphe mp hm (co) 1981 TCR: **147**
Muin et aq dr hc (co) 1977 AMI: clp128 TCR: **143**
Ngetal et aq en dr tl oi-pk (co) 1977 AGM: **94** TCR: **143** TGX: **87**
Nomer mp hm (co) 1981 TCR: **145**
Onon et aq dr en hc (co) 1977 TCR: **142**
Owad mp hm (co) 1981 TCR: **146** TGX: **84**
Ruis et aq en hc (co) 1977 TCR: **143**
Saille et aq hc (co) 1977 TCR: **142**
Six Frogs sc 1985 PAP: 70
Tate mp hm (co) 1981 TCR: **146**
Toch et aq dr en hc (co) 1977 TCR: **142** TGX: **86**
Turnal mp hm (co) 1981 TCR: **147**
See also:
Padon, Thomas. *Nancy Graves: Excavations in Print: A
 Catalogue Raisonné.* New York: Harry N. Abrams, Inc., in
 association with the American Federation of Arts, 1996.

GRAY, MAURICE L. 1947-
 Biographical dictionaries:
 Art books and catalogs: CUN
 Harigata in re sk mp CUN: 39
 Rub of the Brush li cg sk (co) CUN: **91**
 Solo Stunner li in sk CUN: 40
 Suburban Sprawl, Baby You Got It All cg re sk (co) CUN: **90**

GRAY, NANCY 1950-
 Biographical dictionaries:
 Art books and catalogs: ENP
 El at Myrtle Avenue sk 1971 ENP: *abc*

GREBINAR, KENNETH 1948-
 Biographical dictionaries:
 Art books and catalogs: TYA
 Triptych et tp 1975 TYA: 50

GREEN, ALAN 1932-
 Biographical dictionaries:
 Art books and catalogs: TWO
 Center to Edge—Neutral to Black et 1979 TWO: 83

GREEN, ART 1941-

Biographical dictionaries: WAA 76, 78, 80, 82, 84, 86, 89-90, 91-92, 93-94, 95-96, 97-98

Artbooks and catalogs: CHI

Alex Waugh wo 1963 CHI: 58

Art Green co-of-li (co) 1973 CHI: 61

da Hairy Who Kamic Kamie Page (*comic strip page by James Falconer, Art Green, Gladys Nilsson, Jim Nutt, Suellen Rocca, and Karl Wirsum*) of-li 1967 CHI: 200

Dis is THE catalog (*catalogue/checklist/price list by James Falconer, Art Green, Gladys Nilsson, Jim Nutt, Suellen Rocca, and Karl Wirsum*) of-li 1969 CHI: 203

Excavation sk co-mp (co) 1962 or 1963 CHI: 57

First Etching et dr c.1963 CHI: 58

Hairy Who (cat-a-log) (*comic book by James Falconer, Art Green, Gladys Nilsson, Jim Nutt, Suellen Rocca, and Karl Wirsum*) co-of-li (co) 1968 CHI: **35**, 201-2

Hairy Who (*comic book by James Falconer, Art Green, Gladys Nilsson, Jim Nutt, Suellen Rocca, and Karl Wirsum*) co-of-li (co) 1968 CHI: 199-200

Hairy Who (*poster for 1st "Hairy Who" group exhibition*) of-li 1966 CHI: 194

Hairy Who (*poster for 2nd "Hairy Who" group exhibition*) of-li (co) 1967 CHI: **35**, 196

Hairy Who Sideshow (*comic book by James Falconer, Art Green, Gladys Nilsson, Jim Nutt, Suellen Rocca, and Karl Wirsum*) co-of-li (co) 1967 CHI: 196-98

Indecent Composure co-li (co) 1970 CHI: **24**, 61

Kitchen Still Life wo 1963 CHI: 57

Mineral Spirit [Death by Suffocation] [*States 1-3*] et dr rl 1965-66 CHI: 60

Murray Simon's Motorcycle wo 1963 CHI: 57

One Dollar co-ex-tf-sk (co) 1962-63 CHI: 57

Portable Hairy Who! (*comic book by James Falconer, Art Green, Gladys Nilsson, Jim Nutt, Suellen Rocca, and Karl Wirsum*) bk co-of-li (co) 1966 CHI: 194-95

Roger Brown/Art Green (*based on exquisite corpse by Roger Brown and Art Green*) of-li 1973 CHI: 208

Salvatory Solution et pp 1964 CHI: 59

Second Etching et dr c.1963 CHI: 58

Silent Eclectic Fish Tattoo (*exquisite corpse by Vera Berdich, Art Green, Suellen Rocca, and William Schwedler*) et 1964 CHI: 191

Steal et 1964 CHI: 59

Third Etching et aq c.1964 CHI: 58

Untitled co-sk ps (co) 1962 or 1963 CHI: 57

Untitled ex-tf-sk 1962 or 1963 CHI: 57

Untitled of-li c.1973 CHI: 61

Untitled (*from portfolio* Da Hairy Who) co-sk (co) 1967-68 CHI: 193

GREENBAUM, MARTY 1934-

Biographical dictionaries: WAA 78, 80, 82, 84, 86, 89-90, 91-92, 93-94, 95-96, 97-98

Art books and catalogs: TYA

Bklyn Local in Weege Wisconsin mx 1974 TYA: 50

GREENE, JOHN 1955-

Biographical dictionaries:

Art books and catalogs: NPE

Untitled et hg hm 1978 NPE: 73

Untitled hn wo (co) 1978 NPE: 74

GREENE, STEPHEN 1918-

Biographical dictionaries: WAA 40-47, 53, 56, 62, 66, 70, 73, 76, 78, 80, 82, 84, 86, 89-90, 91-92, 93-94, 95-96, 97-98

Art books and catalogs: CAM

Untitled (*figures*) mo 1982 CAM: 33/44

GREENWALD, BERNARD 1941-

Biographical dictionaries:

Art books and catalogs: TYA

Creole Jazz Band III in 1974 TYA: 50

GROOMS, RED 1937-

Biographical dictionaries: WAA 66, 70, 73, 76, 78, 80, 82, 84, 86, 89-90, 91-92, 93-94, 95-96, 97-98

Art books and catalogs: AMI, CAM, PIA, TWO, TYA

AARRRRRRHH (*from portfolio* No Gas) li td (co) 1971 PIA:

146/114

Downhill Skier mo 1983 CAM: 29/44

Gertrude li as (co) 1974 *or* 1975 AMI: clp133 TYA: 51

Nervous City li 1972 TYA: 51

No Gas Cafe (*from portfolio* No Gas) li (co) 1971 PIA: **147**/114-15

Stamped Indelibly [*Plate 2*] (*created with Kenneth Kock*) rs 1967 TWO: 49

See also:

Alexander, Brooke, and Virginia Cowles. *Red Grooms: A Catalogue Raisonné of his Graphic Work 1957-1981* (exhibition catalog). Cheekwood/Nashville: The Fine Arts Center, 1981.

GROSCH, LAURA **1945-**

Biographical dictionaries: WAA 76, 78, 80, 82, 84, 86, 89-90, 91-92, 93-94, 95-96, 97-98

Art books and catalogs: TYA

Gloxinia on an Oriental Rug li 1974 TYA: 52

Iris on Bokhara li 1976 TYA: 52

GROSS, ANTHONY **1905-84**

Biographical dictionaries:

Art books and catalogs:

See also:

Herdman, Robin. *The Prints of Anthony Gross: A Catalogue Raisonné.* Aldershot, Hants, England: Scolar Press; Brookfield, VT: Gower Publishing Co., c.1991.

GUASTELLA, C. DENNIS **1947-**

Biographical dictionaries: WAA 82, 84, 86, 89-90, 91-92, 93-94, 95-96, 97-98

Artbooks and catalogs: CIP

Timepiece co-sc (co) 1982 CIP: **35**

Patching co-sc (co) 1982 CIP: **35**

GURA, KATHY **1952-**

Biographical dictionaries:

Art books and catalogs: NPE

Box Series II li ch em ce (co) 1977 NPE: 75

Square Site I li ch em 1978 NPE: 76

GUSTON, PHILIP 1913-80
Biographical dictionaries: WAA 40-41, 40-47, 53, 56, 59, 62, 66, 70, 73, 76, 78, 80
Art books and catalogs: AGM, AMI, BWS, PAC, THL
Coat li 1980 AMI: clp142
Elements li 1980 AGM: 31
Street li 1970 PAC: [26]/78
Studio Corner li 1980 BWS: 26/30
Untitled li 1963 THL: 16

GUZAK, KAREN W. 1939-
Biographical dictionaries: WAA 89-90, 91-92, 93-94, 95-96, 97-98
Art books and catalogs: PNW
Geometrics: Circle, Cross, Square, Diamond li (co) 1992 PNW: 63
Jewels for Taj co-li (co) 1987 PNW: 65
Traces of Taj #17 mp 1995 PNW: 64

GWYN, WOODY 1944-
Biographical dictionaries:
Art books and catalogs: PNM
Interstate co-li (co) 1981 PNM: 119

HAAS, RICHARD JOHN 1936-
Biographical dictionaries: WAA 73, 76, 78, 80, 82, 84, 86, 89-90, 91-92, 93-94, 95-96, 97-98
Art books and catalogs: APP, TYA
Flatiron Building et dr 1973 APP: 247
Great Hall, Kip Riker Mansion aq 1975 TYA: 52

HAFFTKA, MICHAEL D. 1953-
Biographical dictionaries: WAA 97-98
Art books and catalogs: PAP
Undertones (*one from portfolio of 4*) hg mo (co) 1985 PAP: 71

HAHN, BETTY 1940-
Biographical dictionaries: WAA 78, 80, 82, 84, 86, 89-90, 91-

92, 93-94, 95-96, 97-98
Art books and catalogs: PNM
Botanical Layout: Peony co-li (co) 1979 PNM: 94

HAINES, (CHARLES) RICHARD 1906-84
Biographical dictionaries: WAA 40-41, 56, 62, 66, 70, 73, 76,
78, 80, 82, 84
Art books and catalogs: LAP
Bus Stop li 1948 LAP: 60/102

HAKSAR, MANJULA 1944-
Biographical dictionaries:
Art books and catalogs: GAP
Letter Series #55 mp 1984 GAP: 8/30

HALE, KENNETH JOHN 1948-
Biographical dictionaries: WAA 76, 78, 80, 82, 84, 86, 89-90
Art books and catalogs: FTP
Solitude li re (co) 1987 FTP: **41**

HALL, JOAN
Biographical dictionaries:
Art books and catalogs: CUN
Brenton Reef/June '89 cn-hm 1990 CUN: 43
Culebra's Remnants cn-hm 1989 CUN: 44
Flight to Yuma cn-hm (co) 1989 CUN: **92**
Wrecked Dreams cn-hm (co) 1988 CUN: **93**

HALL, SUSAN 1943-
Biographical dictionaries: WAA 78, 80, 82, 84, 86, 89-90, 91-
92, 93-94, 95-96, 97-98
Art books and catalogs: AAP, PWP
Morning Glory sf dr aq sb sa ch (co) 1982 AAP: **13**, 68
Secret Journey mo (co) 1989 PWP: clp47/113

HALLEY, PETER 1953-
Biographical dictionaries: WAA 91-92, 93-94, 95-96, 97-98
Art books and catalogs: PRO
Tour of the Monuments of Passaic, New Jersey (*suite of 5*) co-lv

(co) 1988-89 PRO: clp35

HALTON, KATHERINE 1952-
Biographical dictionaries:
Art books and catalogs: TYA
Untitled sk of-li hd 1975 TYA: 53

HAMBLETON, RICHARD A. 1954-
Biographical dictionaries: WAA 89-90, 91-92, 93-94
Art books and catalogs: PAP
Figure [Monsoon] sc hc (co) 1985 PAP: 72

HAMILTON, KEVIN 1957-
Biographical dictionaries:
Art books and catalogs: GAP
Sellin' sk 1985 GAP: 20/30

HAMILTON, RICHARD 1922-
Biographical dictionaries:
Art books and catalogs: TCR, TGX, TPI, TWO
Adonis in Y Fronts co-sc (co) 1963 TPI: 83
Fashion Plate co-of-li ce sc pc rd (co) 1969-70 TPI: 84
Flower-Piece B li (co) 1976 TCR: **148, 150** TGX: **124-26**
Flower-Piece B, Crayon Study li (co) 1976 TCR: **151** TGX: **127**
Flower-Piece B, Cyan Separation li 1976 TCR: **150**
I'm Dreaming of a White Christmas rd-dt 1969 TPI: 84
I'm Dreaming of a White Christmas sc 1967 TGX: 123
Interior co-sk (co) 1964-65 TPI: 83 TWO: 38
Just what is it that makes today's homes so different, so
 appealing? ce (co) 1956 TGX: 122 TPI: **fcv, 12**
Kent State co-sk (co) 1970 TPI: **37** TWO: 65
My Marilyn co-sc (co) 1965 TPI: **20**
Solomon R. Guggenheim co-sc (co) 1965 TPI: **36**
Sunset li cq hm 1976 TCR: **151**
Swinging London 67 co-et em ce me-fl (co) 1968 TPI: **37**

HAMILTON, SUSAN 1949-
See BOLT, SUSAN HAMILTON

HAMMERSLEY, FREDERICK 1919-
Biographical dictionaries: WAA 70, 73, 76, 78, 80, 82, 84, 86, 89-90, 91-92, 93-94, 95-96, 97-98
Art books and catalogs: PNM
Clout co-li (co) 1988 PNM: clp16

HAMMOND, HARMONY 1944-
Biographical dictionaries: WAA 76, 78, 80, 82, 84, 86, 89-90, 91-92, 93-94, 95-96, 97-98
Art books and catalogs: AAP, CAM, PNM, PWP, RBW
Blue Spirit co-li (co) 1978 PNM: 92
Fan Lady and Forms of Desire mo oi 1982 CAM: 40/44
Las Animas II li 1988 PWP: clp5/113
Odd Personage mo 1982 RBW: [15]
Ruffled Waters mo oc 1982 AAP: 69

HAMMOND, JANE 1950-
Biographical dictionaries: WAA 91-92, 93-94, 95-96, 97-98
Artbooks and catalogs: PRO, PWP
Untitled mo et ch 1989 PWP: clp44/113
Untitled #13 (*from series of 41*) et ch co-xx wc hd rs (co) 1988 PRO: clp36
Untitled #17 (*from series of 41*) et ch co-xx wc hd rs (co) 1988 PRO: clp37

HAMMONS, DAVID 1943-
Biographical dictionaries: WAA 93-94, 95-96, 97-98
Art books and catalogs: LAP
Injustice Case by mx 1970 LAP: 81/106

HAN, H. N. 1939-
Biographical dictionaries:
Art books and catalogs: ENP
On the Circle Line No. 1 sk 1971 ENP: *abc*

HANLEY, JACK 1952-
Biographical dictionaries: WAA 89-90, 91-92, 93-94, 95-96, 97-98
Art books and catalogs: FTP

Plague-Doctor sg co-aq bg (co) 1990 FTP: **43**

HANNAH, JOHN JUNIOR 1923-
Biographical dictionaries: WAA 76, 78, 80, 82, 84, 86, 89-90,
 91-92, 93-94, 95-96, 97-98
Art books and catalogs: TYA
Deity in re 1971 TYA: 53

HANSELL, FREYA 1947-
Biographical dictionaries: WAA 91-92, 93-94, 95-96, 97-98
Artbooks and catalogs: PWP
Untitled mo 1989 PWP: clp10/114

HANSEN, ART 1929-
Biographical dictionaries:
Art books and catalogs: PNW
Flower Landscape co-et (co) 1987 PNW: **67**
Lunch Counter et 1976 PNW: 69
Winter 1977 et 1977 PNW: 68

HANSEN, ROBERT (WILLIAM) 1924-
Biographical dictionaries: WAA 70, 73, 76, 78, 80, 82, 84, 86,
 89-90, 91-92, 93-94, 95-96, 97-98
Art books and catalogs: ENP
Man-Men li 1965 ENP: *abc*

HANSMANN, GARY 1940-
Biographical dictionaries:
Art books and catalogs: NPE
Ancestor mo 1977 NPE: 78
Ghost Dancer in cg 1975 NPE: 77

HANSON, PHILIP HOLTON 1943-
Biographical dictionaries: WAA 73, 76, 78, 80, 82, 84, 86, 89-
 90, 91-92, 93-94, 95-96, 97-98
Artbooks and catalogs: CHI
Baskets pe 1967-70 CHI: 76
Birds pe 1967-70 CHI: 76
Bouquet et 1976 CHI: 76

Bursting Out li 1967 CHI: 64
Chicago Imagist Art co-of-li (co) 1972 CHI: 77
Cloud Theater et aq 1967 CHI: 66
Country Club Dance et hc-wc (co) 1968 CHI: **24**, 72
Dancing Couple I [*Two States*] et co-et (co) 1968 CHI: 72
Dancing Couple II [*Two States*] et co-et (co) 1968 CHI: 72
Dancing Couple III co-et (co) 1968 CHI: 73
Dancing Couple IV [*Two States*] et co-et (co) 1968 CHI: 73
Dancing Couple V et 1968 CHI: 73
Entrance and Pavilion et hc-wc (co) 1967 CHI: 68
Factory Structure li 1966 CHI: 64
False Image (*poster/invitation for 1st "False Image" group exhibition*) of-li ds 1968 CHI: 204
False Image (*price list for 1st "False Image" group exhibition*) of-li 1968 CHI: 206
False Image (*price list for 2nd "False Image" group exhibition*) of-li 1969 CHI: 207
False Image Decals (*created by Roger Brown, Eleanor Dube, Philip Hanson, and Christina Ramberg*) co-sk pp (co) 1969 CHI: **36**, 207
False Image II (*based on exquisite corpse by Roger Brown, Eleanor Dube, Philip Hanson, and Christina Ramberg*) co-of-li (co) 1969 CHI: 206
False Image Postcards (*created by Roger Brown, Eleanor Dube, Philip Hanson, and Christina Ramberg*) co-of-li (co) 1968 CHI: 204-5
Fan li 1966 CHI: 63
Fiesta sk hc (co) 1968 CHI: 77
Flower Presentation [*Two States*] et hc-wc (co) 1974 CHI: 74
Flowing Bands li 1966 CHI: 63
Flying Machine li 1967 CHI: 65
Fountain li 1966 CHI: 63
Future City li 1967 CHI: 65
Grid of Squiggles li 1966 CHI: 63
Head-Pavilion I et aq hc-wc (co) 1967 CHI: 68
Head-Pavilion II et aq 1967 CHI: 68
Head-Pavilion III et hc-wc (co) 1967 CHI: 68
Head-Pavilion IV et aq hc-wc (co) 1967 CHI: 68
Heart Variations et 1968-69 CHI: 73
Machines li 1967 CHI: 65

Magician co-et (co) 1968 CHI: 70
Masked Chorus co-et (co) 1968 CHI: 70
Masked Head co-et aq (co) 1967 CHI: 67
McGovern and Shriver co-sk (co) 1968 CHI: 77
Opening Window [*Two States*] co-et (co) 1967 CHI: 65
Pavilion Park et hc-wc (co) 1968 CHI: 71
Pleasure Park I et hc-wc (co) 1967 CHI: 69
Pleasure Park II et aq 1967 CHI: 69
Pleasure Park III mz 1967 CHI: 70
Purple li (co) 1967 CHI: 64
Radar Pavilion [*States 1, 3, and 4*] co-et et aq dr (co) 1967 CHI:
 66
Room with Covered Vase et 1976 CHI: 75
Room with Niches [*Two States*] et 1975-76 CHI: 75
Room with Shells and Vases et hc-wc (co) 1976 CHI: 75
Room with Vases and Flowers et hc-wc (co) 1974-75 CHI: **25**, 74
Room with Vases and Flowers and Knives et hc-wc (co) 1975
 CHI: 74
Singer co-et aq (co) 1968 CHI: 70
Smoke Machine co-li (co) 1966 CHI: 63
Squiggles li 1966 CHI: 63
St. Anthony Pleasure Park et hc-wc (co) 1968 CHI: 71
Stage et 1967 CHI: 69
Stage with Lights et (co) 1967 CHI: 69
Stage with Staircase et (co) 1967 CHI: 69
Structure [*Two States*] et 1967 CHI: 65
Structure li 1966 CHI: 64
Structures li 1966 CHI: 64
Telescoping Machine li 1967: 64
Theater co-et (co) 1967 CHI: 66
Three Actors et 1967 CHI: 68
Three Stages aq 1967 CHI: 69
Untitled et hc-wc (co) 1968 CHI: 71
Veiled Head I [*Two States*] et aq 1967 CHI: 67
Veiled Head II co-et dr (co) 1967 CHI: 67
Veiled Head III et 1967 CHI: 67
Veiled Head IV aq 1967 CHI: 67
Woman at Swan Vanity et 1977 CHI: 76

HARA, KEIKO 1942-
Biographical dictionaries: WAA 82, 84, 86, 89-90, 91-92, 93-94, 95-96, 97-98
Art books and catalogs: CIP, PNW, TYA
Drawn in the Moon sc li ce (co) 1980 CIP: **37**
Hagoromo mx 1996 PNW: 73
Heart in America mx pp 1976 TYA: 53
Topophilia #7 wt-wb 1995 PNW: 72
Topophilia V: 100 Gates wb sn kz mp (co) 1994 PNW: **71**

HARDEN, MARVIN 1939-
Biographial dictionaries: WAA 76, 78, 80, 82, 84, 86, 89-90, 91-92, 93-94, 95-96, 97-98
Art books and catalogs: TYA
Thing Seen Suggests, This and Other Existences li 1974 TYA: 54

HARELSON, CLINT 1947-
Biographical dictionaries:
Art books and catalogs: NPE
Locking Horns sk 1977 NPE: 79
Strongman sk 1978 NPE: 80

HARING, KEITH 1958-90
Biographical dictionaries: WAA 86, 89-90
Art books and catalogs:
See also:
Haring, Keith. *Keith Haring: Editions on Paper, 1982-1990: The Complete Printed Works.* Stuttgart: Edition Cantz, 1993.

HARRINGTON, SUSAN DIANE 1949-
Biographical dictionaries:
Art books and catalogs: FTP
Untitled mo dp 1989 FTP: **45**

HARRISON, TONY 1931-
Biographical dictionaries: WAA 73, 76, 78, 80, 82, 84, 86, 89-90, 91-92, 93-94, 95-96, 97-98
Art books and catalogs: CMZ
Untitled #7 mz dp 1976 CMZ: fcv/34

Untitled #13 mz 1976 CMZ: [59]/34

HARTIGAN, GRACE 1922-
　Biographical dicationaries: WAA 66, 73, 76, 78, 80, 82, 84, 86, 89-90, 91-92, 93-94, 95-96, 97-98
　Art books and catalogs: AMI, APP, INP, PAP, PIA
　Elizabeth Etched ig aq sb 1985 INP: 9 PAP: 73
　Pallas Athene li (co) 1961 PIA: **129**/112
　Ship li 1960 AMI: clp29
　Untitled li 1961 APP: 195

HARTLEY, JOHN 1958-
　Biographical dictionaries:
　Art books and catalogs: FTP
　Untitled (Nude) mo 1989 FTP: **47**

HASHIMI, ZARINA
　Biographical dictionaries:
　Art books and catalogs: RBW
　Seed li 1984 RBW: [15]

HASSELL, BILLY 1956-
　Biographical dictionaries:
　Art books and catalogs: FTP
　Storm Warnings hc-in (co) 1990 FTP: **49**

HAVENS, JAMES DEXTER 1900-60
　Biographical dictionaries: WAA 40-41, 40-47, 53, 56, 59
　Art books and catalogs: ACW, TYA
　Rabbit Fence wo 1946 TYA: 54
　Scarlet Runner Beans co-wo (co) 1957 ACW: **32**, 101

HAYES, STEPHEN 1955-
　Biographical dictionaries:
　Art books and catalogs: PNW
　Days of Love (*single image from series*) mo 1993-94 PNW: **fpc**, 77
　Found Woman mo (co) 1996 PNW: **75**
　Happy Girl or Boy mo 1996 PNW: 76

HAYNES, NANCY 1947-
Biographical dictionaries: WAA 89-90, 91-92, 93-94, 95-96, 97-98
Art books and catalogs: PIA
Untitled (GT/NH 6-90 W-7) mo hm (co) 1990 PIA: **215**/123

HAYTER, STANLEY WILLIAM **1901-88**
Biographical dictionaries: WAA 40-47, 53, 56, 59, 62, 66, 70, 73, 76
Art books and catalogs: AMI, APP, GMC, PIA, TYA, WAT
Amazon en et sf 1945 APP: 73
Cinque Personnages co-in sf co-sk (co) 1946, 1969 PIA: 27 WAT: **137**
Easy Prey bu-en 1938 GMC: 18-19
Tarantella en et 1943 AMI: clp1
Unstable Woman et en of 1947 TYA: 54
Untitled (*from portfolio* For Meyer Schapiro) co-li (co) 1973 GMC: 64
Witches Sabbath co-et aq hm (co) 1958 GMC: 20
See also:
Black, Peter, and Desiree Moorhead. *The Prints of Stanley William Hayter: A Complete Catalogue.* New York: Moyer Bell, 1992.

HAZEL, STEPHEN 1934-
Biographical dictionaries:
Art books and catalogs: AAP, PAP, PNW, TYA
Beautiful Display 5 [Amor sin Lingua] wo 1973 TYA: 55
Beautiful Display 10 [Beauties of Chinatown] lg aq rp ch 1982 AAP: 70
Biloxi Beach Liner in re 1971 TYA: 55
Garden of the Night in su 1992-95 PNW: 80
Hero Death wb ku (co) 1987 PNW: **79**
Laid Up Stones in su 1992-95 PNW: 81
Structure in Glass li 1985 PAP: 74

HEILMANN, MARY 1940-
Biographical dictionaries:
Artbooks and catalogs: PWP

Rincon, House, Whitewater aq hm 1990 PWP: clp7/114

HEISTERKAMP, PETER
See PALERMO, BLINKY

HEIZER, MICHAEL 1944-
Biographical dictionaries: WAA 86
Art books and catalogs: AAP, AMI, TCR, TGX, TWO
#11 Untitled hc-mo ce (co) 1979 TGX: **115**
#13 Untitled (*from* Monotype, Collage Series) mo ce (co) 1979 TCR: **155**
45°, 90°, 180° li sc et rs hm (co) 1983 TGX: **118** TCR: **152**, **158**
Circle I et aq hm (co) 1977 TCR: **154** TGX: **112**
Circle II et aq hm (co) 1977 TCR: **154** TGX: 112
Circle III et aq rl hm (co) 1977 TCR: **154** TGX: 112 TWO: 59
Circle IV et aq li hm(co) 1977 TCR: **155** TGX: **112**
Dragged Mass li sc et hm (co) 1983 TCR: **158** TGX: **117**
III-8 (*from* 45°, 90°, 180° Monoprints) mp hc hm dp (co) 1983 TCR: **156**
V-1 (*from* 45°, 90°, 180° Monoprints) mp hc hm (co) 1983 TCR: **156**
VII-13 (*from* 45°, 90°, 180° Monoprints) mp hc hm (co) 1983 TCR: **157**
VIII-2 (*from* 45°, 90°, 180° Monoprints) mp hc hm (co) 1983 TCR: **157**
IX-1 (*from* 45°, 90°, 180° Monoprints) mp ce hc hm (co) 1983 TCR: **157**
Levitated Mass li sc et hm (co) 1983 TCR: **158** TGX: **117**
Monoprint III-2 mo et rs sy sc hc tl co-hd dp (co) 1983 AAP: 71
Scrap Metal Drypoint #2 dr 1978 AMI: clp101

HELD, AL 1928-
Biographical dictionaries: WAA 70, 73, 76, 78, 80, 82, 84, 86, 89-90, 91-92, 93-94, 95-96, 97-98
Art books and catalogs: AAP
Stone Ridge IV et 1983 AAP: 72

HELFENSTELLER, VERONICA 1910-64
Biographical dictionaries:

Art books and catalogs: FWC
Beauty and the Beast en c.1950 FWC: 29
Just Waiting li c.1940 FWC: 27
Untitled [Landscape with Animals] et sf aq dr c.1943 FWC: 28
Untitled [Pears] et sf c.1943 FWC: 28

HENDERSON, VIC(TOR) LANCE 1939-
(*alias* LOS ANGELES FINE ARTS SQUAD)
Biographical dictionaries: WAA 78, 80, 82, 84, 86, 89-90, 91-
92, 93-94, 95-96, 97-98
Art books and catalogs: LAP
Isle of California co-li (co) 1973 LAP: 89/107

HENLE, MARIE
Biographical dictionaries:
Art books and catalogs: RBW
In the Clouds co-et (co) 1984 RBW: [15]

HENNING, RONNI 1939-
Biographical dictionaries:
Artbooks and catalogs: PWP
Still Life with Beetle pc 1989 PWP: clp**81**/114

HENRY, JON 1916-
Biographical dictionaries: WAA 62
Art books and catalogs: TYA
King in His Counting House wo 1946 TYA: 55

HERMAN, ROGER 1947-
Biographical dictionaries: WAA 86, 89-90, 91-92, 93-94, 95-96,
97-98
Artbooks and catalogs: GAR, IAI
Fatherland, Mothertongue wo tp (co) 1983 IAI: **29**
Fieldwork wo 1984 IAI: **32**
Van Gogh in Red wo (co) 1983 IAI: **30**
Woman on the Railroad Tracks co-wb (co) 1987 GAR: 57

HERSHEY, NONA 1946-
Biographical dictionaries: WAA 80, 82, 84, 86, 89-90, 91-92,

93-94, 95-96, 97-98
Art books and catalogs: PAP
Suite aq 1984 PAP: 75

HEWITT, CHARLES 1946-
Biographical dictionaries:
Art books and catalogs: PAP
Summer Night et aq dr 1985 PAP: 55

HEYBOER, ANTON 1924-
Biographical dictionaries:
Art books and catalogs: TWO
Culture and Heartbeat et dp 1962-63 TWO: 110

HEYDT, WILLIAM 1949-
Biographical dictionaries:
Art books and catalogs: NPE
Femme de la Nuit et aq dr (co) 1976 NPE: **81**
Proposal dr en aq sf 1978 NPE: 83

HICKEY, CHRISTOPHER 1954-
Biographical dictionaries:
Art books and catalogs: GAP
A-Chair mr 1985 GAP: 25/30

HIGH, TIMOTHY GRIFFIN 1949-
Biographical dictionaries: WAA 78, 80, 82, 84, 86, 89-90, 91-
92, 93-94, 95-96, 97-98
Art books and catalogs: CUN
Days the Locust Have Eaten hr-sk tp 1988 CUN: 48
Madame Butterfly sk-mo (co) 1991 CUN: **94**
rebel earth—Ramath lehi hr-sk 1983 CUN: 47
rebel-earth—Maranatha hr-sk (co) 1980 CUN: **93**

HILDEBRAND, JANET (CARLILE) 1942-
Biographical dictionaries:
Art books and catalogs: TYA
Eagle's Nest- Gore Range et 1975 TYA: 56

HILL, CHARLES CHRISTOPHER 1948-
Biographical dictionaries: WAA 89-90, 91-92, 93-94, 95-96, 97-98
Art books and catalogs: LAP, NAP
Lightning hc-li (co) 1977 LAP: 95/108
Solomonic li 1980 NAP: **35**

HILL, CLINTON J. 1922-
Biographical dictionaries: WAA 73, 76, 78, 80, 82, 84, 86, 89-90, 91-92, 93-94, 95-96, 97-98
Art books and catalogs: APP, TYA
21 hm dy bd 1975 TYA: 56
First Page wo 1956 APP: 118

HILL, RIC(HARD) WAYNE 1950-
Biographical dictionaries: WAA 78, 80, 82, 84, 86, 89-90, 91-92, 93-94
Art books and catalogs: MCN
Mask of the Diamond Lady sk 1989 MCN: **[9]**

HIRATSUKA, YUJI 1954-
Biographical dictionaries:
Art books and catalogs: PNW
Cacnus co-in re ch (co) 1995 PNW: **83**
Judgment co-in re ch (co) 1995 PNW: 84
Morning Glory Sigh co-in ch (co) 1994 PNW: 85

HIRSCH, GILAH YELIN 1944-
Biographical dictionaries: WAA 76, 78, 80, 82, 84, 86, 89-90, 91-92, 93-94, 95-96, 97-98
Art books and catalogs: AWP
III - Sesame Suite tu ss ls cy 1973 AWP: [9]

HIRTZEL, SUE 1945-
Biographical dictionaries:
Art books and catalogs: CIP, TYA
Grace co-cv (co) 1982 CIP: **39**
Infinity Dance co-cv (co) 1982 CIP: **39**
Little Notes II cv 1974 TYA: 56

HNIZDOVSKY, JACQUES 1915-85
 Biographical dictionaries: WAA 62, 66, 70, 73, 76, 78, 80, 82, 84
 Art books and catalogs: WAT
 Pinoak Trees wo 1963 WAT: 289

HOCKENHULL, JO 1942-
 Biographical dictionaries:
 Art books and catalogs: PNW
 Everlovin' Light ac-ca sc (co) 1992 PNW: **87**
 Inheritors ac-ca sc 1993 PNW: **88**
 Silver and Gold, Edged in Black (*from series* Past, Present, Future) sc 1989 PNW: **89**

HOCKNEY, DAVID 1937-
 Biographical dictionaries: WAA 70, 93-94, 95-96, 97-98
 Art books and catalogs: AMI, PAP, PIA, PPP, SMP, TCR, TGX, THL, TPI, TWO
 Afternoon Swimming li (co) 1980 TCR: **172**
 Amaryllis in Vase li hm (co) 1985 TCR: **174**
 Ann Looking at Her Picture li 1984 TCR: **174**
 Ann Seated in Director's Chair li (co) 1980 TCR: **173**
 Bedlam (*from* A Rake's Progre cv1`ss) co-et (co) 1961-63 TPI: **38**
 Black Tulips li 1980 TCR: **170**
 Bora Bora li (co) 1980 TCR: **169**
 Byron on Hand li hm 1980 TCR: **172**
 Celia with Green Hat li hm (co) 1985 TCR: **175**
 Commissioner li hm (co) 1980 TCR: **172**
 Conversation in the Studio hp-fm li hm (co) 1984 TCR: **174**
 Discord Merely Magnifies et aq 1976-77 TGX: 148
 Hollywood Collection (*set of 6*) co-li (co) 1965 TPI: 85
 Home (*from* Six Fairy Tales from the Brothers Grimm) et 1970 TWO: 117
 Hotel Acatlán: First Day li hm (co) 1985 TCR: **177**
 Hotel Acatlán: Second Day li hm (co) 1985 TCR: **180** TGX: **154-55**
 Hotel Acatlan: Two Weeks Later li hm (co) 1985 SMP: **29** TCR: **182**

Image of Celia li sc-ce hp-fm (co) 1984-86 SMP: **33** TGX: **158**

Image of Celia [*State I*] li-ce (co) 1984-86 SMP: **30**

Image of Celia [*State II*] li-ce hp-fm (co) 1984-86 SMP: **31**

Image of Gregory li ce hm hp-fm dp (co) 1984-85 SMP: **27** TCR: **181**

Image of Ken li 1987 TGX: **36**

Joe with David Harte li (co) 1980 AMI: clp134 TCR: **171**

Joe with Green Window li (co) 1980 TCR: **171**

Johnny and Lindsey li (co) 1980 TCR: **170**

Lithograph of Water made of lines li hm (co) 1980 TCR: **166**

Lithograph of Water made of lines and a green wash li hm (co) 1980 TCR: **166**

Lithograph of Water made of lines, a green wash, and a light blue wash li hm (co) 1980 TCR: **166**

Lithograph of Water made of lines with two light blue washes li hm (co) 1980 TCR: **167**

Lithograph of Water made of thick and thin lines and a light blue and a dark blue wash li hm (co) 1980 TCR: **167**

Lithograph of Water made of thick and thin lines and two light blue washes li hm (co) 1980 TCR: **167**

Lithograph of Water made of thick and thin lines, a green wash, a light blue wash, and a dark blue wash li hm (co) 1980 TCR: **165**

Lithographic Water made of lines li hm (co) 1980 TCR: **168** TGX: **151**

Lithographic Water made of lines and crayon li hm (co) 1980 TCR: **168**

Lithographic Water made of lines, crayon, and a blue wash li hm (co) 1980 TCR: **169** TGX: **151**

Lithographic Water made of lines, crayon, and two blue washes li hm (co) 1980 TCR: **168**

Master Printer of Los Angeles li sc (co) 1973 PPP: 6 TGX: **12**

Mist (*from* The Weather Series) li (co) 1973 PIA: **155**/115

Pacific Mutual Life Building with Palm Trees li 1964 THL: 58

Pembroke Studio Interior li hp-fm hm (co) 1985 TCR: **176**

Pembroke Studios with Blue Chairs and Lamp li hm (co) 1985 TCR: **175**

Perspective Lesson li hm (co) 1985 TCR: **181** TGX: **157**

Picture of a Pointless Abstraction Framed Under Glass li (co)

1965 TGX: **147**

Picture of Melrose Avenue with an Ornate Gold Frame co-li (co) 1965 LAP: 74/104

Pool made with paper and blue ink for book li (co) 1980 TCR: **173**

Potted Daffodils li 1980 TCR: **170**

Receiving the Inheritance (*from* A Rake's Progress) et aq hm 1961-63 TGX: 146

Red Celia li hm (co) 1985 PAP: **fcv**, 76 SMP: **32** TCR: **175**

Start of the Spending Spree and the Door opening for a Blonde (*from* A Rake's Progress) co-et (co) 1961-63 TPI: **38**

Study of Byron li hm 1980 TCR: **171**

Two Boys Aged 23 or 24 (*from portfolio* 14 Poems from C. P. Cavafy) et aq 1966 TWO: 117

Two Pembroke Studio Chairs li hm (co) 1985 TCR: **176**

Tyler Dining Room li hm (co) 1985 TCR: **176**

Views of Hotel Well I li hm (co) 1985 TCR: **178**

Views of Hotel Well II li hm (co) 1985 TCR: **178**

Views of Hotel Well III li hm hp-fm (co) 1984-85 SMP: **28** TCR: **160**, **179** TGX: **153**

Walking Past Two Chairs li sc hp-fm (co) 1984-86 SMP: **26**

HODGELL, ROBERT OVERMAN 1922-
Biographical dictionaries: WAA 53, 56, 62, 66, 70, 73, 76, 78, 80, 82, 84, 86, 89-90, 91-92, 93-94, 95-96, 97-98
Art books and catalogs: ACW
Burning Bush co-wo (co) 1955 ACW: **52**, 113

HODGKIN, HOWARD 1932-
Biographical dictionaries:
Art books and catalogs: TWO
For B.J. hc-li dp (co) 1979 TWO: **125**

HOFMANN, GEORGE 1938-
Biographical dictionaries:
Art books and catalogs: TYA
Temtie aq en 1974 TYA: 57
Untitled et 1975 TYA: 57

HOKE, STEPHEN R. 1951-
Biographical dictionaries:
Art books and catalogs: ENP
Waiting for the Freight et 1972 ENP: *abc*

HOLDER, ROBIN
Biographical dictionaries:
Art books and catalogs: RBW
Oya li 1980 RBW: [16]

HOLLAND, TOM 1936-
Biographical dictionaries: WAA 73, 76, 78, 80, 82, 84, 86, 89-
90, 91-92, 93-94, 95-96, 97-98
Art books and catalogs: TYA
Ryder li 1972 TYA: 57

HOLLANDER, IRWIN 1927-
Biographical dictionaries:
Art books and catalogs: TYA
Bread li 1976 TYA: 58

HOLZER, JENNY 1950-
Biographical dictionaries: WAA 84, 86, 89-90, 91-92, 93-94,
95-96, 97-98
Art books and catalogs: FIM
Truisms pf 1977 FIM: **101**

HOOVER, ELLISON 1888-1955
Biographical dictionaries: WAA 40-47, 53
Art books and catalogs: PIA, PNM
George C. Miller, Lithographer li 1949 PIA: 24
Untitled [Taos Pueblo] li PNM: 42

HOPKINS, DONALD 1945-
Biographical dictionaries:
Art books and catalogs: TYA
Somewhere Near the Border et ch hc 1975 TYA: 58

HUGHES, MANUEL 1938-
Biographical dictionaries:
Art books and catalogs: RBW
Untitled li 1976 RBW: [16]

HULTBERG, JOHN PHILLIP 1922-
Biographical dictionaries: WAA 62, 66, 70, 73, 76, 78, 80, 82,
84, 86, 89-90, 91-92, 93-94, 95-96, 97-98
Art books and catalogs: THL
Garage li 1963 THL: 18

HUMPHREY, DAVID AIKEN 1955-
Biographical dictionaries: WAA 86, 89-90, 91-92, 93-94, 95-96,
97-98
Art books and catalogs: PAP
Nocturne lc 1984 PAP: 77

HUMPHREY, MARGO 1942-
Biographical dictionaries:
Artbooks and catalogs: PWP
Lady and the Tiger li (co) 1985 PWP: clp19/114

HUNT, BRYAN 1947-
Biographical dictionaries: WAA 80, 82, 84, 86, 89-90, 91-92,
93-94, 95-96, 97-98
Art books and catalogs: TWO
Fall with a Bend et aq 1979 TWO: 121

HUNT, RICHARD HOWARD 1935-
Biographical dictionaries: WAA 66, 70, 73, 76, 78, 80, 82, 84,
86, 89-90, 91-92, 93-94, 95-96, 97-98
Art books and catalogs: APP, ENP, THL, TYA
Composition li 1969 ENP: *abc* TYA: 58
Untitled (*from portfolio* Details) li 1965 THL: 26
Untitled [No. 17] li c.1965 APP: 143

HUNTOON, MARY 1896-1970
Biographical dictionaries: WAA 36-37, 40-41, 40-47, 53, 56, 62
Art books and catalogs: KSP

Girl with Sand Painting aq et KSP: 57/61
Kansas Harvest et KSP: 58/61
Peaceful Harve Cartoonist en c.1966 KSP: 55/61

HURLEY, DENZIL H. 1949-
Biographical dictionaries: WAA 91-92, 93-94, 95-96, 97-98
Art books and catalogs: NPE
Other Places #I en dr et sl (co) 1977 NPE: **84**
Other Places #VIII en dr et pa-sn sl (co) 1978 NPE: 85

HUSE, MARION BARSTOW 1896-1967
Biographical dictionaries: WAA 36-37, 40-41, 40-47, 53, 56, 62
Art books and catalogs: SIM
Ruins—Tours, France co-mo (co) 1948 SIM: 130

HUSNER, PAUL 1942-
Biographical dictionaries:
Art books and catalogs: RBW
Untitled li 1979 RBW: [16]

IDA, SHOICHI 1941-
Biographical dictionaries: WAA 78, 80, 93-94, 95-96, 97-98
Art books and catalogs: TWO
Paper Between Two Stones and Rock (*from* The Surface is the
 Between) of-li em 1977 TWO: 86

IKEDA, MASUO 1934-
Biographical dictionaries: WAA 76
Art books and catalogs: APP, CMZ
Portrait of Sphinx (*from series* The Sphinx) mz et 1970 APP: 231
Sphinx Covered by a Sheet (*from portfolio* Portrait of Sphinx) co-
 mz dr (co) 1970 CMZ: [55]/36
Sphinx of the Woods (*from portfolio* Portrat of Sphinx) et 1970
 ENP: *abc*
See also:
Nichiwaki, Junzaburo, et al. *Masuo Ikeda—Graphic Works, 1956-
 1971.* Tokyo: Bijutsu Shuppan-sha, 1972.

IKEGAWA, SHIRO 1933-
Biographical dictionaries: WAA 84, 86, 89-90, 91-92, 93-94,
95-96, 97-98
Art books and catalogs: LAP
Issa co-in (co) 1966 LAP: 73/105

IMMENDORFF, JÖRG 1945-
Biographical dictionaries:
Artbooks and catalogs: IAI
Ausgangspunkt (*from portfolio* Naht) lc (co) 1982 IAI: **37**
Brandenburger Tor (*from portfolio* Naht) lc 1982 IAI: **36**
Wir Kommen (*from* Café Deutschland gut) lc (co) 1982 IAI: **38**

INDIANA, ROBERT 1928-
Biographical dictionaries: WAA 66, 70, 73, 76, 78, 82, 84, 86,
89-90, 91-92, 93-94, 95-96, 97-98
Art books and catalogs: AKG, AMI, APS, TPI, TWO, TYA,
WAT
American Dream co-sk (co) 1971 WAT: 282
ERR (*from* The International Anthology of Contemporary
Engraving: The International Avant-Garde: America
Discovered, Volume 5) pn pe 1963 TPI: 85
LOVE co-sc (co) 1965 TPI: 85
LOVE co-sk (co) 1967 AKG: clp15 AMI: clp60 TPI: **40** TWO: **35**
LOVE Wall (*suite of 4*) co-sc (co) 1967 APS: clp36
Numbers (*portfolio of 10*) co-sc (co) 1968 AKG: clp15d TPI: 86
Polygons #4 sc 1975 TYA: 59
Sex Anyone? (*from portfolio* One Cent Life *by Walasse Ting,
edited by Sam Francis*) co-li (co) c.1964 AKG: clp72
See also:
Robert Indiana: The Prints and Posters, 1961-1971 (exhibition
catalog). Stuttgart and New York: Edition Domberger, 1971.
Sheehan, Susan. *Robert Indiana Prints: A Catalogue Raisonné,
1951-1991.* New York: Susan Sheehan Gallery, c.1991.

ISELI, ROLF 1934-
Biographical dictionaries:
Art books and catalogs: TWO
Mushroom Man I dr 1975 TWO: 111

ITCHKAWICH, DAVID MICHAEL 1937-
Biographical dictionaries: WAA 73, 76, 78, 80, 82, 84, 86, 89-
90, 91-92, 93-94, 95-96, 97-98
Art books and catalogs: ENP
Awaiting the Results with Doctor Bassa-Netti at the Institute et
1971 ENP: *abc*

IZQUIERDO, MANUEL 1928-
Biographical dictionaries:
Art books and catalogs: PNW
Grand Rodeo wo 1978 PNW: 93
Jeen-Jo the Dancer wo 1978 PNW: 92
Pierrot's Tapestry wo 1992 PNW: **91**

JACKLIN, BILL (WILLIAM) 1943-
Biographical dictionaries: WAA 95-96, 97-98
Art books and catalogs: CMZ
Moody Rocker (*from series* Rocker) mz 1973 CMZ: [50]/38
Rocking and Rubbing (*from series* Rocker) mz 1973 CMZ:
[51]/38
Rocking my Blues Away (*from series* Rocker) mz 1973 CMZ:
[52]/38

JACKSON, HERB 1945-
Biographical dictionaries: WAA 73, 76, 78, 80, 82, 84, 86, 89-
90, 91-92, 93-94, 95-96, 97-98
Art books and catalogs: TYA
22 x 30: Luna, Eclipse, Down Wind, Sand Dust li pp 1975 TYA:
60
Bloom in 1975 TYA: 59

JACQUETTE, YVONNE HELENE 1934-
Biographical dictionaries: WAA 76, 78, 80, 82, 84, 86, 89-90,
91-92, 93-94, 95-96, 97-98
Art books and catalogs: AAP, AGM, CAM, FIM, PAP, PIA,
PWP, SIM, TYA
Aerial View of 33rd Street li vm 1981 AGM: **98**
Brooklyn-Atlantic Avenue I co-mo (co) 1975 CAM: 39/45

Mississippi Night Lights (Minneapolis) li sc (co) 1985-86 PIA:
 197/120
Northwest View from the Empire State Building li vm 1982 AAP:
 73 AGM: **99**
Sanitation Truck et 1985 PAP: 54
Times Square (Motion Picture) li (co) 1990 PWP: clp95/114
Traffic Light Close Up mo 1975 TYA: 60
Traffic Signal li hc-tl/wc (co) 1973 FIM: **90-91**
Vinalhaven Shelves and Ledges D tl-mo 1991 SIM: **167**

JANOFF-KATJANELSON, ANITA 1925-
 Biographical dictionaries:
 Art books and catalogs: NPE
 Plates X, II, and I et (co) 1978 NPE: 87
 Yellow Afterimage et (co) 1975 NPE: 86

JANSEN, ANGELA BING 1929-
 Biographical dictionaries: WAA 78, 80, 82, 84, 86, 89-90, 91-
 92, 93-94, 95-96, 97-98
 Art books and catalogs: TYA
 Cactus and Cabbage et 1974 TYA: 60

JENKINS, PAUL 1923-
 Biographical dictionaries: WAA 66, 70, 73, 76, 78, 80, 82, 84,
 86, 89-90, 91-92, 93-94, 95-96, 97-98
 Art books and catalogs: TCR
 East Winds (II) mp li hm hc-pa (co) 1980 TCR: **187**
 Emissary et aq hm (co) TCR: **188**
 Four Winds (I) mp re hm hc-pa (co) 1980 1985 TCR: **184**, **187**
 Himalayan Hourglass et aq hm (co) 1980 TCR: **188**
 Katherine Wheel mp li sc hm (co) 1979 TCR: **186**
 Over the Cusp dr mz et hm (co) 1980 TCR: **188**
 West Winds (III) mp re hc-pa (co) 1980 TCR: **187**

JENSEN, ALFRED JULIO 1903-81
 Biographical dictionaries: WAA 62, 66, 70, 73, 76, 78, 80
 Art books and catalogs: AMI, THL, TWO
 [Growth of 4x5 Rectangle] (*from portfolio* A Pythagorean
 Notebook) co-li (co) 1965 THL: 30

Pythagorean Notebook [*plate*] li (co) 1965 AMI: clp102 TWO: 78

JENSEN, BILL 1945-
Biographical dictionaries: WAA 82, 84, 86, 89-90, 91-92, 93-
94, 95-96, 97-98
Art books and catalogs: PAP
Studio et aq 1983-84 PAP: 78

JIMENEZ, LUIS ALFONSO 1940-
Biographical dictionaries: WAA 73, 76, 78, 80, 82, 84, 86, 89-
90, 91-92, 93-94, 95-96, 97-98
Art books and catalogs: FTP, PNM
Baile con la Talaca [Dance with Death] li 1983 FTP: 51
Snake and Eagle co-li (co) 1985 PNM: 122

JOHANSEN, CARL H. 1946-
Biographical dictionaries:
Art books and catalogs: PNM
Artist and Model co-li (co) 1975 PNM: 117

JOHANSON, GEORGE E. 1928-
Biographical dictionaries: WAA 66, 70, 76, 78, 80, 82, 84, 86,
89-90, 91-92, 93-94, 95-96, 97-98
Art books and catalogs: PNW
George Beach co-aq (co) 1991 PNW: **95**
Night Games #5 et wc (co) 1996 PNW: 96
Skulls et pp 1996 PNW: 97

JOHNS, JASPER 1930-
Biographical dictionaries: WAA 66, 70, 73, 76, 78, 80, 82, 84,
86, 89-90, 91-92, 93-94, 95-96, 97-98
Art books and catalogs: AAP, AGM, AKG, AMI, AML, AMP,
APB, APM, APP, APR, APS, BWS, CAM, ENP, FIM, GMC,
PAC, PAP, PIA, POR, PPP, PRO, SIM, SMP, TCA, TGX,
TPI, TWO, TYA, WAT
0 li (co) 1960-63 FIM: **28**
0-9 (*portfolio of 10*) co-li (co) 1960-63 APS: clp17
1 li (co) 1960-63 FIM: **29**
1st Etchings (*portfolio of 7*) et pn 1967-68 APS: clp47

1st Etchings (*portfolio of 13*) et pn 1968 TPI: 87
"5" li 1968 AMP: 91
Ale Cans co-li (co) 1964 TPI: **42**
Alphabet li 1968-69 AKG: clp20
Alphabets li 1962 AMI: clp47
Between the Clock and the Bed li (co) 1989 SMP: **36**
Coat Hanger li 1960 AML: 195 APS: clp19
Coat Hanger I li 1960 WAT: 231
Coat Hanger II li 1960 FIM: **27**
Corpse and Mirror sc 1976 AGM: 26
Critic Sees (*from* Ten from Leo Castelli) sc-at em ce 1967 TPI: 86
Critic Smiles lr gd tn-fl (co) 1969 TPI: **43**
Decoy (I) of-li (co) 1971 AMI: clp**49** APP: 182 TYA: 62
Device li 1962 APS: clp21
Fall (*from suite* The Seasons) co-in aq sb dr le pv (co) 1987 PRO:
 clp38
False Start I li (co) 1962 PIA: **130**/112
False Start II co-li (co) 1962 APS: clp**20**
Figure 0 li 1969 TGX: **16**
Figure 7 (*from series* Colored Numerals) co-li (co) 1969 TPI: **43**
 TWO: 43
Flag III li 1960 AMI: clp46
Flags I sc (co) 1973 PIA: tlp, **156**/115-6
Fool's House co-li (co) 1971-72 WAT: **147**
Gray Alphabets li 1968 APB: clp*117*/44
Hand li 1963 APS: clp22
Hatteras li 1963 AMI: clp48
High School Days ld-re-mt 1969 WAT: 262
Hinged Canvas li 1971 ENP: *abc*
Light Bulb [*working proofs*] li cy ck tu (co) 1976 PPP: **98**, 98-99
Light Bulb li 1976 PPP: 99
Light Bulb lr 1969 TYA: 61
Numbers li 1967 APM: 10/14 APS: clp49 BWS: 16/30
Painting with Two Balls II li 1962 AKG: clp17
Periscope co-et (co) 1978-81 AMP: **fpc**, **93**
Plate No. 6 after Untitled li (co) 1975 APP: clp**10**
Savarin (*#2 of 2*) li-mo 1982 AAP: 74
Savarin 5 (Corpse and Mirror) li 1978 PPP: 101
Savarin 5 (Corpse and Mirror) [*working proof*] li ik hd (co) 1978

PPP: **100**

Savarin co-mo (co) 1982 SIM: **175**

Savarin li 1977-81 PAC: [28]/79

Savarin mo 1978 PAC: [29]/79

Savarin Monotype mo li (co) 1982 AMI: clp**136** PPP: **102**

Savarin Monotype [*cancellation*] mo li (co) 1978 PPP: **103**

Scent li lc wo 1975-76 TYA: 62

Seasons (*series of 4*) aq dr (co) 1987 SMP: **40-41**

Seasons aq dr pp 1989 SMP: 42-43

Seasons in 1990 PIA: **216**/123

Seasons in sl aq sb dr sp bn cs 1989 PRO: clp39

Skin with O'Hara Poem li 1963-65 APS: clp23 WAT: 229

Souvenir co-li (co) 1970 APR: 11/[14] PAC: [2]/79 POR: 263
 WAT: 232

Spring (*from suite* The Seasons) co-in aq sb dr le pv (co) 1987
 PRO: clp38

Summer (*from suite* The Seasons) co-in aq sb dr le pv (co) 1987
 PRO: clp38

Target li 1960 AKG: clp16 APP: 181

Target li 1971 TPI: 22

Target li mx 1960 FIM: **10**

Target (*from portfolio* For Meyer Schapiro) co-sk hm (co) 1973
 GMC: 64

Two Maps I li 1965-66 TYA: 61

Two Maps II co-li (co) 1966 TPI: 86

Untitled cb-et (co) 1988 SMP: **38**

Untitled co-mo (co) 1983 CAM: 31/45

Untitled li (co) 1977 PPP: **97**

Untitled mo 1983 PAC: [30-1]/79 SMP: **37**

Untitled (*one from edition of 78 with 15 proofs*) co-et tp (co) 1981
 AMP: 95

Untitled (Ruler) I et aq 1969 APS: clp48

Untitled [Spring] (*from the book* Poems *by Wallace Stevens*) et dp
 1985 BWS: 22/30

Untitled [*trial proof*] li 1977 PPP: 95

Untitled [*working proofs*] li ck hd ce ik (co) 1977 PPP: **93-94**, **97**

Usuyuki of-li (co) 1979 TWO: 107

Usuyuki sk (co) 1980 AMI: clp**107**

Ventriloquist li (co) 1985 PAP: **6**, 79 SMP: **38**

Ventriloquist li (co) 1986 SMP: **39**
Voice 2 of-li tp (co) 1982 AAP: **26**, 75 SMP: **34-35**
Watchman li (co) 1967 TCA: **[40]**
Winter et tp 1986 BWS: 23/30
Winter (*from suite* The Seasons) co-in aq sb dr le pv (co) 1987
 PRO: clp38
See also:
Field, Richard S. *Jasper Johns: Prints, 1960-1970* (exhibition
 catalog). Philadelphia: Philadelphia Museum of Art, 1970.
---. *Jasper Johns: Prints, 1970-1977* (exhibition catalog).
 Middletown, Conn.: Wesleyan University, 1978.

JOHNSON, JONELLE 1945-
 Biographical dictionaries:
 Art books and catalogs: PNM
 Boats co-aq tp (co) 1995 PNW: **99**
 Quad aq dr pp 1994 PNW: 101
 Quad Without Crows aq dr ch hi pp 1996 PNW: 100

JOHNSON, LOIS MARLENE 1942-
 Biographical dictionaries: WAA 73, 78, 80, 82, 84, 86, 89-90,
 91-92, 93-94, 95-96, 97-98
 Art books and catalogs: AWP, ENP
 Corner-Column sk 1971 ENP: *abc*
 Fat Emma (*from* "Heading East") sk gu to pa-sn 1975 AWP: [10]

JOHNSON, (LEONARD) LUCAS 1940-
 Biographical dictionaries: WAA 73, 76, 78, 80, 82, 84, 86, 89-
 90
 Art books and catalogs: NPE
 Homage to Tamayo et dr 1978 NPE: 89
 Velarde II cy tu li 1978 NPE: 88

JOHNSON, RAY 1927-95
 Biographical dictionaries: WAA 70, 73, 76, 78, 80, 82, 84, 86,
 89-90, 91-92, 93-94
 Artbooks and catalogs: CHI
 Correspondence (*pages 7, 9, and 10 from a collaborative
 print/catalog by Ray Johnson and Karl Wirsum*) of-li 1976

CHI: 208

JOHNSTON, THOMAS ALIX 1941-
Biographical dictionaries: WAA 78, 80, 82, 84, 86, 89-90, 91-92, 93-94, 95-96, 97-98
Art books and catalogs: PNW
Enclosure co-in (co) 1990-92 PNW: **103**
Interieur de Château sb-aq tp 1994 PNW: 104
L'Etranger in ch 1996 PNW: 105

JOHNSTON, YNEZ 1920-
Biographical dictionaries: WAA 56, 62, 66, 70, 73, 76, 78, 80, 82, 84, 86, 89-90, 91-92, 93-94, 95-96, 97-98
Art books and catalogs: LAP
Secret Landscape co-et (co) 1976 LAP: 93/108
Ship and Storm et 1949 LAP: 66/103

JONES, ANITA ROMERO 1930-
Biographical dictionaries:
Art books and catalogs: INN
La Sagrada Familia (*from suite* Seis Santeros) co-li (co) 1990 INN: **22**

JONES, JOHN PAUL 1924-
Biographical dictionaries: WAA 53, 56, 62, 66, 70, 73, 76, 78, 80, 82, 84, 86, 89-90, 91-92, 93-94, 95-96, 97-98
Art books and catalogs: APP, ENP, LAP, THL, WAT
Annunciation et sf 1959 APP: 114 WAT: 217
Boundary et en sf aq 1951 WAT: 216
Landscape #2 et 1950 LAP: 62/102
Votive Woman et 1968 ENP: *abc*
Woman in the Wind li 1962 THL: 47

JONES, LIZA 1944-
Biographical dictionaries:
Art books and catalogs: PNW
Chicago Laundry dr et 1996 PNW: 109
Hamlet dr aq (co) 1994 PNW: **107**
Hat for Tamara Toumanova dr 1994 PNW: 108

JONSON, RAYMOND 1891-1982
Biographical dictionaries: WAA 36-37, 40-41, 40-47, 53, 56,
59, 62, 66, 70, 73, 76, 78, 80, 82
Art books and catalogs: PNM
B. Print li 1965 PNM: 76
Sanctuario li-cy 1927 PNM: 75

JUAREZ, ROBERTO 1952-
Biographical dictionaries: WAA 84, 86, 89-90, 91-92, 93-94,
95-96, 97-98
Art books and catalogs: AAP, PAP
Arrowroot wo (co) 1985 PAP: **bcv**, 80
Boy with Bird (Black) wo 1983 AAP: 76

JUDD, DONALD CLARENCE 1928-94
Biographical dictionaries: WAA 56, 62, 70, 73, 76, 78, 80, 82,
84, 86, 89-90, 91-92, 93-94
Art books and catalogs: AKG, AMI, PIA, PRO, TWO
6-L wo (co) 1961-69 AMI: clp**100** TWO: 58
Untitled (*one of 6*) aq 1980 PIA: **173**/118
Untitled (*one of 13*) wo 1969 AKG: clp24
Untitled (*one of 3 portfolios in red, black, and blue*) co-wo (co)
1988 PRO: clp40
See also:
Schellmann, Jörg, and Mariette Josephus Jitta, eds. *Donald Judd:
Prints and Works in Editions, 1951-1993.* Cologne: Editions
Schellman, 1997.

JULES, MERVIN 1912-94
Biographical dictionaries: WAA 40-41, 40-47, 53, 56, 62, 66,
70, 73, 76, 78, 80, 82, 84, 86, 89-90, 91-92, 93-94
Art books and catalogs: ACW, SIM
Cove co-mo (co) 1980-85 SIM: **136**
Folksinger co-wo (co) 1957 ACW: **57**, 116

JULIAN, PETER 1952-
Biographical dictionaries:
Art books and catalogs: AAP

Untitled [Diptych] li dp 1982 AAP: 77

KADISH, REUBEN 1913-92
Biographical dictionaries: WAA 40-41, 66
Art books and catalogs: APP, SIM
Duo mo 1985 SIM: 137
Untitled, No. 3 et 1975 APP: 142

KAINEN, JACOB 1909-
Biographical dictionaries: WAA 40-41, 40-47, 53, 56, 59, 62,
66, 70, 73, 76, 78, 80, 82, 84, 86, 89-90, 91-92, 93-94, 95-96
Art books and catalogs: SIM, TYA
Cloudy Trophy in 1975 TYA: 63
El Presidente co-mo (co) 1978 SIM: **148**
Sun in the Hills wo sn 1951 TYA: 63

KAKAS, CHRISTOPHER A. 1941-
Biographical dictionaries: WAA 76, 78, 82, 84, 86, 89-90, 91-
92, 93-94, 95-96, 97-98
Art Books and catalogs: CUN
Juneway Edge in (co) 1989 CUN: **96**
Olive's Place li ch 1990 CUN: 51
Presence at Frisco in (co) 1987 CUN: **95**
Vision of Omena in 1989 CUN: 52

KAMINSKY, DAVID J. 1950-
Biographical dictionaries:
Art books and catalogs: TYA
Cigar Box cl 1972-74 TYA: 63

KANEMITSU, MATSUMI 1922-92
Biographical dictionaries: WAA 66, 70, 73, 76, 78, 80, 82, 84,
86, 89-90, 91-92
Art books and catalogs: AML, LAP, THL
Color Formation li 1961 AML: 206
Number Six [*State II*] li 1970 LAP: 82/106
Oxnard Madame co-li (co) 1961 THL: 25

KANESHIRO, ROBIN 1947-
Biographical dictionaries:
Art books and catalogs: NPE
Standing Alligator II et aq sb pe 1977 NPE: 90
Untitled et aq en re in (co) 1977 NPE: 91

KANOVITZ, HOWARD EARL 1929-
Biographical dictionaries: WAA 62, 70, 73, 76, 78, 80, 82, 84,
86, 89-90, 91-92, 93-94, 95-96, 97-98
Art books and catalogs: TYA
Horse li 1974 TYA: 64

KAPROV, SUSAN LEE 1946-
Biographical dictionaries: WAA 80, 82, 84, 86, 89-90, 91-92,
93-94, 95-96, 97-98
Art books and catalogs: TYA
Self-Portraits cx tp 1975 TYA: 64

KARDON, DENNIS 1950-
Biographical dictionaries:
Art books and catalogs: AAP, PAP, PIA
Charlotte's Gaze li wo (co) 1985 PAP: **23**, 81 PIA: **191**/120
Revolutionary Cleanser wo (co) 1983 AAP: **18**, 78

KARLSEN, ANNE-MARIE 1952-
Biographical dictionaries: WAA 82, 84, 86
Art books and catalogs: NPE
M. C. Violation [1^{st} State] li ar-sn (co) 1977 NPE: 92
Violation [2^{nd} State] li ar-sn (co) 1977 NPE: 93

KATZ, ALEX 1927-
Biographical dictionaries: WAA 62, 66, 70, 73, 76, 78, 80, 82,
84, 86, 89-90, 91-92, 93-94, 95-96, 97-98
Art books and catalogs: AAP, AGM, AMI, APP, BWS, FIM,
PAC, PAP, PIA, PRO, TWO, TYA
Ada, Alex (*from portfolio* A Tremor in the Morning) co-wo (co)
1986 PRO: clp41
Ando, Dino (*from portfolio* A Tremor in the Morning) co-wo (co)
1986 PRO: clp41

Anne li 1973 TYA: 64

Carter Ratcliff (*from book* The Face of the Poet) aq 1978 TWO: 119

Carter, Phyllis (*from portfolio* A Tremor in the Morning) co-wo (co) 1986 PRO: clp41

Danny, Laura (*from portfolio* A Tremor in the Morning) co-wo (co) 1986 PRO: clp41

Eric, Anni (*from portfolio* A Tremor in the Morning) co-wo (co) 1986 PRO: clp41

Green Cap wb (co) 1983 PAP: **21**, 82

Jennifer, Eric (*from portfolio* A Tremor in the Morning) co-wo (co) 1986 PRO: clp41

Julian, Jessica (*from portfolio* A Tremor in the Morning) co-wo (co) 1986 PRO: clp41

Kristi, Vincent (*from portfolio* A Tremor in the Morning) co-wo (co) 1986 PRO: clp41

Large Head of Vincent aq (co) 1982 AAP: 7, 79

Luna Park sc (co) 1965 FIM: **52**

Maine Landscape ln 1951 FIM: 51

Peter, Linda (*from portfolio* A Tremor in the Morning) co-wo (co) 1986 PRO: clp41

Rackstraw, Peggy (*from portfolio* A Tremor in the Morning) co-wo (co) 1986 PRO: clp41

Red Coat sk (co) 1983 AMI: clp**109**

Self Portrait aq 1978 APP: 234

Swimmer aq 1974 BWS: 10/30 PIA: **159**/116 AGM: 33

Tony Towle (*from book* The Face of the Poet) aq bk 1978 PAC: [32]/80

See also:

Maravell, Nicholas P. *Alex Katz: The Complete Prints.* New York: Alpine Fine Arts Collection, 1983.

KATZ, CIMA 1949-
Biographical dictionaries:
Art books and catalogs: AWP
Militant Left li ss al co-tr (co) 1974 AWP: [11]

KAUFFMAN, (ROBERT) CRAIG 1932-
Biographical dictionaries: WAA 70, 73, 76, 78, 80, 82, 84, 86, 89-90, 91-92, 93-94

Art books and catalogs: LAP
Untitled (*one from set of 4*) co-li (co) 1971 LAP: 77/106

KAY, BRYAN 1944-
Biographical dictionaries:
Art books and catalogs: TYA
Crowhill [*State 3*] et 1975 TYA: 65

KELLY, DANIEL 1947-
Biographical dictionaries:
Art books and catalogs: PAP
Blaine li 1985 PAP: 83

KELLY, ELLSWORTH 1923-
Biographical dictionaries: WAA 59, 62, 66, 70, 73, 76, 78, 80,
82, 84, 86, 89-90, 91-92, 93-94, 95-96, 97-98
Art books and catalogs: AMI, APM, APS, ENP, FIM, GMC,
PAC, PIA, PRO, TCA, TCR, TGX, TWO, TYA
Black/White/Black li 1970 ENP: *abc*
Blue and Red-Orange li (co) 1964 AMI: clp**81**
Colors on a Grid sc li (co) 1976 TCR: **192** TGX: **104**
Conques (*from series* Third Curve) li de 1976 AMI: clp82
Cyclamen III tf-li 1964-65 APM: 9/15 FIM: **48**
Daffodil li 1980 TCR: **204** TGX: 106
Dark Gray and White sc ce hm (co) 1979 TCR: **204**
Dark Gray Curve co-li (co) 1987 PRO: clp42
Dark Gray Curve [*State I*] co-li (co) 1987 PRO: clp43
Four Blacks and Whites: Upper Manhattan ce 1957 TGX: 109
Germigny (*from series* Third Curve) li de 1967 TWO: 61
Green Curve with Radius of 20 Feet (*from portfolio* For Meyer
Schapiro) li em 1973 GMC: 65
Locust li 1966 TCA: [31]
Mulberry Leaf li 1980 TCR: **205**
Nine Squares sc li (co) 1977 TCR: **201**
Red/Blue (*from the portfolio* Ten Works by Ten Painters) sc (co)
1964 APS: clp**38** FIM: **49**
Red-Orange/Yellow/Blue li 1970 TYA: 65
Red-Orange over Black co-sk (co) 1970 GMC: 30
Saint Martin Landscape li sc ce (co) 1979 TCR: **202-4** TGX: **109**

Sarsaparilla li 1980 TCR: **205**
Wall aq et 1976-79 PAC: [33]/80 PIA: **164**/117 TCR: **202**
Wild Grape Leaf li 1980 TCR: **205** TGX: 107
Woodland Plant li 1979 TCR: **202**
Yellow/Black li 1970 TYA: 66
See also:
Axsom, Richard H. *The Prints of Ellsworth Kelly: A Catalogue Raisonné, 1949-1985.* New York: Hudson Hills Press, 1987.
Bianchini, Paul. *Ellsworth Kelly: Drawings, Collages, Prints.* Greenwich, Conn.: New York Graphic Society, 1971.

KENNEDY, WINSTON 1944-
Biographical dictionaries:
Artbooks and catalogs: BAG
Memories, Dreams and Reflections (*from series* I Remember Memphis) xd-in 1979 BAG: 30/25

KENT, JANE 1952-
Biographical dictionaries:
Artbooks and catalogs: PRO, PWP
Untitled et mz 1989 PWP: clp34/114
Untitled [*#7-12*] (*from portfolio* Habit of Constant Return) mz (co) 1987 PRO: clp44

KENT, ROCKWELL 1882-1971
Biographical dictionaries: WAA 36-37, 40-41, 40-47, 53, 56, 59, 62, 66, 70
Art books and catalogs: AMP, GRE
Europe li 1946 AMP: 47
Fire! li 1948 GRE: clp*102*

(KENT) SISTER MARY CORITA, IHM *see* CORITA, SISTER MARY

KEPETS, HUGH MICHAEL 1946-
Biographical dictionaries: WAA 73, 76, 78, 80, 82, 84, 86, 89-90, 91-92, 93-94, 95-96, 97-98
Art books and catalogs: CIP, ENP, TYA
Astor co-sc (co) 1986 CIP: **41**
Interior No. 1 li 1971 ENP: *abc*

Lenox co-sc (co) 1986 CIP: **42**
Sixth Avenue sc 1976 TYA: 66
Tilden co-sc (co) 1987 CIP: **43**

KERNAN, CATHERINE 1948-
Biographical dictionaries:
Artbooks and catalogs: CIP, PWP
Detalles #6 wc-mo dp (co) 1988 PWP: clp**85**/114
Sticks #1 co-sc (co) 1988 CIP: **46**
Sticks #2 co-sc (co) 1988 CIP: **47**
Transversal I co-sc (co) 1983 CIP: **45**
Traversal II co-sc (co) 1983 CIP: **45**

KERSLAKE, KENNETH ALVIN 1930-
Biographical dictionaries: WAA 66, 70, 73, 76, 78, 80, 82, 84,
 86, 89-90, 91-92, 93-94, 95-96, 97-98
Art books and catalogs: CUN, GAR, TYA
American Patio Series et mo-co dp (co) 1985 CUN: **97**
Circle of Light in 1989 CUN: 57
Magic House: Reverie in pe 1974 TYA: 66
Magic House: Tear pi 1976 CUN: 55
Sarah's Garden in co-li (co) 1987 CUN: **96** GAR: **55**
Sense of Place pi 1976 TYA: 67

KESSLER, DAVID 1950-
Biographical dictionaries:
Art books and catalogs: NPE
Shadow Line ar li (co) 1977 NPE: 94
Surface Disturbance li ar-sn (co) 1978 NPE: **96**

KHALIL, MOHAMMED OMER 1936-
Biographical dictionaries: WAA 97-98
Art books and catalogs: RBW
Mr. Goodbar et RBW: [17]

KIENHOLZ, EDWARD 1927-94
Biographical dictionaries: WAA 66, 70
Art books and catalogs: FIM, TPI
Sawdy sc mx la rn (co) 1971 FIM: **77** TPI: 89

KIM, TCHAH-SUP 1942-
Biographical dictionaries:
Art books and catalogs: TYA
Between Infinities 6 et 1976 TYA: 67

KIMBALL, (WILFORD) WAYNE, JR. 1943-
Biographical dictionaries: WAA 73, 76, 78, 80, 82, 84, 86, 89-
90, 91-92, 93-94, 95-96, 97-98
Art books and catalogs: NPE
Longhorn in Sheep's Clothing co-li (co) 1977 NPE: 98
Properly Mounted Texas Longhorn co-li (co) 1976 NPE: 97

KING, LINDA 1951-
Biographical dictionaries:
Art books and catalogs: AAP
Biwako Series mo 1983 AAP: 80

KIRK, MICHAEL 1947-
Biographical dictionaries: WAA 78, 80, 82, 84, 86, 89-90, 91-
92, 93-94, 95-96, 97-98
Art books and catalogs: ENP
It's Been a Long Time... Since, sk 1972 ENP: *abc*

KIRK, PAT ANGLE 1951-
Biographical dictionaries:
Art books and catalogs: NPE
At the Opera co-li (co) 1977 NPE: 100
Sleeping Saquaro on a Henri Roussean Desert hc-li (co) 1976
NPE: 99

KITAJ, R(ONALD) B(ROOKS) 1932-
Biographical dictionaries: WAA 70, 73, 76, 78, 80 82, 84, 86,
89-90, 91-92, 93-94, 95-96, 97-98
Art books and catalogs: AKG, AMI, ENP, TPI, TWO
Acheson Go Home sk (co) 1963 AMI: clp55
Bub and Sis (*from* In Our Time Covers for a Small Library after
the Life for the Most Part) sk 1969 TWO: 44
London by Night—Life and Art in Photograph; no. Four (*from* In

Our Time) co-sc (co) 1969 TPI: **47**

Nancy and Jim Dine sk 1971 AKG: clp76

Nerves: Massage: Defeat: Heart (*from* Mahler Becomes Politics, Beisbol) co-sc (co) 1964-67 TPI: 89

Outlying London Districts I sc 1971 ENP: *abc*

Partisan Review (*from* In Our Time) co-sc (co) 1969 TPI: **47**

Photo-eye [El Lissitzky] (*from* In Our Time Covers for a Small Library after the Life for the Most Part) sk 1969 TWO: 44

Vernissage-Cocktail co-sc (co) 1967 TPI: **46**

World Ruin Through Black Magic co-sc dp (co) 1965 TPI: 89

See also:

Haftmann, Werner. *R.B.Kitaj: Complete Graphics, 1963-1969.* Berlin: Galerie Mikro, 1969.

KITCHENS, WILLIAM 1951-
Biographical dictionaries:
Art books and catalogs: GAP
No Excuse for Self Abuse li 1984 GAP: 22/30

KLINE, FRANZ JOSEF 1910-62
Biographical dictionaries: WAA 62
Art books and catalogs: AMI, APS, PPP, TPI
Untitled (*illustration for "Poem" by Frank O'Hara, from* 21 Etchings and Poems) et aq pn 1960 AMI: clp30 APS: clp2 PPP: 51 TPI: 14

KMETKO, ALISON 1953-
Biographical dictionaries:
Art books and catalogs: NPE
Collage Series aq sp bn 1977 NPE: 101
La Bajada aq en sp bn 1978 NPE: 102

KOBASHI, YASUHIDE 1931-
Biographical dictionaries:
Art books and catalogs: APP
Lead Colored Plant re c.1960 APP: 139

KOHLMEYER, IDA RENÉE (RITTENBERG) 1912-
Biographical dictionaries: WAA 62, 66, 70, 73, 76, 78, 80, 82, 84, 86, 89-90, 91-92, 93-94, 95-96, 97-98

Artbooks and catalogs: PWP
Semiosis sc 1984 PWP: clp45/114

KOHN, GABRIEL 1910-75
Biographical dictionaries: WAA 66, 70, 73
Art books and catalogs: THL
Untitled co-li (co) 1963 THL: 19

KOHN, MISCH 1916-
Biographical dictionaries: WAA 59, 62, 66, 70, 73, 76, 78, 80,
 82, 84, 86, 89-90, 91-92, 93-94, 95-96, 97-98
Art books and catalogs: AMI, APP, TYA, TYA, WAT
Construction with F et en ch hm (co) 1977 APP: clp17
Death Rides a Dark Horse wn 1949 WAT: 185
Disappearing 8 et en 1976 TYA: 67
Florentine Figure wn 1956 WAT: 186
Giant li 1961 WAT: 245
Kabuki Samurai wn 1955 APP: 89
Labyrinth aq en 1974 TYA: 68
Season in Hell wd-en 1951 AMI: clp23
Sleeping Soldier wn 1951 WAT: 185

KOKOSCHKA, OSKAR 1906-80
Biographical dictionaries:
Artbooks and catalogs:
See also:
Kokoschka, Oskar. *Orbis Pictus: The Prints of Oskar Kokoschka,
 1906-1976.* Santa Barbara, Calif.: Santa Barbara Museum of
 Art, 1987

KON, MARIO 1944-
Biographical dictionaries:
Art books and catalogs: PAP
Untitled mo 1985 PAP: 84

KONDOS, GREGORY 1923-
Biographical dictionaries:
Art books and catalogs: AAP, CAM
River Mansions, Sacramento River co-mo (co) 1985 CAM: 16/45
River Reflection, Sacramento River mo (co) 1983 AAP: **24**, 81

KONZAL, JOSEPH CHARLES 1905-94
 Biographical dictionaries: WAA 53, 56, 62, 66, 70, 73, 76, 78,
 80, 82, 84, 86, 89-90, 91-92, 93-94
 Art books and catalogs: APP
 Tubularities sc em 1970 APP: 140

KOPPELMAN, CHAIM 1920-
 Biographical dictionaries: WAA 62, 66, 70, 73, 76, 78, 80, 82,
 84, 86, 89-90, 91-92, 93-94, 95-96, 97-98
 Art books and catalogs: APP
 Retired Napoleons in cu-pa 1965 APP: 161

KORN, MARIAN 1914-87
 Biographical dictionaries:
 Art books and catalogs:
 See also:
 Korn, Marian. *The Prints of Marian Korn: A Catalogue
 Raisonné*. New York: Weatherhill/Graphics Editions, 1988.

KOSTABI, MARK 1960-
 Biographical dictionaries: WAA 86, 89-90, 91-92, 93-94, 95-96,
 97-98
 Art books and catalogs: PAP
 Climbing sc 1985 PAP: 85

KOUNELIS, JANNIS 1936-
 Biographical dictionaries:
 Art books and catalogs: TWO
 Untitled aq pe (co) 1979 TWO: **128**

KOUTROULIS, ARIS GEORGE 1938-
 Biographical dictionaries:
 Art books and catalogs: TYA
 Fallup cv 1973 TYA: 68

KOZAK, ELLEN 1955-
 Biographical dictionaries:
 Artbooks and catalogs: PWP

Descent (II) mo (co) 1990 PWP: clp49/114

KOZLOFF, JOYCE (BLUMBERG) 1942-
Biographical dictionaries: WAA 73, 76, 78, 80, 82, 84, 86, 89-
90, 91-92, 93-94, 95-96 97-98
Artbooks and catalogs: AGM, AMI, AWP, PWP, TWO
Acoma li tu li-cy hd ss (co) 1972 AWP: [12]
Cochiti li (co) 1972 AGM: **106**
Harvard Litho li hc (co) 1986 PWP: clp87/114
Homage to Robert Adam cs-ml sf aq ob (co) 1982 AGM: **108-9**
Is It Still High Art? [*State Ia*] li 1979 TWO: 124
Is It Still High Art? [*State III*] li em (co) 1979 AGM: **107**
Longing ce li co-hd (co) 1977 AMI: clp**114**

KRAMER, LOUISE 1923-
Biographical dictionaries: WAA 86, 89-90, 91-92, 93-94, 95-96,
97-98
Art books and catalogs: ENP
Untitled mp 1971 ENP: *abc*

KRASNER, LEE 1908-84
Biographical dictionaries: WAA 66, 70, 73, 76, 78, 80, 82, 84
Art books and catalogs: BWS
Civet li 1962 BWS: 27/30

KRAVER, RONALD T. 1944-
Biographical dictionaries:
Art books and catalogs: TYA
Untitled in 1970 TYA: 68

KRENECK, LYNWOOD 1936-
Biographical dictionaries: WAA 70, 73, 76, 78, 80, 82, 84, 86,
89-90, 91-92, 93-94, 95-96, 97-98
Art books and catalogs: CUN, ESS
Every Artist Has an Attic mc-sc ar-sn (co) 1984 CUN: **98**
From the Sketchbook of Da Vinci's Dalmation wt-sc 1988 CUN:
61
Great Moments in Domestic Mishaps/Sticky Syrup mc-sc ar-sn
(co) 1982 CUN: **99**

Great Moments in Food Law/Yankee Potatoes sc ar-sn 1986 CUN:
60
Space Probe-Ice Palace sk an 1976 ESS: [11]

KREPPS, JERALD A.
Biographical dictionaries:
Art books and catalogs: CUN
Mid-Life Crisis in 1988 CUN: 65
Pleiku Follies in-re hm (co) 1990 CUN: **99**
Reflection cg hm mx (co) 1987 CUN: **100**
Time Loop li re mx 1988 CUN: 66

KRUGER, BARBARA 1945-
Biographical dictionaries: WAA 76, 78, 80, 82, 84, 86, 89-90,
91-92, 93-94, 95-96, 97-98
Art books and catalogs: INP, PIA, PWP
Savoir c'est pouvoir li (co) 1989 PWP: **bcv**, clp97/114
Untitled ["Printed Matter Matters"] pi li 1989 INP: 16
Untitled [We Will No Longer Be Seen and Not Heard] of-li sc pp
(co) 1985 PIA: **192**/120

KRUSHENICK, NICHOLAS 1929-
Biographical dictionaries: WAA 66, 70, 73, 76, 78, 80, 82, 84,
86, 89-90, 91-92, 93-94, 95-96, 97-98
Artbooks and catalogs: AKG, AMI, THL
Untitled co-li (co) 1965 THL: 32
Untitled li (co) 1965 AMI: clp**65**
Untitled (*from portfolio* New York Ten) c.1965 AKG: clp71/3

KUCHAR, MARK 1952-
Biographical dictionaries:
Art books and catalogs: NPE
Line #2 (*from suite* Ten Lines) et en aq 1977 NPE: 103
Perimeter Series #1 et sf aq en fb 1978 NPE: 104

KUNC, KAREN 1952-
Biographical dictionaries: WAA 91-92, 93-94, 95-96, 97-98
Art books and catalogs: ACW, CUN, PWP
Drama of Source wo (co) 1990 CUN: **102**

In Spiral Drama co-wo (co) 1990 ACW: **74**, 124
Mirrored Touchpoints wo 1989 CUN: 69
Solace and Frenzy wo (co) 1988 CUN: **101**
Two Waters re (co) 1985 PWP: clp29/114
Unbound Above wo 1989 CUN: 71

KUOPUS, CLINTON 1942-
Biographical dictionaries: WAA 80, 82, 84, 86, 89-90, 91-92, 93-94, 95-96, 97-98
Artbooks and catalogs: CIP
Downwind co-sc (co) 1990 CIP: **49**
Mustard Fields co-sc (co) 1990 CIP: **49**

KUSHNER, ROBERT ELLIS 1949-
Biographical dictionaries: WAA 76, 78, 80, 82, 84, 86, 89-90, 91-92, 93-94, 95-96, 97-98
Art books and catalogs: AAP, AMI, APM, BWS, PAP, PIA
Angelique li fa sq ac 1980 APM: 27/15
Bibelot aq (co) 1985 PAP: **26**, 86
Joy of Ornament [#18] aq dr et (1980 *or* 1983) BWS: 19/30
National Treasure li (co) 1981 AMI: clp**138**
Rhoda VIII 3 li-ce eb-hm fa sq (co) 1982 AAP: **21**, 82
Rhonda VII [sic] mx-mp li ce hm vt fa sq (co) 1982 PIA: **179**/118

LANDACRE, PAUL HAMBLETON 1893-1963
Biographical dictionaries: WAA 36-37, 40-41, 40-47, 53, 56, 62
Artbooks and catalogs: PFB
Smoke Tree wn 1952-53 PFB: 14

LANDAU, JACOB 1917-
Biographical dictionaries: WAA 66, 70, 73, 76, 78, 80, 82, 84, 86, 89-90, 91-92, 93-94, 95-96, 97-98
Art books and catalogs: THL, WAT
Untitled (*from portfolio* Charades) li 1965 THL: 48
Violent Against Themselves. Circle VII, Canto XIII li 1975 WAT: 250
See also:
Landau, Jacob. *Jacob Landau, the Graphic Work: Catalogue Raisonné.* Trenton: New Jersey State Museum, 1982.

LANDECK, ARMIN 1905-84
 Biographical dictionaries: WAA 36-37, 40-41, 40-47, 53, 56,
 59, 62, 66, 70, 73, 76, 78, 80, 82, 84
 Art books and catalogs: APP, TYA, WAT
 Rooftops—14th Street dr 1947 APP: 76 TYA: 68
 Stairway Hall en dr 1950 WAT: 197
 See also:
 Kraeft, June Kysilko, and Norman Kraeft. *Armin Landeck: The
 Catalogue Raisonné of His Prints.* 2nd ed., Carbondale, Ill.:
 Southern Illinois University Press, 1994.

LANDERS, BERTHA 1911-
 Biographical dictionaries: WAA 40-47, 53, 56, 62, 78, 80, 82,
 84, 86, 89-90, 91-92, 93-94, 95-96
 Art books and catalogs: FWC
 Life Under the Sea et sf aq bn c.1945 FWC: 30

LANE, LOIS 1948-
 Biographical dictionaries: WAA 80, 82, 84, 86, 89-90, 91-92,
 93-94, 95-96, 97-98
 Art books and catalogs: AAP, PWP, TWO
 Untitled re ch (co) 1990 PWP: clp48/114
 Untitled sf aq sb sl gl (co) 1981 AAP: 83
 Untitled (*from* Six Aquatints) aq 1979 TWO: 122

LANGE, VIDIE 1932-
 Biographical dictionaries:
 Art books and catalogs: ENP
 Hank Smith, Lac Court Oreilles Indian Reservation, Wisconsin
 (*from portfolio* Some Americans) sk in 1972 ENP: *abc*

LA NOUE, TERENCE DAVID 1941-
 Biographical dictionaries: WAA 73, 76, 78, 80, 82, 84, 86, 89-
 90, 91-92, 93-94, 95-96, 97-98
 Art books and catalogs: PAP, PRO
 Fossil Garden (*from* Ritual Series) co-et aq li ce wo en dr hm (co)
 1987 PRO: clp46
 Fossil Garden [*State I*] (*from* Ritual Series) cr aq en hm 1987

PRO: clp**45**

Palace of Quetzacoatl co-et aq li wo en dr ce hm (co) 1987 PRO: clp**48**

Palace of Quetzacoatl [*State I*] et aq en hm 1987 PRO: clp**47**

Ritual Series: XII mp hc tl hm (co) 1987 PRO: clp**49**

S. F. Monterey Series #8 mp cg ce hc hd tl (co) 1985 PAP: **25**, 87

LANYON, ELLEN 1926-
Biographical dictionaries: WAA 66, 70, 73, 76, 78, 80, 82, 84, 86, 89-90, 91-92, 93-94, 95-96, 97-98
Art books and catalogs: AWP
Thimblebox li li-hd ss 1973 AWP: [13]

LARK, SYLVIA 1947-91
Biographical dictionaries: WAA 82, 84, 86, 89-90, 91-92
Art books and catalogs: CAM, NCP
Guy #2 mo hm tl ce 1984 NCP: 14
Renewed Light mo 1982 CAM: 38/45

LARMEE, KEVIN 1946-
Biographical dictionaries:
Art books and catalogs: PAP
Cigarette li 1985 PAP: 88

LAROCHE, CAROLE 1939-
Biographical dictionaries:
Artbooks and catalogs: PWP
Medicine Bowl mp tl 1989 PWP: clp69/115

LAROUX, LEONARD JOHN 1944-
Biographical dictionaries:
Art books and catalogs: CUN
Gateway li (co) 1988 CUN: **102**
Icon #2 li 1991 CUN: 76
Icon #4 li 1991 CUN: 74
Keystone li (co) 1990 CUN: **103**

LASANSKY, LEONARDO DAIOWA 1946-
Biographical dictionaries: WAA 76, 78, 80, 82, 84, 86, 89-90,

91-92, 93-94, 95-96, 97-98
Art books and catalogs: APP, EIE, NPE
Orientalia sf et en dr rl (co) 1976 NPE: 105
Tomás co-in EIE: 15
Tomás sf sl sp en bn (co) 1976 NPE: 107
Young Nahua Dancer et mz dr rg-sf en el sp bn (co) 1961-73
 APP: clp16

LASANSKY, MAURICIO L. 1914-
Biographical dictionaries: WAA 40-47, 53, 56, 59, 62, 66, 70,
 73, 76, 78, 80, 82, 84, 86, 89-90, 91-92, 93-94, 95-96, 97-98
Art books and catalogs: AMI, APP, TYA, WAT
Doma en 1944 WAT: 155
España et aq en sf 1956 APP: 100 WAT: 165
Eye for an Eye IV et en 1946-48 AMI: clp7
For an Eye an Eye, III et aq 1946-48 WAT: 165
La Jimena in (1960 *or* 1961) TYA: 69
Quetzalcoatl co-in (co) 1972 TYA: 69 WAT: **266**

LASUCHIN, MICHAEL 1923-
Biographical dictionaries: WAA 76, 78, 80, 82, 84, 86, 89-90,
 91-92, 93-94, 95-96, 97-98
Art books and catalogs: NPE
Trans sk (co) 1976 NPE: 107
Triad sk (co) 1976 NPE: 108

LAUFER, SUSAN 1950-
Biographical dictionaries: WAA 93-94, 95-96, 97-98
Artbooks and catalogs: PWP
Transformation Series—I le-en hc (co) 1989 PWP: clp55/115

LAURENCE, SPENCER
Biographical dictionaries:
Art books and catalogs: RBW
Bay Woman et 1979 RBW: [17]

LAW, CAROLYN 1951-
Biographical dictionaries:
Art books and catalogs: TYA

Paper Layers re em 1975 TYA: 70

LAWRENCE, JACOB ARMSTEAD 1917-
Biographical dictionaries: WAA 56, 62, 66, 70, 73, 76, 78, 80, 82, 84, 86, 89-90, 91-92, 93-94, 95-96, 97-98
See also:
Hills, Patricia, and Peter Nesbitt. *Jacob Lawrence: Thirty Years of Prints (1963-1993): A Catalogue Raisonné.* Seattle and London: Francine Seders Gallery, in association with University of Washington Press, 1994.

LAZAROF, ELEANORE BERMAN
See BERMAN, ELEANORE

LAZZELL, BLANCHE 1878-1956
Biographical dictionaries: WAA 36-37, 40-41, 40-47, 53, 56
Art books and catalogs: AMP
Little Church, New York City wo (co) 1951-52 AMP: 49

LEARY, DANIEL 1955-
Biographical dictionaries: WAA 91-92, 93-94, 95-96, 97-98
Art books and catalogs: INP
Hugh wg 1986 INP: 10

LEBRUN, RICO 1900-64
Biographical dictionaries: WAA 53, 56, 59, 62
Art books and catalogs: AMI, AML, APP, LAP, PIA, THL, WAT
Grünewald Study li 1961 AMI: clp33 APP: 103 PIA: **128**/112 THL: 49 WAT: 247
Grünewald Study II li 1961 LAP: 70/104
Rabbit li 1945 AML: 169 APP: 104

LEE, DORIS EMRICK 1905-83
Biographical dictionaries: WAA 36-37, 40-41, 40-47, 53, 56, 59, 62, 66, 70, 73, 76, 78, 80, 82
Art books and catalogs: GRE
Helicopter li 1948 GRE: clp*103*

LEE, MARJORIE JOHNSON 1911-
Biographical dictionaries:
Art books and catalogs: FWC
Untitled [Woman at Table] et aq 1946 FWC: 31

LEECH, MERLE EUGENE 1941-
Biographical dictionaries: WAA 76, 78, 80, 82, 84, 86, 89-90
Art books and catalogs: TYA
Divine Power sk 1976 TYA: 70

LEECH, RICK 1957-
Biographical dictionaries:
Art books and catalogs: GAP
Gregor Samsa's Family wo 1985 GAP: 15/30

LEHRER, LEONARD 1935-
Biographical dictionaries: WAA 73, 76, 78, 80, 82, 84, 86, 89-
90, 91-92, 93-94, 95-96, 97-98
Art books and catalogs: ENP, GAR, PNM
Tepotzotlan li 1973 PNM: 93
Terrace li 1979 GAR: 15
Welshpool et 1971 ENP: *abc*

LEIBER, GERSON AUGUST 1921-
Biographical dictionaries: WAA 66, 70, 73, 76, 78, 80, 82, 84,
86, 89-90, 91-92, 93-94, 95-96, 97-98
Art books and catalogs: APP, WAT
Beach et aq rl 1965 APP: 201 WAT: 302

LEITHAUSER, MARK ALAN 1950-
Biographical dictionaries: WAA 84, 86, 89-90, 91-92, 93-94,
95-96, 97-98
Art books and catalogs: TYA
Horological Fascination et en dp 1974 TYA: 70
Migration et en 1976 TYA: 71

LERNER, ALLAN JAY 1951-
Biographical dictionaries:
Art books and catalogs: NPE

Laughing Cow xx sk mo du to-mn tf (co) 1978 NPE: 109
Laughing Gas xx sk mo du to-mn tf (co) 1978 NPE: 110

LESLIE, ALFRED 1927-
Biographical dictionaries: WAA 62, 66, 70, 73, 76, 78
Art books and catalogs: TYA
Alfred Leslie li 1974 TYA: 71

LETENDRE, RITA (LETENDRE-ELOUL) 1928-
Biographical dictionaries: WAA 70, 73, 76, 78, 80, 82, 84, 86,
 89-90, 91-92, 93-94, 95-96, 97-98
Art books and catalogs: ENP
Point sk 1971 ENP: *abc*

LETSCHER, LANCE 1962-
Biographical dictionaries:
Art books and catalogs: FTP
Two Weeds dr ch (co) 1987 FTP: **53**

LE VA, BARRY 1941-
Biographical dictionaries: WAA 73, 76, 86, 89-90, 91-92, 93-
 94, 95-96, 97-98
Art books and catalogs: PRO
Sculptured Activities 1-5 (*portfolio*) co-wo (co) 1987-89 PRO:
 clp50

LEVERS, ROBERT 1930-
Biographical dictionaries:
Art books and catalogs: FTP
Terrorist Juggling Plates sg 1990 FTP: **55**

LEVINE, LES 1935-
Biographical dictionaries: WAA 70, 73, 76, 78, 80, 82, 84, 86,
 89-90, 91-92, 93-94, 95-96, 97-98
Art books and catalogs: AAP, AMI, TWO
Conceptual Decorative sk 1970 TWO: 74
Grow et aq 1982 AAP: 84
Iris Print-out Portrait [*plate*] sk 1969 AMI: clp119

LEVINE, MARTIN 1945-
Biographical dictionaries: WAA 78, 80, 82, 84, 86, 89-90, 91-92, 93-94, 95-96, 97-98
Art books and catalogs: TYA
Barn in 1974 TYA: 71
Pardee House (West View), Oakland, CA et 1976 TYA: 72

LEVINE, SHERRIE 1947-
Biographical dictionaries:
Art books and catalogs: PIA
Meltdown (After Kirchner) *(from suite of 4)* wo (co) 1989 PIA: **212**/122

LEVY, MARILYN W. 1936-
Biographical dictionaries:
Art books and catalogs: AWP
Black and Gray #4 li al 1974 AWP: [14]

LEVY, PAUL M. 1944-
Biographical dictionaries:
Art books and catalogs: TYA
Commonwealth of Massachusetts Building Code sk 1975 TYA: 72

LEWIS, JACK 1938-
Biographical dictionaries:
Art books and catalogs: GAP
Melinda—Somewhere Between Loneliness and Solitude pe aq dr dp 1986 GAP: 11/30

LEWIS, T. REGIS 1959-
Biographical dictionaries:
Art books and catalogs: GAP, MCN
Death of a Conscious Called Freedom sk 1989 MCN: [11]
Liberty Taking Advantage re-cg 1984 GAP: 6/30

LEWITT, SOL 1928-
Biographical dictionaries: WAA 70, 73, 76, 78, 80, 82, 84, 86, 89-90, 91-92, 93-94, 95-96, 97-98

Art books and catalogs: AMI, APB, APM, APP, ENP, FIM, PIA,
 TWO

Composite Series (*set of 5*) sc (co) 1970 FIM: **70-71**

Composite Series [*plate 5*] sk (co) 1970 AMI: clp**97**

Lines from corners, sides and the center to points on a grid et aq
 1977 APB: clp*130*/51

Lines from Sides, Corners and Center et aq 1977 AMI: clp98
 TWO: 81

Lines in Color from Corners Sides and Centers to Specific Points
 on a Grid (a set of 6) co-sk (co) 1978 APM: 16

Squares with a Different Line Direction in Each Half Square et
 1971 PIA: **148**/115

Untitled et 1972 ENP: *abc*

Untitled (*from series of 16*) et 1971 APP: 150

See also:

Sol LeWitt Graphik, 1970-1975. Basel and Bern: Kunsthalle Basel
 and Verlag Kornfeld und Cie., c.1975.

LIAO, SHIOU-PING 1936-

 Biographical dictionaries: WAA 82, 84, 86, 89-90, 91-92, 93-
 94, 95-96, 97-98

 Art books and catalogs: RBW

 Friendship mx 1984 RBW: [17]

LIBERMAN, ALEXANDER 1912-

 Biographical dictionaries: WAA 66, 70, 73, 76, 78, 80, 82, 84,
 86, 89-90, 91-92, 93-94, 95-96, 97-98

 Art books and catalogs: AMI

 Untitled li (co) 1961 AMI: clp**83**

LICHTENSTEIN, ROY 1923-

 Biographical dictionaries: WAA 66, 70, 73, 76, 78, 80, 82, 84,
 86, 89-90, 91-92, 93-94, 95-96, 97-98

 Art books and catalogs: ACW, AKG, AMI, APB, APM, APP,
 APS, FIM, GMC, PAC, PAP, PIA, SMP, TCA, TCR, TGX,
 TPI, TWO, TYA, WAT

 American Indian Theme I wo hm (co) 1980 TCR: **216**

 American Indian Theme II wo hm (co) 1980 TCR: **216**

 American Indian Theme III wo hm (co) 1980 TCR: **206, 216**

TGX: **131**

American Indian Theme IV wo li hm (co) 1980 TCR: **217** TGX: **120**

American Indian Theme V wo hm (co) 1980 TCR: **217**

American Indian Theme VI wo hm (co) 1980 TCR: **217** TGX: **6**

Blue Face (*from series* Brushstroke Figures) li wo sc (co) 1989 SMP: **50**

Brushstrokes co-sk (co) 1967 AKG: clp**33** APB: bcv/49 TPI: 91

Cathedral #4 co-li (co) 1969 AMI: clp**61** WAT: **203**

Cathedral #5 co-li (co) 1969 TPI: **49**

Cathedrals #2, #3, and #4 (*from series of 6*) li (co) 1969 AMI: clp**61**

CRAK! co-of-li (co) 1963-64 APM: 11/15 TPI: **49** WAT: **206**

Dancing Figures et aq en (co) 1980 TCR: **219**

Dr. Waldmann wo (co) 1980 AMI: clp**135**

Entablature I sc ce em fl lm (co) 1976 TCR: **209** TGX: **129**

Entablature II sc li ce em fl lm (co) 1976 TCR: **209** TYA: 72

Entablature III sc ce em fl lm (co) 1976 TCR: **210**

Entablature IV sc ce em fl lm (co) 1976 TCR: **210** TGX: **130**

Entablature V sc li ce em fl lm (co) 1976 TCR: **211**

Entablature VI sc ce em fl lm (co) 1976 TCR: **211**

Entablature VII sc ce em fl lm (co) 1976 TCR: **212**

Entablature VIII sc ce em fl lm (co) 1976 TCR: **213** TYA: 73

Entablature IX sc li ce em fl lm (co) 1976 TCR: **213**

Entablature X sc li ce em fl lm (co) 1976 TCR: **214** TGX: **130**

Entablature XA sc li ce em fl lm (co) 1976 TCR: **215**

Figure with Teepee et en (co) 1980 TCR: **218** TGX: **132**

Fresh Air 1$25¢ (*from* 1¢ Life) li 1964 AMI: clp**45**

Goldfish Bowl wo hm (co) 1981 TCR: **221** TGX: **135**

Head with Braids et aq en (co) 1980 TCR: **219**

Head with Feathers and Braid et aq en (co) 1980 TCR: **218** TGX: **133**

Homage to Max Ernst sk (co) 1975 TCR: **208** TYA: 73

Imperfect 58" x 92 3/8" (*from series* Imperfect) wo sc ce (co) 1988 SMP: **46**

Imperfect 63 3/8" x 88 7/8" (*from series* Imperfect) wo sc (co) 1988 SMP: **47**

Inaugural Print sc (co) 1977 TCR: **215**

Indian with Pony wo 1953 PAC: [34]/83

Lamp wo hm (co) 1981 TCR: **220** TGX: **135**

Modern Object sc my px 1967 PIA: 43

Night Scene et aq en (co) 1980 TCR: **218**

Nude (*from series* Brushstroke Figures) li wo sc (co) 1989 SMP: **51**

On (*from portfolio* International Anthology of Contemporary Engraving: The International Avant-Garde: America Discovered, Volume 5) et 1962 APS: clp24 FIM: **37**, fcv TPI: 90

Peace Through Chemistry IV sc 1970 APP: 177

Picture and Pitcher co-wo hm (co) 1981 ACW: **75**, 124 TCR: **221**

Pyramid sc fd 1968 TPI: 91

Reclining Nude wo(co) 1980 PAC:[35]/83 TCA: [**46**]

Reverie [The Melody Haunts My Reverie] (*from* 11 Pop Artists, Volumes I & II) co-sk (co) 1965 AMI: clp59 PIA: **136**/113 TPI: **50** TWO: 37

Sandwich and Soda (*from* Ten Works, Ten Painters) co-sc pt (co) 1964 TGX: 128 TPI: 90

Sower (*from series* Landscapes) li wo sc (co) 1985 SMP: **48**

Still Life with Crystal Bowl li sk 1976 TYA: 73

Sunrise co-of-li (co) 1965 TPI: 90

Sweet Dreams Baby! (*from* 11 Pop Artists, Volume III) co-sc (co) 1965 AKG: clp31 APS: clp35 TPI: **48**

This Must Be the Place co-of-li (co) 1965 TPI: 91

To Battle wo 1950-51 FIM: 36 WAT: 280

Turkey Shopping Bag co-sc (co) 1964 TPI: 90

Twin Mirrors co-sk (co) 1970 GMC: 39

Two Figures with Teepee et aq en (co) 1980 TCR: **219**

Two Paintings wo li sc ce 1984 PAP: 89

Two Paintings: Dagwood (*from series* Paintings) li wo (co) 1984 SMP: **45**

Two Paintings: Sleeping Muse (*from series* Paintings) li wo sc (co) 1984 SMP: **44**

Untitled (Guggenheim Museum Print) sk 1969 GMC: 38

Untitled (*from portfolio* For Meyer Schapiro) li sk em 1974 GMC: 66

Untitled I et (co) 1981 TCR: **220**

Untitled II et (co) 1981 TCR: **220**

View from the Window (*from series* Landscapes) li wo sc (co)

1985 SMP: **49**
See also:
Bianchini, Paul. *Roy Lichtenstein Drawings and Prints.* New
 York: Chelsea House Publishers, 1969.
Corlett, Mary Lee. *The Prints of Roy Lichtenstein: A Catalogue
 Raisonné, 1948-1993.* New York: Hudson Hills Press, 1994.

LIEBER, TOM (THOMAS ALAN) **1949-**
 Biographical dictionaries: WAA 82, 84, 86, 89-90, 91-92, 93-
 94, 95-96, 97-98
 Art books and catalogs: CAM
 Untitled EXP-TL-02-14 mo 1983 CAM: 14/45

LIFA, SHAIH **1938-**
 Biographical dictionaries:
 Art books and catalogs: ENP
 Untitled sk 1972 ENP: *abc*

LILLIGREN, INGRID
 Biographical dictionaries:
 Art books and catalogs: NCP
 Untitled lc 1987 NCP: 13

LINDNER, RICHARD **1901-78**
 Biographical dictionaries: WAA 56, 59, 62, 66, 70, 73, 76, 78
 Art books and catalogs: AMI, APP, TYA, WAT
 Fun City co-li (co) 1971 TYA: 74 WAT: 288
 Hit (*from portfolio* Fun City) li cl vy (co) 1971 AMI: clp**129**
 Miss American Indian (*from* Afternoon) co-li (co) 1974 WAT:
 265
 Profile (*from series* Afternoon) li (co) APP: clp**26**

LIVESAY, WILLIAM T. **1956-**
 Biographical dictionaries:
 Art books and catalogs: GAP
 Large Oak Tree hc-mi (co) 1985 GAP: 28/31

LOBDELL, FRANK **1921-**
 Biographical dictionaries: WAA 66, 70, 73, 76, 78, 80, 82, 84,

86, 89-90, 91-92, 93-94, 95-96, 97-98
Art books and catalogs: AML, CAM, INP
10-12-81 mo 1981 CAM: 12/45
Untitled li 1948 AML: 162
Untitled (*from portfolio* Seven Etchings) hg aq 1988 INP: 8

LOCKWOOD, DENNIS 1937-
Biographical dictionaries:
Art books and catalogs: PNW
Feed and Seed wb 1996 PNW: 45
Hats and Boots wb (co) 1996 PNW: **43**
Locks wb 1995 PNW: 44

LOCKWOOD, (JOHN) WARD 1894-1963
Biographical dictionaries: WAA 36-37, 40-41, 40-47, 53, 56, 62
Art books and catalogs: PNM
Target cg c.1962 PNM: 74

LOMAS GARZA, CARMEN 1948-
Biographical dictionaries:
Artbooks and catalogs: PWP
Heaven and Hell li gl (co) 1991 PWP: clp**18**/113

LONGO, ROBERT 1953-
Biographical dictionaries: WAA 86, 89-90, 91-92, 93-94, 95-96, 97-98
Art books and catalogs: AAP, APR, BWS, FIM, PAC, PIA
Frank li 1982-83 AAP: 85
Jules, Gretchen, Mark li em tp 1982-83 APR: 13/[15] BWS: 14/30
FIM: **129** PAC: [37]/83
Men in Cities [Jonathon] li 1988 PIA: **184**/119

LONGO, VINCENT 1923-
Biographical dictionaries: WAA 66, 70, 73, 76, 78, 91-92, 93-94, 95-96, 97-98
Art books and catalogs: APP, PPP, TYA
ABCD et aq 1971 TYA: 74
First Cut, Second Cut, Third Cut wo tp 1974-75 TYA: 74
Net #1 et aq 1976 PPP: 112

Net #1 [*trial proof*] et aq sf sp dr 1976 PPP: 111
Net #2 et aq 1976 PPP: 113
Net #2 [*working proof*] et aq cr 1976 PPP: 112
Net #3 [*working proof*] et aq tl er 1976 PPP: 113
Passing Through [*States I and VII*] wo 1976-77 PPP: 108-9
Screen et 1967 PPP: 104-6
Temenos et aq 1978 APP: 216
Untitled aq (co) 1976 APP: clp25 TYA: 75

LOS ANGELES FINE ARTS SQUAD 1969-73
(*see* HENDERSON, VIC *and* SCHOONHOVEN, TERRY)

LOVELL, WHITFIELD
Biographical dictionaries:
Art books and catalogs: RBW
Nanny dr 1982 RBW: [18]

LOWENGRUND, MARGARET 1902-57
Biographical dictionaries: WAA 36-37, 40-41, 53, 56
Art books and catalogs: AML
Milkweed li 1952 AML: 189

LOWNEY, BRUCE STARK 1937-
Biographical dictionaries: WAA 73, 76, 78, 80, 82, 84, 86, 89-
 90, 91-92, 93-94, 95-96, 97-98
Art books and catalogs: ENP, PNM
Flower li 1971 ENP: *abc*
Gateway co-li (co) 1975 PNM: clp9

LOZOWICK, LOUIS 1892-1973
Biographical dictionaries: WAA 36-37, 40-41, 40-47, 53, 56,
 59, 62, 66, 70, 73
Art books and catalogs: APP, PFB, TYA
Central Park co-wo (co) 1940 PFB: 17/15
Design in Wire li 1949 APP: 26 TYA: 76
See also:
Flint, Janet. *The Prints of Louis Lozowick: A Catalogue Raisonné.*
 New York: Hudson Hills Press, 1982.

LUCIONI, LUIGI 1900-88
Biographical dictionaries: WAA 36-37, 40-41, 40-47, 53, 56, 59, 62, 66, 70, 73, 76, 78, 80, 82, 84, 86
Art books and catalogs: WAT
Big Haystack et 1947 WAT: 162

LUGINBÜHL, BERNHARD 1929-
Biographical dictionaries:
Art books and catalogs: TWO
Plan for Cyclops en 1967-70 TWO: 70

LUMPKINS, WILLIAM THOMAS 1909-
Biographical dictionaries: WAA 53, 56, 59, 62
Art books and catalogs: PNM
Untitled sk 1958-61 PNM: 56

LUNDEBERG, HELEN (FEITELSON) 1908-
Biographical dictionaries: WAA 73, 76, 78, 80, 82, 84, 86, 89-90, 91-92, 93-94, 95-96, 97-98
Art books and catalogs: LAP
Moonrise li 1948 LAP: 56/101
Untitled sk 1971 LAP: 87/106

LUTZ, WINIFRED ANN 1942-
Biographical dictionaries: WAA 80, 82, 84, 86, 89-90, 91-92, 93-94, 95-96, 97-98
Artbooks and catalogs: AGM
Night Edged Reversal hm-re ab dy-ab 1978 AGM: 20

LYKE, LINDA
Biographical dictionaries:
Art books and catalogs: NCP
View of Nile mo hm 1987 NCP: 11

MABE, JONI 1957-
Biographical dictionaries:
Art books and catalogs: GAP, MCN
Big El hl hm ik gt sq fa 1984 GAP: 4/31
Blessed Elvis Prayer Rug li xt gt vy-at hh 1989 MCN: **[13]**

MACDOUGALL, ANNE (BALLOU) **1944-**
Biographical dictionaries: WAA 82, 84, 86, 89-90, 91-92, 93-94, 95-96, 97-98
Artbooks and catalogs: PWP
Mongo Fongo I mo 1989 PWP: clp26/115

MACHINIST, LESLIE **1957-**
Biographical dictionaries:
Artbooks and catalogs: PWP
Ascension III mo 1989 PWP: clp68/115

MACK, HEINZ **1931-**
Biographical dictionaries:
Art books and catalogs: TWO
Untitled (*from* made in silver) sk 1966 TWO: 55

MACKO, NANCY
Biographical dictionaries:
Art books and catalogs: NCP
Gyotaku IV fp 1987 NCP: 17

MAGEE, ALAN ARTHUR **1947-**
Biographical dictionaries: WAA 80, 82, 84, 86, 89-90, 91-92, 93-94, 95-96, 97-98
Art books and catalogs: SIM
Spirit mo 1990 SIM: 154

MAGENNIS, BEVERLY (LOWNEY) **1942-**
Biographical dictionaries:
Art books and catalogs: PNM
Partial Construction of Improbable Sculpture 1 co-sk td (co) 1981 PNM: 126

MAHAFFEY, RAE **1954-**
Biographical dictionaries:
Art books and catalogs: PNW
Cover co-li ch dp (co) 1995 PNW: 113
Sequence I li pp (co) 1996 PNW: **111**

Twist co-li (co) 1993 PNW: 112

MANGOLD, ROBERT PETER 1937-
Biographical dictionaries: WAA 66, 70, 73, 76, 78, 80, 82, 84, 86, 89-90, 91-92, 93-94, 95-96, 97-98
Art books and catalogs: AMI
Seven Aquatints [*plate*] aq (co) 1973 AMI: clp**92**

MANGOLD, SYLVIA PLIMACK 1938-
Biographical dictionaries: WAA 73, 76, 78, 80, 82, 84, 86, 89-90, 91-92, 93-94, 95-96, 97-98
Art books and catalogs: AGM, PIA, PWP
Nut Trees (Red) dr aq (co) 1985 AGM: **113**
Paper Under Tape, Paint Over Paper et aq (co) 1977 AGM: **111**
Pin Oak et aq dr 1990 PWP: clp**12**/115
View of Schumnemunk Mountain sc li hc (co) 1980 AGM: **112**
 PIA: **175**/118

MANNS, SUZANNE 1950-
Biographical dictionaries:
Art books and catalogs: FTP
Paris li (co) 1983 FTP: **57**

MANZAVRAKOS, MICHAEL
Biographical dictionaries:
Art books and catalogs: PRO
Naken (*three from suite of 8*) co-cg (co) 1988-89 PRO: clp51

MAPPLETHORPE, ROBERT 1946-89
Biographical dictionaries: WAA 82, 84, 86, 89-90
Art books and catalogs: PAP
Gun Blast (*from portfolio* A Season in Hell) pv ch 1986 PAP: 90

MARCUS, PETER E. 1939-
Biographical dictionaries:
Art books and catalogs: CUN, ENP
Untitled hc-cg (co) 1990 CUN: 127, **104**
Untitled hc-cg pa wd ca (co) 1991 CUN: 126, **105**
Untitled li 1972 ENP: *abc*

MARDEN, BRICE 1938-
Biographical dictionaries: WAA 70, 73, 76, 78, 80, 82, 84, 86, 89-90, 91-92, 93-94, 95-96, 97-98
Art books and catalogs: AMI, APB, APM, ENP, PIA, PRO, TWO, TYA
Cold Mountain Series, Zen Studies #5 [*Early State*] et sl-aq 1990 PIA: **217**/123
Etchings to Rexroth (*portfolio of 25*) aq dr sp bn 1986 PRO: clp53
Five Plates [*plate*] et aq 1973 AMI: clp93
Gulf (*from portfolio* New York 10/69) li 1969 PIA: **143**/114
Painting Study II sk wx gr 1974 TYA: 77
Untitled et aq 1972 ENP: *abc*
Untitled (*from portfolio* Ten Days) et 1971 TWO: 82
Untitled (*from portfolio* Five Plates) et aq 1973 APM: 15
Untitled [Two Vertical Rectangles] (*from portfolio* Ten Days) et aq 1971 APB: clp*132*/52
See also:
Lewison, Jeremy. *Brice Marden Prints, 1961-1991: A Catalogue Raisonné*. London: Tate Gallery, 1992.

MARGO, BORIS 1902-95
Biographical dictionaries: WAA 40-47, 53, 56, 59, 62, 66, 70, 73, 76, 78, 80, 82, 84, 91-92, 93-94, 95-96
Art books and catalogs: APP, TYA, WAT
Jewels in Levitation cc (co) 1949 TYA: **78**
Pathway (*from portfolio* 12 Cellocuts) cc 1960-71 APP: 154
Sea ce wo 1949 WAT: 156

MARGOLIUS, BETSY 1951-
Biographical dictionaries:
Artbooks and catalogs: PWP
Japanese Inspired Waterlillies mo pp (co) 1988 PWP: clp**46**/115

MARIONI, TOM 1937-
Biographical dictionaries: WAA 76, 78, 80, 82, 84, 86, 89-90, 91-92, 93-94, 95-96, 97-98
Art books and catalogs: SIM
Process Landscape #5 wc-mo (co) 1992 SIM: 156

MARISOL, (ESCOBAR) 1930-
 Biographical dictionaries: WAA 73, 76, 78, 80, 82, 84, 86, 89-
 90, 91-92, 93-94, 95-96, 97-98
 Art books and catalogs: AMI, APP, TPI
 Furshoe li 1964 TPI: 92
 Pappagallo co-li (co) 1965 AMI: clp**68** TPI: **51**
 Phnom Penh I et 1970 APP: 149

MARK, WENDY
 Biographical dictionaries:
 Art books and catalogs: SIM
 Cry to Me I co-mo (co) 1995 SIM: **151**
 Cry to Me II co-mo (co) 1995 SIM: **151**

MARKOVITZ, SHERRY 1947-
 Biographical dictionaries:
 Art books and catalogs: AAP, TYA
 Ovulation II gb wc 1975 TYA: 79
 Tiger Chase li 1982 AAP: 86

MARSH, GEORGIA
 Biographical dictionaries: WAA 89-90, 91-92, 93-94, 95-96, 97-
 98
 Art books and catalogs: SIM
 Natura Naturata co-mo (co) 1993 SIM: **159**

MARTIN, AGNES BERNICE 1912-
 Biographical dictionaries: WAA 66, 70, 76, 78, 80, 82, 84, 86,
 89-90, 91-92, 93-94, 95-96, 97-98
 Art books and catalogs: PNM
 On a Clear Day co-sk (co) 1972-73 PNM: 84

MARTIN, PERCY 1943-
 Biographical dictionaries:
 Artbooks and catalogs: BAG
 Fall of St. Mar #1 et aq 1979 BAG: 28/25

MARTINELLI, EZIO 1913-
Biographical dictionaries: WAA 40-47, 53, 56, 62, 66, 70, 73, 76, 78, 80
Art books and catalogs: APP
Bog et sn 1952 APP: 128

MARYAN, MARYAN S. 1927-77
Biographical dictionaries: WAA 73, 76
Art books and catalogs: THL
Untitled li 1967 THL: 54

MASON, ALICE TRUMBULL 1904-71
Biographical dictionaries: WAA 40-41, 40-47, 53, 56, 59, 62, 66, 70
Art books and catalogs: APP, GRE
Indicative Displacement sf 1947 GRE: clp*101*
Inverse et aq sf c.1946 APP: 75

MASON, EMILY 1932-
Biographical dictionaries:
Artbooks and catalogs: PWP
Soft the Sun aq (co) 1989 PWP: clp**64**/115

MASSON, ANDRE 1896-1987
Biographical dictionaries:
Artbooks and catalogs:
See also:
Saphire, Lawrence. *Andre Masson, the Complete Graphic Work. Volume I: Surrealism.* New York: Blue Moon Press, 1990.

MATSUTANI, TAKESADA 1937-
Biographical dictionaries:
Art books and catalogs: ENP
Object White sk 1972 ENP: *abc*

MAZUR, MICHAEL BURTON 1935-
Biographical dictionaries: WAA 66, 70, 73, 76, 78, 80, 82, 84, 86, 89-90, 91-92, 93-94, 95-96, 97-98
Art books and catalogs: AAP, AMI, APP, CAM, PAP, PIA,

SIM, THL, TYA
Enemies Sequence #1, Transition co-mo (co) 1978 CAM: 22/46
Griffith Park #1 li 1968 THL: 43
Palette Still Life #53 co-mo (co) 1982 SIM: **fpc**, **170**
Self-Portrait tc 1986 SIM: 165
Smoke en aq 1975 TYA: 79
Three Beds, No. 14 (*from series* Images from a Locked Ward) et
 1962 APP: 219
Untitled 12/31/84 tc 1984 PAP: 91
Wakeby Day li wo ch mp hm (co) 1986 PIA: **200**/121
Wakeby Night co-mo tl tp (co) 1983 SIM: **172**
Wakeby Night II mo dp (co) 1982 AAP: **fcv**, 87
Wakeby Storm III [Morning Rain] mo (co) 1983 AMI: clp**140**

MCAFEE, ILA MAE (TURNER) 1897?-
 Biographical dictionaries: WAA 40-41, 40-47, 53, 56, 59, 62
 Art books and catalogs: PNM
 Small Ranch ["At Evening Time"] li c.1948 PNM: 64

MCCAFFERTY, JAY DAVID 1948-
 Biographical dictionaries: WAA 76, 78, 80, 82, 84, 86, 89-90,
 91-92, 93-94, 95-96, 97-98
 Art books and catalogs: LAP
 #1 Alive sk wb 1977 LAP: 94/108

MCCOMBS, BRUCE 1943-
 Biographical dictionaries:
 Art books and catalogs: TYA, WAT
 Bridge in 1973 WAT: 301
 Street Corner et 1975 TYA: 76

MCCOY, ANN 1946-
 Biographical dictionaries: WAA 76, 78, 80, 82, 84, 86, 89-90,
 91-92, 93-94, 95-96, 97-98
 Art books and catalogs: LAP, NPE
 Meduse li hc hd (co) 1978 NPE: 111
 Night Sea hc-li dp (co) 1978 LAP: 85/108 NPE: 113

McCRAY, DOROTHY MAE (WESTABY) 1915-
Biographical dictionaries: WAA 62, 66, 70, 73, 76, 78, 80, 82,
 84, 95-96, 97-98
Art books and catalogs: PNM
Par Coeur co-li (co) 1955 PNM: clp5

McCULLOCH, FRANK E. 1930-
Biographical dictionaries: WAA 84, 86, 89-90, 91-92, 93-94,
 95-96, 97-98
Art books and catalogs: PNM
79.5 co-li (co) 1979 PNM: 112

McGARRELL, JAMES 1930-
Biographical dictionaries: WAA 66, 70, 73, 76, 78, 80, 82, 84,
 86, 89-90, 91-92, 93-94, 95-96, 97-98
Art books and catalogs: AMI, THL, WAT
Portland I li 1962 AMI: clp34 THL: 44
Quotation with Twister co-li (co) 1975 WAT: 253

McGOWAN, MICHAEL 1952-
Biographical dictionaries:
Art books and catalogs: NPE
Untitled et hm 1977 NPE: 113
Untitled et hm 1978 NPE: 114

McKENZIE, MARY BETH 1946-
Biographical dictionaries: WAA 86, 89-90, 91-92, 93-94, 95-96,
 97-98
Art books and catalogs: CAM
Magic Vendor ha-mo 1985 CAM: 37/45

McLARTY, JACK 1919-
Biographical dictionaries: WAA 40-47, 53, 56, 62, 66, 70, 73,
 76, 78, 80, 82, 84, 86
Art books and catalogs: PNW
Devil Lives Under Ocumicho lc (co) 1985 PNW: **115**
Left Hand of God wo 1996 PNW: 116
Wall City wo 1996 PNW: 117

McLaughlin, John D. 1898-1976
Biographical dictionaries: WAA 66, 70, 73, 76, 78
Art books and catalogs: LAP, THL
Untitled li (co) 1963 THL: **33**
Untitled li 1962 LAP: 78/104

McLean, Jim (James Albert) 1928-
Biographical dictionaries: WAA 78, 80, 82, 84, 86, 89-90, 91-92, 93-94, 95-96, 97-98
Art books and catalogs: TYA
Flight over Busch Gardens rt 1975 TYA: 76

McMillan, Jerry Edward 1936-
Biographical dictionaries: WAA 78, 80, 82, 84, 86, 89-90
Art books and catalogs: LAP
Porch Bag mx of-li 1971 LAP: 83/107

McMillan, Stephen Walker 1949-
Biographical dictionaries: WAA 80, 82, 84, 86, 89-90, 91-92, 93-94, 95-96, 97-98
Art books and catalogs: NPE
Papyrus and Fern aq 1978 NPE: 115
Reflections and Carp wc hc-aq (co) 1978 NPE: **116**

McNeil, George Joseph 1908-95
Biographical dictionaries: WAA 40-41, 40-47, 53, 66, 70, 73, 76, 78, 80, 82, 84, 86, 89-90, 91-92, 93-94
Art books and catalogs: ENP, PAC, PNM
Acoma Mesa I co-li (co) 1976 PNM: 100
Double Head #1 li 1974 PAC: [42]/85
Oblique Figure li 1971 ENP: *abc*

McPhail, Barbara Ann 1940-
Biographical dictionaries:
Art books and catalogs: RBW
Untitled et 1975 RBW: [18]

McPherson, Craig 1948-
Biographical dictionaries: WAA 95-96, 97-98

Art books and catalogs: BWS
Yankee Stadium at Night mz 1983 BWS: 21/31

MCSHEEHY, CORNELIA MARIE 1947-
Biographical dictionaries: WAA 78, 80, 82, 84, 86, 89-90, 91-
92, 93-94, 95-96, 97-98
Art books and catalogs: ENP
Dedication for Manus Pinkwater cg 1972 ENP: *abc*

MCWILLIE, JUDITH 1946-
Biographical dictionaries:
Art books and catalogs: EIE
Obvious Disguises xx EIE: 17

MEAD, RODERICK FLETCHER 1900-71
Biographical dictionaries: WAA 40-41, 40-47, 53, 56, 59, 62
Art books and catalogs: PNM
Summer Night et PNM: 67

MEE, NANCY 1951-
Biographical dictionaries:
Art books and catalogs: TYA
Modesto Truck Driver di xt hc (co) 1975 TYA: **98**

MEEKER, DEAN JACKSON 1920-
Biographical dictionaries: WAA 56, 59, 62, 66, 70, 73, 76, 78,
80, 82, 84, 86, 89-90, 91-92, 93-94, 95-96, 97-98
Art books and catalogs: APP, ESS, WAT
Don Quixote co-sk (co) 1951 WAT: **139**
Genghis Khan cg sc 1962 APP: 202
Joseph's Coat co-pin sk (co) 1965 WAT: 298
Lisa co-in (co) 1974 ESS: [14]
Trojan Horse sk gg (co) 1952 WAT: **145**

MENARD, LLOYD 1938-
Biographical dictionaries:
Art books and catalogs: CUN
Aries Prayer Rug hm mx (co) CUN: **105**
Fragments from Eastern Turkestan Prayer Rug hm mx (co) CUN:

106
Untitled hm mx in cg re CUN: 130, 132

MERSKY, DEBORAH 1955-
Biographical dictionaries:
Art books and catalogs: PNW
Boat Quilt re go (co) 1995 PNW: **119**
Cricket Underneath re go 1996 PNW: 121
Cuttings mx re 1996 PNW: 120

MICHAUX, HENRI 1899-1984
Biographical dictionaries:
Art books and catalogs: TWO
Untitled (*from* Parcours) et 1965 TWO: 88

MICHOS, URANIA 1939-
Biographical dictionaries:
Art books and catalogs: ENP
Untitled ps 1971 ENP: *abc*

MILLER, MELISSA WREN 1951-
Biographical dictionaries: WAA 84, 86, 89-90, 91-92, 93-94, 95-96, 97-98
Art books and catalogs: GAR
Ablaze sc (co) 1986-87 GAR: **53**

MILLS, LEV TIMOTHY 1940-
Biographical dictionaries: WAA 78, 80, 82, 84, 86, 89-90, 91-92, 93-94, 95-96, 97-98
Artbooks and catalogs: BAG
Untitled (*from portfolio* I Do) xd-in (co) 1971 BAG: 22/25

MILTON, PETER WINSLOW 1930-
Biographical dictionaries: WAA 73, 76, 78, 80, 82, 84, 86, 89-90, 91-92, 93-94, 95-96, 97-98
Art books and catalogs: APP, ENP, ESS, PIA, POR, TYA, WAT
Card House et en 1975 TYA: 80
Collecting with Rudi et en 1974 ESS: [17]
Daylilies et en dc-to-tf 1975 APP: 220 PIA: **161**/116 TYA: 80

WAT: 256
Jolly Corner III: 7 et 1971 POR: 267
Julia Passing et en 1967 WAT: 255
Passage II et 1971 ENP: *abc*
Sky-Blue Life et en 1976 TYA: 80
See also:
Milton, Peter. *Peter Milton, Complete Etchings 1960-1976.*
 Edited by Kneeland McNulty. Boston: Impressions
 Workshop, 1977.
Milton, Peter. *Peter Milton: Complete Prints, 1960-1996: A
 Catalogue Raisonné.* San Francisco: Chronicle Books, 1996.

MING-DAO, DENG 1954-
 Biographical dictionaries:
 Art books and catalogs: NPE
 Cloud Shadows co-wo (co) 1978 NPE: 119
 Rain Basin co-wo (co) 1978 NPE: 118

MIRÓ, JOAN 1893-1983
 Biographical dictionaries:
 Artbooks and catalogs: GMC, TWO
 Foresters—Gray co-et aq (co) 1958 GMC: 47
 Large Carnivore aq et cb 1969 TWO: 67

MITCHELL, JEFFRY 1958-
 Biographical dictionaries:
 Art books and catalogs: PNW
 Donkey (*from series* The Bestiary) hc-et (co) 1994 PNW: 125
 Jesus Flower li shl-gn 1991 PNW: 124
 No Title of-ph (co) 1996 PNW: **123**

MITCHELL, JOAN 1926-92
 Biographical dictionaries: WAA 66, 70, 73, 76, 78, 80, 82, 84,
 86, 89-90, 91-92
 Artbooks and catalogs: AGM, PWP, TCR, TGX
 Bedford I (*from* The Bedford Series) li (co) 1981 TCR: **222, 224**
 TGX: **80**
 Bedford II (*from* The Bedford Series) li (co) 1981 AGM: **116**
 TCR: **222, 224** TGX: **81**

Bedford III (*from* The Bedford Series) li (co) 1981 TCR: **222, 224** TGX: **80**

Brush (*from* The Bedford Series) li (co) 1981 TCR: **227**

Flower I (*from* The Bedford Series) li (co) 1981 AGM: **117** PWP: clp90/115 TCR: **226** TGX: **74**

Flower II (*from* The Bedford Series) li (co) 1981 TCR: **226** TGX: **76**

Flower III (*from* The Bedford Series) li (co) 1981 TCR: **226**

Flying Dutchman oi ca 1961-62 TGX: **75**

Sides of a River I (*from* The Bedford Series) li (co) 1981 TCR: **225** TGX: **76**

Sides of a River II (*from* The Bedford Series) li (co) 1981 TCR: **225** TGX: **79**

Sides of a River III (*from* The Bedford Series) li (co) 1981 TCR: **225** TGX: **76**

MIYASAKI, GEORGE JOJI 1935-
Biographical dictionaries: WAA 66, 70, 73, 76, 78, 80, 82, 84, 86, 89-90, 91-92, 93-94, 95-96, 97-98
Art books and catalogs: AAP
Gallop li hc (co) 1983 AAP: 88

MIYAUCHI, HARUO 1943-
Biographical dictionaries:
Art books and catalogs: ENP
In the Sunrise sk 1972 ENP: *abc*

MOCK, RICHARD BASIL 1944-
Biographical dictionaries: WAA 76, 78, 84, 86, 89-90, 91-92, 93-94, 95-96, 97-98
Art books and catalogs: AAP, BWS, PAP
Bird of Paradise lc hc (co) 1979-83 AAP: 89
Crossing Fate's Boundaries lc 1978-82 BWS: 13/31
Racing Beauty wo 1985 PAP: 92

MOHR, MANFRED 1938-
Biographical dictionaries: WAA 97-98
Art books and catalogs: TWO
Prog. 148 dw 1973 TWO: 90

MONTENEGRO, ENRIQUE E. 1917-
 Biographical dictionaries: WAA 66, 70, 73, 76, 78, 80
 Art books and catalogs: PNM
 Woman on a Crosswalk co-li (co) 1966 PNM: 78

MOON, JAY
 Biographical dictionaries:
 Artbooks and catalogs: BAG
 Finger Painter et 1975 BAG: 19/27

MORALES, ARMANDO 1927-
 Biographical dictionaries: WAA 76, 78, 80, 82, 84, 86, 89-90,
 91-92, 93-94, 95-96, 97-98
 Art books and catalogs: GAR
 Dos Ciclistas [Two Cyclists] li 1981 GAR: 29

MORGAN, NORMA 1928-
 Biographical dictionaries:
 Art books and catalogs: APP
 Tired Traveler aq en 1950 APP: 105

MORLEY, MALCOLM 1931-
 Biographical dictionaries: WAA 70, 78, 80, 82, 84, 86, 89-90,
 91-92, 93-94, 95-96, 97-98
 Art books and catalogs: TCR, TGX
 Beach Scene li (co) 1982 TCR: **228, 230** TGX: **144**
 Devonshire Bullocks li (co) 1982 TCR: **230** TGX: **143**
 Devonshire Cows li (co) 1982 TCR: **231** TGX: **142**
 Fish li (co) 1982 TCR: **231** TGX: **145**
 Goat li hm 1982 TCR: **232**
 Goats in a Shed li hm 1982 TCR: **232**
 Horses li hm 1982 TCR: **232**
 On Deck mg lx ca 1966 TGX: 141
 Parrots li (co) 1982 TCR: **230**

MORRIS, KATHLEEN 1946-
 Biographical dictionaries:
 Artbooks and catalogs: PWP

King's Day mo 1988 PWP: clp**82**/115

MORRIS, ROBERT 1931-
Biographical dictionaries: WAA 70, 73, 76, 78, 80, 82, 84, 86, 89-90, 91-92, 93-94, 95-96, 97-98
Art books and catalogs: AMI, APM, ENP, PRO, TWO
Continuities (*portfolio of 5*) le sf aq 1988 PRO: clp52
Crater with Smoke (*from* Five War Memorials) li 1970 APM: 18
Infantry Archive—To Be Walked on Barefoot (*from portfolio* War Memorials) li 1970 ENP: *abc*
Steam (*from portfolio* Earth Projects) li (co) 1969 AMI: clp115 TWO: 72

MORTENSEN, GORDON LOUIS 1938-
Biographical dictionaries: WAA 78, 80, 82, 84, 86, 89-90, 91-92, 93-94, 95-96, 97-98
Art books and catalogs: TYA
Summer Pond wo 1976 TYA: 81

MOSES, ED 1926-
Biographical dictionaries: WAA 73, 76, 78, 80, 82, 84, 86, 89-90, 91-92, 93-94, 95-96, 97-98
Art books and catalogs: AMI, LAP, TYA
Broken Wedge 5 li (co) 1973 AMI: clp**88**
Broken Wedge Series No.6 li si 1973 TYA: 81
Untitled co-li (co) 1968 LAP: 79/105

MOSES, FORREST (LEE), JR. 1934-
Biographical dictionaries: WAA 73, 76, 78, 80, 82, 84, 86, 89-90, 91-92, 93-94, 95-96, 97-98
Art books and catalogs: AAP, CAM
Landscape, Rocks, Water mo 1983 CAM: 18/46
Untitled mo 1981 AAP: 90

MOSKOWITZ, ROBERT S. 1935-
Biographical dictionaries: WAA 66, 70, 73, 76, 78, 80, 82, 84, 86, 89-90, 91-92, 93-94, 95-96, 97-98
Art books and catalogs: FIM
Eddystone sc 1983 FIM: **17**

MOTHERWELL, ROBERT 1915-91

Biographical dictionaries: WAA 40-47, 53, 56, 59, 62, 66, 70, 73, 76, 78, 80, 82, 84, 86, 89-90, 91-92

Art books and catalogs: AAP, AMI, AMP, APP, APS, CMZ, GMC, INP, PAP, PIA, PPP, PRO, TCA, TCR, TGX, TPI, TWO, TYA, WAT

Aberdeen Stone li 1970-71 TGX: 47

Airless Black (*from* El Negro) li hm (co) 1983 TCR: **252** TGX: **58**

Alberti Elegy hm li cq (co) 1982 TCR: **246**

America—La France Variations [*I-VII, IX*] li ce hm (co) 1984 TCR: **258-62**

America—La France Variations IV li ce hm (co) 1984 TCR: **260** TGX: **61**

America—La France Variations VIII li ce (co) 1984 TCR: **262**

Art 1981 Chicago Print li (co) 1981 TCR: **246**

Automatism A li 1965-66 APP: 190 APS: clp5 TGX: 45 WAT: 227

Bastos li (co) 1975 TCR: **234, 236** TGX: **54** TYA: **14**

"Black" 4 [*study*] ce 1969 PPP: 118

"Black" 4 [*trial proof*] et aq 1969 PPP: 119

Black Banners (*from* El Negro) li hm 1983 TCR: **251**

Black Concentrated (*from* El Negro) li hm 1983 TCR: **253**

Black in Black (*from* El Negro) li hm 1983 TCR: **253**

Black Lament (*from* El Negro) li hm (co) 1983 TCR: **254**

Black of the Echo (*from* El Negro) li hm 1983 TCR: **251**

Black Rumble li (co) 1985 TCR: **267**

Black Sounds li re ce hm (co) 1984 TCR: **263**

Black Undone by Tears li cq hm (co) 1983 TCR: **255**

Black Wall of Spain (*from* El Negro) li hm 1983 TCR: **252**

Black with No Way Out (*from* El Negro) li hm (co) 1983 TCR: **254** TGX: **50-51**

Blue I-3 (*from* A la Pintura *by Rafael Alberti*) et aq 1972 TWO: 62

Brushstroke li 1980 TCR: **245**

Burning Sun li (co) 1985 TCR: **267**

Dalton Print li 1979 TCR: **242**

Djarum li sc ce hc hm (co) 1975 TCR: **238**

Easter Day 1979 li 1980 TCR: **242**

El General li hm 1980 TCR: **243**

El Negro (*back endleaf*) li hm (co) 1983 TCR: **256**

El Negro [Colophon] li hm 1983 TCR: **256**

El Negro (*front endleaf*) li hm (co) 1983 TCR: **249**

El Negro (*half title page*) li hm 1983 TCR: **249**

El Negro [Preface] li hm 1983 TCR: **249**

El Negro [Title Page] li hm 1983 TCR: **249**

Elegy Black Black (*from* El Negro) li hm 1983 TCR: **251**

Eternal Black (*from* El Negro) li hm 1983 TCR: **252**

First Mezzotint (*from series* "Open Series") co-mz (co) 1968
 CMZ: [63]/39

For Meyer Schapiro (*from portfolio* For Meyer Schapiro) lg aq
 1973 GMC: 67

Forever Black (*from* El Negro) li hm 1983 TCR: **253**

Gauloises Bleues aq ce (co) 1968 TCA: **[41]**

Gypsy Curse li cq hm (co) 1983 TCR: **255**

Hermitage li sc (co) 1975 TCR: **240**

In Black with Yellow Ochre co-li (co) 1963 AMI: clp38 APS: clp4

Invisible Stab (*from* El Negro) li hm (co) 1983 TCR: **254**

La Guerra I li hm 1980 TCR: **245**

La Guerra II li (co) 1980 TCR: **245**

Lament for Lorca li hm (co) 1982 AAP: 91 TCR: **247** TGX: **39**

Le Coq li sc (co) 1975 TCR: **237**

Mediterranean li sc (co) 1975 TCR: **239**

Mexican Night II et aq (co) 1984-85 INP: 7 PIA: **186**/119

Monster li hm 1974-75 PPP: 120-21 TCR: **236**

Monster [*working proof, signed* "Trial Proof"] li go 1974-75 PPP:
 120

Mourning (*from* El Negro) li hm (co) 1983 TCR: **250**

Naples Yellow Open et aq (co) 1984 PAP: 93

Negro (*from* El Negro) li hm (co) 1983 TCR: **249**

Night Arrived (*from* El Negro) li cq hm 1983 TCR: **250**

On Stage li hm (co) 1983 TCR: **257**

On the Wing li em ce (co) 1984 TCR: **264**

Personnage en na 1943-44 AMI: clp5 TGX: 41 TPI: 14

Poe's Abyss li (co) 1975 TCR: **237**

Poem (*from* El Negro) li hm 1983 TCR: **250**

Poet II li 1961-62 TGX: 41

Poor Spain li hm (co) 1983 TCR: **256**

Quarrel li (co) 1984 TCR: **257**

"Red" 4-7 [*study*] (*from* A la Pintura) ac cy (co) 1969 PPP: **116**

"Red" 4-7 [*trial proof*] (*from* A la Pintura) et sl aq (co) 1969 PPP: **117**

Redness of Red li sc ce hm (co) 1985 TCR: **265-66** TGX: **57**

Rite of Passage I li hm hc-pa (co) 1980 TCR: **244**

Rite of Passage II li hm hc-pa (co) 1980 TCR: **244**

Rite of Passage III li cq hm (co) 1980 TCR: **244**

Robinson Jeffers Print li hm 1981 TCR: **246**

Samurai II li ce hm lm-hm 1980 TCR: **242** TGX: 56

San Ildefenso Nocturne (*from portfolio* 3 Poems, Octavio Paz) li hm dl-cg 1988 PRO: clp54

Spanish Elegy I li hm 1975 TCR: **238**

Spanish Elegy II li hm 1975 TCR: **238**

St. Michael I li sc mp (co) 1979 TCR: **240-41**

St. Michael II li sc mp (co) 1979 TCR: **241**

St. Michael III li sc hm (co) 1975-79 PPP: **123** TCR: **241** TGX: **55**

Stoneness of the Stone li hm 1974 TCR: **236** TYA: 82

Through Black Emerge Purified li hm (co) 1983 TCR: **255**

Tobacco Roth-Händle li sc hm (co) 1975 TCR: **237**

Untitled aq (co) 1975 AMI: clp75

Untitled li 1968 TGX: 47

Untitled li 1978 AMP: 97

Untitled li em (co) 1982 TCR: **247**

Untitled, A li (co) 1984 TCR: **264**

Untitled, B li (co) 1984 TCR: **265**

Untitled, C li (co) 1984 TCR: **265**

Untitled [beige/blue/black] aq 1975 TYA: 82

Untitled (*from* Portfolio 9) li 1967 TCA: 14

Water's Edge li re ce em hm (co) 1984 TCR: **263**

Wave sf ce (co) 1974-78 APP: clp14

White I-2 (*from* A la pintura) et aq lp 1971 TGX: 48

"White" I-2 [*study*] (*from* A la Pintura) cy 1968 PPP: 114

"White" I-2 [*trial proofs*] (*from* A la Pintura) et sl aq 1971 PPP: 115

See also:

Terenzio, Stephanie, and Dorothy C. Belknap. *The Prints of Robert Motherwell: A Catalogue Raisonné, 1943-1990.* 3rd

ed. New York: Rizzoli, 1990.

MOY, SEONG 1921-
Biographical dictionaries: WAA 56, 59, 62, 66, 70, 73, 76, 78, 80, 82, 84, 86, 89-90, 91-92, 93-94, 95-96, 97-98
Art books and catalogs: ACW, APP, WAT
Black Stone and Red Pebble cd-re (co) 1972 APP: clp19
Classical Horse and Rider co-wo (co) 1953 ACW: **40**, 106 WAT: 182
Dancer in Motion [*plate 5*] (*from portfolio* Rio Grande Graphics) wo 1952 APP: 87

MOYANO, SERGIO 1934-
Biographical dictionaries:
Art books and catalogs: PNM
Backstage (SFO) li 1988 PNM: 120

MUELLER, ROBERT 1954-
Biographical dictionaries:
Art books and catalogs: CUN
Butte 818 mp 1990 CUN: 136
Canyon li (co) 1990 CUN: **108**
Landlife in mp (co) 1988 CUN: **107**
Leveled Scene #5 [*State 2*] li 1989 CUN: 135

MULLEN, PHILIP E. 1942-
Biographical dictionaries: WAA 73, 76, 78, 80, 82, 84, 86, 89-90, 91-92, 93-94, 95-96, 97-98
Art books and catalogs: NPE
ADI Blue sk (co) 1977 NPE: **18**,121
Kathmandu Eccentric sk (co) 1977 NPE: 120

MULLICAN, LEE 1919-
Biographical dictionaries: WAA 56, 62, 66, 70, 73, 76, 78, 80, 82, 84, 86, 89-90, 91-92, 93-94, 95-96, 97-98
Art books and catalogs: LAP
Mountain co-li (co) 1969 LAP: 82/105

MULLICAN, MATT 1951-
Biographical dictionaries:
Art books and catalogs: PRO
Untitled (*portfolio of 16*) co-et (co) 1988 PRO: **fcv**

MURRAY, ELIZABETH 1940-
Biographical dictionaries: WAA 76, 78, 80, 82, 84, 86, 89-90, 91-92, 93-94, 95-96, 97-98
Art books and catalogs: AAP, AGM, AMI, FIM, PAP, PIA, PRO, PWP
Her Story (*portfolio of 13*) co-et pf-li cs chp (co) 1989 PRO: clp55
Inside Story li hc (co) 1984 AGM: **121** PAP: 94
Untitled sk (co) 1982 AAP: 92 AMI: clp147 PWP: clp8/115
Untitled [*States I-V*] li (co) 1980 AGM: **122-24** FIM: **115-17** PIA: **174/118**

MURRAY, JOHN MICHAEL 1931-
Biographical dictionaries: WAA 73, 76, 78, 80, 82, 84, 86, 89-90, 91-92, 93-94, 95-96, 97-98
Art books and catalogs: ENP
Graf Zeppelin at Lakehurst 1929 sk 1971 ENP: *abc*

MYERS, FRANCES 1936-
Biographical dictionaries: WAA 73, 76, 78, 80, 82, 84, 86, 89-90, 91-92, 93-94, 95-96, 97-98
Art books and catalogs: ACW, AWP, PAP, PWP,TYA, WAT
Classical Horse and Rider co-wo (co) 1953 WAT: 182
Dragon Brew in-re (co) 1990 PWP: clp62/115
Gotham in aq cp 1974 AWP: [15]
Martyrdom lc sn 1984 PAP: 95
Monte Alban I aq 1976 TYA: 82
Monte Alban II co-aq (co) 1976 WAT: 304
Saint Teresa's Seventh Mansion re et (co) 1992 ACW: **88**, 131
Taliesin West co-aq sf (co) 1979 WAT: **275**

MYERS, MALCOLM HAYNIE 1917-
Biographical dictionaries: WAA 53, 56, 59, 62, 66, 70, 73, 76, 78, 80, 82, 84, 86, 89-90, 91-92, 93-94, 95-96, 97-98
Art books and catalogs: APP, WAT

Fox in Costume mx 1967 APP: 205
St. Anthony in 1946 WAT: 166

MYERS, VIRGINIA ANNE 1927-
 Biographical dictionaries: WAA 76, 78, 80, 82, 84, 86, 89-90,
 91-92, 93-94, 95-96, 97-98
 Art books and catalogs: WAT
 Self Portrait with Hat en 1960 WAT: 298

MYSLOWSKI, TADEUSZ 1943-
 Biographical dictionaries:
 Art books and catalogs: ENP
 I New York City sk 1972 ENP: *abc*

NADLER, HARRY 1930-90
 Biographical dictionaries: WAA 76, 78, 80, 82, 84, 86, 89-90
 Art books and catalogs: PNM
 Grey Labyrinth co-li (co) 1976 PNM: 97

NADLER, SUSAN 1946-
 Biographical dictionaries:
 Art books and catalogs: ENP
 Untitled mp 1972 ENP: *abc*

NAGANO, MIKI
 Biographical dictionaries:
 Art books and catalogs: RBW
 Spirit Q et 1983 RBW: [18]

NAGATANI, PATRICK AUGUST 1945-
 Biographical dictionaries: WAA 95-96, 97-98
 Art books and catalogs: PNM
 Trinitite Tempest co-li (co) 1988 PNM: 137

NAMA, GEORGE ALLEN 1939-
 Biographical dictionaries: WAA 73, 76, 78, 80, 82, 84, 86, 89-
 90, 91-92, 93-94, 95-96, 97-98
 Art books and catalogs: TYA
 Reeds cg in sk 1975 TYA: 83

NANAO, KENJILO 1929-
 Biographical dictionaries:
 Art books and catalogs: ENP, TYA
 Dream Over the Hills li 1971 ENP: *abc*
 Further Variations on a Sucker li 1973 TYA: 83

NARES, JAMES
 Biographical dictionaries:
 Art books and catalogs: PRO
 Artaud's Arms co-mo (co) 1986 PRO: clp56
 Strange Fruit co-mo (co) 1986 PRO: clp57

NARTONIS, CYNTHIA 1943-
 Biographical dictionaries:
 Artbooks and catalogs: PWP
 Untitled sc mo (co) 1988 PWP: clp4/115

NAUMAN, BRUCE 1941-
 Biographical dictionaries: WAA 78, 80, 82, 84, 86, 89-90, 91-
 92, 93-94, 95-96, 97-98
 Art books and catalogs: AAP, AKG, AMI, APB, APM, ENP,
 FIM, LAP, PIA, PNM, TWO
 Earth-World li 1986 PNM: 116
 M. Ampere co-li (co) 1973 TYA: 84 APM: 19
 Normal Desires li 1973 APB: clp*129*/50
 No-State li 1981 AAP: 93
 Raw-War li (co) 1971 PIA: **149**/115
 Studies for Holograms (*suite of 5*) sc (co) 1970 FIM: **66-67**
 Untitled co-li (co) 1971 ENP: *abc* LAP: 90/107 TYA: 83
 Untitled (*from* Studies for Holograms) sk 1970 AKG: clp79b
 AMI: clp118 TWO: 69
 See also:
 Cordes, Christopher, and Debbie Taylor, eds. *Bruce Nauman
 Prints, 1970-1989: A Catalogue Raisonné*. New York:
 Castelli Graphics, 1989.

NAWARA, JIM 1945-
 Biographical dictionaries: WAA 82, 84, 86, 89-90, 91-92, 93-
 94, 95-96, 97-98

Art books and catalogs: CIP, TYA
Dartmoor co-sc (co) 1981 CIP: **51**
Deadwood li 1975 TYA: 84
Quebrada co-sc (co) 1980 CIP: **51**

NAWARA, LUCILLE PROCTER 1941-
Biographical dictionaries: WAA 82, 84, 86, 89-90, 91-92, 93-94, 95-96, 97-98
Artbooks and catalogs: CIP
Bash Bish Falls co-sc (co) 1989 CIP: **53**

NEBEKER, ROYAL 1945-
Biographical dictionaries:
Art books and catalogs: PNW
Dream hc-wo (co) 1993 PNW: 129
Jacob's Ladder mo (co) 1996 PNW: **127**
Still I Don't Know li 1991 PNW: 128

NEFERTITI
Biographical dictionaries:
Artbooks and catalogs: BAG
Getting Fixed to Look Pretty lc 1978 BAG: 20/27

NEIMAN, LEROY 1927-
Biographical dictionaries: WAA 66, 70, 73, 76, 78, 80, 82, 84, 86, 89-90, 91-92, 93-94, 95-96, 97-98
Artbooks and catalogs:
See also:
Leibovitz, Maury, ed. *The Prints of Leroy Neiman: A Catalogue Raisonné of Serigraphs, Lithographs and Etchings.* New York: Knoedler, 1980.

NELSON, BARRY 1949-
Biographical dictionaries:
Art books and catalogs: ENP
F Sharp et 1972 ENP: *abc*

NELSON, KEIKO
Biographical dictionaries:

Art books and catalogs: NCP
Myth of Changmai (*from* Thailand Series) mo hp cs 1987 NCP:
12

NELSON, MARK 1953-
Biographical dictionaries:
Art books and catalogs: NPE
Deathmask co-li (co) 1978 NPE: 122
Remains B^3 co-li (co) 1977 NPE: 122

NELSON, RICHARD L. 1901-
Biographical dictionaries: WAA 62, 66, 70, 73
Art books and catalogs: RBW
How Fate Works en 1982 RBW: [19]

NELSON, ROBERT ALLEN 1925-
Biographical dictionaries: WAA 66, 70, 73, 76, 78, 80, 82, 84,
86
Art books and catalogs: ESS, TYA, WAT
Bombs of Barsoom li ce 1971 TYA: 85
Cat and Mice li 1975 TYA: 85
Light Load li 1979 WAT: 297
Prince of Atlantis co-li (co) 1976 ESS: [20]
Torpedo Tabby li ce 1974 TYA: 85

NESBITT, LOWELL (BLAIR) 1933-93
Biographical dictionaries: WAA 70, 73, 76, 78, 80, 82, 84, 86,
89-90, 91-92, 93-94
Art books and catalogs: ENP, TYA
Barriers li 1971 ENP: *abc*
Lily [*State I*] dr 1975 TYA: 86
Sandstone Tulip li 1976 TYA: 86

NEVELSON, LOUISE 1900-88
Biographical dictionaries: WAA 53, 56, 59, 62, 66, 70, 73, 76,
78, 80, 82, 84, 86
Art books and catalogs: AMI, APP, AWP, ENP, THL, TYA,
WAT
Ancient Garden et 1954 TYA: 86
By the Lake (*from* Facade Suite) sk pa-ce ps 1966 AWP: [16]

In the Land Where the Trees Talk et dr sf c.1953 WAT: 219
Tropical Leaves (*from lead intaglio series*) ld-in 1970-73 APP:
131
Two Pair Black Night li 1971 ENP: *abc*
Untitled co-li dp (co) 1967 AMI: clp113
Untitled li 1963 THL: 15
See also:
Baro, Gene. *Nevelson: The Prints.* New York: Pace Editions,
1974.

NEWMAN, (BENEDICT) BARNETT 1905-70
Biographical dictionaries: WAA 53, 56, 59, 62, 66, 70
Art books and catalogs: AKG, AMI, APM, APS, PIA
18 Cantos (*series of 18*) co-li (co) 1964 AKG: clp39
Canto XVI (*from* 18 Cantos) li (co) 1963-64 PIA: 75, **132**/113
Cantos VII, VIII, and IX (*from* 18 Cantos) li 1963-64 AMI: clp**39**
Untitled li 1961 AKG: clp37
Untitled li 1961 APS: clp14
Untitled li 1961 APS: clp15
Untitled li 1961 APS: clp16
Untitled II et aq 1969 AMI: clp94
Untitled Etching #1 [*First Version*] et aq 1969 APM: 5/18
Untitled Etching #2 et aq 1969 APS: clp59
See also:
Davies, Hugh Marlais. *The Prints of Barnett Newman.* New York:
Barnett Newman Foundation, 1983.
Schor, Gabriele. *The Prints of Barnett Newman 1961-1969.*
Stuttgart: Hatje Verlag, 1997.

NEWMAN, JOHN 1952-
Biographical dictionaries: WAA 95-96, 97-98
Art books and catalogs: PIA, PRO
Grande Romano blu co-et aq dr sf (co) 1988 PRO: clp58
Medio Romano giallo co-et aq dr sf (co) 1988 PRO: clp59
Two Pulls et aq dr (co) 1986 PIA: **201**/121

NEWSOM, CAROL 1946-
Biographical dictionaries:
Art books and catalogs: AWP
Network, "Soft Lattice 2" in le 1975 AWP: [17]

NICE, DON 1932-
 Biographical dictionaries: WAA 84, 86, 89-90, 91-92, 93-94,
 95-96, 97-98
 Art books and catalogs: CIP, ENP, TYA
 Big Sneaker li 1972 ENP: *abc*
 Double Sneaker li 1975 TYA: 87
 Heartland co-sc (co) 1984 CIP: **55**
 Tootsie Pops li 1974 TYA: 87

NILSSON, GLADYS 1940-
 Biographical dictionaries: WAA 84, 86, 89-90, 91-92, 93-94,
 95-96, 97-98
 Artbooks and catalogs: CHI
 Christ in the Garden co-wo (co) 1963 CHI: 80
 da Hairy Who Kamic Kamie Page (*comic strip page by James
 Falconer, Art Green, Gladys Nilsson, Jim Nutt, Suellen
 Rocca, and Karl Wirsum*) of-li 1967 CHI: 200
 Dis is THE Catalog (*catalog/checklist/price list by James
 Falconer, Art Green, Gladys Nilsson, Jim Nutt, Suellen
 Rocca, and Karl Wirsum*) of-li 1969 CHI: 203
 Europa and the Bull li 1962 CHI: 79
 Expulsion wo 1963 CHI: 80
 Flying Flowers (*from* Portfolio No. 4) co-wo (co) CHI: 191
 Four People et dr 1964 CHI: 81
 Gladys Nilsson of-li c.1973 CHI: 87
 Gladys Nilsson: Paintings, Phyllis Kind Gallery of-li 1972 CHI:
 87
 Group of Three Figures co-wo (co) 1963 CHI: 190
 Hairy Who (*comic book by James Falconer, Art Green, Gladys
 Nilsson, Jim Nutt, Suellen Rocca, and Karl Wirsum*) co-of-li
 (co) 1968 CHI: 199-200
 Hairy Who (*poster for 1st "Hairy Who" group exhibition*) of-li
 1966 CHI: 194
 Hairy Who (*poster for 2nd "Hairy Who" group exhibition*) of-li
 1967 CHI: **35**, 196
 Hairy Who (cat-a-log) (*comic book by James Falconer, Art
 Green, Gladys Nilsson, Jim Nutt, Suellen Rocca, and Karl
 Wirsum*) co-of-li (co) 1968 CHI: **35**, 201-2
 Hairy Who Sideshow (*comic book by James Falconer, Art Green,*

Gladys Nilsson, Jim Nutt, Suellen Rocca, and Karl Wirsum)
co-of-li (co) 1967 CHI: 196-98

Holes with a Muse co-sk fa (co) 1981 CHI: 85

Hoofers and Tootsies et dr 1964 CHI: 83

Jim Nutt: Paintings/Roger Vail: Photographs of-li c.1973 CHI: 87

Masked Eunuch et dr 1963 CHI: 80

Nightclub et dr 1963 CHI: 80

Nudes at Water wo 1963 CHI: 80

Plate Dancing in Carbondale et dr 1984 CHI: 86

Portable Hairy Who! (*comic book by James Falconer, Art Green, Gladys Nilsson, Jim Nutt, Suellen Rocca, and Karl Wirsum*) bk co-of-li (co) 1966 CHI: 194-95

Problematical Tripdickery co-et dr re in tp (co) 1984 CHI: **26**, 85

Self-Portrait as White Rock Lady li 1961-62 CHI: 79

Smoker (*from* Portfolio No. 4) wo CHI: 191

Street Scene et dr 1964 CHI: 81

Terrible Dragon (*from* Portfolio No. 2) wo 1963 CHI: 190

Thats Me: Gladys Nilsson of-li 1969 CHI: 87

Untitled (*dimensions: 2 5/8 x 13 29/32*) et 1964 CHI: 81

Untitled (*dimensions: 7 9/16 x 7*) et 1964 CHI: 82

Untitled (*dimensions: 5 ¾ x 6 15/16*) et 1964 CHI: 82

Untitled (*dimensions: 6 3/8 x 10*) et 1964 CHI: 82

Untitled (*dimensions: 5 1/8 x 5 1/8*) et dr 1963 CHI: 79

Untitled (*dimensions: 3 5/8 x 5 3/32*) et dr 1963 CHI: 79

Untitled (*dimensions: 5 11/16 x 4 ¼*) et dr 1963 CHI: 79

Untitled (*dimensions: 6 ½ x 5 11/16*) et dr 1963 CHI: 79

Untitled (*dimensions: 4 15/16 x 4 5/8*) et dr 1964 CHI: 81

Untitled (*dimensions: 7 15/16 x 3 11/16*) et dr 1964 CHI: 82

Untitled et dr 1964 CHI: 83

Untitled (*from portfolio* Da Hairy Who) co-sk (co) 1967-68 CHI: 193

Untitled (*from* Portfolio No. 4) wo 1964 CHI: 191

Untitled [My Name is Jim Nutt] (*artist is either Jim Nutt or Gladys Nilsson*) wo wc (co) 1963 or 1964 CHI: 190

Women (*announcement*) of-li 1982 CHI: 87

Women (*poster*) co-of-li (co) 1982 CHI: 87

Young Girls co-wo (co) 1963 CHI: 190

NISHIMURA, NORINE
Biographical dictionaries:

Art books and catalogs: NCP
Self-Portrait wo et ty-ab-hm ch wi mx be 1987 NCP: 10

NOAH, BARBARA 1949-
Biographical dictionaries:
Art books and catalogs: PNW
Big et 1988 PNW: 133
Ooh oi pm 1990 PNW: 132
Pioneer et (co) 1993 PNW: **131**

NOLAND, KENNETH CLIFTON 1924-
Biographical dictionaries: WAA 62, 66, 70, 73, 76, 78, 80, 82, 84, 86, 89-90, 91-92, 93-94, 95-96, 97-98
Art books and catalogs: AAP, CAM, TCR, TGX
Blush li (co) 1978 TCR: **270** TGX: **103**
Doors and Ghosts DG-83-04 hp-mo em-pa 1984 CAM: 42/46
Echo aq em (co) 1978 TCR: **270** TGX: **102**
Winds 82-34 mo ac dm ik 1982 AAP: 94

NORTHINGTON, THOMAS WILSON 1947-
Biographical dictionaries:
Art books and catalogs: NPE
Encroaching on the Continent cg pe in re 1977 NPE: 125
University Bridge cg ik cb 1976 NPE: 124

NUSHAWG, MICHAEL ALLAN 1944-
Biographical dictionaries: WAA 82, 84, 86, 89-90, 91-92, 93-94, 95-96, 97-98
Art books and catalogs: NPE
(Dové Te) Destiny Kinnel in si li et re sk ce (co) 1977 NPE: 127
RE-4 in et re li ch ce (co) 1977 NPE: 127

NUTT, JIM (JAMES TUREMAN) 1938-
Biographical dictionaries: WAA 84, 86, 89-90, 91-92, 93-94, 95-96, 97-98
Art books and catalogs: CHI
[title=drawing of two fingers] et hc-wc (co) 1968 CHI: 95
[title=drawing of waterfall] et 1970-71 CHI: 98
[title=drawing of adhesive bandage] et 1968-69 CHI: 95

Jim Nutt co-li (co) 1964 CHI: 91
Jim Nutt of-li (co) 1974 CHI: 106
Jim Nutt of-li (co) 1974 CHI: 107
Jim Nutt (*dimensions: 8 ½ x 16*) of-li (co) 1975 CHI: 107
Jim Nutt (*dimensions: 4 13/16 x 9 3/8*) of-li (co) 1975 CHI: 107
Jim Nutt of-li ds 1971-72 or 1973 CHI: 106
Look snay et 1970 CHI: 97
Miss Gladys Nilsson of-li 1969: 105
Nacktes Weib co-wo (co) 1963-64 CHI: 90
Not about to have wool pulled over his eyes co-wo (co) 1964 CHI:
 191
Now! Hairy Who Makes You Smell Good of-li (co) 1968 CHI:
 105
Nutt's Frames et re (co) 1964-65 CHI: 92
oh Dat Sally [*2States*] et 1967-68 CHI: 94
oh! my goodness (NO NO) et hm 1977 CHI: 101 PIA: **165**/117
Paintings by Jim Nutt of-li ds 1972 CHI: 106
Pit er Pat et hc-wc (co) 1968-69 CHI: 95
Portable Hairy Who! (*comic book by James Falconer, Art Green,
 Gladys Nilsson, Jim Nutt, Suellen Rocca, and Karl Wirsum*)
 bk co-of-li (co) 1966 CHI: 194-95
Sally Slips Bye-Bye et hc-wc (co) 1967-68 CHI: 93
seams straight! et hc-wc hc-ba (co) 1967-68 CHI: **27**, 93
Selbst Bildnis sg 1960-61 CHI: 90
Selbst-Explanatory wo 1963-64 CHI: 90
Self-Portrait et aq 1960-61 CHI: 90
Smack Smack li 1968-69 CHI: 96
soft touch me et 1970-71 CHI: 98
Space Man li 1963-64 CHI: 91
Star et 1967 CHI: 91
stomping et 1969 CHI: 95
sweet note of regret et 1970 CHI: 97
Three Famous Artists: Gladys Nilsson, Joseph E. Yoakum, Jim
 Nutt of-li 1970 CHI: 105
toe tapping Nose et hc-wc (co) 1967-68 CHI: 93
Toleit co-wo (co) 1963-64 CHI: 90
ummmph.... [*2 States*] et 1967-68 CHI: 94
Untitled co-of-ph 1970 CHI: 105
Untitled (*dimensions: 13 3/8 x 10 7/16*) li 1969 CHI: 96
Untitled (*dimensions: 5 3/8 x 7 3/8*) li 1969 CHI: 96

Untitled of-li 1974 CHI: 107

Untitled (*from* Portfolio No. 2) wo 1963 CHI: 190

Untitled #1 et 1976-77 CHI: 103

Untitled #2 [*6 States*] et aq 1976-77 CHI: 102

Untitled #3 [*3 States*] et aq 1976-77 CHI: 102

Untitled #4 sf (co) 1976-77 CHI: 103

Untitled #5 [*4 States*] et aq (co) 1976-77 CHI: 103

Untitled [My Name is Jim Nutt] (*artist is either Jim Nutt or Gladys Nilsson*) wo wc (co) 1963 or 1964 CHI: 190

Who Chicago? bk bx sk fa 1980 CHI: 104

Wishpered! et 1970 CHI: 98

yoo hoo-little boy [*3 States*] et 1977 CHI: 99

"your so coarse" (tish tish) (*one of 4 from portfolio* Untitled) et hm (1975 *or* 1977) APM: 24/18 CHI: 100 PIA: **165**/117

O'HARA, (JAMES) FREDERICK 1904-80

Biographical dictionaries: WAA 40-47, 53, 56, 59, 62, 70, 73, 76, 78

Art books and catalogs: ACW, PNM

Comanche Gap IV li 1959 PNM: 50

Garden of Folly, Series II co-wo (co) 1954 PNM: clp4

Riders co-wo (co) 1954 ACW: **59**, 117

OLDENBURG, CLAES THURE 1929-

Biographical dictionaries: WAA 66, 70, 73, 76, 78, 80, 82, 84, 86, 89-90, 91-92, 93-94, 95-96, 97-98

Art books and catalogs: AKG, AMI, APP, APS, BWS, ENP, FIM, GMC, PAC, PIA, PPP, TCA, TCR, TGX, TPI, TWO, TYA, WAT

Chicago Stuffed with Numbers li (co) 1977 TCR: **280** TGX: **136**

Double Screwarch Bridge [*State I*] et 1980 PPP: 124

Double Screwarch Bridge [*State II*] et aq hd gr er 1980-81 AMI: clp137 BWS: 25/31 PAC: [43]/87 PPP: 125-26

Double Screwarch Bridge [*State III*] et aq mo (co) 1981 PIA: **177**/118 PPP: **127**, **129** TCA: [35]

Floating Three-Way Plug et aq (co) 1976 APP: clp8 TYA: **fpc**/4

Flying Pizza (*from* New York Ten) co-li (co) 1964 TPI: 92

Letter Q as a Beach House, with Sailboat li (co) 1972 TGX:**139**

Map of Chicago Stuffed with Soft Numbers ik 1963 TGX: 138

Mickey Mouse li 1968 TYA: 88

Orpheum Sign (*from portfolio* International Anthology of
Contemporary Engraving: The International Avant-Garde:
America Discovered, Volume 5) et aq 1961-62 AMI: clp42
APS: clp24 FIM: **35**

Profile Airflow co-li (co) 1969 TPI: **53**

Profile Airflow—Test Mold, Front End co-sk ur px we-al-fm (co)
1968-72 WAT: **204**

Store Poster co-of-li hc (co) 1961 APS: clp1 TPI: 92

Store Window: Bow, Hats, Heart, Shirt, 29° li 1972 TYA: 88

System of Iconography: Plug Mouse, Good Humor, Lipstick,
Switches of-li 1971 ENP: *abc*

Tea Bag (*from* Four on Plexiglas) sk ft px pt 1965-66 AMI: clp**54**
APS: clp28 TWO: 39

Teapot li 1975 TYA: 88

Three Hats (*from portfolio* For Meyer Schapiro) co-li hm (co)
1974 GMC: 67

Typewriter Eraser of-sc 1969-70 AKG: clp43

Untitled (*from portfolio* One Cent Life *by Walasse Ting, edited by
Sam Francis*) co-li (co) 1964 AKG: clp72

See also:

Axsom, Richard H. *Printed Stuff: Prints, Posters, and Ephemera
by Claes Oldenburg: A Catalogue Raisonné 1958-1996.* New
York: Hudson Hills Press, 1997.

Oldenburg, Claes. *Claes Oldenburg: Works in Edition.* Los
Angeles: Margo Leavin Gallery, 1971.

OLITSKI, JULES 1922-

Biographical dictionaries: WAA 62, 66, 70, 73, 76, 78, 80, 82,
84, 86, 89-90, 91-92, 93-94, 95-96, 97-98

Art books and catalogs: AMI, ENP

Untitled li (co) 1968 AMI: clp**89**

Untitled sk 1970 ENP: *abc*

OLIVEIRA, NATHAN 1928-

Biographical dictionaries: WAA 66, 78, 80, 82, 84, 86, 89-90,
91-92, 93-94, 95-96, 97-98

Art books and catalogs: AAP, AML, CAM, ENP, PAP, PNM,
PPP, SIM, TYA, WAT

Acoma Hawk I co-li (co) 1965 WAT: **202**
Acoma Hawk V li 1975 PNM: 99
Archive Site [*working proofs*] et aq ik hd ck ce wc go 1979 PPP: 136-37
Bundle ii 7.13.75 mo 1975 TYA: 89
Elder li 1957 AML: 167
Homage to Carrière li 1963 WAT: 248
Kestrel Series #10 wo hc tl gr-hd (co) 1985 PAP: **fpc**, 96
London Site 2, Sequence 11 hc-mo (co) 1984 CAM: 11/46
London Site 6 co-mo (co) 1984 SIM: **189**
Man [*unique images*] li 1971 PPP: 130-31
Mask co-mo (co) 1969 SIM: **178**
Ryan Site 86 mo 1982 AAP: 95
Tauromaquia 6.20.73 III mo 1973 SIM: 168
Tauromaquia 6.21.73 III mo 1973 SIM: 168
Tauromaquia 6.21.73 IV mo 1973 SIM: 168
To Edgar Allan Poe [*plate IV*] li 1970 ENP: *abc*
Woman's Face li (co) 1966 PPP: **133**
Woman's Face [*State II*] li 1966 PPP: 134
Woman's Face with Grey Oval li go (co) 1966 PPP: **135**

OLSEN, DENNIS 1941-
Biographical dictionaries:
Art books and catalogs: FTP, SIM
Castiglioncello L mo (co) 1989 FTP: **59**
Pentimento XXII wc-mo (co) 1991 SIM: **184**

OPALKA, ROMAN 1931-
Biographical dictionaries:
Art books and catalogs: TWO
And to that posterity I will grant increase, till it lies like dust on the ground.... aq 1970 TWO: 91

OROPALLO, DEBORAH 1954-
Biographical dictionaries: WAA 93-94, 95-96, 97-98
Artbooks and catalogs: PWP
Rescue Device aq wo 1989 PWP: clp15/115

O'ROURKE, JUDITH 1960-
Biographical dictionaries:
Art books and catalogs: CUN
Brazilian Rain Forest #2 mo (co) 1990 CUN: **109**
Lovers vg 1989 CUN: 139
New Life mo 1991 CUN: 140
Pool vg (co) 1989 CUN: **108**

ORTMAN, GEORGE EARL 1926-
Biographical dictionaries: WAA 62, 66, 70, 73, 76, 78, 80, 82,
84, 86, 89-90, 91-92, 93-94, 95-96, 97-98
Art books and catalogs: THL
Flight (*from portfolio* Oaxaca) li 1966 THL: 36

OSBORNE, ELIZABETH 1936-
Biographical dictionaries: WAA 82, 84, 86, 89-90, 91-92, 93-
94, 95-96, 97-98
Artbooks and catalogs: ENP, PWP
Passage sk 1971 ENP: *abc*
Rockwood Still Life II sc 1987 PWP: clp72/116

OSORIO, J. HERNANDO
Biographical dictionaries:
Art books and catalogs: RBW
In the N.Y. Sub li 1982 RBW: [19]

OVERTON, JOHN 1948-
Biographical dictionaries:
Art books and catalogs: PAP, TYA
Blue Zone sf re in (co) 1983 PAP: 97
Crown of Thorns wo 1975 TYA: 89
Sunflower wo 1975 TYA: 90

OVIETTE, VEVEAN
Biographical dictionaries:
Art books and catalogs: TYA
Dance—Variation II wo 1958 TYA: 90

OXMAN, KATJA 1942-
Biographical dictionaries: WAA 89-90, 91-92, 93-94, 95-96, 97-98
Artbooks and catalogs: PWP
In the Chamber et (co) 1989 PWP: clp74/116

PALERMO, BLINKY (PETER HEISTERKAMP) 1943-77
Biographical dictionaries:
Art books and catalogs: TWO
4 Prototypes sk dp (co) 1970 TWO: 108

PALMORE, TOM 1945-
Biographical dictionaries:
Art books and catalogs: GAR, PNM
Bevo with Birds co-li sc co-hd ar (co) 1982 GAR: 31
Rare Southwestern Toucan co-sk li (co) 1980 PNM: 125

PAOLOZZI, EDUARDO (LUIGI) 1924-
Biographical dictionaries:
Art books and catalogs: PIA, TPI, TWO
As Is When (*one from portfolio of 12*) co-sc (co) 1965 TPI: 93
Silken World of Michelangelo (*from portfolio* Moonstrips Empire News) sc 1967 PIA: 41
Universal Electronic Vacuum (*one from portfolio of 10*) co-sc (co) 1967 TPI: 94
Wittgenstein in New York (*from* As Is When) co-sk (co) 1965 TPI: **54** TWO: 40

PARIS, HAROLD PERSICO 1925-79
Biographical dictionaries: WAA 66, 70, 73, 76, 78
Art books and catalogs: AML, RBW
Caballa li 1952 AML: 163
Untitled li RBW: [19]

PARKER, RAYMOND 1922-90
Biographical dictionaries: WAA 66, 70, 73, 76, 78, 80, 82, 84, 86
Art books and catalogs: AML
Untitled co-li (co) 1961 AML: 190

PARKER, ROBERT ANDREW 1927-
Biographical dictionaries: WAA 62, 66, 70, 73, 76, 78, 80, 82,
84, 86, 89-90, 91-92, 93-94, 95-96, 97-98
Art books and catalogs: PAP, THL
Chester Johnson and Myself, Mombasa—Nairobi et aq hc (co)
1984 PAP: 98
Squirrel Monkey co-li (co) 1967 THL: 46

PARTRIDGE, ROI 1888-1984
Biographical dictionaries: WAA 36-37, 40-41, 40-47, 53, 56,
76, 78, 80, 82, 84
Artbooks and catalogs:
See also:
White, Anthony R. *The Graphic Art of Roi Partridge: A*
Catalogue Raisonné. Los Angeles: Hennessy & Ingalls, 1988.

PASCHKE, ED(WARD) F. 1939-
Biographical dictionaries: WAA 76, 78, 80, 82, 84, 86, 89-90,
91-92, 93-94, 95-96, 97-98
Art books and catalogs: CHI, FIM, PIA
29 Arbour Hill cv 1961 CHI: 111
Ben Hur [*5 States*] co-sk (co) 1969-70 CHI: 115
Bistro co-li (co) 1981-82 CHI: 120
Bridge [*3 States*] co-et (co) c.1960 CHI: 111
Budget Floors [*3 States*] co-sk (co) 1968 CHI: **28**,112
Chuletas co-li (co) 1985 CHI: 123
Corporation et aq (co) 1969 CHI: 114
Crawjack [*7 States*] co-et aq dr (co) c.1960 CHI: 111
Dayton Ohio co-sk (co) 1970 CHI: 116
Ed Paschke Show [*3 States*] co-sk (co) 1970 CHI:125
Execo co-li (co) 1983 CHI: 121
Fem-Rouge co-li (co) 1987 CHI: 124
Fem-Verde co-li (co) 1987 CHI: 124
Godzilla Rainbow Troupe in "Turds in Hell" of-li (co) 1972 CHI:
125
Guano co-li (co) 1983 CHI: 121
Hairy Shoes co-li (co) 1971 CHI: 116 FIM: **79**
Hat et sf hb (co) 1976-77 CHI: 120
Ho Chi Minh [*3 States*] co-sk (co) 1969 CHI: 114

Hubert co-li/li (co) 1976-77 CHI: 118 PIA: 86, **163**/116
Klaus co-li/li (co) 1976 CHI: 119
Kontato co-li (co) 1984 CHI: 122-23
Landscape [*2 States*] et rl (co) c.1959 CHI: 110
Limone co-li (co) 1982-83 CHI: **28**,121
Mandrix co-li (co) 1979-80 CHI: 120
Mask Man co-sk (co) 1970 CHI: 116
Open Karate [*3 States*] co-sk (co) 1968-69 CHI: 113
Opusculum #5 co-et aq (co) c.1960 CHI: 110
Peace Employee [*4 States*] et aq c.1960 CHI: 110
Rosarita li 1973 CHI: 117
Tudor co-li/li (co) 1976-77 CHI: 119
Turds in Hell 1/3 Dollar of-li 1972 CHI: 125
Untitled co-sk (co) 1970 CHI: 116
Untitled et aq en c.1960 CHI: 110
Untitled li 1976 CHI: 118
Untitled pe 1968 CHI: 112
Untitled [*2 States*] co-sk (co) 1968-69 CHI: 113
Untitled 1974 li 1974 CHI: 118
Violencia co-li (co) 1979-80 CHI: 120
Viscon co-li (co) 1983-84 CHI: 122

PASSMORE, GEORGE 1942-
 Biographical dictionaries:
 Art books and catalogs: TWO
 Dark Shadows (*in collaboration with Gilbert Proersch*) pf 1976
 TWO: 98

PATE, LEE 1952-
 Biographical dictionaries: WAA 78, 80
 Art books and catalogs: RBW
 Square into Round, Hard into Soft mo 1979 RBW: [20]

PATKIN, IZHAR 1955-
 Biographical dictionaries: WAA 89-90, 91-92, 93-94, 95-96, 97-98
 Art books and catalogs: PRO
 Augusta Snow... Olympia's Maid (*from portfolio* From the Black
 Paintings) li lc 1988 PRO: clp60
 Edgars Alas Newport News... Winston Robinson (*from portfolio*

From the Black Paintings) li lc 1988 PRO: clp60
Stephanie Virtue Secret... Rose Drop (The Meta Bride) (*from
 portfolio* From the Black Paintings) li lc 1988 PRO: clp60
Valet... Al Jolson (*from portfolio* From the Black Paintings) li lc
 1988 PRO: clp60

PATTERSON, CLAYTON IAN 1948-

Biographical dictionaries: WAA 86, 89-90, 91-92, 93-94, 95-96,
 97-98
Art books and catalogs: PAP
Black Beauty wo wc tl (co) 1984 PAP: 99

PEAK, ELIZABETH JAYNE 1952-

Biographical dictionaries: WAA 82, 84, 86, 89-90, 91-92, 93-
 94, 95-96, 97-98
Artbooks and catalogs: CAM, PWP
Morning mo 1981 CAM: 27/46
View of a City et aq dp 1987 PWP: clp11/116

PEARLSTEIN, PHILIP 1924-

Biographical dictionaries: WAA 56, 59, 62, 66, 70, 73, 76, 78,
 80, 82, 84, 86, 89-90, 91-92, 93-94, 95-96, 97-98
Art books and catalogs: AAP, AMI, APM, APP, PAP, PIA,
 PNM, PPP, TWO, WAT
Female Nude with Legs Up (*two states*) li 1976 PPP: 144, **145**
Girl on Orange and Black Mexican Rug co-li (co) 1973 WAT:
 264
Model in Green Kimono [*trial proofs*] et aq hd (co) 1979 PPP:
 139-40, **141-42**
Model in Green Kimono et aq (co) 1979 PPP: **143**
Models with Mirror et aq rl (co) 1983-85 PAP: 100
Nude in Hammock et aq rl 1982 AAP: 96
Nude Lying on Black and Red Blanket aq et (co) 1974 AMI:
 clp111
Nude on Mexican Blanket aq 1971 TWO: 100
Reclining Nude on Green Couch co-li (co) 1971 APM: 21/19
Ruins at Gran Quivira li 1975 PNM: 98
Two Nudes li 1969 PIA: **142/114**
Untitled (*from portfolio* Six Lithographs Drawn from Life) li 1970

APP: 239

PEARSON, HENRY CHARLES 1914-
Biographical dictionaries: WAA 66, 70, 73, 76, 78, 80, 82, 84,
86, 89-90, 91-92, 93-94, 95-96, 97-98
Art books and catalogs: THL
Red and Blue co-li (co) 1964 THL: **40**

PENCK, A. R. (RALF WINKLER) 1939-
Biographical dictionaries:
Art books and catalogs: TWO
Ur End Standart [*plates 6 and 9*] sk 1967 TWO: 113

PEPPER, BEVERLY 1924-
Biographical dictionaries: WAA 70, 73, 76, 78, 80, 82, 84, 86,
89-90, 91-92, 93-94, 95-96, 97-98
Art books and catalogs: PAP
Medieval Axe mo 1985 PAP: 101

PETERDI, GABOR F. 1915-
Biographical dictionaries: WAA 53, 56, 59, 62, 66, 70, 73, 76,
78, 80, 82, 84, 86, 89-90, 91-92, 93-94, 95-96, 97-98
Art books and catalogs: AMI, APP, TYA, WAT
Alexander et aq en 1950 TYA: 90
Apocalypse en et sf 152 WAT: 193
Cathedral et en 1958 WAT: 196
Germination aq et en sn (co) 1951-52 AMI: clp**8** WAT: 194
Poppies of Csobanka I re-et en (co) 1977 APP: clp**13**
Time of the Beast et en 1964 TYA: 91
Vertical Rocks et en aq 1959 APP: 99

PETERSON, ROBERT BAARD 1943-
Biographical dictionaries: WAA 73, 76
Art books and catalogs: AAP, PNM
May 1980 et ce hp 1982 AAP: 97
Shop Towel over Block co-li (co) 1983 PNM: 133

PETTET, WILLIAM 1942-
Biographical dictionaries: 76, 78, 80, 82, 84, 86, 89-90, 91-92

Art books and catalogs: LAP
Untitled co-li (co) 1970 LAP: 82/106

PFAFF, JUDY 1946-
Biographical dictionaries: WAA 86, 89-90, 91-92, 93-94, 95-96, 97-98
Artbooks and catalogs: AGM, PAP, PWP, PRO
Las Margaritas wo (co) 1987 PWP: clp94/116
Manzanas y Naranjas (from series Six of One...) co-wo (co) 1987-88 PRO: clp61
Melón (from series Six of One...) co-wo ch (co) 1987-88 PRO: clp62
Yoyogi [State I] wb (co) 1985 PAP: 102
Yoyogi II wo (co) 1985 AGM: 127

PFANSCHMIDT, M.J. 1954-
Biographical dictionaries:
Art books and catalogs: PNW
Bamboo Cage mz 1991 PNW: 136
Heart House mz 1996 PNW: 137
Turning mz (co) 1994 PNW: 135

PHELAN, ELLEN DENISE 1943-
Biographical dictionaries: WAA 84, 86, 89-90, 91-92, 93-94, 95-96, 97-98
Artbooks and catalogs: PWP
Untitled mo (co) 1990 PWP: clp57/116

PHILLIPS, JAY 1954-87
Biographical dictionaries:
Art books and catalogs: AAP, PAP, PNM
Descent of Discord co-li (co) 1984 PNM: clp14
Landscape IV mp li mo 1984 PAP: 103
Melrose sc 1981 AAP: 98

PHILLIPS, MATT 1927-
Biographical dictionaries: WAA 73, 76, 78, 80, 82, 84, 86, 89-90, 91-92, 93-94, 95-96, 97-98
Art books and catalogs: CAM, SIM

Among the Waves co-mo (co) 1971 SIM: **160**
Figures with Golden Bowl mo (co) 1983 CAM: 25/46
Large Reader #2 co-mo (co) 1983 SIM: **179**
Serenade co-mo hd (co) 1965 SIM: **159**

PHILLIPS, TOM 1937-
Biographical dictionaries:
Art books and catalogs: TWO
Birth of Art (*ten etchings*) et 1973 TWO: 85

PIENE, OTTO 1928-
Biographical dictionaries: WAA 70, 78, 80, 82, 84, 86, 89-90,
91-92, 93-94, 95-96, 97-98
Art books and catalogs: AMI
Sky Art [*plate from portfolio*] co-li (co) 1969 AMI: clp120

PIERCE, DANNY PARCEL 1920-
Biographical dictionaries: WAA 56, 62, 66, 70, 76, 78, 80, 82,
84, 86, 89-90, 91-92, 93-94, 95-96, 97-98
Art books and catalogs: ACW
In the Fields wo (co) 1954 ACW: **60**, 117

PINDELL, HOWARDENA DOREEN 1943-
Biographical dictionaries: WAA 73, 76, 78, 80, 82, 84, 86, 89-
90, 91-92, 93-94, 95-96, 97-98
Artbooks and catalogs: AGM, PRO
Art Crow/Jim Crow bk pe lp 1988 PRO: clp63
Kyoto: Positive/Negative et li dy-pa (co) 1980 AGM: **131**
Untitled li ch (co) 1976 AGM: **130**

PIPER, JOHN 1903-92
Biographical dictionaries:
Artbooks and catalogs:
See also:
Levinson, Orde, ed.. *John Piper:The Complete Graphic Works: A*
Catalogue Raisonné 1923-1983: Etchings and Aquatints,
Wood Engravings, Lithographs and Screenprints. London;
Boston: Faber and Faber, 1987.

PLETKA, PAUL 1946-
Biographical dictionaries: WAA 82, 84, 86, 89-90, 91-92, 93-94, 95-96, 97-98
Art books and catalogs: PNM
Raven co-li (co) 1979 PNM: 90

PLOTKIN, LINDA 1938-
Biographical dictionaries: WAA 86, 89-90, 91-92, 93-94, 95-96, 97-98
Art books and catalogs: AWP, ESS, PWP, TYA, WAT
Blue House in 1975 WAT: 303
Intersection li li-cy tu 1975 AWP: [18]
Morning Light in 1976 ESS: [23] TYA: 91
Still Life with Tangerine hc-in (co) 1982 PWP: clp53/116

POGANY, MIKLOS 1945-
Biographical dictionaries: WAA 89-90, 91-92, 93-94, 95-96, 97-98
Art books and catalogs: AAP, CAM
Klarika [February] mo mx 1983-84 CAM: 17/47
Requiem for the Fisherman (O) mo tl ac ge wx oi wc (co) 1983 AAP: 99

POGUE, STEPHANIE ELAINE 1944-
Biographical dictionaries: WAA 78, 80, 82
Artbooks and catalogs: BAG
Arabesque et 1977 BAG: 34

POKORNY, EVA 1949-
Biographical dictionaries:
Art books and catalogs: NPE
In the Ravine mo (co) 1978 NPE: **14**, 131
My Life mo (co) 1978 NPE: **14**

POLLOCK, JACKSON 1912-56
Biographical dictionaries: WAA 40-47, 53
Artbooks and catalogs: AMI, APP, TPI
Untitled 1 en dr 1944 AMI: clp2
Untitled 4 en dr 1945 AMI: clp3 TPI: 15

Untitled, No. 5 (*from series of 7*) en 1944-45 APP: 74

POMODORO, GIO 1930-
Biographical dictionaries:
Art books and catalogs: THL
Black Seal li 1967 THL: 28

PONCE DE LEON, MICHAEL 1922-
Biographical dictionaries: WAA 56, 59, 62, 66, 70, 73, 76, 78,
80, 82, 84, 86, 89-90, 91-92, 93-94, 95-96, 97-98
Art books and catalogs: APP, ENP, ESS, WAT
Man is the Measure of All Things ce-in 1972 ESS: [25]
Omen co-bsf (co) 1963 WAT: **276**
Recycling of Gran'ma to-ce-in cs 1972 ENP: *abc*
Succubus cs ce (co) 1967 APP: clp**9**

POND, CLAYTON 1941-
Biographical dictionaries: WAA 73, 76, 78, 80, 82, 84, 86, 89-
90, 91-92, 93-94, 95-96, 97-98
Art books and catalogs: APP, WAT
Doubledoozium cum Skinnionic et Scrawlium (*from series
Capital Ideas*) sc (co) 1974 APP: clp**27**
Kitchen in My Studio on Broome Street co-sk (co) 1971 WAT:
212

PORTER, FAIRFIELD 1907-75
Biographical dictionaries: WAA 70, 73
Artbooks and catalogs: AGM, PAC
Isle au Haut li 1975 AGM: 16
Table li 1971 PAC: [44]/88
See also:
Ludman, Joan. *Fairfield Porter: A Catalogue Raisonné of his
Prints.* Westbury, N.J.: Abrams, 1981.

POSTER, MADELINE 1948-
Biographical dictionaries:
Art books and catalogs: NPE
Festival of San Gennaro—Mulberry St. hg 1978 NPE: 133
Rockefeller Center sk (co) 1976 NPE: 132

POWELL, RICHARD J. 1953-
Biographical dictionaries:
Art books and catalogs: RBW
Richard Wright Series #7: Cerebrus et 1976 RBW: [20]

POZZATTI, RUDY OTTO 1925-
Biographical dictionaries: WAA 53, 56, 59, 62, 66, 70, 73, 76,
 78, 80, 82, 84, 86, 89-90, 91-92, 93-94, 95-96, 97-98
Art books and catalogs: ACW, ESS, TYA, WAT
Cosmorama co-li (co) 1976 ESS: [28]
Etruscan Lady li 1963 TYA: 91
Grasshopper wo 1954 WAT: 198
Venetian Domes en 1955 WAT: 215
Venetian Sun co-wo (co) 1954 ACW: **56**, 115

POZZI, LUCIO 1935-
Biographical dictionaries: WAA 78, 80, 82, 84, 86, 89-90, 91-
 92, 93-94, 95-96, 97-98
Art books and catalogs: RBW
Diddles et 1983 RBW: [20]

PRATT, CHRISTOPHER
Biographical dictionaries:
Art books and catalogs:
See also:
Scott, Jay. *The Prints of Christopher Pratt, 1958-1991: Catalogue
 Raisonné*. St. John's, Newfoundland: Breakwater Books, in
 association with Mira Godard Gallery, c.1991.

PRENTICE, MARGARET HAUGH 1944-
Biographical dictionaries:
Art books and catalogs: CUN, GAR, PNW
Another Flying Dream wo hm (co) 1992 PNW: 141
Constructing Layers of Time I, II, III et hm co-pu tp (co) 1990
 CUN: **110**
Implications of Sound I in hm dp (co) 1985 GAR: 45
Implications of Sound II in hm (co) 1985 GAR: 45
Kozo wo hm (co) 1995 PNW: **139**
Never Say Never et hm co-pu (co) 1989 CUN: 144

Primal Time I, II, III et hm co-pu tp (co) 1991 CUN: **110-11**
PNW: 140
Waiting in the Garden wo hm co-pu (co) 1989 CUN: 143

PRICE, GORDON 1944-
Biographical dictionaries:
Art books and catalogs: TYA
Table sk 1975 TYA: 92

PRICE, KEN(NETH) 1935-
Biographical dictionaries: WAA 70, 73, 76, 78, 80, 82, 84, 86,
89-90, 91-92, 93-94, 95-96, 97-98
Art books and catalogs: ENP, LAP, PNM, THL, TYA
Coffee Shop at the Chicago Art Institute sk 1971 ENP: *abc*
Figurine Cup VI li sk 1970 TYA: 92
Japanese Tree Frog Cup co-li (co) 1968 THL: **53**
Lizard Cup sk 1971 LAP: 88/107
Untitled co-li (co) 1977 PNM: clp**8**

PRINCE, RICHARD EDMUND 1949-
Biographical dictionaries: WAA 76, 78, 80, 82, 84, 86, 89-90,
91-92, 93-94, 95-96, 97-98
Art books and catalogs: TYA
Post Studio Artist mx 1976 TYA: 92
Property Owner mx 1976 TYA: 93

PROCHASKA, TOM 1945-
Biographical dictionaries:
Art books and catalogs: PNW
Den Armen Duval et sl-aq 1995 PNW: 144
Maybe et sl-aq 1996 PNW: 145
Oh Yes et (co) 1995 PNW: **143**

PROERSCH, GILBERT 1943-
Biographical dictionaries:
Art books and catalogs: TWO
Dark Shadows (*in collaboration with George Passmore*) pf 1976
TWO: 98

PROVISOR, JANIS 1946-
 Biographical dictionaries: WAA 93-94, 95-96, 97-98
 Artbooks and catalogs: PWP
 About Face li re tp (co) 1989 PWP: clp39/116

PUSEY, MAVIS 1931-
 Biographical dictionaries: WAA 76, 78, 80, 82, 84, 86, 89-90
 Art books and catalogs: RBW
 Operation et 1973 RBW: [21]

QUAYTMAN, HARVEY 1937-
 Biographical dictionaries: WAA 70, 73, 76, 78, 80, 82, 84, 86,
 89-90, 91-92, 93-94, 95-96, 97-98
 Art books and catalogs: CMZ
 Untitled mz en ch 1977 CMZ: [58]/42

RABEL, KATHLEEN J. 1943-
 Biographical dictionaries:
 Art books and catalogs: AAP, PAP, PNW, TYA
 Dobro re hc (co) 1976 TYA: 93
 Fata Morgana [Blue Sky] et aq dr 1983 AAP: 100
 Fata Morgana [Sky River] lg sf aq sb hc (co) 1985 PAP: 104
 São Tomé et wb ku (co) 1996 PNW: **147**
 Santuário para Toda ku 1995 PNW: 149
 School Crossing et aq 1995 PNW: 148
 Trinity in 1975 TYA: 93

RABKIN, LEO 1919-
 Biographical dictionaries: WAA 66, 70, 73, 76, 78, 80, 82, 84,
 86, 89-90, 91-92, 93-94, 95-96, 97-98
 Art books and catalogs: ENP
 Thumbprint Print td-rs ac 1971 ENP: *abc*

RAETZ, MARKUS 1941-
 Biographical dictionaries:
 Art books and catalogs: TWO
 Untitled (*plate from untitled portfolio*) aq 1977 TWO: 118

RAFFAEL, JOSEPH 1933-
Biographical dictionaries: WAA 70, 73, 76, 78, 80, 82, 84, 86, 89-90, 91-92, 93-94, 95-96, 97-98
Art books and catalogs: AAP, CAM
Flow and Snow mo 1981 AAP: 101
Shaba III mo 1984 CAM: 41/47

RAINER, ARNULF 1929-
Biographical dictionaries:
Art books and catalogs: TWO
Self-Portrait pv et dr c.1975 TWO: 68

RAMBERG, CHRISTINA (HANSON) 1946-
Biographical dictionaries: WAA 73, 76, 78, 80, 82, 84, 86, 89-90, 91-92, 93-94, 95-96, 97-98
Art books and catalogs: CHI
Altar [Female Altar] et aq 1968 CHI: 128
Altar-Face et 1968 CHI: 128
Back to Back et dp 1973 CHI: 131
Bound Heads I et 1973 CHI: 129
Bound Heads II et 1973 CHI: 129
False Image (*poster/invitation for 1^{st} "False Image" group exhibition*) of-li ds 1968 CHI: 204
False Image (*price list for 1^{st} "False Image" group exhibition*) of-li 1968 CHI: 206
False Image (*price list for 2^{nd} "False Image" group exhibition*) of-li 1969 CHI: 207
False Image II (*based on exquisite corpse by Roger Brown, Eleanor Dube, Philip Hanson, and Christina Ramberg*) co-of-li (co) 1969 CHI: 206
False Image Decals (*created by Roger Brown, Eleanor Dube, Philip Hanson, and Christina Ramberg*) co-sk pp (co) 1969 CHI: **36**, 207
False Image Postcards (*created by Roger Brown, Eleanor Dube, Philip Hanson, and Christina Ramberg*) co-of-li (co) 1968 CHI: 204-5
Flying en masse from Goldblatts et 1967 CHI: 127
Flying from Goldblatts [*2 States*] et aq (co) 1967 CHI: 127
Head co-sk (co) 1969-70 CHI: **29**,129
Heads et 1973 CHI: 130

Heads I et 1968 CHI: 129
Heads II et 1968 CHI: 129
Imaginary Landscape [Smoking City] et aq 1967 CHI: 127
Untitled et 1967 CHI: 127
Untitled et 1968 CHI: 128
Veiled Person et aq 1968 CHI: 128

RAMOS, MEL(VIN JOHN) 1935-
Biographical dictionaries: WAA 73, 76, 78, 80, 82, 84, 86, 89-
90, 91-92, 93-94, 95-96, 97-98
Art books and catalogs: AKG, TPI
A. C. Annic li 1971 AKG: clp80
Miss Comfort Crème (*from* 11 Pop Artists, Volume III) co-sc (co)
1965 TPI: **57**

RANDALL, NANCY 1928-
Biographical dictionaries:
Art books and catalogs: AAP
I Knew a Phoenix mo 1982 AAP: 102

RAPP, RAYMOND 1948-
Biographical dictionaries:
Art books and catalogs: AAP
Black Line wo ch 1981 AAP: 103

RASMUSSEN, KEITH ERIC 1942-
Biographical dictionaries: WAA 78, 80, 82, 84, 86, 89-90
Art books and catalogs: GAP, TYA
Greyfield Ghosts li 1985 GAP: 26/31
House—Savannah Beach li 1975 TYA: 94

RATHBUN, R. KEANEY 1957-
Biographical dictionaries:
Art books and catalogs: PNW
Leap of Faith sc 1994 PNW: 153
Living in Deliberate Optimism sc (co) 1996 PNW: **151**
Opportunity and Distraction sc 1992 PNW: 152

RAUSCHENBERG, ROBERT 1925-
Biographical dictionaries: WAA 66, 70, 73, 76, 78, 80, 82, 84,

86, 89-90, 91-92, 93-94, 95-96, 97-98

Art books and catalogs: AAP, AGM, AKG, AMI, AMP, APB, APP, APR, APS, BWS, FIM, GMC, PAC, PAP, PIA, PPP, SMP, TCA, TGX, TPI, TWO, TYA, WAT

Abby's Bird li (co) 1962 APS: clp9 FIM: **43**

Accident li 1963 AMI: clp50 APS: clp10 PIA: 76, **131**/112 PPP: 56 TPI: 94

Bait (*from* Stoned Moon Series) li (co) 1970 AMP: 101

Banner co-li (co) 1969 APS: clp**42**

Bellini #1 co-pv (co) 1986 APR: **fcv**/[15]

Bellini #4 pe aq et (co) 1988 SMP: **54**

Bellini #5 pe aq et (co) 1989 SMP: **55**

Booster (from *series Booster and 7 Studies*) co-li sk (co) 1967 AMI: clp**52** PIA: **139**/114 TGX: **16** TPI: **58** WAT: 238

Breakthrough I li 1964 TYA: 94

Breakthrough II co-li (co) 1965 WAT: 237

Cardbird, II sk td (co) 1979 WAT: **205**

Centennial Certificate M.M.A. li (co) 1969 TCA: **[44]**

Crocus oi sk ca 1962 TWO:10

Drizzle co-li em (co) 1967 APS: clp44

Estate oi ik ca 1963 AGM: 12

Front-Roll co-li (co) 1964 APP: 184 APS: clp13 PAC: [45]/88 TPI: 95

Gamble co-li em (co) 1968 APS: clp46

Hot Shot li (co) 1983 AAP: **fpc**, 104

Kip-Up li 1964 APS: clp12

Landmark co-li (co) 1968 AKG: clp46

LAW I co-li (co) 1965 AKG: clp45

Link hm eb-sc-ts 1974 TGX: 205

Mark li 1964 TPI: 95

Merger li 1962 FIM: 44

Noname [Elephant] (*from portfolio* For Meyer Schapiro) vn-tf em hp-ge ce 1973 GMC: 68

Passport (*from* Ten from Leo Castelli) co-sc px (co) 1967 TPI: 95

Platter re in fa 1974 TYA: 94

Pledge co-li (co) 1968 APS: clp**43**

Post Rally li 1965 BWS: 20/31

Preview (*from series* Hoarfrost) tf ce fa (co) 1974 TWO: 105

Shades li px 1964 AMI: clp51 WAT: 236

Shadow Play co-sc (co) 1967 TPI: **59**

Signs co-sk (co) 1970 TPI: **59** TWO: 45

Sky Garden co-li co-sk (co) 1969 AMI: clp**122** APS: clp**41**

Sling-Shots Lit #8 ag li sc my fa (co) 1984 PAP: **18**, 105

Soviet/American Array I pe ce (co) 1988-89 SMP: **56**

Soviet/American Array II pe et ce (co) 1988-90 SMP: **57**

Soviet/American Array III pe (co) 1989-90 SMP: **57**

Spot li 1964 APB: clp*118*/44-45 APS: clp11

Tampa 10 li 1973 TYA: 95

Tanya li 1974 PPP: 59

Test Stone #7 li 1967 AMP: 99

Treaty li dp 1974 TYA: 95

Trilogy from the Bellini Series mp pe aq et tp (co) 1987 SMP: **52-53**

See also:

Foster, Edward A. *Robert Rauschenberg: Prints 1948/1970* (exhibition catalog). Minneapolis: The Minneapolis Institute of Arts, 1970.

RAY, MAN [EMANUEL RABINOVITCH] 1890-1976
 Biographical dictionaries:
 Art books and catalogs: AML
 Le Roman Noir co-li (co) 1948 AML: **186**

RAYBERRY© 1952-
 Biographical dictionaries:
 Art books and catalogs: PAP
 Life's Comet mz 1985 PAP: 106

RAYO, OMAR 1928-
 Biographical dictionaries:
 Art books and catalogs: APP
 Last Night in Marienbad in-em 1963 APP: 157

REDDY, KRISTINA (KRISHNA NARAYANA) 1925-
 Biographical dictionaries: WAA 78, 80, 82, 84, 86, 89-90, 91-92, 93-94, 95-96, 97-98
 Art books and catalogs: APP, RBW
 Appu et RBW: [21]

Sun Awakens en et 1978 APP: 233

REDER, BERNARD 1897-1963
Biographical dictionaries: WAA 53, 56, 62
Art books and catalogs: APP
Lady with Veil wo mo 1957 APP: 124

REED, DOEL 1894-1985
Biographical dictionaries: WAA 36-37, 40-41, 40-47, 53, 56, 59, 62, 66, 70, 73, 76, 78, 80, 82, 84
Art books and catalogs: PNM
Adobe and Wild Plum et aq 1965 PNM: 67

REEDER, DICKSON 1912-70
Biographical dictionaries: WAA 40-41
Art books and catalogs: FWC
Abstract Keyhole et sf 1945 FWC: 36
Eidelon et aq (co) c.1960 FWC: **35**
Eryngo en db (co) 1960 FWC: **34**
Mazy en sf 1937 FWC: 33
Mysterious Pool et sf aq en c.1945 FWC: 36

REEDER, FLORA BLANC 1917-
Biographical dictionaries: WAA 56
Art books and catalogs: FWC
Dragon and Saint George en sf 1937 FWC: 37
Primordial et en c.1960 FWC: 37
Variations en sf aq (co) 1960 FWC: **38**

REEDS, SCOTT 1953-
Biographical dictionaries:
Artbooks and catalogs: NPE
End of the Reel aq dr ou 1977 NPE: 134
Side Arm aq dr ou 1978 NPE: 135

REICHEK, JESSE 1916-
Biographical dictionaries: WAA 66, 70, 73, 76, 78, 80, 82, 84, 86, 89-90, 91-92, 93-94, 95-96, 97-98
Art books and catalogs: THL

Untitled co-li (co) 1966 THL: 38

REINHARDT, AD 1913-67
Biographical dictionaries:
Art books and catalogs: AMI
10 Screenprints by Ad Reinhardt [*plate*] sk 1966 AMI: clp80

RENDA, MOLLY 1953-
Biographical dictionaries:
Art books and catalogs: RBW
Untitled mo 1983 RBW: [21]

RESNICK, MINNA 1946-
Biographical dictionaries:
Art books and catalogs: NPE
Entrance co-li (co) 1977 NPE: 137
Stage Spirits II co-li (co) 1978 NPE: 138

RHEINGOLD, LOIS OLIAN 1943-
Biographical dictionaries:
Art books and catalogs: ENP
Country Road sc 1972 ENP: *abc*

RICE, ANTHONY HOPKINS 1948-
Biographical dictionaries: WAA 76, 78, 80, 82, 84, 86, 89-90,
 91-92, 93-94, 95-96, 97-98
Art books and catalogs: PAP
Untitled mo (co) 1985 PAP: 106

RICH, JUDITH 1944-
Biographical dictionaries:
Art books and catalogs: ENP
Woman I li ENP: *abc*

RICHARDSON, SAM 1934-
Biographical dictionaries: WAA 73, 76, 78, 80, 82, 84, 86, 89-
 90, 91-92, 93-94, 95-96, 97-98
Art books and catalogs: ACW
Through the Greened Into rp ch ce hd (co) 1988 ACW: 77, 125

RICHTER, GERHARD 1932-
Biographical dictionaries:
Art books and catalogs: TPI, TWO
Canary Islands Landscape [*plate 4*] pn aq 1970-71 TWO: 99
Elisabeth II co-of-li (co) 1966 TPI: **61**
Hund co-sc (co) 1965 TPI: 96

RIFKA, JUDY 1945-
Biographical dictionaries:
Art books and catalogs: AAP, PWP
Portrait of Dracula cu-li ce 1982 AAP: 105
Still Life wo 1986 PWP: clp43/116

RILEY, BRIDGET 1931-
Biographical dictionaries:
Art books and catalogs: TWO
Print A (*from* 19 Greys) sk 1968 TWO: 51

RINGGOLD, FAITH WALLACE 1934-
Biographical dictionaries: WAA 76, 78, 80, 82, 84, 86, 89-90,
 91-92, 93-94, 95-96, 97-98
Artbooks and catalogs: PWP
Woman, Power, Poverty, and Love et ca 1985 PWP: clp**83**/116

RIISABURO, KIMURA 1924-
Biographical dictionaries: WAA 78, 80, 82, 84, 86, 89-90, 91-
 92, 93-94, 95-96, 97-98
Art books and catalogs: ENP
City No. 115 sk 1971 ENP: *abc*

RIST, LUIGI (LOUIS G.) 1888-1959
Biographical dictionaries: WAA 40-47, 56
Artbooks and catalogs:
See also:
Williams, Reba. *The Prints of Luigi Rist.* United States: R. & D.
 Williams, 1994.

RITCHIE, BILL (WILLIAM H.), JR. 1941-
Biographical dictionaries: WAA 78, 80, 82, 84, 86, 89-90, 91-

92, 93-94, 95-96, 97-98
Art books and catalogs: PNW, TYA
Bridge's Heart et li re 1974 TYA: 95
Canceled Artist's Last Love Letter mx (co) 1996 PNW: **155**
Locus and Sea Squares mx 1981-82 PNW: 157
My Father's Farm from the Moon et re 1976 TYA: 96
Video Target Heart co-li (co) 1972 PNW: 156

RIVERS, LARRY 1925-
 Biographical dictionaries: WAA 62, 66, 70, 73, 76, 78, 80, 82,
 84, 86, 89-90, 91-92, 93-94, 95-96, 97-98
 Art books and catalogs: AKG, AMI, APP, BWS, FIM, PAC,
 PIA, PPP, TPI, WAT
 15 Years (poster) (*working proofs*) li ce cr ac hd cy (co) 1965-66
 PPP: 148, **149-50**
 15 Years (poster) (*working proofs*) li tl ce (co) 1965 PPP: **146**
 15 Years (poster) li (co) 1965 PPP: **147**
 Bird and the Circle [*State IV*] li 1957 FIM: **24**
 Diane Raised III li 1970-71 APP: 187
 Double French Money (*from* Four on Plexiglas) co-sc px ce (co)
 1965 TPI: 96
 Elephants co-sc px al-bx (co) 1970 TPI: 97
 Ford Chassis I li 1961 BWS: 18/31
 Jack of Spades li (co) 1960 PIA: **125**/112
 Last Civil War Veteran sk ce 1970 AKG: clp82
 Last Civil War Veteran I li 1961 AMI: clp35
 Lucky Strike II co-li (co) 1960-63 TPI: 96
 Stones [*plate E12*] (*from suite of 12*) li 1957-59 WAT: 230
 Swimmer A, B, C, and D ce sc px 1970 TPI: 96
 US (*with Frank O'Hara, from the book* Stones) li bk 1957-59
 FIM: **23** PAC: [46]/88

RIZZI, JAMES 1950-
 Biographical dictionaries: WAA 93-94, 95-96, 97-98
 Art books and catalogs: TYA
 It's So Hard to Be a Saint When You're Living in the City et hc
 (co) 1976 TYA: 96

RIZZIE, DAN (DURANT CHARLES) 1951-
Biographical dictionaries: WAA 80, 82, 84, 86, 89-90, 91-92, 93-94, 95-96, 97-98
Art books and catalogs: AAP, FTP, GAR, INN
Red Cross li ch mx (co) 1988 INN: **19**
Untitled mo (co) 1990 FTP: **61**
Untitled mo ch (co) 1985 GAR: **43**
Where the Ceiling Meets the Floor et dr sb ch (co) 1982 AAP: **32**, 106

ROBBINS, JACK C.
Biographical dictionaries: WAA 97-98
Art books and catalogs: FTP
Firehouse mo (co) 1989 FTP: **63**

ROBERTSON, BARBARA 1952-
Biographical dictionaries:
Art books and catalogs: PNW
Double mx-wb cg et (co) 1996 PNW: **159**
Miao et cg wb xt 1996 PNW: 161
Vessel Series #7 (*collaboration with sculptor Paul Martinez*) in ch xt 1995 PNW: 160

ROCCA, SUELLEN 1943-
Biographical dictionaries:
Art books and catalogs: CHI
All Santas et 1964 CHI: 148
Bam-Wer li 1963-64 CHI: 142
Bare Shouldered Beauty [*6 States*] et dr aq 1967 CHI: 150
Birth mz dr c.1963 CHI: 141
Curly Lamp dr aq 1968 CHI: 151
da Hairy Who Kamic Kamie Page (*comic strip page by James Falconer, Art Green, Gladys Nilsson, Jim Nutt, Suellen Rocca, and Karl Wirsum*) of-li 1967 CHI: 200
Dat-Dot Game et 1965 CHI: 148
Dis is THE Catalog (*catalog/checklist/price list by James Falconer, Art Green, Gladys Nilsson, Jim Nutt, Suellen Rocca, and Karl Wirsum*) of-li 1969 CHI: 203
Extra Color [*2 States*] et aq dr 1964 CHI: 146

Flower dr c.1963 CHI: 141

Flower Bird [*4 States*] et aq dr c.1963 CHI: 141

Flower-Rewolf [*4 States*] et dr aq 1962 CHI: 139

Flower-Wer li 1963-64 CHI: 143

Flow-Wer li 1963-64 CHI: 143

Foot Tree [*4 States*] dr 1964 CHI: 147

Goat Leaf [*2 States*] et dr c.1963 CHI: 140

Hairy Who (*comic book by James Falconer, Art Green, Gladys Nilsson, Jim Nutt, Suellen Rocca, and Karl Wirsum*) co-of-li (co) 1968 CHI: 199-200

Hairy Who (*poster for 1st "Hairy Who" group exhibition*) of-li 1966 CHI: 194

Hairy Who (*poster for 2nd "Hairy Who" group exhibition*) of-li 1967 CHI: **35**, 196

Hairy Who (cat-a-log) (*comic book by James Falconer, Art Green, Gladys Nilsson, Jim Nutt, Suellen Rocca, and Karl Wirsum*) co-of-li (co) 1968 CHI: **35**, 201-2

Hairy Who Sideshow (*comic book by James Falconer, Art Green, Gladys Nilsson, Jim Nutt, Suellen Rocca, and Karl Wirsum*) co-of-li (co) 1967 CHI: 196-98

Heart Head [*2 States*] dr 1963 CHI: 141

Hello-Flower-Tongue li 1963-64 CHI: 142

Help-Gun li 1963-64 CHI: 142

Here-Ho-Wer li 1963-64 CHI: 143

House Watching dr ou (co) c.1963 CHI: 140

Late Bloomer et (1966 *or* 1967) CHI: 148

Monkey and Flower [*6 States*] dr (co) 1963-64 CHI: **30**,145

Monkey-Wer li 1963-64 CHI: 143

Mountain and Ring dr 1963-64 CHI: 144

Nine Palm Trees dr (co) 1963-64 CHI: 144

Now-Wer [*2 States*] li 1963-64: CHI: 143

Palm Tree dr mz 1963-64 CHI: 144

Portable Hairy Who! (*comic book by James Falconer, Art Green, Gladys Nilsson, Jim Nutt, Suellen Rocca, and Karl Wirsum*) bk co-of-li (co) 1966 CHI: 194-95

Ring and Palm Tree dr mz 1963-64 CHI: 144

Ring Girl et c.1966 CHI: 148

Rings [*2 States*] et dr c.1966 CHI: **31**,149

Santa Diamond [*4 States*] dr 1963-64 CHI: 146

Secret Origins et 1966-67 CHI: 148

Wiglet et 1967 CHI: 151

ROCKBURNE, DOROTHEA GRACE 1934-
Biographical dictionaries: WAA 73, 76, 78, 80, 82, 84, 86, 89-
90, 91-92, 93-94, 95-96, 97-98
Artbooks and catalogs: AGM, AMI
Locus No. 1 sf aq fd-pa (co) 1972 AGM: **134**
Locus No. 4 sf aq fd-pa (co) 1972 AGM: **135**
Locus Series [*plate*] aq re-et 1972-75 AMI: clp96
Melencolia li vm ds (co) 1983 AGM: **137**
Radiance li vm ds (co) 1983 AGM: **136**

ROCKMAN, ALEXIS 1962-
Biographical dictionaries:
Art books and catalogs: INP, PIA
Macrocosmos aq sb sl wc-hc (co) 1990 INP: 13
Untitled [Squirrel & Amaryllis] mo (co) 1990 PIA: **218**/123

RODRIGUEZ, JOSE 1959-
Biographical dictionaries:
Art books and catalogs: PNM
Sagrado Corazon et dr 1988 PNM: 107

ROMANO, CLARE CAMILLE (ROSS) 1922-
Biographical dictionaries: WAA 59, 62, 66, 70, 73, 76, 78, 80,
82, 84, 86, 89-90, 91-92, 93-94, 95-96, 97-98
Art books and catalogs: AWP, CUN, TYA, WAT
Big Falls wo cg dp (co) 1986 CUN: **111**
Deep Falls cg 1978 CUN: 149
Figure and Hills cg in rp-ce cd pa ac-ge 1974 AWP: [19]
Mammoth Falls cg mp dp (co) 1990 CUN: **112**
Night Canyon cg 1976 CUN: 147
River Canyon cg 1976 TYA: 96
Silver Canyon cg 1977 WAT: 303

ROMERO, MIKE 1950-
Biographical dictionaries: WAA 76, 78, 80
Art books and catalogs: PNM
Mirror of Life Past et 1973 PNM: 111

ROSAS, MEL 1950-
Biograhical dictionaries: WAA 82, 84, 86, 89-90, 91-92, 93-94, 95-96, 97-98
Artbooks and catalogs: CIP
Vanity li 1981 CIP: **57**

ROSE, MARY ANNE 1949-
Biographical dictionaries: WAA 78, 80, 82, 84, 86, 89-90, 91-92, 93-94, 95-96, 97-98
Art books and catalogs: RBW
Untitled et 1984 RBW: [22]

ROSEN, CAROL M. 1933-
Biographical dictionaries: WAA 91-92, 93-94, 95-96, 97-98
Art books and catalogs: ENP
Recycled Image cs ce 1972 ENP: *abc*

ROSENBURG, ANDREA 1948-
Biographical dictionaries:
Art books and catalogs: FTP
Untitled mo (co) 1989 FTP: **65**

ROSENQUIST, JAMES 1933-
Biographical dictionaries: WAA 66, 78, 80, 82, 84, 86, 89-90, 91-92, 93-94, 95-96, 97-98
Art books and catalogs: AKG, AMI, AMP, APB, APM, APP, APS, FIM, PAP, PIA, PPP, SMP, TCA, TPI, TWO, TYA, WAT
Area Code co-li dp (co) 1969 TPI: **64**
Bunraku li 1970 APB: clp*120*/45-46 APM: 13/21
Campaign co-li (co) 1965 TPI: **63**
Caught One Lost One for the Fast Student [Star Catcher] (*from series* Welcome to the Water Planet) co-pd-pu ce-li (co) 1989 SMP: **62**
Certificate pn et 1962 FIM: **39**
Circles of Confusion I co-li (co) 1965-66 PPP: **157** TPI: **65**
Circles of Confusion I [*working proof*] li ce (co) 1966 PPP: **154**
Circles of Confusion I [*working proof*] li ck 1966 PPP: 155

Circles of Confusion I [*working proof*] li hd (co) 1966 PPP: **153**

Cold Light co-li (co) 1971 TYA: 97 WAT: **211**

Dusting Off Roses co-li (co) 1965 APS: clp40 TPI: 97

Electrical Nymphs on a Non-Objective Ground li lm-pt 1984 PAP:
 108

Expo 67 Mural—Firepole 33' x 17' co-li (co) 1967 APS: clp**39**
 TPI: **64**

Flamingo Capsule li sk (co) 1973-74 AMI: clp**58** TYA: 97

Flowers and Females mp-li (co) 1986 SMP: **60**

For Love (*from* 11 Pop Artists, Volume 3) co-sk (co) 1965 AKG:
 clp48

Horse Blinders li (co) 1968 TCA: **[42]**

Horse Blinders (East) sk li ce (co) 1972 TWO: **343**

Iris Lake li (co) 1974 TYA: **99**

New Oxy (*from* 1¢ Life) co-li (co) 1964 TPI: 97

Night Smoke li 1969-70 TYA: 100

Off the Continental Divide li (co) 1973-74 APP: 178 PIA:
 158/116 PPP: **160-61**

Off the Continental Divide [*study*] ik cy ck hd 1973 PPP: 158-59

Roll Down co-li (co) 1964-66 TPI: 97

See-Saw, Class Systems co-li (co) 1968 TPI: **65**

Shriek mp-li (co) 1986 SMP: **58**

Sight Seeing co-li (co) 1972 AMP: 111/100

Sister Shrieks mp-li (co) 1987 SMP: **59**

Space Dust (*from series* Welcome to the Water Planet) co-pd-pu
 ce-li (co) 1989 SMP: **63**

Spaghetti co-li (co) 1970 TPI: 98

Spaghetti and Grass co-li (co) 1964-65 AMI: clp**57** TPI: **17** TYA:
 100

Welcome to the Water Planet aq 1987 SMP: **61**

Where the Water Goes (*from series* Welcome to the Water Planet)
 co-pd-pu li ce (co) 1989 SMP: **64**

ROSOFSKY, SEYMOUR 1924-81

 Biographical dictionaries: WAA 70, 73, 76, 78, 80

 Art books and catalogs: THL

 Untitled II (*from portfolio* The Good Burgers of Lunidam) li 1968
 THL: 45

ROSS, RICHARD H. 1947-
Biographical dictionaries:
Art books and catalogs: TYA
Printed Painter's Palette sk 1976 TYA: 100

ROSSI, BARBARA 1940-
Biographical dictionaries: WAA 73, 76, 78, 80, 82, 84, 86, 89-
90, 91-92, 93-94, 95-96, 97-98
Art books and catalogs: CHI
Armour Defeat [2 *States*] co-et (co) 1969 CHI: 158
Circle Plate [2 *States*] et sf aq 1968-70 CHI: 157
Couple [4 *States*] et aq 1968 CHI: 156
Eye Deal co-li (co) 1973-74 CHI: 171
Eye Deal li ch (co) 1973 CHI: 171
Footnotes on Portraiture [2 *States*] pe tp 1970 CHI: 169
Footnotes on Portraiture [2 *States*] co-pe (co) 1971 CHI: 169
Footnotes on Portraiture [2 *States*] sk (co) 1971-72 CHI: 169
Footprint Picture li 1975 CHI: 172
Male of Sorrows #1 [2 *States*] co-et aq (co) 1970 CHI: 168
Male of Sorrows #3 co-et aq (co) 1972 CHI: **33**,170
Male of Sorrows #4 co-et aq (co) 1971 CHI: 170
Male of Sorrows #5 [2 *States*] co-et aq (co) 1970 CHI: 167
Male of Sorrows #6 sk 1970 CHI: 161
Male of Sorrows #6 [2 *States*] co-et aq (co) 1970 CHI: 163
Merry Model [2 *States*] co-et aq (co) 1969-70 CHI: 162
Pedestrian Rainbow Lady [2 *States*] co-et aq (co) 1969 CHI: 159
Poor Self Trait #1: Dog Girl co-et aq (co) 1970 CHI: **32**,164
Poor Self Trait #2: Shep co-et aq (co) 1970 CHI: 165
Poor Self Trait #3: Curls co-et aq (co) 1970 CHI: 166
Sky Dive et 1973 CHI: 170
Sovereign sk 1970 CHI: 161
Sovereign [2 *States*] co-et aq (co) 1969-70 CHI: 160
Summer 1972/Cloth Class of-li (co) 1972 CHI: 173
Tootle Too li ch (co) 1974 CHI: 172
Untitled co-sk (co) 1980-81 CHI: 173
Untitled et 1968 CHI: 154
Untitled [4 *States*] dr 1968 CHI: 154
Untitled [4 *States*] et aq 1968 CHI: 155
Untitled [5 *States*] et 1968 CHI: 154
Untitled [5 *States*] et aq 1968 CHI: 155

Untitled #1 et 1968 CHI: 156
Untitled #2 et hc-ac/wc (co) 1968 CHI: 156
Untitled #3 et 1968 CHI: 156
Z-Zone li 1975 CHI: 172

ROTH, DAVID 1942-

Biographical dictionaries: WAA 78, 80, 82, 84, 86, 89-90, 91-92, 93-94, 95-96, 97-98

Art books and catalogs: ENP

Metamorphosing of the Tones into Each Tone and the Metamorphosing of Its Return sk 1971 ENP: *abc*

ROTH, DIETER 1930-

Biographical dictionaries:

Art books and catalogs: TPI, TWO

Six Piccadillies [*four*] li sk (co) 1970 TWO: **36**

Six Piccadillies [*plate 4*] co-sc ds (co) 1969-70 TPI: **66**

ROTHENBERG, SUSAN 1945-

Biographical dictionaries: WAA 80, 82, 84, 86, 89-90, 91-92, 93-94, 95-96, 97-98

Art books and catalogs: AAP, ACW, AGM, AMI, APM, APR, FIM, IAI, PAP, PIA

Between the Eyes [*working proof*] co-li wo ce ck cr ik (co) 1984 APR: 3/[16]

Breath-man re in (co) 1986 AGM: **143**

Doubles wo 1980 AMI: clp145

Head and Bones wo 1980 AGM: **142**

Missing Corners M mp wo 1984 PAP: 109

Pinks hp-wo (co) 1980 ACW: **83**, 128 APM: 26/21 IAI: **47**

Puppet wo 1983 IAI: **50**

Untitled li 1983 AAP: 107

Untitled (*one of 18*) hc-li hd go cy tl (co) 1977 FIM: **16**, **99**

Untitled [May #1] ob sb hg bn 1979 AGM: **141**/114 IAI: **49** PIA: **170**

Untitled [May #2] sf sl aq sb sp bn 1979 AGM: **141** IAI: **49**

Untitled [May #4] sf sl sb (co) 1979 PIA: **171**/117

See also:

Maxwell, Rachel Robertson. *Susan Rothenberg, the Prints: A*

Catalogue Raisonné. Philadelphia: P. Maxwell, 1987.

ROWAN, DENNIS MICHAEL 1938-
Biographical dictionaries: WAA 73, 76, 78, 80, 82, 84, 86, 89-90, 91-92, 93-94, 95-96, 97-98
Art books and catalogs: APP, ENP
Encore in pn 1972 APP: 242 ENP: *abc*

ROYCE, RICHARD BENJAMIN 1941-
Biographical dictionaries: WAA 76, 78, 95-96, 97-98
Art books and catalogs: WAT
Glyph cs 1979 WAT: 309

RUBLE, RONALD L. 1935-
Biographical dictionaries: WAA 76, 78, 80, 82, 84
Art books and catalogs: NPE
Dying Rhino et 1978 NPE: 139
She Who Controls Dreams sc 1978 NPE: 140

RUSCHA, EDWARD JOSEPH 1937-
Biographical dictionaries: WAA 70, 73, 76, 78, 80, 82, 84, 86, 89-90, 91-92, 93-94, 95-96, 97-98
Art books and catalogs: AAP, AKG, AMI, APB, APM, APP, APS, ENP, FIM, INN, LAP, PIA, PRO, TCA, THL, TPI, TWO, TYA, WAT
1984 hc li (co) 1967 APS: clp57 TPI: 68
Big Dipper over Desert aq 1982 AAP: 108
Carp with Shadow and Fly co-li (co) 1969 THL: 52
Cheese Mold Standard with Olive co-sc (co) 1969 APS: clp**55**
TPI: **67**
Coyote li ar la 1986 INN: **17**
Eye co-li (co) 1969 AKG: clp49
Flies (*from portfolio* Insects) co-sk wd-ve lm (co) 1972 APM: 20
WAT: 281
Gas li 1962 FIM: 46
Hollywood co-sk (co) 1968 LAP: fcv, 75/105 TPI: 68
Hollywood sk 1971 TYA: 101
Jockey aq 1988 PRO: clp64
Made in California co-li (co) 1971 TPI: **68**, 99

Mocha Standard co-sk (co) 1969 APS: clp56 PIA: **138**/113-14
TCA: [33] WAT: **209**

Pews (*from* News, Mews, Pews, Brews, Stews and Dues) or sc
1970 APB: clp*128*/50

Rooster co-aq et (co) 1988 PRO: clp65

Sin sc 1970 TPI: **68**, 99

Standard Station sk (co) 1966 AMI: clp71 APP: clp29 FIM: **47**
TWO: 41

Swarm of Red Ants (*from portfolio* Insects) sk 1972 APP: 238
ENP: *abc*

Twenty-Six Gasoline Stations pf 1962 TWO: 95

See also:

Foster, Edward A. *Edward Ruscha, Young Artist* (exhibition
catalog). Minneapolis: The Minneapolis Institute of Arts,
1972.

RUSSELL, ALFRED **1920-**
Biographical dictionaries:
Art books and catalogs: GRE
Untitled 63 en aq 1946 GRE: clp*99*

RUTTENBERG, JANET **1931-**
Biographical dictionaries: WAA 80, 82
Art books and catalogs: TYA
Reflections et 1976 TYA: 101

RYAN, ANNE **1889-1954**
Biographical dictionaries: WAA 40-47, 53
Art books and catalogs: ACW, APP, TYA
In a Room wo (co) 1947 APP: clp5 TYA: 101
Two Women wl (co) 1946 ACW: **42**, 107

RYMAN, ROBERT **1930-**
Biographical dictionaries: WAA 70, 73, 76, 78, 80, 82, 84, 86,
89-90, 91-92, 93-94, 95-96, 97-98
Art books and catalogs: AMI
Six Aquatints [*plate*] aq 1975 AMI: clp91

SAAR, BETYE 1926-
Biographical dictionaries: WAA 73, 76, 78, 80, 82, 84, 86, 89-90, 91-92, 93-94, 95-96, 97-98
Art books and catalogs: LAP
Black Girl's Window mx 1969 LAP: 81/105

SAFF, DONALD JAY 1937-
Biographical dictionaries: WAA 78, 80, 82, 84, 86, 89-90, 91-92, 93-94, 95-96, 97-98
Art books and catalogs: TYA
Triptych in 1974 TYA: 102

SAKUYAMA, SHUNJI 1940-
Biographical dictionaries: WAA 84, 86, 89-90, 91-92, 93-94, 95-96, 97-98
Art books and catalogs: NPE
House in Brooklyn cy iky li 1978 NPE: 142
Prospect Park West li (co) 1978 NPE: **bcv**

SALEMME, ATTILIO 1911-55
Biographical dictionaries:
Art books and catalogs: TYA
One Against Many sk c. 1947 TYA: 102

SALLE, DAVID 1952-
Biographical dictionaries: WAA 82, 84, 86, 89-90, 91-92, 93-94, 95-96, 97-98
Art books and catalogs: AGM, AMI, FIM
Until Photographs Could Be Taken from Earth's Satellites [*plates*] aq 1981 AGM: 38 AMI: clp149 FIM: 18

SALLICK, LUCY ELLEN 1937-
Biographical dictionaries: WAA 82, 84, 86, 89-90, 91-92, 93-94, 95-96, 97-98
Artbooks and catalogs: PWP
View from the Deck in Maine, IV mo (co) 1987 PWP: clp51/116

SAMARAS, LUCAS 1936-
Biographical dictionaries: WAA 66, 70, 73, 76, 78, 80, 82, 84,

86, 89-90, 91-92, 93-94, 95-96, 97-98
Art books and catalogs: APP, TPI, TYA
Book mx (co) 1968 TYA: **103**
Book pb co-sc pa fd bk (co) 1968 TPI: 99
Clenched Couple sk 1975 TYA: 104
Ribbon sc 1972 APP: 144

SÁNCHEZ, JUAN **1954-**
Biographical dictionaries:
Art books and catalogs: INN
Para Don Pedro co-li ch ce hc (co) 1992 INN: **fcv**

SANDBACK, FRED (FREDERICK LANE) **1943-**
Biographical dictionaries: WAA 76, 78, 80, 82, 84, 86, 89-90,
91-92, 93-94, 95-96, 97-98
Artbooks and catalogs: AMI, PRO
Twenty-Two Constructions from 1967 (*nine from portfolio of 22*)
nl 1986 PRO: clp66
Untitled et 1975 AMI: clp95

SANDERS, BENITA **1935-**
Biographical dictionaries:
Art books and catalogs: RBW
Symbiotic Shapes et 1967 RBW: [22]

SANDERSON, HARRIET **1947-**
Biographical dictionaries:
Art books and catalogs: PNW
Bed Rest (*from series* Making Amends) ru re (co) 1990 PNW: **163**
Pas de Deux (*from* A Chorusline of Pliers) ds-in 1993 PNW: 164
Playroom [*detail*] mx is 1993-95 PNW: 165

SANDLIN, DAVID THOMAS **1956-**
Biographical dictionaries: WAA 86, 89-90, 91-92, 93-94, 95-96,
97-98
Art books and catalogs: PAP
Living Room with Four Death Daddies of the Copacalypso td-sc
px wd 1985 PAP: 110

SANTLOFER, JONATHAN 1946-
Biographical dictionaries: WAA 78, 80, 82, 84, 86, 89-90, 91-92, 93-94, 95-96, 97-98
Artbooks and catalogs: CIP
Beyond the Forest co-sc (co) 1990 CIP: **59**
Burning Bush co-sc (co) 1990 CIP: **59**

SARET, ALAN DANIEL 1944-
Biographical dictionaries: WAA 78, 80, 82, 84, 86, 89-90, 91-92, 93-94, 95-96, 97-98
Art books and catalogs: PAP
#AS83-103 (*from portfolio* Stars in the Sacred Ground) et 1983 PAP: 111

SARKISIAN, PAUL 1928-
Biographical dictionaries: WAA 76, 78, 80, 82, 84, 86, 89-90, 91-92, 93-94, 95-96, 97-98
Art books and catalogs: PNM
Envelope (Red Background) co-li (co) 1978 PNM: clp10

SASAKI, KENJARO 1936-
Biographical dictionaries:
Art books and catalogs: ENP
Dialogue with Corona, No. 4 li 1972 ENP: *abc*

SATO, NORIE 1949-
Biographical dictionaries: WAA 80, 82, 84, 86, 89-90, 91-92, 93-94, 95-96, 97-98
Art books and catalogs: TYA
Video Sunrise II: Zoom In re in (co) 1974 TYA: **106**

SAUL, PETER 1934-
Biographical dictionaries: WAA 70, 73, 76, 78, 80, 82, 84, 86, 89-90, 91-92, 93-94, 95-96, 97-98
Art books and catalogs: GAR
Cowboy Dentist co-li (co) 1983 GAR: 39

SAVELLI, ANGELO 1911-
Biographical dictionaries: WAA 76, 78, 80, 82, 84

Art books and catalogs: APP
Lotus il-re c.1967-68 APP: 138

SAVINAR, TAD 1950-
Biographical dictionaries: WAA 93-94, 95-96, 97-98
Art books and catalogs: PNW
I Want sk-ca (co) 1996 PNW: **167**
Nothing Lasts Forever sk 1992 PNW: 169
Wallpaper for an Adolescent li 1994 PNW: 168

SCANLON, MARCIA 1945-
Biographical dictionaries:
Art books and catalogs: CAM
Brownsville I oi-mo 1984 CAM: 30/47

SCARLETT, ROLPH 1889-
Biographical dictionaries: WAA 40-41
Art books and catalogs: SIM
Nature's Catalyst co-mo wc (co) 1940s SIM: **140**

SCHAPIRO, MIRIAM 1923-
Biographical dictionaries: WAA 66, 70, 73, 76, 78, 80, 82, 84,
　　86, 89-90, 91-92, 93-94, 95-96, 97-98
Art books and catalogs: AWP, INP, PIA, PWP
Adam and Eve cb pc fa-ce 1990 INP: 11
Frida and Me li ph xg fa-ce (co) 1990 PIA: **219**/123 PWP:
　　clp1/116
Homage li tu li-cy (co) 1975 AWP: [20]

SCHEIER, SHIRLEY 1953-
Biographical dictionaries:
Art books and catalogs: PNW
Leda in 1995 PNW: 172
Shirt in 1993 PNW: 173
Tea Party (*from series* Peacekeeper) in mp (co) 1993 PNW: **171**

SCHLEETER, HOWARD BEHLING 1903-76
Biographical dictionaries: WAA 40-41, 40-47, 53, 56, 59, 62
Art books and catalogs: PNM

Glow Bugs wd-en 1946 PNM: 61

SCHNABEL, JULIAN 1951-
Biographical dictionaries: WAA 86, 89-90, 91-92, 93-94, 95-96, 97-98
Art books and catalogs: AAP, AMI, PAP, PIA
Mother et aq li (co) 1985 PAP: **8**, 112 PIA: **194**/120
Raft [Dream] sl dp 1983 AAP: 109 AMI: clp150

SCHOLDER, FRITZ 1937-
Biographical dictionaries: WAA 62, 66, 70, 73, 76, 78, 80, 82, 84, 86, 89-90, 91-92, 93-94, 95-96, 97-98
Art books and catalogs: ENP, PNM, WAT
Indian at the Bar (*from portfolio* Indians Forever) li 1970 ENP: *abc*
Indian on Galloping Horse after Remington #2 [1^{st} State] co-li (co) 1976 PNM: clp**6**
Indian with Butterfly co-li (co) 1975 WAT: 251

SCHOLDER, LAURENCE T. 1942-
Biographical dictionaries: WAA 73, 76, 78, 80, 82, 84, 86, 89-90, 91-92, 93-94, 95-96, 97-98
Art books and catalogs: FTP
Origin II re-et 1989 FTP: **67**

SCHOOLEY, ELMER WAYNE 1916-
Biographical dictionaries: WAA 40-41, 40-47, 53, 56, 59, 62, 66, 70, 73, 76, 78, 80, 82, 84, 86, 89-90, 91-92, 93-94, 95-96, 97-98
Art books and catalogs: PNM
Garden Walk wo c.1962 PNM: 54
Ravens Feeding in a Field li 1959 PNM: 53

SCHOONHOVEN, TERRY 1945-
(*alias* LOS ANGELES FINE ARTS SQUAD)
Biographical dictionaries:
Art books and catalogs: LAP
Isle of California co-li (co) 1973 LAP: 89/107

SCHORRE, CHARLES 1925-
Biographical dictionaries: WAA 76, 82, 84, 86, 89-90, 91-92, 93-94, 95-96
Art books and catalogs: FTP
Untitled mo (co) 1988 FTP: **69**

SCHRAG, KARL 1912-95
Biographical dictionaries: WAA 40-47, 53, 56, 59, 62, 66, 70, 73, 76, 78, 80, 82, 84, 86, 89-90, 91-92, 93-94, 95-96
Art books and catalogs: APP, RBW, SIM, THL, TYA
Flowering Tree—Bright Night co-mo (co) 1987 SIM: **150**
Pond in a Forest co-li (co) 1962 THL: 31
Portrait of Bernard Malamud aq (co) 1970 APP: clp15
Silence Above the Storm et aq 1964 APP: 197
Tree Tops and Autumn et 1972 RBW: [22]
Woods and Open Sea li (co) 1962 TYA: **107**
See also:
Freundlich, August L. *Karl Schrag: A Catalogue Raisonné of the Graphic Works, Pt. 1, 1939-1970.* Syracuse, N.Y.: Syracuse University Art Collection, 1971.
Freundlich, August L. *Karl Schrag: A Catalogue Raisonné of the Graphic Works, Pt. 2, 1971-1980.* Syracuse, N.Y.: Syracuse University, 1980.
Freundlich, August L. *Karl Schrag: A Catalogue Raisonné of the Graphic Works, Pt. 3, 1981-1990.* Syracuse, N.Y.: Syracuse University Art Collection, 1971.

SCHULTHEISS, CARL MAX 1885-1961
Biographical dictionaries: WAA 40-47, 53, 56, 59, 62
Art books and catalogs: WAT
Pastoral II en 1947 WAT: 163

SCHUSELKA, ELFI 1940-
Biographical dictionaries: WAA 78, 80, 82, 84, 86, 89-90, 91-92, 93-94, 95-96, 97-98
Art books and catalogs: TYA
Untitled li hc (co) 1975 TYA: 104 `

SCHWARTZ, BARBARA ANN 1948-
Biographical dictionaries: WAA 76, 78, 80, 82, 84, 86, 89-90,
 91-92, 93-94, 95-96, 97-98
Artbooks and catalogs: PWP
Untitled mo 1990 PWP: clp36/116

SCHWARTZ, CARL E. 1935-
Biographical dictionaries:
Art books and catalogs: APP, ENP
Heirloom 2 li 1972 ENP: *abc*
Heirloom 4 li 1975 APP: 240

SCHWEDLER, WILLIAM A. 1942-
Biographical dictionaries: WAA 76, 78, 80, 82
Artbooks and catalogs: CHI
Silent Eclectic Fish Tattoo (*exquisite corpse by Vera Berdich, Art
 Green, Suellen Rocca, and William Schwedler*) et 1964 CHI:
 191

SCHWIEGER, (CHRISTOPHER) ROBERT 1936-
Biographical dictionaries: WAA 73, 76, 78, 80, 82, 84, 86, 89-
 90, 91-92, 93-94, 95-96, 97-98
Art books and catalogs: EIE
Chix 'n Cats sk EIE: 19

SCOTT, ARDEN 1938-
Biographical dictionaries: WAA 76, 78, 80, 82, 84, 86, 89-90,
 91-92, 93-94, 95-96, 97-98
Art books and catalogs: PRO
17! aq dr ob wg 1987 PRO: clp68
17! aq dr ob wg 1987 PRO: clp69
Coastlines (*set of 6*) mx 1987 PRO: clp70

SCOTT, SAM 1940-
Biographical dictionaries: WAA 76, 78, 80, 82, 84, 86, 89-90,
 91-92, 93-94, 95-96
Art books and catalogs: PNM
Edge of Autumn co-li (co) 1977 PNM: 91

SCULLY, SEAN 1945-
Biographical dictionaries:
Art books and catalogs: PAP, PIA, SIM
Desire sf 1985 PAP: 113
New York #9 co-mo (co) 1989 SIM: **182**
Sotto Voce co-so-aq co-sb-aq aq dr (co) 1988 PIA: **209**/122

SEAWELL, THOMAS ROBERT 1936-
Biographical dictionaries: WAA 76, 78, 80, 82, 84, 86, 89-90,
 91-92, 93-94, 95-96, 97-98
Art books and catalogs: CUN, TYA
Around Town Vertigo cg-mp 1988 CUN: 154
First Street sk 1975 TYA: 105
Mercury [St.Louis] mx-mp in re hm (co) 1988 CUN: **113**
Snow (*from* "Empty Centers Suite") sk 1983 CUN: 153
Variations on Themes of Callot-V sk (co) 1989 CUN: **114**

SECUNDA, (HOLLAND) ARTHUR 1927-
Biographical dictionaries: WAA 66, 70, 73, 76, 78, 80, 82, 84,
 86, 89-90, 91-92, 93-94, 95-96, 97-98
Art books and catalogs: APP
Road to Arles sc (co) 1976 APP: clp21

SEGAL, GEORGE 1924-
Biographical dictionaries: WAA 66, 70, 76, 78, 80, 82, 84, 86,
 89-90, 91-92, 93-94, 95-96, 97-98
Art books and catalogs: AMI, PRO
Helen III (*from portfolio* Portraits) aq sf dr 1986-87 PRO: clp67
Three Figures in Red Shirts: Two Front, One Back (*from* Blue
 Jeans Series) et aq (co) 1975 AMI: clp**69**
Walter (*from portfolio* Portraits) aq sf dr 1986-87 PRO: clp68

SELIGMANN, KURT 1900-62
Biographical dictionaries: WAA 40-47, 53, 56
Art books and catalogs: AMI, APP
Acteon et 1947 AMI: clp4
Marriage (*from portfolio* The Myth of Oedipus) et 1944 APP: 79

SEMIVAN, DOUGLAS K. 1949-
Biographical dictionaries:
Art books and catalogs: NPE
Black Maru (liner maru) dr et mz rl 1978 NPE: 146
Receiver II wo go (co) 1977 NPE: 145

SERRA, RICHARD 1939-
Biographical dictionaries: WAA 70, 73, 76, 78, 80, 82, 84, 86, 89-90, 91-92, 93-94, 95-96, 97-98
Art books and catalogs: AAP, AGM, APM, PAP, PIA
Circuit li 1972 AGM: 36 APM: 17/21
Clara Clara I sc pk 1985 PIA: **195**/120
Paris hp-pk sk 1984 PAP: 114
St. Louis mo pk 1982 AAP: 110

SESSLER, ALFRED 1909-63
Biographical dictionaries: WAA 40-41, 40-47, 53, 56, 59, 62
Art books and catalogs: ACW, CAP, WAT
Larva co-wo (co) 1957 WAT: **143**
Morning Forum li 1951 WAT: 168
Red Wig co-wo (co) 1957 ACW: **61**, 118
Thorny Crown co-wo (co) 1958 ACW: **62**, 118 WAT: **138**
Tomah Rock li 1949 WAT: 169

SEWARDS, MICHELE BOURQUE 1944-
Biographical dictionaries: WAA 76, 78, 80
Art books and catalogs: PNM
Rain li 1974 PNM: 113

SHAFFER, RICHARD FORREST 1947-
Biographical dictionaries: WAA 80, 82, 84, 86, 89-90, 91-92, 93-94, 95-96, 97-98
Art books and catalogs: FTP
Platform (*from series* Andenken) et rl aq en 1981-82 FTP: **70**

SHAHN, BEN 1898-1969
Biographical dictionaries: WAA 36-37, 40-41, 53, 56, 62, 66
Art books and catalogs: AMI, APP, POR, WAT
Alphabet of Creation sc 1958 APP: 108

Sacco and Vanzetti sk 1958 POR: 265
Scientist sk hc (co) 1957 AMI: clp24
Three Friends co-sk (co) 1941 WAT: 170

SHALALA, EDWARD 1949-
Biographical dictionaries:
Art books and catalogs: CMZ
Eraser co-mz (co) 1973 CMZ: [60]/44
Oil Landscape co-mz (co) 1974 CMZ: [53]/44

SHANNON, BRIAN 1962-
Biographical dictionaries:
Art books and catalogs: PNW
Surface/Within mx 1992 PNW: 176
Untitled dr 1995 PNW: 177
up towards the bottom is-wo (co) 1996 PNW: **175**

SHAPIRO, DAVID JOEL 1944-
Biographical dictionaries: WAA 73, 76, 78, 80, 82, 84, 86, 89-
90, 91-92, 93-94, 95-96, 97-98
Art books and catalogs: AAP, INP
Birnham Wood 1983 li br st 1983 AAP: 111
Kala (*one from set of 6*) cb dr pe 1988-90 INP: 19

SHAPIRO, JOEL (ELIAS) 1941-
Biographical dictionaries: WAA 73, 76, 78, 80, 82, 84, 86, 89-
90, 91-92, 93-94, 95-96, 97-98
Art books and catalogs: AAP, APM, PAC, PAP, PIA, PRO,
TCA
#1 wd-ce 1985 PAP: 115
Untitled et 1975 TCA: [34]
Untitled li 1980-82 AAP: 112
Untitled wo 1988 PRO: clp71
Untitled wo 1989 PIA: **213**/122-3 PRO: clp72
Untitled wo co-lc (co) 1989 PRO: clp73
Untitled (*from series* Untitled) et 1975 PAC: [48]/90
Untitled [Double Red] co-li (co) 1980 APM: 25/21

SHAPIRO, PAUL 1939-
Biographical dictionaries:

Art books and catalogs: PNM
Golem pe aq rl dr ob tp 1988 PNM: 121

SHATTER, SUSAN LOUISE **1943-**
Biographical dictionaries: WAA 78, 80, 82, 84, 86, 89-90, 91-
92, 93-94, 95-96, 97-98
Artbooks and catalogs: AGM, PWP
Canyon Rose li 1987 PWP: clp88/117
Rock Face/Zion Canyon li (co) 1981 AGM: **146**
Vertigo aq et rl (co) 1983 AGM: **147**

SHEDLETSKY, STUART **1944-**
Biographical dictionaries:
Art books and catalogs: TYA
Seven Gardens for Matisse No.5 et 1976 TYA: 105

SHEELER, CHARLES **1883-1965**
Biographical dictionaries: WAA 36-37, 40-41, 40-47, 53, 56, 62
Art books and catalogs: APP, PAC
Architectural Cadences sc 1954 PAC: [49]/90
Delmonico Building li 1927 APP: 25

SHIELDS, ALAN JOSEPH **1944-**
Biographical dictionaries: WAA 73, 76, 78, 80, 82, 84, 86, 89-
90, 91-92, 93-94, 95-96, 97-98
Art books and catalogs: ACW, AMI, FIM, PIA, TCR, TGX,
TYA, WAT
Ahmadabad Silk (*from* The Castle Window Set) wo re et aq ce hm
(co) 1981 TCR: **296**
Alice in Grayland et aq sc rs sw ce hm hc-pa (co) 1980 TCR: **289**
Armie's Tough Course et aq mz dr en rs hm (co) 1978 TCR: **286**
Box Sweet Jane's Egg Triumvirate: I, Kool Set li sc rs hm (co)
1978 TCR: **285**
Box Sweet Jane's Egg Triumvirate: I, Moose Set li sc rs hm (co)
1978 TCR: **284** TGX: **230**
Box Sweet Jane's Egg Triumvirate: I, Roosevelt Set li sc rs hm
(co) 1978 TCR: **284**
Bull-Pen wo et aq ce hm (co) 1984 TCR: **302**
c.b.a.r.l.a.a.(old)y.(odd)o. sc sn wc (co) 1969 FIM: **63**

Chicago Tenement (*from* The Castle Window Set) re et aq ce hm
 hc-pa (co) 1981 TCR: **298**
Color Radar Smile A et aq lc hm (co) 1980 TCR: **292-93**
Color Radar Smile B et aq lc hm (co) 1980 TCR: **293**
Color Radar Smile C et aq lc hm (co) 1980 TCR: **294**
Equatorial Route (*from* The Raggedy Circumnavigation Series) re
 wo sw ce hm (co) 1985 TCR: **305**
Fire Escape Plan (*from* The Castle Window Set) wo ce hm hc-pa
 (co) 1981 TCR: **298**
Fran Tarkington's Tie (*from* The Castle Window Set) wo lc aq ce
 hm (co) 1981 TCR: **297**
Gas-Up wo et aq re kn ce hm (co) 1984 TCR: **302**
Guardian Mole et aq re hm (co) 1978 TCR: **286**
Hazel's Witch Hat sc re rs sw ce hm (co) 1980 TCR: **288**
Home Route (*from* The Raggedy Circumnavigation Series) re sc
 sw ce hm (co) 1985 TCR: **308**
Houston Oil co-mx (co) 1974 WAT: **277**
Jason's Rabbit Holler with Flying Rabbits (*from* The Castle
 Window Set) wo re aq ce (co) 1981 TCR: **299**
Josh's Route (*from* The Raggedy Circumnavigation Series) re sc
 sw ce hm (co) 1985 TCR: **305**
Kite Riddle (*from* The Castle Window Set) lc wo re ce hm (co)
 1981 TCR: **296**
Milan Fog wb et aq sw ce hm (co) 1984 TCR: **303**
Odd-Job wo et re sw ce hm (co) 1984 TCR: **301** TGX: **233**
Plastic Bucket (*from* The Castle Window Set) lc et aq re ce hm
 (co) 1981 TCR: **299**
Polar Route (*from* The Raggedy Circumnavigation Series) re sc sw
 ce hm (co) 1985 TCR: **282, 306**
Rain Dance Route (*from* The Raggedy Circumnavigation Series)
 re wo sw ce hm hc-pa (co) 1985 TCR: **307**
Rare Pyramid aq et sc en hm (co) 1978 TCR: **286**
Santa's Collar re wo lc aq sw ce hm (co) 1981 TCR: **300** TGX:
 232
Scaba Pro sc re em 1974 TYA: **105**
Soft Action lc re sw ce hm (co) 1980 TCR: **289**
Sun/Moon Title Page [Pampas Little Joe] sn li ce vp rp sc ds dy-
 cu-sw-pa (co) 1971 AMI: **clp124** PIA: **150/115** TYA: **108**
Trade Route (*from* The Raggedy Circumnavigation Series) re sc

wo sw ce hm (co) 1985 TCR: **309**
Treasure Route I re rs lc ce hm hc-pa (co) 1980 TCR: **290**
Treasure Route II re aq lc vr ce hm (co) 1980 TCR: **292**
TV Rerun, A lc vr rf hm (co) 1978 TCR: **287**
TV Rerun, B lc mz dr rf hm (co) 1978 TCR: **287**
TV Rerun, C lc mz dr rs co-hm (co) 1978 TCR: **288** TGX: **231**
Two Birds, Woodcock I li hm (co) 1978 TCR: **285**
Two Birds, Woodcock II li hm (co) 1978 TCR: **285**
Two Four Too co-wo em sw (co) 1978 ACW: **71**, **122**
Uncle Ferdinand's Route (*from* The Raggedy Circumnavigation
Series) re sc wo ce hm (co) 1985 TCR: **307**

SHIELDS, JODY **1952-**
Biographical dictionaries:
Art books and catalogs: TYA
#1 April '76 and #2 April '76 mx 1976 TYA: 109
Book with Silk Papers bk si hm 1975 TYA: 108

SHIN, HYUN KWANG **1937-**
Biographical dictionaries:
Art books and catalogs: RBW
Untitled et 1984 RBW: [23]

SHORR, HARRIET **1939-**
Biographical dictionaries: WAA 86, 89-90, 91-92, 93-94, 95-96,
97-98
Artbooks and catalogs: PWP
Casablanca Lillies et aq 1988 PWP: clp**38**/117

SIEGEL, IRENE **1932-**
Biographical dictionaries: WAA 70, 73, 76, 78, 80, 82
Art books and catalogs: AWP, ENP, THL
Sunset li li-cy ss 1967 AWP: [21]
Twin Beds, I Presume (*from portfolio* Bliss Suite) co-li (co) 1967
ENP: *abc* THL: 57

SIGLER, HOLLIS **1948-**
Biographical dictionaries: WAA 86, 89-90, 91-92, 93-94, 95-96,
97-98

Art books and catalogs: AAP, INN, PIA, PWP
Every Chance She Gets She Takes It co-li (co) 1990 INN: **20**
If She Could Free Her Heart To Her Wildest Desires li pb (co)
 1982 AAP: **16**, 113
"The Dance of Life" mo hc-fm (co) 1989 PWP: **fcv**, clp**61**/117
Where Daughters Fear Becoming Their Mothers li td (co) 1985
 PIA: **196**/120

SIHVONEN, OLI 1921-
 Biographical dictionaries: WAA 73, 76, 78, 80, 82, 84, 86, 89-
 90, 91-92
 Art books and catalogs: PNM
 Block Print IV wo 1949 PNM: 60

SILER, PATRICK WALTER 1939-
 Biographical dictionaries: WAA 93-94, 95-96, 97-98
 Art books and catalogs: PNW
 Bug Comes Out wo pp 1986 PNW: 180
 He Shits on the World wo 1992 PNW: 181
 I Like to be Abroad These Moonlit Nights in my Studebaker wo
 1987 PNW: **179**

SKELLEY, ROBERT CHARLES 1934-
 Biographical dictionaries: WAA 76, 78, 80, 82, 84, 86, 89-90,
 91-92, 93-94, 95-96, 97-98
 Art books and catalogs: TYA
 War wo 1974 TYA: 109

SKINNER, ARTHUR 1950-
 Biographical dictionaries:
 Art books and catalogs: TYA
 Lost Train et pe 1976 TYA: 109

SLOAN, JEANETTE PASIN 1946-
 Biographical dictionaries: WAA 78, 80, 82, 84, 86, 89-90, 91-
 92, 93-94, 95-96, 97-98
 Artbooks and catalogs: PWP
 Sears Tower li 1986 PWP: clp**22**/117

SMITH, AJ 1952-
Biographical dictionaries:
Art books and catalogs: RBW
Untitled li 1979 RBW: [23]

SMITH, CARL F. 1955-
Biographical dictionaries:
Art books and catalogs: NPE
Daydream aq re (co) 1978 NPE: 148
Numbered Chair aq re (co) 1978 NPE: 147

SMITH, CHARLES WILLIAM 1893-1987
Biographical dictionaries: WAA 40-41, 40-47, 53, 56, 62, 73,
76, 78, 80
Art books and catalogs: ACW
Red and Green Discs co-wo (co) c.1950 ACW: **48**, 110

SMITH, DAVID (ROLAND) 1906-65
Biographical dictionaries: WAA 40-41, 53, 56, 59, 62
Art books and catalogs: AMI, GRE, PAC
Composition li 1954 AMI: clp27
Don Quixote li 1952 GRE: clp*109* PAC: [50]/91
See also:
Schwartz, Alexandra. *David Smith: The Prints.* New York: Pace
Prints, c.1987.

SMITH, D.G. 1946-
Biographical dictionaries:
Art books and catalogs: NPE
Prickly Pear cactus co-li (co) 1977 NPE: 149
Sweet Memories co-li (co) 1978 NPE: 150

SMITH, JAUNE QUICK-TO-SEE 1940-
Biographical dictionaries: WAA 93-94, 95-96, 97-98
Art books and catalogs: INN, PNM, PWP
Fancy Dancer li (co) 1988 PWP: clp27/116
Salish (*from portfolio* Artists Impressions) li 1989 INN: **27**
Sandhill South co-li hc (co) 1982 PNM: 82

SMITH, KIKI 1954-
 Biographical dictionaries:
 Art books and catalogs: PAP, PRO
 All Souls sc ts 1988 PRO: clp74
 Lungs (*from portfolio* Possession is Nine-Tenths of the Law) mp
 sc mo 1985 PAP: 117

SMITH, KIMBER 1922-81
 Biographical dictionaries:
 Artbooks and catalogs: AKG
 Rainbow co-li (co) 1961 AKG: clp50
 Untitled (*from portfolio* One Cent Life *by Walasse Ting, edited by
 Sam Francis*) co-li (co) 1964 AKG: clp72

SMITH, LEE N. III 1950-
 Biographical dictionaries:
 Art books and catalogs: FTP
 Dog Spirits li hc (co) 1983 FTP: **73**

SMITH, LEON POLK 1906-96
 Biographical dictionaries: WAA 40-47, 53, 56, 62, 66, 70, 73,
 76, 78, 80, 82, 84, 86, 89-90, 91-92, 93-94, 95-96, 97-98
 Artbooks and catalogs: THL
 Untitled co-li (co) 1968 THL: **fpc**

SMITH, MEI-TEI-SING
 Biographical dictionaries:
 Art books and catalogs: RBW
 Loong et 1983 RBW: [23]

SMITH, MOISHE 1929-93
 Biographical dictionaries: WAA 73, 76, 78, 80, 82, 84, 86, 89-
 90, 91-92, 93-94
 Art books and catalogs: TYA, WAT
 Cow sk 1976 TYA: 110
 Four Seasons—Winter in 1958 WAT: 198

SMITH, PHILIP RAND 1952-
 Biographical dictionaries: WAA 95-96, 97-98

Art books and catalogs: PAP
Charm mo 1985 PAP: 118

SMITH, RICHARD 1931-
Biographical dictionaries:
Art books and catalogs: TCR, TGX, TWO
Cam (*from* The Field and Stream Series) aq et li (co) 1982 TCR:
316
Double Meadow (*from* The Field and Stream Series) aq et li (co)
1982 TCR: **315**
Hiz (*from* The Field and Stream Series) aq et li (co) 1982 TCR:
316
Ick (*from* The Field and Stream Series) aq et li (co) 1982 TCR:
314
Ouse (*from* The Field and Stream Series) aq et li (co) 1982 TCR:
316 TGX: **226**
Pix (*from* The Field and Stream Series) aq li dr (co) 1982 TCR:
315
Pix [*State I*] (*from* The Field and Stream Series) aq dr 1982 TCR:
315
Russian I et 1975 TWO: 87

SMITH, SCOTT 1951-
Biographical dictionaries:
Art books and catalogs: NPE
Friday Night en px 1977 NPE: 151
House on the Hill en px 1977 NPE: 152

SMITH, WILLIAM KANE 1955-
Biographical dictionaries:
Art books and catalogs: NPE
Houses in the Rain sc-re-sn sf re 1977 NPE: 153
Monobath mo 1978 NPE: 154

SNIDOW, GORDON E. 1936-
Biographical dictionaries: WAA 76, 78, 80, 82, 84, 86, 89-90,
91-92, 93-94, 95-96, 97-98
Art books and catalogs: PNM
Baby Sitter co-li (co) 1975 PNM: 89

SNOW, MICHAEL 1929-
Biographical dictionaries: WAA 66, 70, 73, 76, 78, 80, 82, 84, 86, 89-90, 91-92, 93-94, 95-96, 97-98
Art books and catalogs: TWO
Carla Bley from Toronto 20 pf re 1965 TWO: 96

SNYDER, JOAN 1940-
Biographical dictionaries: WAA 73, 76, 78, 80 82, 84, 86, 89-90, 91-92, 93-94, 95-96, 97-98
Art books and catalogs: AGM, PAP, PIA
Can We Turn Our Rage to Poetry? li (co) 1985 AGM: **151**
Dancing in the Dark wo 1982-84 AGM: **150**
Things Have Tears and We Know Suffering wo hc (co) 1983-84 AGM: **149** PAP: 119 PIA: **187**/119

SOAVE, SERGIO 1961-
Biographical dictionaries:
Art books and catalogs: CUN
Architecture I cn 1991 CUN: 158
Immigrate cn (co) 1989 CUN: **114**
Proper Departure ce 1990 CUN: 157
Reaping What You Have Sown cn (co) 1988 CUN: **115**

SOLIEN, T.L. 1949-
Biographical dictionaries:
Art books and catalogs: AAP, FIM, IAI, PIA, TCR
Boatman's Rescue (*from portfolio* Fragments of Hope) dr 1982 IAI: **55**
Fragments of Hope (*portfolio of 6*: Title Page; I, Sunken Treasure; II, Boatman's Rescue; III, Tower of Strength; IV, Handle and Tow; V, Memoir Den) dr 1982 IAI: **55**
Handle and Tow (*from portfolio* Fragments of Hope) dr 1982 IAI: **55**
Memoir Den (*from portfolio* Fragments of Hope) dr 1982 FIM: 124 IAI: **55**
Night Watchman li sc px dp 1982-83 AAP: 114
Psyche: The Blue Martin wo aq et hm hc-pa (co) 1985 TCR: **318**
Sunken Treasure (*from portfolio* Fragments of Hope) dr 1982 IAI: **55**

Three Sailors li in sc (co) 1982 FIM: **125** IAI: **54** PIA: **180/118**
Tin Man wo (co) 1984 IAI: **5**
Tower of Strength (*from portfolio* Fragments of Hope) dr 1982
 IAI: **55**
Victim of Doubt mo 1983 IAI: 7

SOLMAN, JOSEPH **1909-**
 Biographical dictionaries: WAA 40-41, 53, 56, 62, 66, 70, 73,
 76, 78, 80, 82, 84, 86, 89-90, 91-92, 93-94, 95-96, 97-98
 Art books and catalogs: SIM
 High Button Shoes co-mo (co) c.1970 SIM: 164

SOLOMON, BERNARD ALAN **1946-**
 Biographical dictionaries: WAA 89-90, 91-92, 93-94, 95-96
 Art books and catalogs: GAP
 Song of Songs bk sv-bl ty 1983 GAP: 23/31

SOMMERS, JOHN SHERMAN **1927-**
 Biographical dictionaries: WAA 76, 78, 80, 82, 84, 86, 89-90
 Art books and catalogs: NPE, PNM
 Alaskan Postcard co-li (co) 1978 NPE: 155
 Dawn co-li (co) 1978 NPE: 156
 Wold [Ambiance] co-li (co) 1978 PNM: 86

SONENBERG, JACK **1925-**
 Biographical dictionaries: WAA 62, 66, 70, 73, 76, 78, 80, 82,
 84, 86, 89-90, 91-92, 93-94, 95-96, 97-98
 Art books and catalogs: APP
 Perimeter in re 1975-76 APP: 160

SONNEMAN, EVE **1946-**
 Biographical dictionaries: WAA 76, 78, 80, 82, 84, 86, 89-90,
 91-92, 93-94, 95-96, 97-98
 Artbooks and catalogs: PWP
 Deep Runners ph dp (co) 1987 PWP: clp**58**/117

SORMAN, STEVEN ROBERT **1948-**
 Biographical dictionaries: WAA 82, 84, 86, 89-90, 91-92, 93-
 94, 95-96, 97-98

Art books and catalogs: AAP, FIM, NAP, NPE, PAP, PIA, SIM, TCR, TGX

After Still Whom after Whom mp re et wo ce hc hm (co) 1985 TCR: **328**

Before Is Was Will Be mp re et wo ce hc (co) 1985 TCR: **329**

Blue (*one from portfolio of 9*) dr mo ch (co) 1985 PAP: **20**, 120

First Building Project According to What Plan li et aq cg (co) 1978 FIM:103

Forgetting and Forgetting re et ce hc hm (co) 1985 TCR: **320**, **328**

Going for a Reason mo brl 1981 NAP: **42**

Havannah Lake li lc wo en ce gl go wc gr or-pa (co) 1986 PIA: **202**/121

I Am Looking at You, I Am Looking at You re et li ce hc hm (co) 1985 TCR: **326**

In Residence (In the United States) wo re li et ce hm (co) 1984 TCR: **323**

Letter to Matisse go ce li rs (co) 1985 NPE:158

No Near Room co-mo ce tl (co) 1992 SIM: **180**

Now at First and When wo re et ce hm (co) 1985 TCR: **327**

Outside the House (Inside the Yard) mp ce hc (co) 1984 TCR: **322**

Spaces between Words/A Deaf Man Sees ce li tp (co) 1978 NPE: 157

Still Standing Still re et wo li ce hc hm (co) 1985 TCR: **324**

This: Stand within Feet wo re et ce hc hm (co) 1985 TCR: **326**

Trees Blowing and Blowing like Arms Akimbo wo et re li ce hc-hm (co) 1985 TCR: **324** TGX: **237**

Trees like Men Walking re wo et ce hc hm (co) 1985 TCR: **325**

What's This, What's That et aq li wb hs dp 1982 AAP: 115

Years and When wo re et li ce hm (co) 1985 TCR: **323**

SOTO, JESÚS RAFAEL 1923-
Biographical dictionaries:
Art books and catalogs: TWO
Untitled B em-sk (co) 1971 TWO: **56**

SOWISKI, PETER 1949-
Biographical dictionaries:
Art books and catalogs: CMZ
Bull Shoulders mz 1977 CMZ: [61]/45

SOYER, RAPHAEL **1899-1987**
Biographical dictionaries: WAA 36-37, 40-41, 40-47, 53, 56,
59, 62, 66, 70, 73, 76, 78, 80, 82, 84, 86
Art books and catalogs: APP, TYA
Artist's Parents et aq 1963 TYA: 110
Toward the Light li c.1935 APP: 56

SPAFFORD, MICHAEL CHARLES **1935-**
Biographical dictionaries: WAA 76, 78, 80, 82, 84, 86, 89-90,
91-92, 93-94, 95-96, 97-98
Art books and catalogs: PNW
Battle of Lapiths and Centaurs wo 1993 PNW: **183**
Origin of Pegasus #2 wo 1985 PNW: 184
Split Laocoön wo 1988 PNW: 185

SPANDORFER, MERLE SUE **1934-**
Biographical dictionaries: WAA 80, 82, 84, 86, 89-90, 91-92,
93-94, 95-96, 97-98
Art books and catalogs: ENP
Hematic [Blood Process] sk 1972 ENP: *abc*

SPARAGANA, JOHN **1958-**
Biographical dictionaries:
Art books and catalogs: FTP
Untitled mo (co) 1990 FTP: **75**

SPARLING, CINDA **1953-**
Biographical dictionaries:
Artbooks and catalogs: PWP
Peony Series I li wc (co) 1988 PWP: clp54/117

SPERO, NANCY **1926-**
Biographical dictionaries: WAA 76, 78, 80, 82, 84, 86, 89-90,
91-92, 93-94, 95-96, 97-98
Artbooks and catalogs: PWP
Ballade von der Judenhure Marie Sanders li 1991 PWP: clp9/117

SPRUANCE, BENTON MURDOCH 1904-67
Biographical dictionaries: WAA 36-37, 40-41, 53, 56, 62, 66
Art books and catalogs:
See also:
Fine, Ruth. *The Prints of Benton Murdoch Spruance: A Catalogue Raisonné.* Philadelphia: The University of Pennsylvania Press, in cooperation with the Free Library of Philadelphia, 1986.

SPRUNT, VERA HENDERSON 1954-
Biographical dictionaries:
Art books and catalogs: PNM
Layered Passages co-pg (co) 1990 PNM: 131

SQUERI, ROBERT 1923-
Biographical dictionaries:
Art books and catalogs: ENP
Manoa Series VI ly 1970 ENP: *abc*

STACKHOUSE, ROBERT 1942-
Biographical dictionaries: WAA 93-94, 95-96, 97-98
Art books and catalogs: PRO
Gohstad (*from portfolio* Sources and Structures I) co-aq sb sf (co) 1988-89 PRO: clp75
Lake Garda (*from portfolio* Sources and Structures I) co-aq sb sf (co) 1988-89 PRO: clp75
Naja (*from portfolio* Sources and Structures I) co-aq sb sf (co) 1988-89 PRO: clp75

STADLER, ALBERT 1923-
Biographical dictionaries: WAA 40-41, 73, 76, 78, 80, 82, 84, 86, 89-90, 91-92, 93-94, 95-96, 97-98
Art books and catalogs: TYA
Diptych: Cross Creek et 1976 TYA: 110
Lifting et 1976 TYA: 111

STALEY, EARL 1938-
Biographical dictionaries:
Art books and catalogs: FTP
Self 1 mo (co) 1990 FTP: 77

Self 3 mo (co) 1990 FTP: **fcv**

STAMOS, THEODOROS (THEODORE) S. 1922-97
Biographical dictionaries: WAA 40-47, 53, 56, 62, 66, 70, 73,
76, 78, 80, 82, 84, 86, 89-90, 91-92, 93-94, 95-96, 97-98
Art books and catalogs: ENP, SIM
Delphic Sun Box I sc 1971 ENP: *abc*
Divining Rod III co-mo (co) 1950 SIM: **144**

STANCZAK, JULIAN 1928-
Biographical dictionaries: WAA 66, 70, 73, 76, 78, 80, 82, 84,
86, 89-90, 91-92, 93-94, 95-96, 97-98
Art books and catalogs: TYA
Solar sk fl 1973 TYA: 111

STANUGA, TED 1948-
Biographical dictionaries:
Art books and catalogs: AAP
Killer li 1982 AAP: 116

STASIK, ANDREW J. 1932-
Biographical dictionaries: WAA 70, 73, 76, 78, 80, 82, 84, 86,
89-90, 91-92, 93-94, 95-96, 97-98
Art books and catalogs: APP, ENP
Moment I li sc 1971 ENP: *abc*
Still Life Landscape, No. 5 li ai 1969 APP: 245

STEINBERG, SAUL 1914-
Biographical dictionaries: WAA 40-47, 53, 56, 59, 62, 66, 70,
78, 80, 82, 84, 86, 89-90, 91-92, 93-94, 95-96, 97-98
Art books and catalogs: AMI, ENP, GMC, TYA
Millet ce li 1970 ENP: *abc*
Museum li 1972 TYA: 111
Sam's Art (*from portfolio* New York International) co-li (co) 1966
AMI: clp131
Untitled (*from portfolio* For Meyer Schapiro) co-sk et-pa (co)
1974 GMC: 68

STEIR, PAT IRIS 1940-

Biographical dictionaries: WAA 78, 80, 82, 84, 86, 89-90, 91-92, 93-94, 95-96, 97-98

Art books and catalogs: AAP, ACW, AGM, AWP, CAM, FIM, PAP, PIA, PWP

Abstraction, Belief, Desire sl-aq ob-aq hg sf dr (co) 1981 AGM: **154**

At Sea #13 (Dread) mo 1982 AAP: 117

Between the Lines li tu li-hd ss AWP: [22]

Kweilin Dreaming, Part C wo hp ch 1989 PWP: clp56/117

Kyoto Chrysanthemum co-wo (co) 1982 ACW: **78**, 126

Roll Me a Rainbow li (co) 1974 FIM: **93** PIA: **160**/116

Self Drawn as though by Early Matisse mo 1985 PAP: 121

Self-Portrait after Rembrandt with Pursed Lips et-ik 1985 CAM: 32/47

Tree After Hiroshige ob-aq et dr (co) 1984 AGM: **155**

Wish #3—Transformation li (co) 1974 AGM: **156**

STELLA, FRANK 1936-

Biographical dictionaries: WAA 66, 70, 73, 76, 78, 80, 82, 84, 86, 89-90, 91-92, 93-94, 95-96, 97-98

Art books and catalogs: AAP, AGM, AKG, AMI, AMP, APM, APR, APS, BWS, ENP, FIM, GMC, PAC, PIA, PPP, SMP, TCA, TCR, TGX, TWO, TYA, WAT

Arundel Castle li 1967 FIM: 12

Bermuda Petrel sc sn hc (co) 1979 TCR: **338** TGX: **168**

Bethlehem's Hospital li 1976 TGX: 163

Black Series I, No. 1 li 1967 AKG: clp53

Black Series II (*suite of 8*) li 1967 APS: clp58

Black Stack li tp 1970 BWS: 12/31

Bonin Night Heron sc sn hc (co) 1979 TCR: **340**

Butcher Came and Slew the Ox (*from* Illustrations after El Lissitzky's Had Gadya) li lc sc hc ce (co) 1984 SMP: **66**

Double Gray Scramble sk 1973 TYA: 112

Effingham li sc (co) 1974 TGX: **163**

Eskimo Curlew (*from* Exotic Bird Series) li sc (co) 1977 TCR: **334**

Estoril Five I (*from series* Circuits) re wo hm hc-pa (co) 1982 TCR: **343**

(co) 1984 TCR: **361** TGX: **33**

Polar Co-ordinates for Ronnie Peterson III li sc 1979-80 PPP: 166

Polar Co-ordinates for Ronnie Peterson III [*trial proofs*] li sc (co)
1979-80 PPP: 163, **164**

Polar Co-ordinates for Ronnie Peterson III [*working proof*] li sc
hp (co) 1979-80 PPP: 162, **165**

Polar Co-ordinates for Ronnie Peterson Variant IIIA li sc (co)
1979-80 PPP: **167**

Port aux Basques li sk 1971 ENP: *abc*

Puerto Rican Blue Pigeon (*from* Exotic Bird Series) li sc (co) 1977
TCR: **335** TGX: **167**

Sidi Isni II co-li (co) 1973 AMP: 103

Squid (*from series* The Waves) li lc sc hc ce (co) 1988 SMP: **71**

Star of Persia I co-li (co) 1967 FIM: **61** PIA: **140**/114 TYA: 112
WAT: 261

Star of Persia II li 1967 TWO: 60

Steller's Albatross (*from* Exotic Bird Series) li sc (co) 1977 TCR:
337 TGX: **167**

Swan Engraving I (*from series* Swan Engraving) et hm 1982
TCR: **345**

Swan Engraving II (*from series* Swan Engraving) et hm 1982
TCR: **346**

Swan Engraving III (*from series* Swan Engraving) et re hm 1982
APR: bcv/[16] PAC: fpc/92 TCA: 8 TCR: **346**

Swan Engraving IV (*from series* Swan Engraving) et re hm 1982
TCR: **346**

Swan Engraving Blue (*from series* Swan Engraving) et re en hm
(co) 1983 TCR: **349**

Swan Engraving Blue, Green, Grey (*from series* Swan Engraving)
re et hm 1985 TCR: **363**

Swan Engraving Circle I (*from series* Swan Engraving) et en wo
re hm 1983 AAP: 119 TCR: **354**

Swan Engraving Circle I [*States I-V*] (*from series* Swan
Engraving) et re en hm (co) 1983 TCR: **354-56**

Swan Engraving Circle II (*from series* Swan Engraving) et re en
hm (co) 1983 TCR: **356**

Swan Engraving Circle II [*States I-V*] (*from series* Swan
Engraving) et re en hm (co) 1983 TCR: **356-58**

Swan Engraving Framed I (*from series* Swan Engraving) re et hm

1985 TCR: **362**

Swan Engraving Framed II (*from series* Swan Engraving) re et hm 1985 TCR: **363**

Swan Engraving Square I (*from series* Swan Engraving) et hm 1982 AAP: 118 TCR: **347**

Swan Engraving Square II (*from series* Swan Engraving) et re hm 1982 TCR: **347** TGX: 174

Swan Engraving Square III (*from series* Swan Engraving) et hm 1982 TCR: **347**

Swan Engraving Square IV (*from series* Swan Engraving) et re hm 1982 TCR: **348**

Swan Engraving V (*from series* Swan Engraving) re et en hm 1985 TCR: **362**

Talladega Five I (*from series* Circuits) re wo hc-hm (co) 1982 AAP: 122 PAC: [53]/93 TCR: **342**

Talladega Three I (*from series* Circuits) et hm 1982 PAC: [52]/93 TCR: **341**

Talladega Three II (*from series* Circuits) re hc-hm (co) 1982 TCA: [47] TCR: **330, 341** TGX: **160**

Talladega Three III (*from series* Circuits) re hm 1982 TCR: **342**

Tetuan III (*from portfolio* For Meyer Schapiro) co-li sk (co) 1973 GMC: 69

Then Came Death and Took the Butcher (*from* Illustrations after El Lissitzky's Had Gadya) li lc sc rb-re hc ce (co) 1984 SMP: **67**

Wake Island Rail sc hc (co) 1979 TCR: **339**

Yellow Journal li (co) 1982 TCR: **345**

Yellow Journal [*State I*] li (co) 1984 TCR: **358**

See also:

Axsom, Richard H., with the assistance of Phyllis Floyd and Matthew Rohn. *The Prints of Frank Stella, 1967-1982: A Catalogue Raisonné* (exhibition catalog). New York; Ann Arbor: Hudson Hills Press in association with The University of Michigan Museum of Art, 1983.

STEPHENS, SCOTT 1954-

Art books and catalogs: CUN

Untitled (201) in re dp (co) 1988 CUN: **116**

Untitled (195) in re dp (co) 1988 CUN: **117**

Untitled (335) cr 1991 CUN: 161
Untitled (152) pe 1986 CUN: 162

STEVENS, MAY 1924-
Biographical dictionaries: WAA 62, 66, 70, 73, 76, 78, 80, 82,
84, 86, 89-90, 91-92, 93-94, 95-96, 97-98
Art books and catalogs: AWP, ENP
Big Daddy Paper Doll sk 1970 AWP: fcv, [23] ENP: *abc*

STEWART, NORMAN (WILLIAM) 1947-
Biographical dictionaries: WAA 78, 80, 82, 86, 89-90, 91-92,
93-94, 95-96, 97-98
Artbooks and catalogs: CIP, NPE,
April co-sc (co) 1985 CIP: **65**
Bias hp sk (co) 1977 NPE: **144**, 160
Cranbrook Suite: Gossamer sk (co) 1977 NPE: 159
Echelon co-sc (co) 1987 CIP: **65**
Harbinger co-sc (co) 1989 CIP: **67**
Hi-Flyer co-sc (co) 1990 CIP: **61**
Mirage co-sc (co) 1982 CIP: **63**
Nokomis co-sc (co) 1988 CIP: **66**
Onyx I co-sc (co) 1983 CIP: **64**
Onyx II co-sc (co) 1983 CIP: **64**
Rhombus co-sc (co) 1981 CIP: **62**
Serac co-sc (co) 1982 CIP: **62**
Simokon co-sc (co) 1988 CIP: **66**
Sonata co-sc (co) 1987 CIP: **65**
Tartan co-sc (co) 1984 CIP: **64**
Trifles co-sc (co) 1980 CIP: **62**

STEWART, PAUL LEROY 1928-
Biographical dictionaries: WAA 84, 86, 89-90, 91-92, 93-94,
95-96, 97-98
Artbooks and catalogs: CIP
Aerial co-in (co) 1988 CIP: **69**

STILLMAN, GEORGE 1921-
Biographical dictionaries: WAA 80, 82, 84, 86, 89-90, 91-92,
93-94, 95-96, 97-98

Artbooks and catalogs: SIM
Untitled (#4) co-mo (co) 1949 SIM: **113**

STOCK, MARK 1951-
Biographical dictionaries:
Art books and catalogs: AAP, PIA, TYA
Air Whale li 1982 AAP: 123
Butler's in Love li (co) 1989 PIA: **214**/123
Keys li pp 1975 TYA: 113

STOLAROFF, JOYCE 1957-
Biographical dictionaries:
Artbooks and catalogs: PWP
Woman with Feathers li 1987 PWP: clp66/118

STONE, CAROLYN 1936-
Biographical dictionaries:
Artbooks and catalogs: PWP
In February et hm 1988 PWP: clp**42**/118

STONE, JEFFREY INGRAM 1945-
Biographical dictionaries: WAA 82, 84, 86, 89-90, 91-92, 93-
94, 95-96, 97-98
Art books and catalogs: ENP
Mia li 1971 ENP: *abc*

STOREY, DAVID 1948-
Biographical dictionaries: WAA 93-94, 95-96, 97-98
Art books and catalogs: INN
Stumbler's Parade co-li (co) 1993 INN: **21**

STROH, EARL 1924-
Biographical dictionaries:
Art books and catalogs: PNM
Mesa Verde et c.1955 PNM: 88
Symbiosis I co-li (co) 1979 PNM: clp7

STROMBOTNE, JAMES 1934-
Biographical dictionaries: WAA 66, 70, 73, 76, 78

Art books and catalogs: LAP, THL
Smokers co-li (co) 1968 LAP: 88/105
Smokers II co-li (co) 1968 THL: 50

STRUNCK, JUERGEN 1943-
Biographical dictionaries:
Art books and catalogs: CUN
STS-6 ik fr re pp (co) 1991 CUN: **117**
STS-15 ik fr re pp (co) 1991 CUN: **118**

STUART, MICHELLE 1919-
Biographical dictionaries: WAA 76, 78, 80, 82, 84, 86, 89-90,
91-92, 93-94, 95-96, 97-98
Art books and catalogs: FIM, PIA, PRO, PWP
Charting Arcadia and the Transit of Venus (*from* Navigating
Coincidences: Reflecting on the Voyages of Captain James
Cook) co-in le hg sf aq (co) 1987 PRO: clp**1.2**
Directions for Seamen Bound for Far Voyages (*from* Navigating
Coincidences: Reflecting on the Voyages of Captain James
Cook) co-in le hg sf aq (co) 1987 PRO: clp**1.1**
Kealakekua Morai: The Artists of the Chief Mourner (*from*
Navigating Coincidences: Reflecting on the Voyages of
Captain James Cook) co-in le hg sf aq (co) 1987 PRO: clp**1.4**
Navigating Coincidence: Reflecting on the Voyages of Captain Js.
Cook (*portfolio of 5*) in (co) 1987 PIA: **205**/121
Okuping li (co) 1975 FIM: **97**
Otaheite or Port Desire (*from* Navigating Coincidences: Reflecting
on the Voyages of Captain James Cook) co-in le hg sf aq (co)
1987 PRO: clp**1.3** PWP: clp**71**/118
tides here carried great white frogs to Tongatapu (*from*
Navigating Coincidences: Reflecting on the Voyages of
Captain James Cook) co-in le hg sf aq (co) 1987 PRO: clp**1.5**
Tsikupuming li (co) 1975 FIM: **95**
Tunyo li (co) 1974 FIM: **96**

STURMAN, EUGENE 1945-
Biographical dictionaries: WAA 76, 78, 80, 82, 84, 86, 89-90,
91-92, 93-94, 95-96, 97-98
Art books and catalogs: LAP

Quadrant #4 sk wx gd 1977 LAP: 94/108

STUSSY, JAN 1921-90
Biographical dictionaries: WAA 76, 78, 80, 82, 84, 86, 89-90
Art books and catalogs: AML, LAP
Coast Tree [Witches' Tree] li 1948 AML: 174
Family of Acrobatic Jugglers li 1970 LAP: 73/106

SUGARMAN, GEORGE 1912-
Biographical dictionaries: WAA 66, 70, 73, 76, 78, 80, 82, 84, 86, 89-90, 91-92, 93-94, 95-96, 97-98
Artbooks and catalogs: AKG, THL
Red and White co-li (co) 1965 THL: 39
T. 1340 li 1965 AKG: clp58a

SULLIVAN, DAVID FRANCIS 1941-
Biographical dictionaries: WAA 80, 82, 84, 86, 89-90, 91-92, 93-94, 95-96, 97-98
Art books and catalogs: NPE
Asymmetry sk (co) 1978 NPE: 162
Façade sk (co) 1977 NPE: 161

SULTAN, ALTOON 1948-
Biographical dictionaries: WAA 78, 80, 82, 84, 86, 89-90, 91-92, 93-94, 95-96, 97-98
Artbooks and catalogs: PWP
Red Roofs, North Island, New Zealand hc-et (co) 1990 PWP: clp92/118

SULTAN, DONALD KEITH 1951-
Biographical dictionaries: WAA 84, 86, 89-90, 91-92, 93-94, 95-96, 97-98
Art books and catalogs: AAP, FIM, IAI, PAP, PIA, PRO
Black Lemons and Egg, April 14, 1987 (*from portfolio* Lemons) aq 1987 PIA: **206**/121
Black Tulips (*suite of 4*) aq 1983 IAI: **61**
But they are thinking of you (*from book* Warm and Cold, *collaboration with writer David Mamet*) li hc-wc (co) 1985 PAP: 122

Female Series (*two from portfolio of 7*) aq 1988 PRO: clp76
French Stacks (*from portfolio* Cypresses and Stacks) lc (co) 1982
 IAI: **59**
Sailor Hats, March 21, 1979 aq dr 1979 FIM: **111**
Water under the Bridge (*set of 8*) aq 1979 FIM: 110
"Yellow Iris" June 1, 1982 wb hd gr 1982 AAP: 124
See also:
Friedman, Ciel. *Donald Sultan Prints, 1979-1985* (exhibition
 catalog). Boston: Barbara Krakow Gallery, 1985.

SUMMER, EVAN **1948-**
 Biographical dictionaries:
 Art books and catalogs: NPE
 Dream from a Majestic Past III cg cb at 1976 NPE: 163
 Untitled et dr 1978 NPE: 164

SUMMERS, CAROL **1925-**
 Biographical dictionaries: WAA 66, 70, 73, 76, 78, 80, 82, 84,
 86, 89-90, 91-92, 93-94, 95-96, 97-98
 Art books and catalogs: ACW, AMI, APP, ESS, TYA, WAT
 Chinese Landscape wo 1951 AMI: **clp19**
 Dark Vision of Xerxes co-wo (co) 1958 WAT: 190
 Mezzogiorno co-wo (co) 1960 WAT: **141**
 Monsoon co-wo (co) 1982 ACW: **55**, 114
 Rajasthan wo (co) 1967 APP: **clp20**
 Road to Ketchikan co-wo (co) 1976 ESS: [31] TYA: 113
 See also:
 Baro, Gene. *Carol Summers Woodcuts*. San Francisco: ADI
 Gallery, 1977.

SUNDSTROM, MARY **1950-**
 Biographical dictionaries:
 Artbooks and catalogs: PWP
 In Praise of the Carp li ch 1989 PWP: clp14/118

SURLS, JAMES **1943-**
 Biographical dictionaries: WAA 80, 82, 84, 86, 89-90, 91-92,
 93-94, 95-96, 97-98
 Art books and catalogs: FTP, GAR

See Across the See li 1985 GAR: 47
Through It All wo 1990 FTP: **79**

SWANN, JAMES 1905-85
 Biographical dictionaries: WAA 36-37, 40-41, 40-47, 53, 56,
 62, 76
 Art books and catalogs:
 See also:
 Czestochowski, Joseph S. *James Swann: In Quest of a*
 Printmaker. Cedar Rapids, Iowa: Cedar Rapids Museum of
 Art, c.1990.

TAKAL, PETER 1905-
 Biographical dictionaries: WAA 56, 62, 66, 70, 73, 76, 78, 80,
 82, 84, 86, 89-90, 91-92, 93-94, 95-96
 Art books and catalogs:
 See also:
 Takal, Peter. *Catalogue Raisonné of the Prints of Peter Takal*.
 East Lansing, Mich.: Kresge Art Museum, Michigan State
 University, 1986.

TANNING, DOROTHEA 1910-
 Biographical dictionaries:
 Art books and catalogs:
 See also:
 Waddell, Roberta, and Louisa Wood Ruby, eds. *Dorothea*
 Tanning: Hail, Delirium!: A Catalogue Raisonné of the
 Artist's Illustrated Books and Prints, 1942-1991. New York:
 Miriam and Ira D. Wallach Division of Art, Prints and
 Photographs, the New York Public Library, 1992.

TÀPIES, ANTONI 1923-
 Biographical dictionaries: WAA 95-96, 97-98
 Art books and catalogs: TWO
 Impressions of Hands et aq 1969 TWO: 66

TARNOWER, JAIN 1946-
 Biographical dictionaries:
 Art books and catalogs: CAM
 Marta Black ik-mo 1984 CAM: 15/47

TATSCHL, JOHN 1906-82
Biographical dictionaries: WAA 56, 59, 62, 66, 70, 73, 76, 78, 80
Art books and catalogs: PNM
Pietà wo c.1947 PNM: 52

TAYLOR, AL C. 1948-
Biographical dictionaries: WAA 91-92, 93-94, 95-96, 97-98
Art books and catalogs: PRO
Untitled [Double Spiral] aq sb sl le of 1988 PRO: clp77
Untitled [Large Map] dr aq sl le 1988 PRO: clp78
Untitled [Large Tape] aq sl sb le 1988 PRO: clp79 PIA: 210/122

TAYLOR, MAXWELL
Biographical dictionaries:
Art books and catalogs: RBW
Man's Problems wo 1975 RBW: [24]

TAYLOR, PRENTISS (HOTTEL) 1907-91
Biographical dictionaries: WAA 36-37, 40-41, 40-47, 53, 56, 62, 70, 73, 76, 78, 80, 82, 84, 86, 89-90, 91-92
Art books and catalogs: PNM
Towards Santa Fe li 1958 PNM: 44
See also:
Rose, Ingrid, and Roderick S. Quiroz. *The Lithographs of Prentiss Taylor: A Catalogue Raisonné.* Bronx, N.Y.: Fordham University Press, 1996.

TEICHMAN, MARY MELINDA 1954-
Biographical dictionaries: WAA 86, 89-90, 91-92, 93-94, 95-96, 97-98
Art books and catalogs: RBW
Token Et Cetera et 1981 RBW: [24]

THIEBAUD, (MORTON) WAYNE 1920-
Biographical dictionaries: WAA 66, 70, 73, 76, 78, 80, 82, 84, 86, 89-90, 91-92, 93-94, 95-96, 97-98
Art books and catalogs: AAP, ACW, AMI, APS, ENP, PAP,

PIA, SIM, TPI, TYA, WAT
Apartment Hill dr ch 1985 PAP: 123
Boston Cremes co-lc (co) 1970 ACW: **66**, 120 AMI: clp72 WAT:
268
Dark Cake wb 1983 AAP: 125
Delights *(four of 17)* et aq dr 1964 PIA: **134**/113
Delights *(portfolio of 17)* et 1965 TPI: 99
Jan Palach co-sc ce (co) 1970 TPI: 101
N.Y. Decals 1&2 co-sc gn (co) 1967 TPI: 100
New Colored Fire from the Vast Strange Country co-sc ce (co)
1968 TPI: 101
Rabbit *(from portfolio* Seven Still Lives and a Rabbit) li 1970-71
ENP: *abc* TYA: 114
Rainbow Grill co-sc vf-py (co) 1965 TPI: 100
Suckers [*State II*] co-li (co) 1968 TPI: **70**
Three Streets Down co-mo (co) c.1975 SIM: 155
Yo-yo's wo 1964 APS: clp25

THOMAS, C. DAVID 1946-
Biographical dictionaries: WAA 84, 86, 89-90, 91-92, 93-94,
95-96, 97-98
Art books and catalogs: TYA
Banana li 1976 TYA: 114
Moonrise II li 1976 TYA: 114

THOMAS, LARRY W. 1943-
Biographical dictionaries: WAA 89-90, 91-92, 93-94, 95-96, 97-
98
Art books and catalogs: PAP, TYA
Forgotten Moments in History #4 li 1975 TYA: 115
Nagheezi Series #3 mo gr-hd (co) 1985 PAP: **13**, 124
No Kid of Mine Works for Peanuts li 1975 TYA: 115

THOMAS, THEODORE J.
Biographical dictionaries:
Art books and catalogs: CUN
Built for Speed sk 1988 CUN: 168
Dream Lover sk 1987 CUN: 167
Last Date sk (co) 1987 CUN: **119**

Take Time to Know Her sk (co) 1988 CUN: **120**

THOMPSON, MARGOT VOORHIES 1948-
Biographical dictionaries:
Art books and catalogs: PNW
Dance Mandala, Lapis Twirl su tl re-ce 1995 PNW: 189
Leaf Wheel, Forest Song in dr pp (co) 1996 PNW: **187**
Night Journal et dr sl aq sf sb tp 1991 PNW: 188

THOMPSON, MILDRED 1936-
Biographical dictionaries:
Artbooks and catalogs: BAG
Love for Sale et 1959 BAG: 18/29

THOMPSON, PHYLLIS 1946-
Biographical dictionaries: WAA 78, 80
Art books and catalogs: BAG, RBW
Untitled et 1978 RBW: [24]
Untitled et hc (co) 1977 BAG: 40/29

THOMPSON, RICHARD CRAIG 1945-
Biographical dictionaries: WAA 76, 78, 80, 82, 84, 86, 89-90,
 91-92, 93-94, 95-96, 97-98
Art books and catalogs: FTP
Vessel Study-Lily mo (co) 1988 FTP: **81**

THORN, ROBERT 1953-
Biographical dictionaries:
Art books and catalogs: NPE
160 Lines sk (co) 1978 NPE: 165
It's All the Same sk 1978 NPE: 166

THRALL, ARTHUR 1926-
Biographical dictionaries: WAA 73, 76, 78, 80, 82, 84, 86, 89-
 90, 91-92, 93-94, 95-96, 97-98
Art books and catalogs: WAT
Document co-in (co) 1962 WAT: **270**

TILSON, JOE 1928-
Biographical dictionaries:
Art books and catalogs: TPI, TWO
Is This Ché Guevara? sk ce 1969 TWO: 64
Letter from Ché co-sc ce (co) 1970 TPI: **70**
Sky One co-sc td (co) 1967 TPI: **72**
Software Chart Questionnaire co-sc (co) 1968 TPI: **72**

TING, WALASSE 1929-
Biographical dictionaries: WAA 70, 73, 76, 78, 80, 82, 84, 86, 89-90, 91-92, 93-94, 95-96, 97-98
Art books and catalogs: APP
Miss U.S.A. li 1977 APP: 231

TINGUELY, JEAN 1925-
Biographical dictionaries:
Art books and catalogs: TWO
La Vittoria [*plate*] of rs hd mx 1972 TWO: 96

TITUS-CARMEL, GÉRARD 1942-
Biographical dictionaries:
Art books and catalogs: TWO
Plate 2 (*from* Sarx *by Pascal Quignard*) dr aq 1977 TWO: 120

TOBEY, MARK 1890-1976
Biographical dictionaries: WAA 40-41, 56, 59, 62, 66, 70, 73, 76
Art books and catalogs: AKG, AMI, APP, SIM, TYA, WAT
Blossoming aq 1970 TYA: 116
Brown Composition te-mo (co) 1960 SIM: **143**
Flight over Forms li 1966 TYA: 115
Summer Joy aq 1971 TYA: 116
Trees in Autumn te-mo cm-pa (co) 1962 SIM: **143**
Trio from Suite Transition aq 1970 APP: 212
Untitled li 1970 WAT: 287
Winter co-li (co) 1961 AKG: clp60 AMI: clp31

TOLBERT, FRANK XAVIER, JR. 1945-
Biographical dictionaries:

Art books and catalogs: FTP
Toad Noir wg dr aq 1988 FTP: **83**

TONER, ROCHELLE **1940-**
Biographical dictionaries:
Art books and catalogs: CUN
Didymous et 1988 CUN: 171
Fishermen (*from* the Chesapeake Suite) et 1988 CUN: **120**
Sailmaker (*from* the Chesapeake Suite) et 1988 CUN: **121**
Sensum et 1988 CUN: 172

TORLAKSON, JAMES DANIEL **1951-**
Biographical dictionaries: WAA 80, 82, 84, 86, 89-90, 91-92,
93-94, 95-96, 97-98
Art books and catalogs: AAP, TYA
19th Avenue Booth, 1: 00 A.M. et aq 1975 TYA: 117
51st and Coronado et aq 1973 TYA: 116
Rio et aq hc (co) 1983 AAP: 126

TORRES, FRANCESC **1948-**
Biographical dictionaries: WAA 86, 89-90, 91-92, 93-94, 95-96,
97-98
Art books and catalogs: INP
Northern Guernica aq sl 1986 INP: 18

TORRE-WHITESELL, MARILYN **1950-**
Biographical dictionaries:
Art books and catalogs: NPE
Mosaic Vision sf aq (co) 1976 NPE: 167
Ziggy et (co) 1976 NPE: 168

TREASTER, RICHARD A. **1932-**
Biographical dictionaries: WAA 73, 76, 78, 80, 82, 84, 86, 89-
90, 91-92, 93-94, 95-96, 97-98
Artbooks and catalogs: CIP
Vermeer and Times co-sc (co) 1984 CIP: **71**

TREIMAN, JOYCE WAHL **1922-**
Biographical dictionaries: WAA 40-47, 53, 56, 62, 66, 70, 73,

76, 78, 80, 82, 84, 86, 89-90, 91-92
Art books and catalogs: SIM
Edwin Dickinson co-mo hc hd (co) 1987 SIM: **156**

TROTTER, MCKIE 1909-
Biographical dictionaries:
Art books and catalogs: FWC
Sea Change (*from untitled portfolio*) et sf 1951 FWC: 40

TROVA, ERNEST TINO 1927-
Biographical dictionaries: WAA 66, 70, 73, 76, 78, 80, 82, 84, 86, 89-90, 91-92, 93-94, 95-96, 97-98
Art books and catalogs: AMI, APP
F. M. Manscapes [*plate*] sk 1969 AMI: clp66 APP: 146

TROWBRIDGE, DAVID 1945-
Biographical dictionaries:
Art books and catalogs: TYA
Untitled sk my 1972 TYA: 117

TRUE, DAVID F. 1942-
Biographical dictionaries: WAA 93-94, 95-96, 97-98
Art books and catalogs: FIM, PAP
Cold Romance aq sb dp 1985 PAP: 125
Savannah Sea aq sf sb (co) 1983 FIM: **131**

TUBIS, SEYMOUR 1919-93
Biographical dictionaries: WAA 53, 56, 59, 62, 66, 70, 73, 76, 78, 80, 82, 84, 86, 89-90, 91-92, 93-94
Art books and catalogs: PNM
Pueblo Ceremonial Trio wo 1975 PNM: 110

TURMO, PAT 1931-75
Biographical dictionaries:
Art books and catalogs: AWP
Yellow Light #9 sk os lf-pa-sn vm (co) 1973 AWP: [24]

TURNBULL, WILLIAM 1922-
Biographical dictionaries:

Art books and catalogs: THL
Untitled li 1961 THL: 41

TURNER, ALAN 1943-
Biographical dictionaries: WAA 76, 78, 80, 82, 84, 86, 89-90,
91-92, 93-94, 95-96, 97-98
Art books and catalogs: AAP
Tree Felled by Swirl I, II, III li tp 1981 AAP: 127

TURNER, JANET ELIZABETH 1914-88
Biographical dictionaries: WAA 53, 56, 59, 62, 66, 70, 73, 76,
78, 80, 82, 84, 86
Art books and catalogs: ACW, TYA
Dead Snow Goose II in sk 1974 TYA: 117
Frightened Jack Rabbit Hiding co-wo (co) 1950s ACW: 47, 110
See also:
Turner, Janet E. *Janet Turner, 1914-1988: Catalogue Raisonné,
Drawings, Paintings and Graphic Works.* Chico, Calif.: Chico
Museum Association, 1989.

TURRELL, JAMES ARCHIE 1943-
Biographical dictionaries: WAA 78, 80, 82, 84, 86, 89-90, 91-
92, 93-94, 95-96, 97-98
Art books and catalogs: FIM, PAP
Deep Sky (*one of 7*) aq 1984 FIM: **133**
Untitled #5 (*from portfolio* Deep Sky) aq 1984 PAP: 126

TUTTLE, RICHARD 1941-
Biographical dictionaries: WAA 70, 73, 76, 78, 80, 82, 84, 86,
89-90, 91-92, 93-94, 95-96, 97-98
Artbooks and catalogs: AKG
Two Books (*selection from two books*) sk 1970 AKG: clp62

TWOMBLY, CY 1928-
Biographical dictionaries: WAA 70, 73, 76, 78, 80, 82, 84, 86,
89-90, 91-92, 93-94, 95-96, 97-98
Art books and catalogs: AKG, AMI, APS, CMZ, ENP, TWO,
TYA
8 Odi di Orazio et 1968 AKG: clp64

Note I et 1968 TYA: 118
Note II et 1967 APS: clp**53**
Sketches (*portfolio of 6*) et 1967 APS: clp50
Untitled li 1971 ENP: *abc*
Untitled mz dr 1968 CMZ: [62]/47
Untitled I et aq 1967-74 APS: clp51
Untitled II et aq 1967-74 AMI: clp76 APS: clp52 TWO: 89
See also:
Bastian, Heiner. *Cy Twombly, Das Graphische Werk, 1953-1984:
 A Catalogue Raisonné of the Printed Graphic Work.* New
 York: New York University Press, 1985.
Lambert, Yvon. *Cy Twomby: Catalogue Raisonné des Oeuvres
 sur Papier de Cy Twombly.* Milano: Multhipla Edizioni,
 1979.
Lambert, Yvon. *Cy Twombly: Catalogue Raisonné des Oeuvres
 Sur Papier. Volume VII: 1977-1982.* Milan: Multhipla
 Edizioni, 1991.

TWORKOV, JACK 1900-82
 Biographical dictionaries: WAA 40-47, 53, 56, 59, 62, 66, 70,
 73, 76, 78, 80, 82
 Art books and catalogs: TCR, TGX, TYA
 KTL #1 li (co) 1982 TCR: **364** TGX: **97**
 L.P. #3 Q3-75 li 1975 TYA: 118

UCHIMA, ANSEI 1921-
 Biographical dictionaries: WAA 66, 70, 73, 76, 78, 80, 82, 84,
 86, 89-90, 91-92, 93-94, 95-96, 97-98
 Art books and catalogs: ACW, APP, ESS
 Flight co-wo (co) 1968 ACW: **54**, 114
 In Blue [Dai] co-wo (co) 1975 ESS: [34]
 Light Mirror, Water Mirror wo (co) 1977 APP: clp**28**

UTTER, BROR 1913-
 Biographical dictionaries:
 Art books and catalogs: FWC
 Creatcher et sf en 1946 FWC: 43
 Foo Dog and Jellyfish co-et aq (co) 1968 FWC: **39**
 Man in the Pit et sf bn 1941 FWC: 41
 Strata et sf c.1944 FWC: 42

VANDERPERK, TONY 1944-
 Biographical dictionaries:
 Art books and catalogs: TYA
 Untitled wd-in 1974 TYA: 119

VAN HOESEN, BETH (ADAMS) 1926-
 Biographical dictionaries: WAA 59, 62, 66, 70, 73, 76, 78, 80,
 82, 84, 86, 89-90, 91-92, 93-94, 95-96, 97-98
 Art books and catalogs: APP, TYA
 Nap dr 1961 APP: 210 TYA: 120

VAN HOUTEN, KATRINE 1940-
 Biographical dictionaries:
 Art books and catalogs: ENP
 Passage I sk ENP: *abc*

VAN SOELEN, THEODORE 1890-1964
 Biographical dictionaries: WAA 36-37, 40-41, 40-47, 53, 56,
 59, 62
 Art books and catalogs: PNM
 Cook li 1952 PNM: 63

VAN VLIET, CLAIRE 1933-
 Biographical dictionaries: WAA 78, 80, 82, 84, 86, 89-90, 91-
 92, 93-94, 95-96, 97-98
 Artbooks and catalogs: AWP, ENP, PWP
 Horbylunde Storm li 1965 ENP: *abc*
 Snow Cloud li ri ss 1973 AWP: [25]
 Wheeler Rocks Series, #21 mp hm 1989 PWP: clp79/118

VASARELY, VICTOR 1908-97
 Biographical dictionaries:
 Art books and catalogs: TWO
 Homage to the Hexagon (*two from portfolio*) sk (co) 1969 TWO:
 54

VATH, MARY JO 1956-
 Biographical dictionaries:

Artbooks and catalogs: PWP
Lure sl aq (co) 1989 PWP: clp30/118

VICENTE, ESTEBAN 1906-
Biographical dictionaries:
Art books and catalogs: THL
Untitled li 1962 THL: 17

VIDA
Biographical dictionaries:
Art books and catalogs: NCP
Avebury by Air rc-to bf 1984 NCP: 16

VIESULAS, ROMAS 1918-86
Biographical dictionaries: WAA 56, 59, 62, 66, 70, 73, 76, 78,
80, 82, 84, 86
Art books and catalogs: AML, APP, RBW, TYA
Annunciation vl fa 1970 TYA: 120
Island Omega li 1979 RBW: [25]
On the Brass Gate vl fa 1971 TYA: 120
Paso Doble [Toro Desconocido V] li 1960 AML: 202
Yonkers II li in-em 1967 APP: 159

VISSER, CAREL 1928-
Biographical dictionaries:
Art books and catalogs: TWO
Untitled wo 1965 TWO: 57

VITAL, NOT 1948-
Biographical dictionaries:
Art books and catalogs: PRO
Snowblind (*set of 7*) aq re pe tc 1987 PRO: clp81

VON WICHT, JOHN 1888-1970
Biographical dictionaries: WAA 40-41, 40-47, 53, 56, 59, 62,
66, 70
Art books and catalogs: APP, RBW, TYA
Black and White sn 1960 TYA: 121
Dawn li 1953 RBW: [26]
Juggler sn 1963 APP: 93

WAGNER, NORMAN J. 1938-
Biographical dictionaries:
Art books and dictionaries: GAP
Spatial Continuum #12...From the Cave of the Unknown sv-wo
1985 GAP: 9/31

WALD, SYLVIA 1914-
Biographical dictionaries: WAA 53, 56, 62, 66, 70, 73, 76, 78,
80, 82, 84, 86, 89-90, 91-92, 93-94, 95-96, 97-98
Art books and catalogs: APP, WAT
Dark Wings co-sk (co) 1953-54 APP: 120 WAT: 222

WALKER, SANDY 1942-
Biographical dictionaries:
Art books and catalogs: PRO
Forest Suite (*suite of 4*) wo 1989 PRO: clp80

WALKER, (HAROLD) TODD 1917-
Biographical dictionaries:
Art books and catalogs: TYA
Untitled (*dimensions: 13 x 19 ½*) sk (co) 1975 TYA: 121
Untitled (*dimensions: 12 ¼ x 8 ¼*) sk (co) 1975 TYA: 123

WALKINGSTICK, KAY 1935-
Biographical dictionaries: WAA 82, 84, 86, 89-90, 91-92, 93-
94, 95-96, 97-98
Artbooks and catalogs: PWP
Triphammer et ch tp (co) 1987 PWP: clp93/118

WALMSLEY, WILLIAM AUBREY 1923-
Biographical dictionaries: WAA 76, 78, 80, 82, 84, 86, 89-90,
91-92, 93-94, 95-96, 97-98
Art books and catalogs: CUN, ESS, TYA
Ding Dong Daddy #4 Oars li (co) 1966 TYA: **122**
Ding Dong Daddy #8.2 co-li (co) 1966 CUN: 176
Ding Dong Daddy #11 Never co-li (co) 1967 CUN: 175
Ding Dong Daddy Crap Art dg-li (co) 1987 CUN: **123**
Ding Dong Daddy Non Dairy Creamers co-li (co) 1975 ESS: [36]

Ding Dong Daddy Whew li (co) 1973 TYA: 123
Walmsley in 2288 dg-li (co) 1989 CUN: **122**

WALTERS, ROBERT 1925-
Biographical dictionaries:
Art books and catalogs: PNM
Whorlworm (*from portfolio* Prints in the Desert) co-wo (co) 1950
PNM: clp3

WALTERS, SYLVIA SOLOCHEK 1938-
Biographical dictionaries: WAA 78, 80, 82, 84, 86, 89-90, 91-92, 93-94, 95-96, 97-98
Art books and catalogs: ACW, AWP
Potato Low re wo sn hf 1975 AWP: [26]
Summer Self-Portrait rv-co-wo (co) 1977 ACW: **68**, 121

WARD, LYND (KENDALL) 1905-85
Biographical dictionaries: WAA 36-37, 40-41, 40-47, 53, 56, 62, 66, 70, 73, 76, 78, 80, 82, 84
Art books and catalogs: WAT
Two Men wo-en 1960 WAT: 290

WARHOL, ANDY 1928?-87
Biographical dictionaries: WAA 66, 70, 73, 76, 78, 80, 82, 84, 86
Art books and catalogs: AAP, AKG, AMI, AMP, APM, APP, APS, BWS, FIM, GMC, PAC, PAP, PIA, POR, TCA, TPI, TWO, TYA, WAT
Beef with Vegetables and Barley (*from portfolio* Campbell's Soup Can I) co-sk (co) 1969 AKG: clp69
Birmingham Race Riot sc 1964 TPI: **75**
Cagney co-sc (co) 1964 TPI: **75**
Campbell's Soup I (*portfolio of 10*) co-sc (co) 1968 APS: clp34
Chairman Mao (*from portfolio of 10*) co-sk (co) 1972 APM: fcv/22
Chicken Noodle Soup (*from* Campbell's Soup I) co-sc (co) 1968 APS: **fcv** TPI: **19**
Cooking Pot (*from portfolio* International Anthology of Contemporary Engraving: The International Avant-Garde:

America Discovered, Volume 5) et pn 1962 AMI: clp43 APS:
 clp24 FIM: **41** TPI: 101
Cow co-sc (co) wp 1966 TPI: 102
Cream of Mushroom Soup (*from* Campbell's Soup I) co-sc (co)
 1968 TPI: 103
Electric Chair (*one from series of 10*) co-sk (co) 1971 AKG:
 clp69a GMC: 60
Fiesta Pig sc (co) 1979 AMP: 107
Flowers sk (co) 1970 AMI: clp**63**
Jackie I (*from* 11 Pop Artists, Volume I) co-sc (co) 1965 TPI: **74**
Jackie III co-sk (co) 1965 AMI: clp62 TPI: 23
Kiss (*from* Seven Objects in a Box) sc px 1966 TPI: 102
Liz co-of-li (co) 1964 APS: clp**30a**, clp**30b** TPI: 102
Mao Tse-Tung (*from portfolio* Mao Tse-Tung) sc 1972 PAC:
 [54]/94
Mao Tse-Tung (*portfolio*) sk 1972 POR: 262
Marilyn co-sc (co) 1967 APS: clp**31-33**
Marilyn Monroe (*from portfolio* Marilyn Monroe) co-sk (co) 1967
 AKG: clp67 PIA: **141**/114 TCA: [32] TPI: **20**, 103 TYA: 123
 WAT: **207**
Marilyn Monroe Diptych sk am ac ca (co) 1962 TWO: **33**
Marilyn Monroe I Love Your Kiss Forever Forever (*from* 1¢ Life)
 li 1964 AMI: clp**44**
Mick Jagger sc 1975 APP: 176
Paris Review Poster co-sc (co) 1967 TPI: 103
Plate 11 (*from* Flash *by Phillip Green*) sk 1968 TWO: 63
Portrait of Jane Fonda sc 1982 AAP: 128
Portraits of the Artists (*from* Ten from Leo Castelli) sc co-sr-bx
 (co) 1967 TPI: 106
Print #8 (*from the set* Mick Jagger) sk wc (co) 1975 TYA: **119**
"Rebel Without a Cause" [James Dean] (*from portfolio* Ads) sc
 (co) 1985 PAP: **11**, 127
S&H Greenstamps [*detail*] co-of-li (co) 1965 TPI: **end**
Self Portrait co-sc (co) 1967 APS: clp29 BWS: 24/31 TPI: 103
Tomato Soup (*from* Campbell's Soup I) co-sk (co) (1968 *or* 1969)
 AMP: 6, **109** TPI: **19**
Untitled (*from portfolio* For Meyer Schapiro) co-sk (co) 1974
 GMC: 69
See also:

Warhol, Andy. Edited by Frayda Feldman and Jörg Schellmann. *Andy Warhol Prints: A Catalogue Raisonné*. New York: Abbeville Press, 1985.

WARSHAW, HOWARD 1920-77
Biographical dictionaries: WAA 62, 66, 70, 73, 76, 78
Art books and catalogs: LAP
Hands co-et (co) 1951 LAP: 61/102
Head of Traffic Victim li c.1950 LAP: 59/102

WASHINGTON, TIMOTHY 1946-
Biographical dictionaries: LAP
One Nation Under God en al (co) 1970 LAP: 88/106

WAYNE, JUNE CLAIRE 1918-
Biographical dictionaries: WAA 70, 73, 76, 78, 80, 82, 84, 86, 89-90, 91-92, 93-94, 95-96, 97-98
Art books and catalogs: AMI, AML, GAR, LAP, THL, WAT
Adam en Attente li 1958 LAP: 64/103
At Last a Thousand II co-li (co) 1965 LAP: 71/104
At Last a Thousand III li 1965 THL: 22 WAT: **201**
Eve Tentee li 1958 LAP: 64/103
Glitterwind co-li (co) 1981 GAR: 27
Shine Here to Us and Thou Art Everwhere li 1956 AML: 184 WAT: 240
Tower of Babel A li 1955 WAT: 239
Travellers li 1954 AMI: clp32
Tunnel li 1951 LAP: 63/103
"Twicknam Garden" (*from* John Donne: Songs and Sonnets) li 1958 AML: 197
Witnesses li 1952 LAP: 63/103

WEARE, SHANE 1936-
Biographical dictionaries: WAA 76, 78, 80, 82, 84, 86, 89-90, 91-92, 93-94, 95-96, 97-98
Art books and catalogs: TYA
Meeting Place et 1975 TYA: 124

WEBER, IDELLE LOIS 1932-
Biographical dictionaries: WAA 66, 70, 73, 76, 78, 80, 82, 84,

86, 89-90, 91-92, 93-94, 95-96, 97-98
Art books and catalogs: SIM
Untitled (*from series* Cambridge Series A11) mo 1992 SIM: 153

WEBER, STEPHANIE **1943-**
Biographical dictionaries:
Art books and catalogs: NPE
Opening Thoughts IV hm cg ce-xx et (co) 1978 NPE: 169
Reliquary IX et em co-xx hc wc (co) 1978 NPE: **10**, 170

WEEGE, WILLIAM **1935-**
Biographical dictionaries: WAA 73, 76, 78, 80, 82, 84, 86, 89-
90, 91-92, 93-94, 95-96, 97-98
Art books and catalogs: ACW, EIE, GAR, TYA, WAT
Dance of Death co-wb hm (co) 1990 ACW: **89**, 131
He----in Chicago sk 1973 TYA: 124
Record Trout sk fk-gt at (co) 1976 WAT: **278**
Untitled #10 co-mo re hm (co) 1982 GAR: **35**
Yes Virginia There Really Was a Turkey EIE: 23

WEGMAN, WILLIAM **1943-**
Biographical dictionaries: WAA 76, 78, 80, 82, 84, 86, 89-90,
91-92, 93-94, 95-96, 97-98
Art books and catalogs: AAP
Missing Dog li 1983 AAP: 129

WEICHSELBAUM, WILMA JANE **1948-**
Biographical dictionaries:
Art books and catalogs: ENP
Emergence of the Butterfly li 1971 ENP: *abc*

WEIL, SUSAN
Biographical dictionaries:
Art books and catalogs: RBW
Folding Folds et 1984 RBW: [25]

WEISBERG, RUTH ELLEN **1942-**
Biographical dictionaries: WAA 78, 80, 82, 84, 86, 89-90, 91-
92, 93-94, 95-96, 97-98

Artbooks and catalogs: PWP, SIM
Before the Bath co-mo (co) 1990 SIM: **163**
Good Daughter li 1989 PWP: clp67/118
See also:
Weisberg, Ruth. *Ruth Weisberg Prints: Mid-life Catalogue
Raisonné, 1961-1990: Fresno Art Museum, June 1990.*
Fresno, Calif.: Fresno Art Museum, 1990.

WELLIVER, NEIL G. 1929-
Biographical dictionaries: WAA 62, 66, 70, 73, 76, 78, 80, 82,
84, 86, 89-90, 91-92, 93-94, 95-96, 97-98
Art books and catalogs: TYA
Brown Trout et wc 1975 TYA: 124
Si's Hill sk 1973 TYA: 125

WELLS, JAMES LESESNE 1902-93
Biographical dictionaries: WAA 36-37, 40-41, 40-47, 53, 56,
62, 66, 70, 73, 76, 78, 80
Artbooks and catalogs: BAG
Bus Stop, Ghana co-li (co) 1975 BAG: 44/31

WENGENROTH, STOW 1906-78
Biographical dictionaries: WAA 36-37, 40-41, 40-47, 53, 56,
59, 62, 66, 70, 73, 76
Art books and catalogs: APP, GRE, TYA
Meeting House li 1949 GRE: clp*106*
Quiet Hour li 1947 TYA: 125
Untamed li 1947 APP: 38 TYA: 125

WERGER, ART(HUR LAWRENCE) 1955-
Biographical dictionaries: WAA 86, 89-90, 91-92, 93-94, 95-96,
97-98
Art books and catalogs: CUN, GAP, MCN
By Force mo 1988 MCN: **[15]**
Cloudburst mo 1991 CUN: 179
Incident Before Dawn et aq 1985 GAP: 5/31
Neighborhood Watch: The Fight et (co) 1988 CUN: **124**
Other Side et (co) 1989 CUN: **123**
Violation mo 1987 CUN: 181

WESSELMANN, TOM 1931-
> **Biographical dictionaries:** WAA 66, 70, 73, 76, 78, 80, 82, 84, 86, 89-90, 91-92, 93-94, 95-96, 97-98
> **Art books and catalogs:** AKG, AMI, APS, PIA, TPI, TYA, WAT
> Christmas Collage co-cl (co) 1961 AKG: clp70a
> Foot co-sk (co) 1968 AKG: clp70
> Great American Nude co-sk (co) 1969 WAT: **208**
> Nude li sk 1976 TYA: 127
> Nude (*from* 11 Pop Artists, Volume III) co-sc (co) 1965 TPI: **76**
> Nude (for SEDFRE) co-sc (co) 1969 APS: clp37 PIA: **144/114**
> Nude Print sk (co) 1969 AMI: clp**64**
> Smoker li em (co) 1976 TYA: **126**
> T.V. Still Life co-sc (co) 1965 TPI: 77
> Untitled sk 1965 TYA: 127
> **See also:**
> Fairbrother, Trevor J. *Tom Wesselmann: Graphics, 1964-1977* (exhibition catalog). Boston: The Institute of Contemporary Art, 1978.

WESTERMANN, H.C. (HORACE CLIFFORD) 1922-81
> **Biographical dictionaries:** WAA 66, 70, 73, 76, 78, 80, 84, 86, 89-90, 91-92, 93-94, 95-96, 97-98
> **Art books and catalogs:** AMI, APM, THL
> Human Fly wo 1971 APM: 24
> See America First [*Plate 16*] co-li (co) 1968 THL: 59
> See America First [*Plate 17*] li 1968 AMI: clp70

WHITE, CHARLES WILBERT 1918-79
> **Biographical dictionaries:** WAA 40-47, 53, 56, 62, 66, 70, 73, 76, 78
> **Art books and catalogs:** LAP, RBW
> Exodus II co-li (co) 1966 LAP: 80/105
> Frederick Douglas li 1973-74 RBW: [25]

WHITEHORSE, EMMI 1960-
> **Biographical dictionaries:**
> **Artbooks and catalogs:** PWP
> Yei's Divisive Manner hc-li (co) 1987 PWP: clp**86**/118

WILEY, WILLIAM T. 1937-
Biographical dictionaries: WAA 70, 73, 76, 78, 80, 82, 84, 86, 89-90, 91-92, 93-94, 95-96, 97-98
Art books and catalogs: AAP, AMI, ENP, INP, FIM, PAC, PIA, TYA
Coast Reverse li pa cm hp dp (co) 1972 FIM: 88 PIA: **152**/115
Ecnud li wv 1973 TYA: 127
Hanging Up the Frame (*from book* Suite of Daze) bk 1977 PAC: [55]/95
Moon Mullings li (co) 1972 ENP: *abc* FIM: **87**
Pilgrim Repair sf aq ce 1989 INP: 16
Scarecrow et aq 1974 TYA: 128
Seasonall Gate et 1975 AMI: clp132
Who the Alien? et cm 1983 AAP: 130

WILLIAMS, DANNY 1950-
Biographical dictionaries:
Art books and catalogs: FTP
Study: Temples and Monuments et ch 1985 FTP: **85**

WILLIAMS, MICHAEL KELLY 1950-
Biographical dictionaries:
Art books and catalogs: RBW
House of Somnus et 1983 RBW: [26]

WILLIAMS, WILLIAM THOMAS 1942-
Biographical dictionaries: WAA 80, 82, 84, 86, 89-90, 91-92, 93-94, 95-96, 97-98
Art books and catalogs: RBW
Ellington et 1984 RBW: [26]

WILSON, ROBERT A. 1941-
Biographical dictionaries: WAA 82, 84, 86, 89-90, 91-92, 93-94, 95-96, 97-98
Art books and catalogs: GAR, PAP
"Alceste," Act III, Scene 9 li 1985 GAR: 51
Golden Windows ps 1986 GAR: 49
Untitled #5 (*from* Parsifal) li 1985 PAP: 128

WILSON, WENDY
 Biographical dictionaries:
 Art books and catalogs: RBW
 Bambara Memories et 1973 RBW: [27]

WINKLER, RALF
 See PENCK, A. R.

WINTERS, TERRY 1949-
 Biographical dictionaries:
 Art books and catalogs: AAP, APR, FIM, PAC, PAP, PIA, PRO
 Double Standard li (co) 1984 PIA: **188**/119
 Factors of Increase li 1983 FIM: **19** AAP: 131
 Folio (*portfolio of 11*) co-li hm (co) 1985-86 PRO: clp82
 Morula II co-li (co) 1983-84 APR: 5/[16] PAC: [58]/95
 Ova li 1982 FIM: **127**
 Primer li 1985 PAP: 129

WIRSUM, KARL 1939-
 Biographical dictionaries: WAA 86, 89-90, 91-92, 93-94, 95-96,
 97-98
 Art books and catalogs: CHI, GAR, PIA
 BAD BLUE Boys Make Good! co-sk (co) 1980 CHI: 183
 Before you Go with the Glow lets SPLIT the Difference co-ps (co)
 1980 CHI: 183 GAR: 19
 Bell Hop of-li 1978 CHI: 178
 Bird in the Hand is Worth Two in the Bus co-sk (co) 1978 CHI:
 178
 Blue Boys SPLIT the Difference co-sk (co) 1980 CHI: 183
 Bows without Buttons lc 1971 CHI: 176
 Chain Mail Stationery lc 1971 CHI: 176
 Chalk it off to Tex perience co-sk (co) 1980 CHI: 183
 Cheek-Cargo's Own Eddie Foy (*from portfolio* Da Hairy Who) sk
 (co) 1967-68 CHI: 193
 Chris Mist Cowboy co-li (co) 1980 CHI: 182 GAR: 17
 Correspondence (*pages 7, 9, and 10 from a collaborative
 print/catalog by Ray Johnson and Karl Wirsum*) of-li 1976
 CHI: 208
 Cracked Record lc 1971 CHI: 176

Painter's Cap lc c.1972 CHI: 177

Portable Hairy Who! (*comic book by James Falconer, Art Green, Gladys Nilsson, Jim Nutt, Suellen Rocca, and Karl Wirsum*) bk co-of-li (co) 1966 CHI: 194-95

Pumpkin Mask (H) of-li 1978 CHI: 179

Pumpkin Mask (V) of-li 1978 CHI: 179

Pumpkin Print #1 re 1978 CHI: 179

Pumpkin Print #2 re 1978 CHI: 179

Remind Me to Call Off the Dogs co-sk (co) 1974 CHI: 178

Santa Hat of-li (co) 1980 CHI: 189

Santi-Cloth of-li 1972 CHI: 187

Self Portrait et 1959-60 CHI: 175

She Was Impressive et re-bs (co) 1980 CHI: 184

Single Signed li 1994 PIA: 108

Skull Daze co-li (co) 1971 CHI: 177

Skull Mask of-li 1978 CHI: 179

Skull Quiet lc c.1972 CHI: 177

Street Corner Santa of-li 1978 CHI: 180

Surplus Slop from...the Windy City of-li 1970 CHI: 186

Tattoo Stamp rs 1972 CHI: 177

Tex Tour co-li (co) 1980 CHI: **34**, 182

Transplant: Famous Heart-Tits from Chicago (*invitation*) of-li 1970 CHI: 186

Transplant: Famous Heart-Tits from Chicago (*poster*) sk co-fk (co) 1970 CHI: 186

Wade "N" C Policy co-li (co) 1983 CHI: 185

Wake Up Yer Scalp with Chicago of-li 1970 CHI: 187

We Got Nuthun to Hyde! Unique Art Auction at 8/Special Fund Razor sk (co) 1974 CHI: 188

Weasel While You Work (#1) co-of-li (co) c.1972 CHI: 187

Weasel While You Work (#2) of-li c.1972 CHI: 187

Whats the Coinfusion I Can't Make Heads or Tails of It? Sum One Flipped! Now That Makes Cents. co-sk (co) 1974 CHI: **34**, 178

Woman and Birds li 1959-60 CHI: 175

Woman's Head et (co) 1959-60 CHI: 175

Women with Birds and Flowers mo hc-wc (co) 1960-61 CHI: 175

Worse Sum Show of-li 1970 CHI: 186

WOEHRMAN, RALPH 1940-
Biographical dictionaries: WAA 76, 78, 80
Art books and catalogs: TYA
Attacus Edwards II in 1975 TYA: 128
Henrietta in 1974 TYA: 128

WOELFFER, EMERSON SEVILLE 1914-
Biographical dictionaries: WAA 40-41, 70, 73, 76, 78, 80, 82,
 84, 86, 89-90, 91-92, 93-94, 95-96, 97-98
Art books and catalogs: AML, LAP, THL
O=X li 1951 AML: 171
Untitled co-li (co) 1961 LAP: 68/104 THL: 24

WOLF, SHERRIE 1952-
Biographical dictionaries:
Art books and catalogs: PNW
Cup Collection hc-et aq (co) 1995 PNW: 192
Persistence hc-et aq (co) 1996 PNW: **191**
Stripes and Pear hc-et aq cp (co) 1995 PNW: 193

WOLFF, DEE I. 1948-
Biographical dictionaries: WAA 91-92, 93-94, 95-96, 97-98
Art books and catalogs: NPE
Crossroads One hm li-cy li et tp (co) 1978 NPE: 172
Untitled et 1978 NPE: 171

WOLFF, EFFRAM 1950-
Biographical dictionaries:
Art books and catalogs: NCP, PNW
Bean Soup et aq (co) 1992 PNW: **195**
Giant Auto Wreckers hc-le (co) 1996 PNW: 197
Terminal mu-in 1986 NCP: 8
Trailers et aq 1995 PNW: 196

WONG, PAUL KAN 1951-
Biographical dictionaries: WAA 84, 86, 89-90, 91-92, 93-94,
 95-96, 97-98
Art books and catalogs: NPE
Sites for Three Sunken Trapezoids li 1978 NPE: 174

Winds and Moods li 1977 NPE: 173

WOOD, THOMAS 1951-
Biographical dictionaries:
Art books and catalogs: PNW
Creatures of the Sky et ch (co) 1995 PNW: **199**
Some Beasts Will Eat Anything et aq 1986 PNW: 201
Young Icarus dr 1988 PNW: 200

WOODMAN, GEORGE 1932-
Biographical dictionaries:
Art books and catalogs: ENP
Algebraic Pattern sk 1971 ENP: *abc*

WOODRUFF, HALE ASPACIO 1900-80
Biographical dictionaries: WAA 40-41, 40-47, 53, 56, 62, 66,
70, 73, 76, 78, 80
Art books and catalogs: RBW
Prominade lc RBW: [27]

WORLEY, TAJ 1947-
Biographical dictionaries:
Art books and catalogs: NPE
Interweave sk et sc (co) 1976 NPE: **fpc**, 175
Pathways et sf ob 1977 NPE: 176

WRAY, DICK 1933-
Biographical dictionaries: WAA 70, 73, 76, 78, 80, 82, 84, 86,
89-90, 91-92, 93-94, 95-96, 97-98
Art books and catalogs: FTP, THL
Untitled li 1964 THL: 21
Untitled mo wo (co) 1987 FTP: **87**

WRIGHT, DMITRI 1948-
Biographical dictionaries:
Art books and catalogs: ENP
Untitled sn 1970 ENP: *abc*

WUJCIK, THEO 1936-
Biographical dictionaries: WAA 73, 76, 78, 86, 89-90, 91-92, 93-94, 95-96, 97-98
Art books and catalogs: PPP, TYA
Portrait of June Wayne li hc (co) 1973 PPP: 62 TYA: 129
Larry Bell, John Altoon, Ed Moses st-en tp 1970 TYA: 129

WYCKOFF, CHRISTY N. 1946-
Biographical dictionaries:
Art books and catalogs: PNW
Look Out sc 1991 PNW: 205
Slope II li 1995 PNW: 204
Wizard ij (co) 1996 PNW: **203**

YAMAZAKI, KAZUHIDE 1951-
Biographical dictionaries:
Art books and catalogs: AAP
House Wife mo 1983 AAP: 132

YANG, JANET F. 1955-
Biographical dictionaries:
Art books and catalogs: NPE
Cloud Bank pe ch 1976 NPE: 177
Sunset: Hanalei pe ag hc in wc go (co) 1977 NPE: 178

YARDE, RICHARD FOSTER 1939-
Biographical dictionaries: WAA 80, 82
Art books and catalogs: RBW
Falls li 1983 RBW: [27]

YATES, STEVE (STEVEN A.) 1949-
Biographical dictionaries: WAA 82, 84, 86, 89-90, 91-92, 93-94, 95-96, 97-98
Art books and catalogs: PNM
Quartet EPC, I ek li 1988 PNM: 132

YOUKELES, ANNE 1920-
Biographical dictionaries: WAA 78, 80, 82, 84, 86, 89-90, 91-92, 93-94, 95-96, 97-98

Art books and catalogs: ENP
Shining Darkly sk 1971 ENP: *abc*

YOUNG, ALFRED 1936-
Biographical dictionaries:
Art books and catalogs: PNM
Sandia co-li (co) 1966 PNM: 77

YOUNG, FRANK HERMAN 1888-
Biographical dictionaries: WAA 40-47, 53, 56, 62
Art books and catalogs: RBW
Baby II pe dp 1983 RBW: [28]

YOUNGBLOOD, JUDY
Biographical dictionaries: WAA 82, 84, 86, 89-90, 91-92, 93-
94, 95-96, 97-98
Art books and catalogs: FTP
Primary Head #4 lc (co) 1990 FTP: **89**

YOUNGERMAN, JACK 1926-
Biographical dictionaries: WAA 62, 66, 70, 73, 76, 78, 82, 84,
86, 89-90, 91-92, 93-94, 95-96, 97-98
Art books and catalogs: APP
Suite of Changes [*Plate I*] sc (co) 1970 APP: clp**12**

YUNKERS, ADJA 1900-83
Biographical dictionaries: WAA 53, 56, 59, 62, 66, 70, 73, 76,
78, 80, 82, 84
Art books and catalogs: AAP, ACW, AMI, AML, APP, PIA,
PNM, SIM, THL, TYA, WAT
Aegean II li em 1967 APP: 90
Big Kiss wo (co) 1946 TYA: **6**
La Mesa co-mo (co) c.1948 SIM: **141**
Magnificat co-wo (co) 1953 WAT: 181
Miss Ever-Ready (*from* Rio Grande Graphics) co-wo (co) 1952
AMI: clp**18** PNM: 49
Moment into Eternity II sc li et 1982 AAP: 133
Ostia Antica IV, Roma wo (co) 1955 APP: clp**4**
Ostia Antica VI co-wo (co) 1955 ACW: **39**, 105

Skies of Venice [*Plate IV*] li 1960 THL: 20
Skies of Venice [*Plate V*] li (co) 1960 PIA: **126**/112
Skies of Venice I li 1960 WAT: 246
Skies of Venice VIII li 1960 AML: 203
Succubae (*from portfolio* Prints in the Desert) co-wo (co) 1950
 PNM: clp**2**

ZAKANITCH (*OR* ZAKANYCH), ROBERT RAHWAY 1935-
 Biographical dictionaries: WAA 78, 80, 82, 84, 86, 89-90, 91-
 92, 93-94, 95-96, 97-98
 Art books and catalogs: TCR
 Double Geese Mountain sc li sn hm (co) 1981 TCR: **369**
 Hearts of Swan (Black) sc li sn hm (co) 1981 TCR: **368**
 Hearts of Swan (Red) sc li hm (co) 1981 TCR: **368**
 How I Love Ya, How I Love Ya sc li sn (co) 1981 TCR: **370-71**

ZAMMITT, NORMAN 1931-
 Biographical dictionaries: WAA 66, 70, 76, 78, 80, 82, 84, 86,
 89-90, 91-92, 93-94, 95-96, 97-98
 Art books and catalogs: LAP
 Untitled co-li (co) 1967 LAP: 76/105

ZEBRUN, CAMERON 1955-
 Biographical dictionaries:
 Art books and catalogs: NPE
 Ocean Song li hc hd (co) 1977 NPE: 179
 Triangle Landscape li 1977 NPE: 180

ZELT, MARTHA 1930-
 Biographical dictionaries: WAA 76, 78, 80, 82, 84, 86, 89-90,
 91-92, 93-94, 95-96, 97-98
 Art books and catalogs: PNM, PWP, TYA
 Glimmering mx 1976 TYA: 129
 Grey Cat sw-li fa pa 1986 PWP: clp24/118
 Return to A-qq #3 co-li sw pa-ce fa (co) 1983 PNM: 129

ZIEMANN, RICHARD CLAUDE 1932-
 Biographical dictionaries: WAA 66, 70, 73, 76, 78, 80, 82, 84,
 86, 89-90, 91-92, 93-94, 95-96, 97-98

Art books and catalogs: TYA
Back Woods et en tp 1971-76 TYA: 130
Edge of the Woods et en 1968-69 TYA: 130

ZIMMERMAN, LOIS 1914-
Biographical dictionaries:
Art books and catalogs: PNM
Mt. Shuksan lc 1990 PNW: 209
Outback lc 1988 PNW: 208
Storm Over the Cascades sm-co-et (co) 1985 PNW: **207**

ZIRKER, JOSEPH 1924-
Biographical dictionaries: WAA 73, 76, 78, 80, 82, 84, 86, 89-
 90, 91-92, 93-94, 95-96, 97-98
Art books and catalogs: CAM, SIM
JZ-MV-11B mo 1983 CAM: 23/47
Wrestling, Graeco-Roman (after *Muybridge*) cr mo 1976 SIM:
 173

ZLAMANY, BRENDA LOUISE 1959-
Biographical dictionaries:
Art books and catalogs: RBW
Untitled pe pp 1982 RBW: [28]

ZUNIGA, FRANCISCO 1912-
Biographical dictionaries: WAA 73, 76, 78, 95-96, 97-98
Artbooks and catalogs:
See also:
Brewster, Jerry. *Zuniga: The Complete Graphics, 1972-1984.*
New York: Alpine Fine Arts Collection, 1984.

SUBJECT INDEX

Nilsson, G.	Gladys Nilsson: Paintings…
Nilsson, G.	Hairy Who (*poster for 1ˢᵗ*…)
Nilsson, G.	Hairy Who (*poster for 2ⁿᵈ*…)
Nilsson, G.	Jim Nutt: Paintings…
Nilsson, G.	Thats Me: Gladys Nilsson
Nilsson, G.	Women (*announcement*)
Nilsson, G.	Women (*poster*)
Nutt, J.	Advertisement for Nutt's Frames
Nutt, J.	Hairy Who (*poster for 1ˢᵗ*…)
Nutt, J.	Hairy Who (*poster for 2ⁿᵈ*…)
Nutt, J.	Hairy Who (*poster for group*…)
Nutt, J.	J. Nutt
Nutt, J.	Jim Nutt [1974, *p. 107*]
Nutt, J.	Miss Gladys Nilsson
Nutt, J.	Now! Hairy Who Makes You…
Nutt, J.	Nutt's Frames
Ramberg, C.	False Image (*poster/invitation*…)
Ramberg, C.	False Image II
Ramberg, C.	False Image Postcards
Rocca, S.	Hairy Who (*poster for 1ˢᵗ*…)
Rocca, S.	Hairy Who (*poster for 2ⁿᵈ*…)
Rocca, S.	Toys Made by Chicago Artists
Rossi, B.	Summer 1972/Cloth Class
Warhol, A.	Cooking Pot
Westermann, H.C.	See America First [*Plate 16*]
Wirsum, K.	Dr. Chicago
Wirsum, K.	Hairy Who (*poster for 1ˢᵗ*…)
Wirsum, K.	Hairy Who (*poster for 2ⁿᵈ*…)
Wirsum, K.	Hare Toddy Kong Tamari
Wirsum, K.	Karl Wirsum
Wirsum, K.	Moming Masked Ball
Wirsum, K.	Santi-Cloth
Wirsum, K.	Surplus Slop from…the Windy…
Wirsum, K.	Transplant: Famous Heart-Tits…
Wirsum, K.	Wake Up Yer Scalp with Chicago
Wirsum, K.	Worse Sum Show

African-Americans

Adams, R.	Profile in Blue
Alexander, J.	Queen for a Day

Afterlife
Lomas-Garza, C. Heaven and Hell

Agony
Baskin, L. Every Man
Baskin, L. Torment
Golub, L. Wounded Warrior
Kohn, M. Season in Hell

Agriculture *see* Farms and Farming

Airplane Pilots
Nelson, Robert Torpedo Tabby

Airplanes *see also* Paper Airplanes
Anderson, Laurie Mt. Daly/US IV
Brown, Roger Airplane
Celmins, V. Concentric Bearings B
Celmins, V. Concentric Bearings D
Seawell, T. Around Town

Alabama
Warhol, A. Birmingham Race Riots

Alcoves *see also* Architecture
Hanson, P. Room with Niches

Alienation
Bourgeois, L. "In the mountains of central..."
Prentice, M. Implications of Sound, I
Solien, T.L. Three Sailors
Wolff, E. Trailers

Alligators
Kaneshiro, R. Standing Alligator II

Altars
Bomar, B. Altar

Steinberg, S. Sam's Art
Walmsley, W. Ding Dong Daddy Crap Art
Walmsley, W. Ding Dong Daddy Whew

Amputation
Nutt, J. Crushed Flowers
Nutt, J. SMack SMack

Amusement Parks
Hanson, P. Pavilion Park
Hanson, P. Pleasure Park I
Hanson, P. Pleasure Park II
Hanson, P. Pleasure Park III
Hanson, P. St. Anthony Pleasure Park
Johanson, G. Night Games #5

Angels *see also* Biblical Figures and Themes, Spirits
Williams, M.K. House of Somnus

Anguish
Baskin, L. Mantegna at Eremitani
Prentice, M. Implications of Sound, I
Prentice, M. Implications of Sound, II

Animals *see also* individual names of animals
Avery, March Striped Cat
Barrett, L. Untitled [Horses in Winter]
Baskin, L. Frightened Boy and His Dog
Beck, E. Geek's Picnic
Beck, H. St. Francis
Boxer, S. Argumentofnoavail
Boxer, S. Carnival of Animals [Title Page]
Boxer, S. Conventionofslydiscussants
Boxer, S. Curioustalking
Boxer, S. Finale
Boxer, S. Personages with Long Ears
Boxer, S. Spawnofcloverwithcuriousoccupants
Brown, Joan Donald
Burgess, C. Beast Series: Untitled
Caporeal, S. White Horse

Raffael, J.	Shaba III
Rathbun, R.K.	Living in Deliberate Optimism
Rivers, L.	Elephants
Rocca, S.	Monkey and Flower
Rothenberg, S.	Untitled
Scheier, S.	Shirt
Scholder, F.	Indian on Galloping Horse...
Sigler, H.	If She Could Free Her Heart...
Smith, J.Q.	Salish
Smith, J.Q.	Fancy Dancer
Smith, Lee	Dog Spirits
Smith, Moishe	Cow
Snidow, G.	Baby Sitter
Solomon, B.	Song of Songs
Sowiski, P.	Bull Shoulders
Stanuga, T.	Killer
Steinberg, S.	Untitled
Thiebaud, W.	Rabbit
Turner, J.	Frightened Jack Rabbit Hiding
Warhol, A.	Cow
Warhol, A.	Untitled
Wegman, W.	Missing Dog

Ants

Brown, Roger	Shit to Gold
Hockenhull, J.	Inheritors
Ruscha, E.	Swarm of Red Ants
Siler, P.	Bug Comes Out

Apparitions *see also* Dreams and Visions, Spirits

Nilsson, G.	Untitled [1964, *p. 83*]

Apples

Freckelton, S.	Openwork
Treaster, R.	Vermeer and Times

Appliances (Kitchen) *see also* Blenders

Glier, M.	Entertaining
Pond, C.	Kitchen in My Studio...

Aquariums

Boxer, S.	Aquarium
Lichtenstein, R.	Goldfish Bowl

Arc de Triomphe

Manns, S.	Paris

Arches

Acconci, V.	Building Blocks for a Doorway
Cumming, R.	Two Frame Arc
Davis, R.W.	Arch
LaRoux, L.	Keystone
Rabel, K.	Santuário para Toda

Architecture *see also* Alcoves, Arches, Bridges, Buildings, Cathedrals, Churches, Domes, Doors and Doorways, Hotels, Houses and Housing, Skyscrapers

Acconci, V.	Building Blocks for a Doorway
Artschwager, R.	Interior
Berger, P.	Treroll$_3$
Berman, Eugene	Nocturnal Cathedral
Bourgeois, L.	"In the mountains of central..."
Brown, Roger	1986 Navy Pier
Brown, Roger	Obelisk
Capps, C.	Mission at Trampas
Christo	MOMA (Rear)
Crane, P.	Neo-Colorado
Crutchfield, W.	Tamarind-Tanic
Estes, R.	Seagram Building
Estes, R.	Urban Landscapes No. 2
Farnsworth, D.	Counterpoint Series/Quatrefoil
Gilkey, G.	Theme Center, New York...
Goldman, J.	To the Garden
Haas, R.	Flatiron Building
Haas, R.	Great Hall, Kip Riker Mansion
Hamilton, R.	Solomon R. Guggenheim
Hanson, P.	Room with Niches
Hanson, P.	Room with Shells and Vases
Hockney, D.	Hotel Acatlán: First Day
Hockney, D.	Hotel Acatlán: Second Day

Hockney, D.	Views of Hotel Well III
Kepets, H.	Astor
Kepets, H.	Lenox
Kepets, H.	Tilden
Kerslake, K.	Magic House: Tear
Levine, M.	Pardee House (West View)...
Lichtenstein, R.	Untitled (Guggenheim Museum...)
Lichtenstein, R.	Cathedral #5
Lockwood, D.	Hats and Boots
Lowney, B.	Gateway
Milton, P.	Passage II
Myers, F.	Monte Alban I
Myers, F.	Taliesin West
Nesbitt, L.	Barriers
Oldenburg, C.	Double Screwarch Bridge
Olsen, D.	Castiglioncello L
Olsen, D.	Pentimento XXII
Pozzatti, R.	Venetian Domes
Rabel, K.	São Tomé
Sakuyama, S.	House in Brooklyn
Sakuyama, S.	Prospect Park West
Sheeler, C.	Architectural Cadences
Soave, S.	Architecture I
Williams, D.	Study: Temples and Monuments

Arctic

| Westermann, H.C. | See America First [*Plate 16*] |

Arizona

| Myers, F. | Taliesin West |

Armor

| Frasconi, A. | Franco I |

Arms (Body Parts)

| Johns, J. | Savarin [1977-81] |
| Rosenquist, J. | Certificate |

Arrows

| D'Arcangelo, A. | Landscape No. 3 |

Johns, J. Periscope
Johns, J. Untitled [1981]
Johns, J. Voice 2
Pindell, H. Kyoto: Positive/Negative

Art
Baldessari, J. I Will Not Make Any More...
Broodthaers, M. Museum
Brown, Roger False Image (*poster/invitation*...)
Brown, Roger False Image (*price list for 1st*...)
Brown, Roger False Image (*price list for 2nd*...)
Brown, Roger False Image II
Brown, Roger False Image Postcards
Brown, Roger Giotto in Chicago
Brown, Roger Shit to Gold
Cage, J. Not Wanting to Say Anything...
Colescott, W. History of Printmaking: Goya...
Colescott, W. Judgment Day at NEA
Cunningham, D. Pesca Cabeza #7
Damer, R.W. I Bombed the Taj Mahal...
Dine, J. Black and White Cubist Venus
Dube, E. False Image (*poster/invitation*...)
Dube, E. False Image (*price list for 1st*...)
Dube, E. False Image (*price list for 2nd*...)
Dube, E. False Image II
Dube, E. False Image Postcards
Eckart, C. Cimabue Restoration Project
Falconer, J. Hairy Who (*poster for 1st*...)
Falconer, J. Hairy Who (*poster for 2nd*...)
Falconer, J. Hairy Who (cat-a-log)
Green, Art Hairy Who (*poster for 1st*...)
Green, Art Hairy Who (*poster for 2nd*...)
Green, Art Hairy Who (cat-a-log)
Green, Art Untitled [c.1973]
Hanson, P. Chicago Imagist Art
Hanson, P. False Image (*poster/invitation*...)
Hanson, P. False Image (*price list for 1st*...)
Hanson, P. False Image (*price list for 2nd*...)
Hanson, P. False Image II
Hanson, P. False Image Postcards

Hockney, D.	Ann Looking at Her Picture
Hockney, D.	Perspective Lesson
Hockney, D.	Picture of a Pointless Abstraction...
Johansen, C.	Artist and Model
Johns, J.	Hinged Canvas
Kozloff, J.	Is It Still High Art?
Levine, L.	Conceptual Decorative
Nilsson, G.	Gladys Nilsson
Nilsson, G.	Gladys Nilsson: Paintings...
Nilsson, G.	Hairy Who (*poster for 1st...*)
Nilsson, G.	Hairy Who (*poster for 2nd...*)
Nilsson, G.	Hairy Who (cat-a-log)
Nilsson, G.	Jim Nutt: Paintings...
Nilsson, G.	Thats Me: Gladys Nilsson
Nutt, J.	Hairy Who (*poster for 1st...*)
Nutt, J.	Hairy Who (*poster for 2nd...*)
Nutt, J.	Hairy Who (*poster for group...*)
Nutt, J.	Hairy Who (cat-a-log)
Nutt, J.	Jim Nutt [1974, *p. 107*]
Nutt, J.	Now! Hairy Who Makes You...
Nutt, J.	Three Famous Artists...
Paschke, E.	Ed Paschke Show
Ramberg, C.	False Image (*poster/invitation...*)
Ramberg, C.	False Image (*price list for 1st...*)
Ramberg, C.	False Image (*price list for 2nd...*)
Ramberg, C.	False Image II
Ramberg, C.	False Image Postcards
Rauschenberg, R.	Centennial Certificate M.M.A.
Rocca, S.	Hairy Who (*poster for 1st...*)
Rocca, S.	Hairy Who (*poster for 2nd...*)
Rocca, S.	Hairy Who (cat-a-log)
Rocca, S.	Toys Made by Chicago Artists
Stasik, A.	Moment I
Steinberg, S.	Millet
Steinberg, S.	Sam's Art
Wirsum, K.	Dr. Chicago
Wirsum, K.	Hairy Who (*poster for 1st...*)
Wirsum, K.	Hairy Who (*poster for 2nd...*)
Wirsum, K.	Hairy Who (cat-a-log)
Wirsum, K.	Hare Toddy Kong Tamari

Dine, J.	Eleven Part Self Portrait
Dine, J.	Photographs and Etchings...
Dine, J.	Self Portrait as a Negative
Ehlbeck, M.	Untitled
Frasconi, A.	Self-Portrait with Don Quixote
Frasconi, A.	Untitled
Gelman, A.	Self-Portrait II
Gloeckler, R.	Big Biker
Herman, R.	Van Gogh in Red
Hockney, D.	Conversation in the Studio
Hockney, D.	Picture of Melrose Avenue...
Hoover, E.	George C. Miller, Lithographer
Huntoon, M.	Peaceful Harve Cartoonist
Izquierdo, M.	Grand Rodeo
Johansen, C.	Artist and Model
Johns, J.	Savarin
Johns, J.	Souvenir
Kaprov, S.	Self-Portraits
Katz, A.	Self Portrait
Kitaj, R.B.	Nancy and Jim Dine
Kitaj, R.B.	Vernissage-Cocktail
Kreneck, L.	Every Artist Has an Attic
Kushner, R.	Joy of Ornament
Leslie, A.	Alfred Leslie
Lichtenstein, R.	Homage to Max Ernst
Mazur, M.	Self-Portrait
Mazur, M.	Untitled 12/31/84
McLarty, J.	Left Hand of God
Moon, J.	Finger Painter
Myers, V.	Self Portrait with Hat
Nilsson, G.	Gladys Nilsson: Paintings...
Nilsson, G.	Self-Portrait as White Rock Lady
Nilsson, G.	Thats Me: Gladys Nilsson
Nilsson, G.	Untitled [1963 *or* 1964]
Nilsson, G.	Untitled [1963, *3 5/8 x 5 3/32*]
Nishimura, N.	Self-Portrait
Nutt, J.	J. Nutt
Nutt, J.	Jim Nutt [1964]
Nutt, J.	Jim Nutt [1974, *p. 106*]
Nutt, J.	Jim Nutt [1974, *p. 107*]

Artists' Studios

Hoover, E. George C. Miller, Lithographer
Huntoon, M. Peaceful Harve Cartoonist
Johansen, C. Artist and Model
Johns, J. Souvenir

Artists' Tools *see* Tools

Ashtrays
Mazur, M. Smoke

Asia
Lark, S. Guy #2

Astronauts
Rauschenberg, R. Hot Shot

Athletes
Crossgrove, R. Three Athletes [Vaulters VIII]

Attorneys *see* Law and Lawyers

Audiences (Performing Arts) *see also* Performers and
 Performances, Stage
Brown, Roger Theater Row
Nilsson, G. Hoofers and Tootsies
Nilsson, G. Untitled [1964, *7 15/16 x 3 11/16*]

Authors *see* Writers

Auto Parts
Kienholz, E. Sawdy

Automobiles (Moving) *see also* Traffic
De Lamonica, R. Untitled [1984]
Gardner, S. Missing Person's Reports
Jacquette, Y. Aerial View of 33rd Street
Jacquette, Y. Northwest View from the…
Jacquette, Y. Times Square (Motion Picture)
McCombs, B. Bridge
Prentice, M. Implications of Sound, II

Prince, R. Property Owner
Rizzi, J. It's So Hard to Be a Saint...
Ruttenberg, J. Reflections
Seawell, T. Snow
Siler, P. I Like to be Abroad...
Thomas, T. Built for Speed
Werger, A. Other Side

Automobiles (Resting) *see also* Auto Parts, Traffic
Estes, R. Untitled, 40c
Johns, J. 1st Etchings
Johnson, Lucas Velarde II
McCombs, B. Street Corners
Oldenburg, C. Profile Airflow—Test Model...
Rauschenberg, R. Preview
Rivers, L. Ford Chassis I
Rosenquist, J. Roll Down
Seawell, T. Around Town
Torlakson, J. 51st and Colorado
Werger, A. Other Side
Wolff, E. Bean Soup
Wolff, E. Giant Auto Wreckers

Autumn
Burchfield, C. Autumn Wind
Fish, J. Pears and Autumn Leaves
Johns, J. Fall
Johns, J. Seasons
Schrag, K. Tree Tops and Autumn
Tobey, M. Trees in Autumn

Axes
Pepper, B. Medieval Axe

Babies
Fichter, R. Bones Alone Has Looked on Beauty...
Fischl, E. Untitled (*from* Floating Islands)
Lasansky, M. España
Lifa, S. Untitled
Smith, Kiki All Souls

Young, F. Baby II

Backpacks
Nelson, Robert Light Load

Badminton Courts
Longo, V. Net [*all*]

Bags
Lichtenstein, R. Turkey Shopping Bag
McMillan, J. Porch Bag

Balance *see* Scales (Weighing)

Ballet
Jones, L. Hat for Tamara Toumanova

Balls *see* Spheres (Shapes)

Bananas
Rocca, S. Late Bloomer
Rocca, S. Sugar Loaf and Palm Trees
Thomas, C.D. Banana

Barbed Wire
Baskin, L. Man of Peace
Mock, R. Crossing Fate's Boundaries

Barber Poles
Johnson, R. Correspondence
Wirsum, K. Correspondence

Barns
Levine, M. Barn
Lucioni, L. Big Haystack

Barrels
Green, Art Murray Simon's Motorcycle
Shalala, E. Oil Landscape

Bathtubs
Nutt, J. oh Dat Sally
Smith, W.K. Monobath

Battles *see* Fighting, War

Beaches *see also* Coastlines
Andell, N. Picnic at Crane's Beach
Beck, E. Geek's Picnic
Fischl, E. Year of the Drowned Dog
Hamilton, R. My Marilyn
Johanson, G. George Beach
Leiber, G. Beach
Lichtenstein, R. View from the Window
Morley, M. Beach Scene
Oldenburg, C. Letter Q as a Beach House

Beans
Allen, T. Pinto to Paradise
Havens, J.D. Scarlet Runner Beans

Beasts and Fantastic Creatures *see also* Dinosaurs, Dragons
Baynard, E. China Pot
Beck, E. Geek's Picnic
Benney, P. Untitled [1987]
Berdich, V. Silent Eclectic Fish Tattoo
Bontecou, L. Fourth Stone
Borofsky, J. Stick Man
Boxer, S. Aquarium
Boxer, S. Buddingwithoutpast
Boxer, S. Conventionofslydiscussants
Boxer, S. Curioustalking
Boxer, S. Fossils
Boxer, S. Pauseofnoconcern
Colescott, W. Tremble Sin City (San Andreas Fault)
Crull, F. Le Rêve
De Saint Phalle, N. Zoo with You
Denes, A. Introspection IV. The Kingdom
Ellis, J. Mook Woman
Falconer, J. Hairy Who (*poster for 2^{nd} ...*)

Nutt, J.	yoo hoo-little boy
Nutt, J.	"your so coarse" (tish tish)
Parker, Robert	Squirrel Monkey
Patterson, C.	Black Beauty
Peterdi, G.	Time of the Beast
Pfanschmidt, M.J.	Turning
Piene, O.	Sky Art
Rauschenberg, R.	Trilogy from the Bellini Series
Reeder, F.B.	Dragon and Saint George
Rice, A.	Untitled [1985]
Rocca, S.	Hairy Who (*poster for 2nd...*)
Rocca, S.	Hairy Who (cat-a-log)
Rocca, S.	Silent Eclectic Fish Tattoo
Rockman, A.	Macrocosmos
Rossi, B.	Circle Plate [*2 states*]
Rossi, B.	Male of Sorrows #3
Rossi, B.	Male of Sorrows #6 [*2 states*]
Rossi, B.	Merry Model
Rossi, B.	Poor Self Trait #1: Dog Girl
Rossi, B.	Sovereign
Rossi, B.	Untitled #1
Rossi, B.	Untitled #2
Rossi, B.	Untitled #3
Rothenberg, S.	Puppet
Schwedler, W.	Silent Eclectic Fish Tattoo
Seligmann, K.	Acteon
Shapiro, P.	Golem
Spafford, M.	Battle of Lapiths and Centaurs
Spafford, M.	Origin of Pegasus #2
Surls, J.	See Across the See
Thomas, L.	Forgotten Moments in History #4
Thomas, T.	Dream Lover
Thomas, T.	Last Date
Thomas, T.	Take Time to Know Her
Utter, B.	Creatcher [sic]
Utter, B.	Man in the Pit
Wirsum, K.	Dr. Chicago
Wirsum, K.	Girl and Creatures
Wirsum, K.	Hairy Who (*poster for 2nd...*)
Wirsum, K.	Hairy Who (cat-a-log)

Bellies *see* Torsos

Berries
Bolton, R. Berry Pickers

Berry-Picking
Bolton, R. Berry Pickers

Beverages *see also* Beer, Coffee, Martinis, Soft Drinks, Tea Bags
Albright, R. Coffee by the Pool
Beal, J. Oysters with White Wine and...
Johns, J. Decoy (I)
Lichtenstein, R. Sandwich and Soda

Biblical Figures and Themes *see also* Adam and Eve, Angels,
 Mary Mother of God, Moses, Pietà
Allison, D. East of Eden/West of Eden
Avery, E. Massacre of Innocents
Baskin, L. Eve
Chase, L. Red Sea
Chicago, J. Creation
Corita, Sr.M. This Beginning of Miracles
Cremean, R. Fourteen Stations of the Cross
Damer, J. Fog Mourn II
Day, W. Burning Bush
Driesbach, D. St. Luke Paints the Madonna
Eckart, C. Cimabue Restoration Project
Eichenberg, R. Book of Jonah
Fearing, K. Annunciation
Frankenthaler, H. Lot's Wife
Gongora, L. Transformation of Samson &...
High, T.G. Madame Butterfly
Hodgell, R. Burning Bush
Jones, A.R. La Sagrada Familia
Jones, J.P. Annunciation
La Roux, L.J. Icon #2
La Roux, L.J. Icon #4
Lasansky, M. For an Eye an Eye, III
Lebrun, R. Grünewald Study
Lebrun, R. Grünewald Study II

McLarty, J. Devil Lives Under Ocumicho
Meeker, D. Joseph's Coat
Nilsson, G. Christ in the Garden
Nilsson, G. Expulsion
Nutt, J. Christmas Card
Santlofer, J. Burning Bush
Schapiro, M. Adam and Eve
Schnabel, J. Raft [Dream]
Sessler, A. Thorny Crown
Solomon, B. Song of Songs
Tatschl, J. Pietà
Wayne, J. Adam en Attente
Wayne, J. Eve Tentee
Wayne, J. Shine Here to Us...
Wayne, J. Tower of Babel A
Wesselmann, T. Christmas Collage

Bicycles and Bicycling

Cadmus, P. Going South [Bicycle Riders]
Fenton, J. Open Road
Gloeckler, R. Big Biker
Gloeckler, R. Eeny Meeny Miney Moe
Morales, A. Dos Ciclistas [Two Cyclists]
Rauschenberg, R. Test Stone #7

Binoculars

Johnson, R. Correspondence
Wirsum, K. Correspondence

Birdhouses

Nilsson, G. Untitled [1964, *7 9/16 x 7*]

Birds and Bird Family *see also* Chickens and Roosters, Cockatoos, Hawks, Owls, Parrots, Ravens, Swans, Toucans

Avery, Milton Birds and Sea
Avery, Milton Three Birds
Avery, Milton Two Birds
Baskin, L. Frightened Boy and His Dog
Baskin, L. Man of Peace
Baskin, L. Torment

Beck, H.	St. Francis
Becker, F.	Cage
Boxer, S.	Birds Soaring
Boxer, S.	Chicken and Cock
Boxer, S.	Finale
Boxer, S.	Oddconversationatnoon
Childs, B.	Images from Hawaiian Legends...
Dine, J.	Girl and Her Dog
DuBasky, V.	Heron Cove
Duchamp, M.	Selected Details after Courbet
Erskine, E.	Firebird
Erskine, E.	Icarus
Fish, J.	Pears and Autumn Leaves
Frank, M.	Astronomy
Frasconi, A.	Boy with a Cock
Fussell, V.C.	Memento Mori
Gloeckler, R.	Eeny Meeny Miney Moe
Goldman, J.	Ellen's Window
Graves, N.	Six Frogs
Hanson, P.	Birds
Hanson, P.	McGovern and Shriver
Hassell, B.	Storm Warnings
Havens, J.	Rabbit Fence
Humphrey, D.	Nocturne
Jimenez, L.	Snake and Eagle
Johnson, J.	Quad
Juarez, R.	Boy with Bird (Black)
Kozloff, J.	Is It Still High Art? [*State III*]
Lanyon, E.	Thimblebox
Nelson, Richard	How Fate Works
Nilsson, G.	Untitled [1964, *7 9/16 x 7*]
Oliveira, N.	Acoma Hawk I
Oliveira, N.	Acoma Hawk V
Oliveira, N.	Kestrel Series #10
Oxman, K.	In the Chamber
Palmore, T.	Rare Southwestern Toucan
Pletka, P.	Raven
Pokorny, E.	My Life
Rathbun, R.K.	Leap of Faith
Rathbun, R.K.	Living in Deliberate Optimism

Bird-Watchers and Bird-Watching

Birmingham, Alabama

Birth

Blacks *see* African-Americans

Blankets

Blenders (Kitchen Appliance)
Glier, M. Entertaining

Blimps *see* Zeppelins

Blindfolds
De Mauro, D. Trapeze Figures

Blindness
Ward, L. Two Men

Blue (Color)
Antreasian, G. Quantum Suite [*Plate VII*]
Avery, Milton Two Birds
Boshier, D. Watch
Brown, Roger Rain Print
Chase, L. Chasm
Davis, S. Detail Study for Cliché
di Suervo, M. Afterstudy for Marianne Moore
Diebenkorn, R. Blue
Diebenkorn, R. Blue Surround
Diebenkorn, R. Large Bright Blue
Dine, J. Nine Views of Winter I
Francis, S. Hurrah for the Red, White and Blue
Frankenthaler, H. Cameo
Frankenthaler, H. Cedar Hill
Frankenthaler, H. Dream Walk
Frankenthaler, H. First Stone
Frankenthaler, H. Persian Garden
Golub, L. Wounded Warrior
Gottlieb, A. Untitled [1973]
Green, Art One Dollar
Green, Art Untitled [1962 or 1963]
Hanson, P. Dancing Couple IV
Hanson, P. McGovern and Shriver
Hanson, P. Singer
Hanson, P. Smoke Machine
Hanson, P. Stage with Lights
Hanson, P. Stage with Staircase
Haynes, N. Untitled [GT/NH 6-90 W-7]

Boats and Boating *see also* Canals and Locks, Harbors, Rafts

Crutchfield, W.	Tamarind-Tanic
Drewes, W.	Calm Morning
Eichenberg, R.	Book of Jonah
Frasconi, A.	Monterey Fisherman
Hall, S.	Secret Journey
Hartigan, G.	Ship
Johanson, G.	Night Games #5
Johnson, J.	Boats
Johnson, J.	Quad Without Crows
Johnston, Y.	Ship and Storm
Katz, A.	Maine Landscape
Lockwood, D.	Locks
Marcus, P.	Untitled
Margo, B.	Sea
Mersky, D.	Boat Quilt
Mersky, D.	Cricket Underneath
Morley, M.	On Deck
Oldenburg, C.	Letter Q as a Beach House
Overton, J.	Blue Zone
Solien, T.L.	Sunken Treasure
Sultan, D.	Sailor Hats, March 21, 1979
Sultan, D.	Water under the Bridge
Thomas, L.	Nagheezi Series #3
True, D.	Cold Romance
True, D.	Savannah Sea
Westermann, H.C.	See America First [*Plate 16*]

Body Parts *see also* individual names

Dennis, C.	Stones/Bones
Nilsson, G.	Untitled (*from portfolio* Da ...)
Nutt, J.	[title=drawing of two fingers]
Nutt, J.	[title=drawing of waterfall]
Nutt, J.	Don't do it
Nutt, J.	He snort
Nutt, J.	Look snay
Nutt, J.	oh Dat Sally
Nutt, J.	SMack SMack
Nutt, J.	stomping
Nutt, J.	Untitled [1969, *13 3/8 x 10 7/16*]
Sanderson, H.	Playroom

Scheier, S. Shirt
Sultan, D. Female Series, April 1988

Bombing
Damer, R.W. I Bombed the Taj Mahal...

Bombs
Gloeckler, R. Eeny Meeny Miney Moe
Nelson, Robert Bombs of Barsoom
Nelson, Robert Torpedo Tabby
Scheier, S. Tea Party
Weege, W. Dance of Death

Bondage
Chan, J. Time Series, No. 3
Hammond, J. Untitled #17
Hammons, D. Injustice Case
Myers, F. Martyrdom
Oropallo, D. Rescue Device
Spero, Nancy Ballade von der Judenhure...

Bones and Skulls *see also* Skeletons
Basquiat, J-M. Back of the Neck
Buck, J. Les Grande Eclipse
Chagoya, E. Life Is a Dream, Then...
Condeso, O. And Only the Wind...
Delos, K. Imago: State Three: VI
Denes, A. Introspection IV. The Kingdom
Dine, J. My Nights in Santa Monica
Dine, J. Side View in Florida
Dine, J. Sovereign Nights
Feddersen, J. Veiled Memory
Frank, M. Dinosaur
Gorny, A. A-B-D-O-M-A-N
Graves, N. Calibrate
Hansmann, G. Ancestor
Johanson, G. Skulls
Kreneck, L. From the Sketchbook of...
Phillips, M. Figures with Golden Bowl
RoRomero, M. Mirror of Life Past

Rothenberg, S. Head and Bones
Tolbert, F. Toad Noir
Warshaw, H. Head of Traffic Victim
Weege, W. Dance of Death
Wirsum, K. Skull Mask
Wirsum, K. Skull Quiet
Wirsum, K. Museum...: Bull Dog and Bone

Books
Andre, C. Xerox Book
Boxer, S. Carnival of Animals [Title Page]
Cumming, R. Alexandria
Darboven, H. Diary NYC February 15 Until...
Dubuffet, J. Parade funèbre pour Charles...
Falconer, J. Hairy Who (cat-a-log)
Green, Art Hairy Who (cat-a-log)
Hanson, P. Chicago Imagist Art
Hara, K. Hagoromo
Johnston, T. L'Etranger
Jones, L. Hamlet
Nilsson, G. Gladys Nilsson
Nilsson, G. Hairy Who (cat-a-log)
Nutt, J. Hairy Who (cat-a-log)
Nutt, J. Jim Nutt [1974, *p. 106*]
Nutt, J. Jim Nutt [1975, *8 ½ x 16*]
Nutt, J. Who Chicago?
Rocca, S. Hairy Who (cat-a-log)
Rosenquist, J. Off the Continental Divide
Ruscha, E. Twenty-Six Gasoline Stations
Samaras, L. Book
Shields, J. Book with Silk Papers
Treaster, R. Vermeer and Times
Tuttle, R. Two Books
Wirsum, K. Hairy Who (cat-a-log)

Boots *see also* Shoes
Lockwood, D. Hats and Boots

Bora Bora
Hockney, D. Bora Bora

Rauschenberg, R. Tampa 10
Resnick, M. Entrance
Shannon, B. Surface/Within
Shields, A. Box Sweet Jane's Egg…Moose Set
Weber, S. Reliquary IX

Boxing
Africano, N. Shadow

Boys
Bartlett, J. In the Garden #116
Baskin, L. Frightened Boy and His Dog
Fischl, E. Digging Kids
Frasconi, A. Boy with a Cock
Grooms, R. Stamped Indelibly [*Plate 2*]
Hayes, S. Happy Girl or Boy
Juarez, R. Boy with Bird (Black)
Katz, A. Swimmer
Smith, Lee Dog Spirits
Wood, T. Young Icarus

Brazil
O'Rourke, J. Brazilian Rain Forest #2

Breakfast *see also* Coffee, Eggs, Fruit, Syrup, Waffles
Kreneck, L. Great Moments in Domestic Mishaps…
Plotkin, L. Morning Light

Breast Feeding *see* Nursing (Babies)

Bricks
Fried, R. Dylan's Drifter
Levy, P. Commonwealth of…

Brides *see also* Weddings
Alexander, J. Queen for a Day

Bridges
Cunningham, E.C. Road Work
McCombs, B. Bridge

Christo	MOMA (Rear)
Crane, P.	Neo-Colorado
Cumming, R.	Burning Box
Davis, S.	Sixth Avenue El
Dennis, D.	Deep Station: View from the Track
Di Cerbo, M.	Untitled [77A]
Di Cerbo, M.	Untitled [78C]
Diamond, M.	Manhattan Suite
Estes, R.	Nass Linoleum
Estes, R.	Seagram Building
Estes, R.	Untitled, 40c
Estes, R.	Urban Landscapes No. 2
Estes, R.	Urban Landscapes 3
Feldman, A.	Midday
Fortess, K.	Cityscape
Friedlander, I.	East Side
Goldman, J.	Norris Court #4
Green, Art	Salvatory Solution
Guston, P.	Street
Haas, R.	Flatiron Building
Hamilton, R.	Solomon R. Guggenheim
Hanson, P.	Entrance and Pavilion
Hanson, P.	Head-Pavilion I
Hanson, P.	Head-Pavilion II
Hanson, P.	Head-Pavilion III
Hanson, P.	Head-Pavilion IV
Hanson, P.	Pavilion Park
Hanson, P.	Pleasure Park I
Hanson, P.	Pleasure Park II
Hanson, P.	Radar Pavilion
Hanson, P.	St. Anthony Pleasure Park
Hockney, D.	Hotel Acatlán: Second Day
Hockney, D.	Picture of Melrose Avenue…
Hockney, D.	Views of Hotel Well III
Huse, M.	Ruins—Tours, France
Jacquette, Y.	Northwest View from the…
Jacquette, Y.	Traffic Signal
Landeck, A.	Rooftops—14th Street
Lazzell, B.	Little Church, New York City
Lehrer, L.	Terrace

Lichtenstein, R. Cathedral #5
Lockwood, D. Feed and Seed
McLarty, J. Wall City
Motherwell, R. Untitled [1982]
Myers, F. Monte Alban I
Myers, F. Taliesin West
Nartonis, C. Untitled
Nesbitt, L. Barriers
Peak, E. View of a City
Plotkin, L. Intersection
Pozzatti, R. Venetian Sun
Price, K. Untitled
Prince, R. Property Owner
Ramberg, C. Imaginary Landscape
Rauschenberg, R. Estate
Rosas, M. Vanity
Roth, Dieter Six Piccadillies [*four*]
Roth, Dieter Six Piccadillies [*plate 4*]
Ruscha, E. Cheese Mold Standard with Olive
Ruscha, E. Mocha Standard
Ruscha, E. Standard Station
Sakuyama, S. Prospect Park West
Sheeler, C. Architectural Cadences
Sheeler, C. Delmonico Building
Sorman, S. First Building Project...
Steinberg, S. Museum
Torlakson, J. Rio
Westermann, H.C. Human Fly
Wolff, E. Terminal
Zimmerman, L. Outback

Bulls *see* Cattle

Bullseyes *see* Targets

Bumpers (Automobiles)
Oldenburg, C. Profile Airflow—Test Model...

Burden
Nelson, Robert Light Load

Solien, T.L. Handle and Tow
Taylor, M. Man's Problems

Burials
Crutchfield, W. Burial at Sea

Buses
Roth, Dieter Six Piccadillies [*four*]
Seawell, T. Around Town
Seawell, T. First Street

Bushes *see* Shrubbery

Butlers
Stock, M. Butler's in Love

Butterflies
Boxer, S. Obliquequestionofaturtle
Erskine, E. Icarus
Gardner, S. Missing Person's Reports
High, T.G. Madame Butterfly
Scholder, F. Indian with Butterfly
Weichselbaum, W. Emergence of the Butterfly

Cabbages
Jansen, A. Cactus and Cabbage

Cacti
Hiratsuka, Y. Cacnus
Jansen, A. Cactus and Cabbage
Kirk, P. At the Opera
Kirk, P. Sleeping Saquaro…
Lichtenstein, R. American Indian Theme III
Noah, B. Pioneer
Smith, D.G. Prickly Pear Cactus
Thomas, T. Last Date

Cages
Becker, F. Cage
Dass, D. Within—Without

Pfanschmidt, M.J. Bamboo Cage
Solien, T.L. Psyche: The Blue Martin

Cake Decorators
Green, Art Art Green

Cakes and Pastries
Colangelo, C. Upside Down Cake
Green, Art Art Green
Oldenburg, C. Untitled
Thiebaud, W. Boston Cremes
Thiebaud, W. Dark Cake
Thiebaud, W. Delights

Calendars
Petersen, R. May 1980
Wirsum, K. We Got Nuthun to Hyde!...

California *see also* Hollywood, Oakland, Sacramento, San Francisco
Fiscus, R. Presidio
Henderson, V. Isle of California
Kondos, G. River Reflection, Sacramento River
Levine, M. Pardee House (West View)...
Ruscha, E. Hollywood
Schoonhoven, T. Isle of California

Calves *see* Cattle

Camping
Van Soelen, T. Cook

Canals and Locks
Lockwood, D. Locks

Candles
Colangelo, C. Upside Down Cake

Candy
Caulfield, P. Sweet Bowl
Nanao, K. Dream Over the Hills

Nanao, K. Further Variations on a Sucker
Nice, D. Tootsie Pops

Canes *see* Walking Cane

Canoes *see* Boats and Boating

Canning (Preserves)
Fish, J. Preserved Peaches

Cans *see also* Containers, Spray Cans
Johns, J. Ale Cans
Johns, J. Decoy (I)
Johns, J. Savarin
Johns, J. Savarin [1977-81]
Johns, J. Savarin [1978]
Johns, J. Savarin Monotype
Rosen, C. Recycled Image
Rosenquist, J. Iris Lake
Ruscha, E. Gas
Warhol, A. Beef with Vegetables and Barley
Warhol, A. Campbell's Soup I
Warhol, A. Chicken Noodle Soup
Warhol, A. Cream of Mushroom Soup
Warhol, A. Tomato Soup
Warhol, A. Untitled

Canvases
Johns, J. Hinged Canvas

Canyons *see also* Abysses, Chasm, Gorges
Mueller, R. Canyon
Romano, C. Night Canyon
Romano, C. River Canyon
Romano, C. Silver Canyon
Shatter, S. Canyon Rose
Shatter, S. Rock Face/Zion Canyon

Cape Canaveral
Rauschenberg, R. Sky Garden

Caps *see also* Dunce Caps, Hats, Head Coverings, Swimming Caps

Beal, J.	Self-Portrait
Katz, A.	Green Cap
Nice, D.	Heartland
Wiley, W.	Ecnud
Wirsum, K.	Painter's Cap

Cardboard

Rauschenberg, R.	Cardbird, II

Cards (Playing)

Arakawa, S.	Degrees of Meaning
Rivers, L.	Jack of Spades

Carp

McMillan, S.	Reflections and Carp
Sundstrom, M.	In Praise of the Carp
Ruscha, E.	Carp with Shadow and Fly

Carriages *see* Chariots, Wagons

Carrying

Nelson, Robert	Light Load
Taylor, M.	Man's Problems

Cars *see* Automobiles (moving or resting)

Cartoonists

Huntoon, M.	Peaceful Harve Cartoonist

Cartoons *see also* Stories

Brown, Roger	Giotto in Chicago
Falconer, J.	da Hairy Who Kamic Kamie Page
Green, Art	da Hairy Who Kamic Kamie Page
Grooms, R.	Stamped Indelibly [*Plate 2*]
Lichtenstein, R.	CRAK!
Lichtenstein, R.	Reverie
Lichtenstein, R.	Sweet Dreams, Baby!
Lichtenstein, R.	Two Paintings: Dagwood

Nilsson, G.	da Hairy Who Kamic Kamie Page
Nutt, J.	da Hairy Who Kamic Kamie Page
Nutt, J.	ummmph....
Oldenburg, C.	Mickey Mouse
Rocca, S.	da Hairy Who Kamic Kamie Page
Salle, D.	Until Photographs Could Be...
Siler, P.	Bug Comes Out
Wirsum, K.	da Hairy Who Kamic Kamie Page
Wirsum, K.	Draw Dick Tracy the Hard Way

Castration

Kienholz, E.	Sawdy
Lasansky, M.	Doma

Cathedrals *see also* Churches, Temples

Berman, Eugene	Nocturnal Cathedral
Lichtenstein, R.	Cathedral #4
Lichtenstein, R.	Cathedral #5
Lichtenstein, R.	Cathedrals #2, #3, and #4

Catholic Church

Frasconi, A.	Franco I

Catholicism *see also* Christianity, Saints

Beck, H.	St. Francis
Cremean, R.	Fourteen Stations of the Cross
La Roux, L.J.	Icon #2
La Roux, L.J.	Icon #4
Myers, F.	Saint Teresa's Seventh Mansion
Myers, M.	St. Anthony
Reeder, F.B.	Dragon and Saint George
Rossi, B.	Poor Self Trait #2: Shep

Cats and Cat Family *see also* Lions

Avery, March	Striped Cat
Boxer, S.	Introduction, Royal Prance...
Brown, Joan	Donald
Castellon, F.	Roman Urchins
Clemente, F.	Not St. Girolamo
Hanson, P.	Birds

Hassell, B. Storm Warnings
Humphrey, M. Lady and the Tiger
Kirk, P. Sleeping Saquaro...
Kreneck, L. Great Moments in Food Law...
Markovitz, S. Tiger Chase
Miller, M. Ablaze
Morley, M. Parrots
Nelson, Robert Cat and Mice
Nelson, Robert Torpedo Tabby
Nutt, J. Jim Nutt [1971-72 *or* 1973]
Ponce de Leon, M. Recycling of Gran'ma
Thomas, T. Dream Lover

Cattle
Ehlbeck, M. Untitled
Harden, M. Thing Seen Suggests, This...
Izquierdo, M. Grand Rodeo
Kimball, W. Longhorn in Sheep's Clothing
Kimball, W. Properly Mounted Texas Longhorn
Morley, M. Devonshire Bullocks
Morley, M. Devonshire Cows
Nilsson, G. Europa and the Bull
Oliveira, N. Tauromaquia 6.20.73 III
Palmore, T. Bevo with Birds
Smith, Moishe Cow
Snidow, G. Baby Sitter
Sowiski, P. Bull Shoulders
Warhol, A. Cow
Warhol, A. Untitled

Caves
Chase, L. Cave

Cellular Life
Blaedel, J.R. Head, Cell + Soul I

Cemeteries *see* Graveyards

Chains
Wirsum, K. Chain Mail Stationery

Chairs

Allen, T.	Pinto to Paradise
Barrera, A.	Untitled
Berg, T.	Dark Adirondack
Chesebro, E.	Random Chair #4
Cumming, R.	Adirondack Chair I
Cumming, R.	Adirondack Chair V
Cumming, R.	Adirondack Chair XI
Diebenkorn, R.	Seated Woman Drinking...
Freckelton, S.	All Over Red
Freckelton, S.	Red Chair
Freckelton, S.	Tulips
Green, Art	Mineral Spirit
Green, Art	Murray Simon's Motorcycle
Grooms, R.	Gertrude
Hickey, C.	A-Chair
Hockney, D.	Home
Hockney, D.	Pembroke Studios with Blue...
Hockney, D.	Perspective Lesson
Hockney, D.	Two Pembroke Studio Chairs
Hockney, D.	Walking Past Two Chairs
Johns, J.	Watchman
Kerslake, K.	American Patio Series
Kerslake, K.	Circle of Light
Kimball, W.	Longhorn in Sheep's Clothing
Mazur, M.	Enemies Sequence #1, Transition
Miyauchi, H.	In the Sunrise
Pearlstein, P.	Model in Green Kimono [all]
Pearlstein, P.	Two Nudes
Price, G.	Table
Price, K.	Coffee Shop at the Chicago Art...
Ramberg, C.	Flying en masse from Goldblatts
Ramberg, C.	Flying from Goldblatts
Rasmussen, K.	Greyfield Ghosts
Rauschenberg, R.	Booster
Smith, C.F.	Daydream
Smith, C.F.	Numbered Chair
Warhol, A.	Electric Chair

Chalkboards
Berger, P. Mathguy

Chandeliers
Haas, R. Great Hall, Kip Riker Mansion

Chaos
Becker, F. Inferno
Colescott, W. Raft of the Titanic
Colescott, W. Tremble Sin City (San Andreas Fault)
Grooms, R. Nervous City
Seawell, T. Variation on Themes of Callot-V

Charades
Nutt, J. toe tapping Nose

Chariots
Rauschenberg, R. Bellini #5

Charts
Detamore, R.C. Secret Letters and Private Numbers
Fisher, V. Perdido en el Mar
Henderson, V. Isle of California
Martin, A. On a Clear Day
Schoonhoven, T. Isle of California
Stuart, M. Navigating Coincidence...

Chasm *see also* Abysses, Canyons, Gorges
Chase, L. Chasm
Romano, C. Deep Falls
Shatter, S. Vertigo

Chefs
Green, Art Art Green
Kitaj, R.B. Outlying London Districts I

Chemistry
Lichtenstein, R. Peace Through Chemistry IV

Cherries
Goldyne, J. One, Two, Three...All Gone

Chicago
Brown, Roger Famous Artists from Chicago
Brown, Roger Giotto in Chicago
Gray, N. El at Myrtle Avenue
Jones, L. Chicago Laundry
Oldenburg, C. Chicago Stuffed with Numbers
Oldenburg, C. Map of Chicago...Soft Numbers

Chickens and Roosters
Alps, G. Three Chickens
Baskin, L. Frightened Boy and His Dog
Boxer, S. Chicken and Cock
Frasconi, A. Boy with a Cock
Ruscha, E. Rooster
Thomas, T. Take Time to Know Her

Children *see also* Boys, Daughters, Fathers and Children,
 Mothers and Children, Sons
Avery, E. Massacre of Innocents
Barnet, W. Child Among Thorns
Baskin, L. Frightened Boy and His Dog
Becker, D. In A Dark Time
Bolton, R. Winter Storm
Brekke, M. Passage VII
Castellon, F. Roman Urchins
Deines, E.H. Joy on Kaw Valley Loam
Feigin, M. Woman, Child, Umbrella
Forbis, S. Sharing Traditions
Frasconi, A. Boy with a Cock
Gorny, A. H.T.A.D.
Grace, C. Key Limes Marigot Harbour
Milton, P. Card House
Milton, P. Julia Passing
Milton, P. Sky-Blue Life
Morris, K. King's Day
Rabel, K. School Crossing
Rauschenberg, R. Bellini #4

Rauschenberg, R. Bellini #5
Rauschenberg, R. Trilogy from the Bellini Series
Smith, A. Untitled
Smith, Kiki All Souls
Snyder, J. Things Have Tears...
Solien, T.L. Sunken Treasure

Chimneys *see also* Smokestacks
Green, Art Salvatory Solution

China (Country)
Baynard, E. China Pot
Castellon, F. China [Title Page]
Diao, D. Untitled [China in Russian]
Paschke, E. Ben Hur
Paschke, E. Ho Chi Minh
Rosenquist, J. Cold Light
Summers, C. Chinese Landscape

Choir *see also* Singers and Singing
Hanson, P. Masked Chorus

Christianity
Avery, E. Massacre of Innocents
Chicago, J. Creation
Damer, J. Fog Mourn II
Jones, J.P. Annunciation
Lebrun, R. Grünewald Study
Schnabel, J. Raft [Dream]
Tatschl, J. Pietà

Christmas
Nutt, J. Christmas Card
Wesselmann, T. Christmas Collage

Churches *see also* Cathedrals, Missions, Temples
Jonson, R. Sanctuario
Lazzell, B. Little Church, New York City
Rabel, K. São Tomé
Wengenroth, S. Meeting House

Cigarettes

Fink, A.	Blue Smoker
Larmee, K.	Cigarette
Mazur, M.	Smoke
Motherwell, R.	Bastos
Motherwell, R.	Djarum
Motherwell, R.	Gauloises Bleues
Motherwell, R.	Hermitage
Motherwell, R.	St. Michael I
Motherwell, R.	Tobacco Roth—Händle
Rivers, L.	Lucky Strike II
Wesselmann, T.	Great American Nude
Wesselmann, T.	Smoker
Wirsum, K.	Chris Mist Cowboy
Wirsum, K.	Tex Tour

Cigars and Cigar Boxes

Kaminsky, D.	Cigar Box

Circles (Shapes)

Azuma, N.	Image of a City
Berger, P.	Mathematics #57
Bochner, M.	Rules of Inference
Bontecou, L.	Etching One
Bontecou, L.	First Stone
Bontecou, L.	Seventh Stone
Brach, P.	Silver Series
Bury, P.	Circle and Ten Triangles...
Cage, J.	Fire #9
Cage, J.	Fire #10
Cherry, H.	Untitled
Childs, B.	Eyeball of the Sun
Clemente, F.	Tondo
Conner, B.	Mandala
Crile, S.	Palio
David, M.	Blue
David, M.	Red
David, M.	White
Dehner, D.	Lunar Series

Shields, A.	Ahmadabad Silk
Shields, A.	Alice in Grayland
Shields, A.	Armie's Tough Course
Shields, A.	Equatorial Route
Shields, A.	Guardian Mole
Shields, A.	Hazel's Witch Hat
Shields, A.	Home Route
Shields, A.	Josh's Route
Shields, A.	Polar Route
Shields, A.	Rain Dance Route
Shields, A.	Rare Pyramid
Shields, A.	Scaba Pro
Shields, A.	Soft Action
Shields, A.	Trade Route
Shields, A.	Treasure Route I
Shields, A.	Treasure Route II
Shields, A.	TV Rerun, A
Shields, A.	TV Rerun, B
Shields, A.	TV Rerun, C
Shields, A.	Two Birds, Woodcock I
Shields, A.	Two Birds, Woodcock II
Shields, A.	Uncle Ferdinand's Route
Smith, Kimber	Untitled
Smith, R.	Russian I
Squeri, R.	Manoa Series VI
Stanczak, J.	Solar
Stasik, A.	Still Life Landscape, No. 5
Steir, P.	Abstraction, Belief, Desire
Summers, C.	Rajasthan
Taylor, A.	Untitled [Double Spiral]
Thorn, R.	160 Lines
Toner, R.	Sailmaker
Wiley, W.	Coast Reverse (Diptych)
Wiley, W.	Ecnud
Winters, T.	Double Standard
Winters, T.	Morula II

Cities *see also* Skyscrapers, names of specific cities

Avery, E.	Massacre of Innocents
Baczek, P.	Lombard Street Triptych

Brown, Roger	short Introduction to a lady...
Carnwath, S.	Unknown Quantities
Carnwath, S.	We All Want to Believe
Dine, J.	Bathrobe
Dine, J.	Five Layers of Metal Ties
Dine, J.	Painted Self-Portrait
Dine, J.	Photographs and Etchings...
Dine, J.	Picture of Dorian Gray
Dine, J.	Red Bathrobe
Dine, J.	Self-portrait in zinc and acid
Dine, J.	Self-Portrait: The Landscape
Eichenberg, F.	Bestiarium Juvenille
Esaki, Y.	Jacket
Fink, A.	Blue Smoker
Guston, P.	Studio Corner
Hamilton, R.	Adonis in Y Fronts
Hanson, P.	Three Actors
Izquierdo, M.	Jeen-Jo the Dancer
Kushner, R.	Rhoda VIII 3
Lane, L.	Untitled [1990]
Lasansky, L.	Orientalia
Lasansky, M.	Young Nahua Dancer
McPhail, B.	Untitled
Meeker, D.	Joseph's Coat
Meeker, D.	Lisa
Myers, M.	Fox in Costume
Nilsson, G.	Holes with a Muse
Nutt, J.	[title=drawing of adhesive...]
Nutt, J.	arm band
Nutt, J.	Don't do it
Nutt, J.	Pit er Pat
Oldenburg, C.	Store Window: Bow, Hats, Heart...
Paschke, E.	Hubert
Paschke, E.	Klaus
Paschke, E.	Tudor
Rivers, L.	Swimmer A, B, C, and D
Rocca, S.	Late Bloomer
Schapiro, M.	Frida and Me
Scheier, S.	Shirt
Siegel, I.	Twin Beds, I Presume

Clover (Shapes)

Clowns

Coastlines *see also* Beaches, Seascapes

Coat Hangers

Coats *see also* Cloaks, Robes

Clemente, F.	Untitled [1983]
Conover, R.	Tree
Crawford, R.	Third Avenue Elevated #1
Davis, R.W.	Invert Span
Davis, R.W.	Cube I
Davis, R.W.	Cube II
Davis, S.	Detail Study for Cliché
De Lamonica, R.	Untitled [1984]
Diebenkorn, R.	Green
Dine, J.	Red Bathrobe
di Suervo, M.	Afterstudy for Marianne Moore
di Suervo, M.	Centering
di Suervo, M.	Jak
di Suervo, M.	Tetra
Erskine, E.	Firebird
Fink, A.	Portrait I
Francis, S.	Hurrah for the Red, White and Blue
Francis, S.	Slant
Francis, S.	Untitled [1963]
Francis, S.	Untitled [1978]
Francis, S.	Untitled [1982]
Francis, S.	Untitled [SFM82-049]
Francis, S.	Upper Yellow
Francis, S.	White Line
Frankenthaler, H.	Barcelona
Frankenthaler, H.	Bay Area Sunday VI
Frankenthaler, H.	Bay Area Tuesday IV
Frankenthaler, H.	Cameo
Frankenthaler, H.	Dream Walk
Frankenthaler, H.	Essence Mulberry
Frankenthaler, H.	First Stone
Frankenthaler, H.	Harvest
Frankenthaler, H.	Persian Garden
Frankenthaler, H.	Red Sea
Frankenthaler, H.	Savage Breeze
Gilliam, S.	Nile
Gilliam, S.	Pink Horse Shoes
Gottlieb, A.	Germination II
Gottlieb, A.	Untitled
Graves, N.	Alloca

Kelly, E.	Nine Squares
Kelly, E.	Red-Orange/Yellow/Blue
Kelly, E.	Red-Orange over Black
Kohn, G.	Untitled [1963]
Kozloff, J.	Cochiti
Kozloff, J.	Longing
Krushenick, N.	Untitled [1965]
Kunc, K.	Solace and Frenzy
Kuopus, C.	Downwind
Kuopus, C.	Mustard Fields
LaRoux, L.	Keystone
Levine, S.	Meltdown (After Kirchner)
Lewis, T.R.	Death of a Conscious Called…
LeWitt, S.	Composite Series
Lichtenstein, R.	Brushstrokes
Lichtenstein, R.	Cathedral #5
Lichtenstein, R.	Lamp
Longo, V.	Untitled
Mahaffey, R.	Sequence I
Mason, E.	Soft the Sun
McLaughlin, J.	Untitled
Mitchell, Joan	Bedford I
Mitchell, Joan	Bedford II
Mitchell, Joan	Bedford III
Mitchell, Joan	Flower I
Mitchell, Joan	Flower II
Mitchell, Joan	Flower III
Mitchell, Joan	Sides of a River I
Mitchell, Joan	Sides of a River II
Motherwell, R.	Bastos
Motherwell, R.	Burning Sun
Motherwell, R.	Gauloises Bleues
Motherwell, R.	Gypsy Curse
Motherwell, R.	On the Wing
Motherwell, R.	Redness of Red
Motherwell, R.	Rite of Passage I
Motherwell, R.	Rite of Passage II
Motherwell, R.	Water's Edge
Murray, E.	Untitled [1982]
Murray, E.	Untitled [States I-V]

Yunkers, A. Big Kiss

Columns
Arakawa, S. Signified or If
Hanson, P. Room with Shells and Vases
Johnson, Lois Corner-Column
Kepets, H. Astor
Lewis, J. Melinda
Pond, C. Doubledoozium cum Skinnionic...
Soave, S. Architecture I
Sorman, S. Trees Blowing and Blowing...

Comets
Rayberry© Life's Comet
Rosenquist, J. Caught One Lost One for the...

Comics or Comic Strips *see* Cartoons

Communism or Communists
Warhol, A. Mao Tse-Tung

Concerts *see* Audiences, Performers and Performances

Cones (Shapes)
Falkenstein, C. From Point to Cone
Prentice, M. Kozo
Rizzie, D. Untitled [1985]
Stella, F. Had Gadya: Back Cover
Stella, F. Then Came Death and Took...
Wiley, W. Ecnud

Confederate States of America
Rivers, L. Last Civil War Veteran
Rivers, L. Last Civil War Veteran I

Conflicts *see also* Fighting, Struggles
Anderson, A. Trilogy
Falconer, J. Hairy Who (cat-a-log)
Green, Art Hairy Who (cat-a-log)
Hamilton, R. Kent State

Cookware
Rosenquist, J. Caught One Lost One for the...
Warhol, A. Cooking Pot

Coral
McCoy, A. Night Sea

Cords *see also* Ropes
Schuselka, E. Untitled

Corn
Goulet, C. Wide Cornfields #571
Hammond, J. Untitled #13
Nice, D. Heartland

Cornucopia
Bush, S. Memories—Cornucopia...

Correspondence *see also* Envelopes, Postcards
Caulfield, P. Letter
Nutt, J. Christmas Card
Wiley, W. Moon Mullings
Wirsum, K. Karl Wirsum

Costumes *see also* Masks
Hanson, P. Three Actors
Izquierdo, M. Jeen-Jo the Dancer

Couches
Pearlstein, P. Reclining Nude on Green Couch

Country Clubs
Hanson, P. Country Club Dance

Couples *see also* Homosexuality, Lovers, Men and Women
Alexander, J. Queen for a Day
Brown, Roger Così Fan Tutte
Brown, Roger Tree in Sunderland
Dixon, K. Wildflowers of Texas: LBJ &...

Gelman, A.	Serpents
Hamilton, R.	Just What Is It That Makes...
Hanson, P.	Country Club Dance
Hanson, P.	Dancing Couple I
Hanson, P.	Dancing Couple II
Hanson, P.	Dancing Couple III
Hanson, P.	Dancing Couple IV
Hanson, P.	Dancing Couple V
Herman, R.	Fatherland, Mothertongue
Kadish, R.	Duo
Katz, A.	Ada, Alex
Katz, A.	Ando, Dino
Katz, A.	Carter, Phyllis
Katz, A.	Danny, Laura
Katz, A.	Eric, Anni
Katz, A.	Jennifer, Eric
Katz, A.	Julian, Jessica
Katz, A.	Kristi, Vincent
Katz, A.	Peter, Linda
Kirk, P.	At the Opera
Nilsson, G.	Expulsion
Nilsson, G.	Untitled [1964, *4 15/16 x 4 5/8*]
Nutt, J.	Back Scratch
Nutt, J.	Hairy Who (*poster for group...*)
Phillips, M.	Serenade
Prochaska, T.	Den Armen Duval
Prochaska, T.	Maybe
Prochaska, T.	Oh Yes
Rocca, S.	Dat-Dot Game
Rossi, B.	Couple
Schapiro, M.	Adam and Eve
Soyer, R.	Artist's Parents
Woodruff, H.	Prominade

Courage

Allen, T.	Palabras Malo

Courts (Law) *see* Law and Lawyers

Coves
DuBasky, V. Heron Cove

Cowboys
Lockwood, D. Hats and Boots
Saul, P. Cowboy Dentist
Van Soelen, T. Cook
Westermann, H.C. See America First [*Plate 17*]
Wiley, W. Seasonall Gate
Wirsum, K. Chris Mist Cowboy
Wirsum, K. Tex Tour

Cows *see* Cattle

Coyotes
Ruscha, E. Coyote

Craftsmen
Leithauser, M. Horological Fascination

Craters
Morris, R. Crater with Smoke
Turrell, J. Deep Sky

Credos or Creeds
Carnwath, S. We All Want to Believe
Holzer, J. Truisms
Shahn, B. Sacco and Vanzetti

Crickets
Mersky, D. Cricket Underneath

Crosses (Shapes)
Barnet, W. Singular Image
Casarella, E. Rock Cross
Dine, J. Car Crash I-V
Dine, J. End of the Crash
Eckart, C. Cimabue Restoration Project
Green, Art Salvatory Solution
Guzak, K. Geometrics: Circle, Cross...

Shields, A. Color Radar Smile A
Shields, A. Color Radar Smile B
Shields, A. Color Radar Smile C
Shields, A. Treasure Route I
Shields, A. Treasure Route II

Crosswalks
Montenegro, E. Woman on a Crosswalk

Crowds (People)
Berman, Eugene Pisan Fantasy
Borofsky, J. People Running
Colescott, W. History of Printmaking: Goya...
Colescott, W. Tremble Sin City (San Andreas Fault)
Corita, Sr.M. This Beginning of Miracles
Cunningham, D. N.W. Notgelt
Ellison, M.E. International Boulevard
Evergood, P. Cool Doll in Pool
Frank, M. Untitled
Frasconi, A. Franco I
Friedlander, I. East Side
Grooms, R. Downhill Skier
Grooms, R. Nervous City
Haines, R. Bus Stop
Hockney, D. Bedlam
Izquierdo, M. Pierrot's Tapestry
Leiber, G. Beach
Milton, P. Collecting with Rudi
Milton, P. Daylilies
Morley. M. Beach Scene
Nutt, J. "your so coarse" (tish tish)
Paolozzi, E. Wittgenstein in New York
Paris, H. Caballa
Piene, O. Sky Art
Poster, M. Festival of San Gennaro—...
Rizzi, J. It's So Hard to Be a Saint...

Crowns
Basquiat, J-M. Back of the Neck
Francis, M. Shattered King

Morris, K. King's Day
Rothenberg, S. Pinks

Crows
Johnson, J. Quad

Crucifixion
Cremean, R. Fourteen Stations of the Cross
Lebrun, R. Grünewald Study
Lebrun, R. Grünewald Study II
Sessler, A. Thorny Crown

Crutches
Lebrun, R. Rabbit

Crying
Hammond, H. Blue Spirit
Solien, T.L. Memoir Den

Cubes (Shapes)
Bochner, M. First Quartet
Bochner, M. Fourth Quartet
Bochner, M. Second Quartet
Bochner, M. Third Quartet
Davis, R.W. Cube I
Davis, R.W. Cube II
Guzak, K. Jewels for Taj
Kelly, E. Yellow/Black
Vasarely, V. Homage to the Hexagon

Cups
Albright, R. Coffee by the Pool
Cumming, R. Untitled [Cup]
Diebenkorn, R. Cup and Saucer
Fontecilla, E. Belgium Interior
Liao, S.P. Friendship
Murray, E. Inside Story
Plotkin, L. Morning Light
Price, K. Figurine Cup VI
Price, K. Japanese Tree Frog Cup

Nilsson, G. Untitled [1964, *7 15/16 x 3 11/16*]
Nutt, J. Gay Nurse
Nutt, J. Untitled [1975]
Oviette, V. The Dance—Variation II
Rocca, S. Dat-Dot Game
Rocca, S. Rings
Sigler, H. "The Dance of Life"
Smith, J.Q. Fancy Dancer
Snyder, J. Dancing in the Dark
Wirsum, K. Moming
Wirsum, K. Wake Up Yer Scalp with Chicago

Danger
Humphrey, D. Nocturne
Rathbun, R.K. Leap of Faith
Siler, P. I Like to be Abroad...

Darts
High, T.G. rebel earth—Ramath lehi

Daughters *see also* Mothers and Children
Sigler, H. Where Daughters Fear...

Dean, James
Warhol, A. "Rebel Without a Cause"

Death *see also* Burials, Crucifixion, Drowning,
 Execution and Executioners, Graveyards,
 Murder, Pietà, Slaughter, Suicide, War
Alexander, J. Queen for a Day
Allen, T. Palabras Malo
Allen, T. Pinto to Paradise
Anderson, Larry Ecce Homo
Arneson, R. Nuclear War Head
Avery, E. Watson and the Shark
Baskin, L. Angel of Death
Baskin, L. Hydrogen Man
Becker, D. In A Dark Time
Becker, D. Tremble in the Air
Biddle, M. Untitled

Spero, Nancy Ballade von der Judenhure...
Stella, F. Then Came Death and Took...
Thiebaud, W. Jan Palach
Tilson, J. Is This Ché Guevara?
Tilson, J. Letter from Ché
Turner, J. Dead Snow Goose II
Warhol, A. Electric Chair
Warhol, A. Plate 11 (*from* Flash...)
Weege, W. Dance of Death
Wegman, W. Missing Dog
Wolff, E. Trailers
Wood, T. Some Beasts Will Eat Anything

Death Shrouds *see* Shrouds (Death)

Decapitation
Nutt, J. Look snay

Decay
Brants, C. Deserted House
Dine, J. Youth and the Maiden
Nelson, M. Remains B^3
Thomas, L. Nagheezi Series #3

Deceit
Hockney, D. Receiving the Inheritance

Decisions
Colescott, W. Judgment Day at NEA

Deer
Hoke, S. Waiting for the Freight
Markovitz, S. Tiger Chase

Defecation
Siler, P. He Shits on the World

Demons *see* Beasts, Devil

Destruction *see also* Chaos, Decay, Devastation
Baskin, L. Hydrogen Man
Baskin, L. Mantegna at Eremitani
Brown, Roger Disasters
Colescott, W. Birdbrain
Colescott, W. Tremble Sin City (San Andreas Fault)
Dine, J. Car Crash I-V
Fisher, V. Hanging Man
Francis, M. Shattered King
Landau, J. Violent Against Themselves...
Mersky, D. Cuttings
Seawell, T. Variation on Themes of Callot-V
Siler, P. He Shits on the World
Thomas, T. Last Date
Torres, F. Northern Guernica
Wolff, E. Giant Auto Wreckers

Detective *see* Police

Devastation
Frasconi, A. Franco I

Devil
McLarty, J. Devil Lives Under Ocumicho
Wirsum, K. Museum...: Devil

Diagrams
Calder, A. Score for Ballet 1-100
Chryssa Weather Map
Denes, A. Dialectic Triangulation: ...
Dine, J. Picture of Dorian Gray
High, T.G. Madame Butterfly
Kreneck, L. From the Sketchbook of...
Morris, R. Steam (*from* Earth Projects)
Oldenburg, C. System of Iconography: ...
Rauschenberg, R. Bait
Sorman, S. First Building Project...
Wright, D. Untitled

Diamonds (Shapes)

Anuszkiewicz, R.	Diamond Chroma
Conn, D.	Hobo Signs Portfolio
David, M.	Blue
David, M.	Red
David, M.	White
Green, Art	Second Etching
Guzak, K.	Geometrics: Circle, Cross...
Guzak, K.	Jewels for Taj
Tworkov, J.	KTL #1
Vasarely, V.	Homage to the Hexagon

Diamonds (Stones)

Crutchfield, W.	Diamond Express
Hill, R.	Mask of the Diamond Lady

Diners *see* Restaurants

Dining Rooms

Hockney, D.	Tyler Dining Room

Dinnerware *see* Dishes

Dinosaurs

Boxer, S.	Fossils
Frank, M.	Dinosaur
Herman, R.	Fatherland, Mothertongue
Nelson, Robert	Bombs of Barsoom

Dirigibles *see* Zeppelins

Disability *see also* Blindness, Paraplegics, Quadriplegics

Andrews, B.	Pusher
De Mauro, D.	Trapeze Figures
Lebrun, R.	Rabbit

Disease

Hanley, J.	Plague-Doctor

Distress
Stock, M. Butler's in Love

Dishes *see also* Bowls, Cups, Glasses (Drinking),
 Plates
Albright, R. Coffee by the Pool
Beal, J. Brook Trout
Cumming, R. Untitled [Cup]
Diebenkorn, R. Cup and Saucer
Goode, J. Glass Middle Left—Spoon...
Green, Art Kitchen Still Life
Hansen, A. Lunch Counter
Levers, R. Terrorist Juggling Plates
Liao, S.P. Friendship
Miyauchi, H. In the Sunrise
Plotkin, L. Morning Light
Porter, F. Table
Sloan, J. Sears Tower
Warhol, A. Fiesta Pig
Wolf, S. Cup Collection

Disrespect *see also* Insolence, Mockery
Siler, P. He Shits on the World

Divers and Diving
Amos, E. Diver

Diving Boards
Hockney, D. Lithograph of Water... [*all*]
Hockney, D. Lithographic Water... [*all*]
Hockney, D. Pool made with paper and blue...

DNA
Hockenhull, J. Inheritors

Doctors *see also* Medicine
Lichtenstein, R. Dr. Waldman

Dogs and Dog Family *see also* Coyotes
Baskin, L. Frightened Boy and His Dog

Doors and Doorways

Acconci, V.	Building Blocks for a Doorway
Bosman, R.	Backdoor
Bosman, R.	Double Trouble
Bosman, R.	Forced Entry
Brown, Roger	Theater Row
Chan, J.	Time Series, No. 3
Cooper, R.	Tri-Axial Rotation of a Floating...
Dickson, J.	Stairwell
Estes, R.	Grant's
Estes, R.	Seagram Building
Haas, R.	Great Hall, Kip Riker Mansion
Hanson, P.	Entrance and Pavilion
Hockney, D.	Start of the Spending Spree...
Kepets, H.	Interior No. 1
Kienholz, E.	Sawdy
Margo, B.	Pathway
McMillan, J.	Porch Bag
Nesbitt, L.	Barriers
Olsen, D.	Pentimento XXII
Rauschenberg, R.	Abby's Bird
Richardson, S.	Through the Greened Into
Rosenquist, J.	Roll Down
Walker, T.	Untitled [*p. 123*]
Werger, A.	By Force

Dots

Bochner, M.	Rules of Inference
Graves, N.	Fra Mauro Region of the Moon
Janoff-Katjanelson, A.	Yellow Afterimage

Doves

Baskin, L.	Man of Peace

Dragonflies

Baynard, E.	Dragonfly Vase

Dragons

Nelson, Robert	Cat and Mice
Nilsson, G.	Terrible Dragon

Reeder, F.B. Dragon and Saint George

Dramatic Productions *see also* Audiences, Performers and
 Performances, Stages
Brown, Roger Pre-View
Brown, Roger Theater Row
Kirk, P. At the Opera
Nilsson, G. Women (*announcement*)
Nilsson, G. Women (*poster*)
Paschke, E. Godzilla Rainbow Troupe...

Drawing
Huntoon, M. Peaceful Harve Cartoonist

Dreams and Visions *see also* Apparitions
Ruble, R. She Who Controls Dreams
Summers, C. Dark Vision of Xerxes

Drinking Straws
Lichtenstein, R. Sandwich and Soda

Drinks *see* Beverages

Drive-In (Movie Theater) *see also* Movie Theaters
Brown, Roger Pre-View

Driveways
Prince, R. Property Owner

Drowning
Bosman, R. Drowning Man I
Bosman, R. Drowning Man II
Chase, L. Red Sea

Dunce Caps
Wiley, W. Ecnud

Eagles
Baselitz, G. Eagle
Jimenez, L. Snake and Eagle

Wengenroth, S. Untamed

Ears
Johns, J. Skin with O'Hara Poem

Earth (Ground)
Celmins, V. Untitled [1971]
Gardner, A. American Air Tourist—1940's...
Gellis, S. Dusk: Lake Rowland
Heizer, M. Dragged Mass
Nawara, J. Dartmoor
Nawara, J. Quebrada
Peterdi, G. Germination I
Sommers, J. Wold [Ambiance]

Earth (Planet)
Berman, V. This Spaceship Earth

Earthquakes
Colescott, W. Tremble Sin City (San Andreas Fault)

Easels (Painting)
Baldessari, J. Fallen Easel
Sigler, H. If She Could Free Her Heart...
Steinberg, S. Sam's Art

Eating and Eating Places *see also* Coffee Shops, Dining
 Rooms, Kitchens, Restaurants
Estes, R. Grant's
Grooms, R. No Gas Cafe
Hansen, A. Lunch Counter
Maryan, M. Untitled
Nutt, J. SMack SMack
Wood, T. Some Beasts Will Eat Anything

Eating Utensils
Diebenkorn, R. Cup and Saucer
Goode, J. Glass Middle Left—Spoon...

Segal, G. Walter
Sessler, A. Red Wig

Electrical Outlets
Oldenburg, C. System of Iconography: Plug...

Electrical Plugs *see* Plugs

Electricians
Lozowick, L. Design in Wire

Electricity
Lozowick, L. Design in Wire

Elephants
Boxer, S. Elephants
Boxer, S. Gatheringforsomereason
Boxer, S. Carnival of Animals [Title Page]
Dine, J. Girl and Her Dog
Nilsson, G. Untitled [1964, *6 3/8 x 10*]
Nilsson, G. Untitled [1964, *p. 83*]
Rivers, L. Elephants

Elvis Presley
Mabe, J. Big El
Mabe, J. Blessed Elvis Prayer Rug

Embrace
Nutt, J. Back Scratch

Embryos
Hockenhull, J. Inheritors

England *see also* London
Askin, W. Bruegel-Brittania
Vida Avebury by Air

Entertaining
Glier, M. Entertaining

Envelopes

Caulfield, P.	Letter
Detamore, R.C.	Secret Letters and Private Numbers
Sarkisian, P.	Envelope (Red Background)
Tilson, J.	Sky One

Environment

Cunningham, D.	Trout Need Trees
Siler, P.	He Shits on the World

Erasers

Oldenburg, C.	Typewriter Eraser
Shalala, E.	Eraser

Escape

Chan, J.	Time Series, No. 3
Lifa, S.	Untitled
Ruble, R.	Dying Rhino

Evenings

Baeder, J.	Empire Diner
Berman, Eugene	Nocturnal Cathedral
Bodger, L.	English Summer Night
Bosman, R.	Man Overboard
Brown, Roger	Così Fan Tutte
Brown, Roger	Sinking
Brown, Roger	Standing While All Around Are...
Camblin, B.	Gone Fishing
Dickson, J.	White Haired Girl
Garet, J.	Night Boy
Gellis, S.	Dusk: Lake Rowland
Gilkey, G.	Theme Center, New York...
Goldman, J.	Summer Nights
Goldstein, D.	Evening Iris
Hewitt, C.	Summer Night
Jacquette, Y.	Mississippi Night Lights...
Jacquette, Y.	Times Square (Motion Picture)
Katz, A.	Luna Park
Kirk, P.	Sleeping Saquaro...
Lichtenstein, R.	Night Scene

Lundeberg, H.	Moonrise
Mangold, S.	View of Schumnemunk Mountain
Margo, B.	Sea
Mazur, M.	Wakeby Night
Mazur, M.	Wakeby Night II
McAfee, I.	Small Ranch ["At Evening Time"]
Mead, R.	Summer Night
Rathbun, R.K.	Living in Deliberate Optimism
Rayberry©	Life's Comet
Romano, C.	Night Canyon
Ruble, R.	She Who Controls Dreams
Saar, B.	Black Girl's Window
Schleeter, H.	Glow Bugs
Sigler, H.	Every Chance She Gets...
Siler, P.	I Like to be Abroad...
Solien, T.L.	Victim of Doubt
Torlakson, J.	19th Avenue Booth, 1:00 AM
Wengenroth, S.	Quiet Hour
Werger, A.	Incident Before Dawn
Werger, A.	Neighborhood Watch
Werger, A.	Other Side
Wiley, W.	Scarecrow

Execution and Executioners

Catlett, E.	My Reward has been bars...
Stevens, M.	Big Daddy Paper Doll
Warhol, A.	Electric Chair

Exile

Nilsson, G.	Expulsion

Expectation

Prochaska, T.	Maybe

Exploration

Rosenquist, J.	Cold Light

Explosions *see also* Gunshots

Hanson, P.	Bursting Out

Katz, A.	Green Cap
Katz, A.	Large Head of Vincent
Katz, A.	Red Coat
Kennedy, W.	Memories, Dreams...
Kent, R.	Europe
Kitaj, R.B.	Photo-eye (El Lissitzky)
Koppelman, C.	Retired Napoleons
Kruger, B.	Savoir c'est pouvoir
Kruger, B.	Untitled [We Will No Longer...]
Kushner, R.	Angelique
Kushner, R.	Bibelot
Kushner, R.	Rhoda VIII 3
Lerner, A.J.	Laughing Gas
Levine, L.	Iris Print-out Portrait
Lewis, T.R.	Liberty Taking Advantage
Lichtenstein, R.	American Indian Theme IV
Lichtenstein, R.	American Indian Theme V
Lichtenstein, R.	Blue Face
Lichtenstein, R.	Fresh Air
Lichtenstein, R.	Head with Braids
Lichtenstein, R.	Sweet Dreams, Baby!
Lichtenstein, R.	Two Paintings: Sleeping Muse
Lindner, R.	Fun City
Lindner, R.	Profile
Lovell, W.	Nanny
Magee, A.	Spirit
Marisol	Phnom Penh I
Mazur, M.	Untitled 12/31/84
McNeil, G.	Double Head #1
McNeil, G.	Oblique Figure
Mills, L.	I Do
Mock, R.	Racing Beauty
Moon, J.	Finger Painter
Morris, K.	King's Day
Nauman, B.	Studies for Hologramss
Nevelson, L.	Ancient Garden
Nevelson, L.	In the Land Where the Trees Talk
Nilsson, G.	Europa and the Bull
Nilsson, G.	Four People
Nilsson, G.	Group of Three Figures 1963

Rocca, S.	Heart Head [2 *States*]
Rocca, S.	Monkey and Flower
Rodriguez, J.	Sagrado Corazon
RoRomero, M.	Mirror of Life Past
Rosenquist, J.	Electrical Nymphs...
Rosenquist, J.	Flowers and Females
Rosenquist, J.	See-Saw, Class Systems
Rosenquist, J.	Where the Water Goes
Rossi, B.	Couple
Rossi, B.	Merry Model
Rossi, B.	Sovereign
Rossi, B.	Untitled #1
Rossi, B.	Untitled #2
Rossi, B.	Untitled #3
Rothenberg, S.	Between the Eyes
Rothenberg, S.	Breath-man
Rothenberg, S.	Pinks
Sessler, A.	Red Wig
Shapiro, J.	Untitled [1989]
Shapiro, P.	Golem
Siler, P.	I Like to be Abroad...
Smith, J.Q.	Salish
Smith, S.	Friday Night
Solien, T.	Night Watchman
Stolaroff, J.	Woman with Feathers
Thiebaud, W.	New Colored Fire...
Thomas, C.D.	Moonrise II
Thompson, Mildred	Love for Sale
Viesulas, R.	Paso Doble [Toro Desconocido V]
Viesulas, R.	Yonkers II
Warhol, A.	Marilyn Monroe Diptych
Wiley, W.	Who the Alien?
Wirsum, K.	Chris Mist Cowboy
Wirsum, K.	Dr. Chicago
Wirsum, K.	Four For You and One For...
Wirsum, K.	Head Print
Wirsum, K.	Karl Wirsum
Wirsum, K.	Museum...: Devil
Wirsum, K.	Pumpkin Mask (H)
Wirsum, K.	Pumpkin Mask (V)

Fans (Hand-Held)
Hanson, P. Fiesta
Kushner, R. National Treasure

Farmers
Deines, E.H. Joy on Kaw Valley Loam
Lichtenstein, R. Sower

Farms and Farming
Blumenschein, H. Untitled [Ranchos de Taos]
Deines, E.H. Joy on Kaw Valley Loam
Goulet, C. Bales of Hay
Goulet, C. Wide Cornfields #571
Herman, R. Fieldwork
Huntoon, M. Kansas Harvest
Kozloff, J. Harvard Litho
Lee, D. Helicopter
Levine, M. Barn
Lichtenstein, R. Sower
Lockwood, D. Feed and Seed
Lucioni, L. Big Haystack
McAfee, I. Small Ranch ["At Evening Time"]
Pierce, D. In the Fields
Sultan, A. Red Roofs, North Island, ...
Weege, W. Dance of Death

Fathers and Children
Buck, J. Father & Son
Seligmann, K. Marriage
Spafford, M. Split Laocoön

Fathers and Mothers *see* Parents

Fatigue
Morgan, N. Tired Traveler

Fear
Baskin, L. Frightened Boy and His Dog
Clemente, F. Not St. Girolamo
Hodgell, R. Burning Bush

McLarty, J. Wall City
Turner, J. Frightened Jack Rabbit Hiding

Feathers
Fricano, T. Drifting
Fricano, T. Texas Adventure
Lichtenstein, R. Head with Feathers and Braid
Oxman, K. In the Chamber
Stolaroff, J. Woman with Feathers

Feces
Paschke, E. Godzilla Rainbow Troupe...
Siler, P. He Shits on the World

Feet
Ay-O Rainbow Night B
Chase, L. Chasm
DeLawrence, N. Untitled
Marisol Pappagallo
Marisol Phnom Penh I
Nutt, J. toe tapping Nose
Rocca, S. Foot Tree
Sanderson, H. Pas de Deux
Wesselmann, T. Foot

Fences
Baskin, L. Man of Peace
Havens, J. Rabbit Fence
Mead, R. Summer Night
Milton, P. Julia Passing
Mock, R. Crossing Fate's Boundaries

Fertility
Daupert, B. Written in the Body...

Festivals
Poster, M. Festival of San Gennaro—...

Fields
Burchfield, C. Summer Benediction

Deines, E.H. Joy on Kaw Valley Loam
Goulet, C. Bales of Hay
Goulet, C. Rolling Fields
Goulet, C. Wide Cornfields #571
Herman, R. Fieldwork
Huntoon, M. Kansas Harvest
Kuopus, C. Mustard Fields
Milton, P. Collecting with Rudi
Peterdi, G. Poppies of Csobanka I
Price, K. Untitled
Schooley, E. Ravens Feeding in a Field

Fighting *see also* Boxing
Golub, L. Combat (I)
Harelson, C. Locking Horns
Lichtenstein, R. To Battle
Werger, A. Incident Before Dawn

Film (Camera)
Tilson, J. Software Chart Questionnaire

Fingerprints
Conner, B. Thumb Print
Rabkin, L. Thumbprint Print

Fingers
Nauman, B. Studies for Holograms
Rocca, S. Untitled (*from portfolio* Da ...)
Samaras, L. Clenched Couple

Fire
Brown, Roger Disasters
Cage, J. Fire #9
Cage, J. Fire #10
Cumming, R. Alexandria
Cumming, R. Burning Box
Hanson, P. Head-Pavilion II
Hanson, P. Pavilion Park
Hodgell, R. Burning Bush
Kent, R. Fire!

Miller, M. Ablaze
Rosenquist, J. Expo 67 Mural—Firepole 33' x 17'
Wirsum, K. Cheek-Chargo's Own Eddie...

Fire Engines
Grooms, R. AARRRRRRHH
Robbins, J. Firehouse
Seawell, T. Around Town

Fire Escape
Kepets, H. Sixth Avenue

Firemen
Grooms, R. AARRRRRRHH
Kent, R. Fire!

Fish *see also* Carp, Sea Life, Sharks, Trout
Anaya, S. Kuraje
Avery, Milton Fish in Dappled Sea
Baldessari, J. Fallen Easel
Beal, J. Brook Trout
Boxer, S. Aquarium
Cunningham, D. N.W. Notgelt
Cunningham, D. Pesca Cabeza #7
Cunningham, D. Trout Need Trees
Day, G. Fishing is Another 9-to-5 Job
Evergood, P. Cool Doll in Pool
Fearing, K. Collector
Henning, R. Still Life with Beetle
Lichtenstein, R. Goldfish Bowl
Macko, N. Gyotaku IV
McMillan, S. Reflections and Carp
Morley, M. Fish
Nelson, M. Deathmask
Raffael, J. Flow and Snow
Rosenquist, J. For Love
Solien, T.L. Victim of Doubt
Sonneman, E. Deep Runners
Sundstrom, M. In Praise of the Carp
Weege, W. Record Trout

Welliver, N. Brown Trout

Fishermen and Fishing
Camblin, B. Gone Fishing
Cunningham, D. Trout Need Trees
Fearing, K. Fishermen
Frasconi, A. Monterey Fisherman
Vath, M.J. Lure
Weege, W. Dance of Death
Wirsum, K. Surplus Slop from...the Windy...

Fishing Lines, Lures, and Rods
Nelson, M. Deathmask
Vath, M.J. Lure

Fishing Nets
Fearing, K. Fishermen

Fists
Bolton, R. Strong Arm
Guston, P. Street
Lichtenstein, R. Sweet Dreams, Baby!

Flags and Banners
Acconci, V. Three Flags for One Space...
Johns, J. Flag III
Johns, J. Flags I
Johns, J. Two Maps I
Johns, J. Two Maps II
Johns, J. Ventriloquist
Rivers, L. Last Civil War Veteran
Rivers, L. Last Civil War Veteran I

Flashlights
Johns, J. 1st Etchings
Johns, J. Souvenir
Nelson, Robert Light Load
Nilsson, G. Problematical Tripdickery
Nutt, J. Jim Nutt [1971-72 *or* 1973]

Flasks *see also* Bottles
Lichtenstein, R. Peace Through Chemistry IV

Flies
Albee, G. Fly Agaric
Corrigan, D. Queen Victoria Troubled by Flies
Ruscha, E. 1984
Ruscha, E. Carp with Shadow and Fly
Ruscha, E. Flies (*from* Insects)

Flight *see* Escape, Flying

Florence (Italy)
Kohn, M. Florentine Figure

Florida *see also* Cape Canaveral
Rauschenberg, R. Banner
Rauschenberg, R. Sky Garden

Flowerpots *see also* Vases
Goldman, J. Grassmere Lane
Hockney, D. Black Tulips

Flowers *see also* Plants (Nonflowering), individual names of flowers
Amen, I. Dreamer Amid Flowers
Antreasian, G. Limes, Leaves, and Flowers
Baynard, E. Blue Tulips
Baynard, E. Dark Pot with Roses
Baynard, E. Diptych 5
Baynard, E. Dragonfly Vase
Baynard, E. E-6
Baynard, E. H-1
Baynard, E. I-1
Baynard, E. J-7
Baynard, E. K-4
Baynard, E. Lilies
Baynard, E. M-1
Baynard, E. N-2
Baynard, E. Print Scarf
Baynard, E. Quarter Moon

Baynard, E.	Roses
Baynard, E.	Still Life with Orchid
Baynard, E.	Sunflower
Baynard, E.	Tulip Pitcher
Beal, J.	Trillium
Bothwell, D.	Memory Machine
Brady, R.	Tiger Lilies
Bratt, B.	Gaia and Uranus
Burchfield, C.	Summer Benediction
Bush, S.	Memories—Cornucopia...
Cheng, A.	Untitled
Dine, J.	Nine Views of Winter I
Dixon, K.	Wildflowers of Texas: LBJ &...
Esaki, Y.	Fourth Iris
Freckelton, S.	All Over Red
Freckelton, S.	Blue Chenille
Freckelton, S.	Plums and Gloriosa Daisies
Freckelton, S.	Red Chair
Freckelton, S.	Souvenir
Freckelton, S.	Tulips
Freilicher, J.	Flowering Cherry
Freilicher, J.	Peonies (Ten-Color)
Freilicher, J.	Poppies and Peonies
Freilicher, J.	Still Life and Landscape
Goldman, J.	Dallas Reflections #15
Goldman, J.	Mid-Summer Light
Goldman, J.	November
Goldman, J.	Sun Porch
Goldstein, D.	Evening Iris
Goldyne, J.	Narcissus
Goldyne, J.	Untitled [Dark Floral]
Grosch, L.	Gloxinia on an Oriental Rug
Grosch, L.	Iris on Bokhara
Hahn, B.	Botanical Layout: Peony
Hamilton, R.	Flower-Piece B
Hansen, A.	Flower Landscape
Hanson, P.	Bouquet
Hanson, P.	Chicago Imagist Art
Hanson, P.	Flower Presentation
Hanson, P.	Room with Vases and Flowers

Rosenquist, J.	Flowers and Females
Rosenquist, J.	Shriek
Rosenquist, J.	Sight Seeing
Rosenquist, J.	Sister Shrieks
Rosenquist, J.	Where the Water Goes
Sallick, L.	View from the Deck in Maine, IV
Schapiro, M.	Frida and Me
Schrag, K.	Flowering Tree—Bright Night
Sewards, M.	Rain
Shorr, H.	Casablanca Lillies
Steir, P.	Kyoto Chrysanthemum
Steir, P.	Roll Me a Rainbow
Steir, P.	Wish #3—Transformation
Sultan, D.	Black Tulips
Sultan, D.	"Yellow Iris" June 1, 1982
Thompson, R.	Vessel Study-Lily
Warhol, A.	Flowers
Wesselmann, T.	Nude
Wirsum, K.	Women with Birds and Flowers
Worley, T.	Interweave
Youngerman, J.	Suite of Changes
Zakanitch, R.	Double Geese Mountain
Zakanitch, R.	Hearts of Swan (Black)
Zakanitch, R.	Hearts of Swan (Red)
Zakanitch, R.	How I Love Ya, How I Love Ya

Flying

Avery, Milton	Three Birds
Boxer, S.	Finale
Brown, Roger	Airplane
Frank, M.	Astronomy
Gardner, A.	American Air Tourist—1940's…
Hanson, P.	Flying Machine
Prentice, M.	Another Flying Dream
Rathbun, R.K.	Leap of Faith
Rauschenberg, R.	Bait
Savinar, T.	I Want

Folly

Baskin, L.	Icarus

Thiebaud, W.	Boston Cremes
Thiebaud, W.	Dark Cake
Thiebaud, W.	Delights
Thiebaud, W.	Suckers [*State II*]
Walters, S.	Potato Low
Warhol, A.	Beef with Vegetables and Barley
Warhol, A.	Campbell's Soup I
Warhol, A.	Chicken Noodle Soup
Warhol, A.	Cream of Mushroom Soup
Warhol, A.	Tomato Soup
Wesselmann, T.	T.V. Still Life
Youngblood, J.	Primary Head #4

Football

Nice, D.	Heartland

Forests

Becker, D.	In A Dark Time
Becker, D.	Union Grove Picnic
Cornell, R.	Resting Women
Fiscus, R.	Presidio
Kay, B.	Crowhill [*State 3*]
Leithauser, M.	Migration
Nilsson, G.	Gladys Nilsson: Paintings…
O'Rourke, J.	Brazilian Rain Forest #2
O'Rourke, J.	New Life
Peterdi, G.	Cathedral
Phillips, J.	Landscape IV
Santlofer, J.	Beyond the Forest
Schrag, K.	Pond in a Forest
Schrag, K.	Woods and Open Sea
Walker, S.	Forest Suite
Wengenroth, S.	Untamed
Ziemann, R.C.	Back Woods
Ziemann, R.C.	Edge of the Woods
Zimmerman, L.	Outback

Forks *see* Eating Utensils

Fornication

Clemente, F.	Not St. Girolamo
Murray, E.	Her Story
Nutt, J.	sweet note of regret

Fountains

Bartlett, J.	In the Garden #116
Bartlett, J.	Shadow
Hanson, P.	Fountain
Sigler, H.	Every Chance She Gets...
Wayne, J.	"Twicknam Garden"

Foxes

Myers, M.	Fox in Costume
Sigler, H.	If She Could Free Her Heart...
Solomon, B.	Song of Songs

Frames (Picture)

Boyd, J.D.	Homage to Rembrandt
Boyd, J.D.	Portrait of Magritte
Boyd, J.D.	Portrait of van Gogh
Hockney, D.	Picture of a Pointless Abstraction...
Kraver, R.	Untitled
Lichtenstein, R.	Two Paintings: Dagwood
Lichtenstein, R.	Two Paintings: Sleeping Muse
Nutt, J.	Advertisement for Nutt's Frames
Nutt, J.	Nutt's Frames
Nutt, J.	Untitled [1969, 5 3/8 x 7 3/8]
Ritchie, B.	My Father's Farm from the Moon
Shields, A.	Santa's Collar

France see also Arc de Triomphe, Cathedrals, Eiffel Tower, Paris, Tours

Colescott, W.	History of Printmaking: Goya...
Huse, M.	Ruins—Tours, France
Manns, S.	Paris
Rivers, L.	Double French Money

Freedom

Lewis, T.R.	Death of a Conscious Called...

French Fries
Kreneck, L. Great Moments in Food Law...

Frogs
Graves, N. Six Frogs
Nebeker, R. Still I Don't Know
Price, K. Japanese Tree Frog Cup
Tolbert, F. Toad Noir

Fruit *see also* individual fruits
Antreasian, G. Limes, Leaves, and Flowers
Antreasian, G. Plums
Beal, J. Oysters with White Wine and...
Brady, R. Tiger Lilies
Cheng, A. Untitled
Cuilty, L. Fruit
Erlebacher, M. Homage to Bacchus
Erlebacher, M. New Potatoes
Fish, J. Pears and Autumn Leaves
Fish, J. Pears and Mittens
Fish, J. Preserved Peaches
Freckelton, S. Openwork
Freckelton, S. Plums and Gloriosa Daisies
Freilicher, J. Still Life and Landscape
Goldman, J. Ellen's Window
Goldman, J. Summer Nights
Goldyne, J. One, Two, Three...All Gone
Hamilton, R. Flower-Piece B
Helfensteller, V. Untitled [Pears]
Lichtenstein, R. Untitled
Nares, J. Strange Fruit
Plotkin, L. Still Life with Tangerine
Rauschenberg, R. Banner
Ryan, A. In a Room
Sallick, L. View from the Deck in Maine, IV
Solomon, B. Song of Songs
Thomas, C.D. Banana
Treaster, R. Vermeer and Times
Wesselmann, T. T.V. Still Life

Funerals *see* Burials

Furniture *see also individual pieces of furniture*

Adams, C.	Second Hand Store I
Artschwager, R.	Interior
Barrera, A.	Untitled
Berg, T.	Dark Adirondack
Chesebro, E.	Random Chair #4
Freckelton, S.	All Over Red
Freckelton, S.	Red Chair
Goldman, J.	Sun Porch
Hamilton, R.	Interior
Hamilton, R.	Just What Is It That Makes...
Hickey, C.	A-Chair
Hockney, D.	Pembroke Studio Interior
Hockney, D.	Pembroke Studios with Blue...
Hockney, D.	Perspective Lesson
Hockney, D.	Two Pembroke Studio Chairs
Hockney, D.	Tyler Dining Room
Lichtenstein, R.	Picture and Pitcher
Mazur, M.	Enemies Sequence #1, Transition
Pearlstein, P.	Reclining Nude on Green Couch
Price, G.	Table
Price, K.	Lizard Cup
Ramberg, C.	Flying en masse from Goldblatts
Ramberg, C.	Flying from Goldblatts
Rasmussen, K.	Greyfield Ghosts
Rocca, S.	Rings
Rosofsky, S.	Untitled II
Weisberg, R.	Good Daughter

Future
Hockenhull, J. Silver and Gold, Edged in Black

Gangsters
Colescott, W. Triumph of St. Valentine

Garbage
Powell, R.J. Richard Wright Series #7: Cerebrus

Garbage Truck

Jacquette, Y. Sanitation Truck

Gardens

Bartlett, J.	In the Garden #116
Bartlett, J.	Shadow
Bothwell, D.	Memory Machine
De Kooning, E.	Jardin du Luxembourg I
Goldman, J.	Breezeway #7
Goldman, J.	To the Garden
Havens, J.	Rabbit Fence
Hockney, D.	Hotel Acatlán: First Day
Hockney, D.	Hotel Acatlán: Second Day
Hockney, D.	Hotel Acatlán: Two Weeks Later
Hockney, D.	Views of Hotel Well I
Hockney, D.	Views of Hotel Well II
Hockney, D.	Views of Hotel Well III
Kerslake, K.	Sarah's Garden
Margolius, B.	Japanese Inspired Waterlillies
McLean, J.	Flight over Busch Gardens
Nilsson, G.	Christ in the Garden
Prentice, M.	Waiting in the Garden
Schooley, E.	Garden Walk

Gasoline Cans

Ruscha, E. Gas

Gasoline Pumps

Seawell, T. First Street
Sullivan, D. Asymmetry

Gasoline Stations

Ruscha, E.	Cheese Mold Standard with Olive
Ruscha, E.	Mocha Standard
Ruscha, E.	Standard Station
Ruscha, E.	Twenty-Six Gasoline Stations

Gateway *see also* Doors and Doorways

Lowney, B. Gateway

Geese

Turner, J.	Dead Snow Goose II
Zakanitch, R.	Double Geese Mountain

Gemstones *see also* Diamonds (Stones)

Guzak, K.	Jewels for Taj
Rocca, S.	Rings

Geometry

Denes, A.	Dialectic Triangulation: ...

Germany *see also* Nuremberg

Cunningham, D.	N.W. Notgelt
Immendorff, J.	Ausgangspunkt
Immendorff, J.	Brandenburger Tor
Immendorff, J.	Wir Kommen
Kitaj, R.B.	Acheson Go Home
Spero, Nancy	Ballade von der Judenhure...
Torres, F.	Northern Guernica

Ghosts *see* Apparitions, Spirits

Giraffes

Boxer, S.	Gatheringforsomereason

Girls

Blackburn, R.	Girl in Red
Blaine, N.	Sleeping Girl
Bolton, J.	Two Girls
Bothwell, D.	Memory Machine
Catlett, E.	Lovey Twice
Close, C.	Georgia
Hayes, S.	Happy Girl or Boy
Huntoon, M.	Girl with Sand Painting
Lasansky, M.	La Jimena
Milton, P.	Julia Passing
Nilsson, G.	Young Girls 1963
Rivers, L.	Swimmer A, B, C, and D
Rossi, B.	Poor Self Trait #1: Dog Girl
Rossi, B.	Poor Self Trait #2: Shep

Rossi, B. Poor Self Trait #3: Curls
Saar, B. Black Girl's Window
Sigler, H. Where Daughters Fear...
Smith, A. Untitled
Wirsum, K. Girl and Creatures

Glasses (Drinking)
Davis, R.T. Bottles
Fontecilla, E. Belgium Interior
Lichtenstein, R. Untitled
Sloan, J. Sears Tower
Warhol, A. Fiesta Pig

Glasses (Eyeglasses) *see* Eyewear

Globes
Fisher, V. Perdido en el Mar
Sigler, H. If She Could Free Her Heart...

Goats
Morley, M. Goat
Morley, M. Goats in a Shed

God
McLarty, J. Left Hand of God

Golf
Nilsson, G. Holes with a Muse

Gorges *see also* Abysses, Canyons, Chasms
Ellis, R. Rio Grande Gorge #16

Gorillas
Wirsum, K. Dancing Hare Toddy/Dancing...

Gossip and Gossiping
Sessler, A. Morning Forum

Government
Colescott, W. Judgment Day at NEA

Grandmothers
Ponce de Leon, M. Recycling of Gran'ma

Grapes
Avery, E. False Bacchus
Solomon, B. Song of Songs

Grass
Rosenquist, J. Spaghetti and Grass
Walker, T. Untitled [*p.121*]

Grasshoppers
Beal, J. Trillium
Brown, Roger Shit to Gold
Pozzatti, R. Grasshopper

Graveyards
Anderson, Larry Ecce Homo
Jonson, R. Sanctuario
Weege, W. Dance of Death

Green (Color)
Diebenkorn, R. Green
Frankenthaler, H. Barcelona
Frankenthaler, H. Savage Breeze
Green, Art Untitled [1962 or 1963]
Hanson, P. Dancing Couple IV
Hockney, D. Lithographic Water... [*all*]
Johns, J. 1
Mitchell, Joan Bedford II
Murray, E. Untitled [1982]
Nilsson, G. Christ in the Garden
Nutt, J. Nacktes Weib
Palermo, B. 4 Prototypes
Reeder, D. Eryngo
Smith, C.W. Red and Green Discs
Stella, F. Imola Five II

Grid

Davis, R.W.	Arc Arch
Davis, R.W.	Arch
Davis, R.W.	Big Open Box
Davis, R.W.	Invert Span
Davis, R.W.	Twin Wave
Davis, R.W.	Upright Slab
Davis, R.W.	Wide Wave
Denes, A.	Dialectic Triangulation: ...
Marden, B.	Untitled [1972]
Morris, R.	Infantry Archive—To Be...
Oldenburg, C.	System of Iconography: Plug...
Roth, David	Metamorphosing of the Tones...

Growth

Peterdi, G.	Germination I

Guns

Bosman, R.	Mutiny
Bosman, R.	Suicide
Hoke, S.	Waiting for the Freight
Lichtenstein, R.	CRAK!
Mapplethorpe, R.	Gun Blast
Warhol, A.	Cagney

Gunshots

Lichtenstein, R.	CRAK!
Mapplethorpe, R.	Gun Blast

Hair

Damer, R.W.	1973 Birdnest, Rose, and Capital
Dine, J.	Braid, second state
Gongora, L.	Transformation of Samson &...
Hockney, D.	Start of the Spending Spree...
Johnston, T.	L'Etranger
Kaprov, S.	Self-Portraits
Lewis, T.R.	Liberty Taking Advantage
Lichtenstein, R.	Head with Braids
Lichtenstein, R.	Head with Feathers and Braid
Marisol	Phnom Penh I

Johns, J.	Hatteras
Johns, J.	Periscope
Johns, J.	Savarin
Johns, J.	Skin with O'Hara Poem
Kaprov, S.	Self-Portraits
Kitaj, R.B.	Photo-eye (El Lissitzky)
Kruger, B.	Untitled ["Printed Matter Matters"]
Kruger, B.	Untitled [We Will No Longer...]
Lark, S.	Guy #2
Marisol	Furshoe
Marisol	Pappagallo
Marisol	Phnom Penh I
McLarty, J.	Left Hand of God
Mills, L.	I Do
Nares, J.	Artaud's Arms
Nauman, B.	Studies for Hologramss
Nutt, J.	Don't do it
Nutt, J.	Pit er Pat
Paschke, E.	Limone
Rocca, S.	Untitled (*from portfolio* Da ...)
Rodriguez, J.	Sagrado Corazon
Rosenquist, J.	For Love
Rothenberg, S.	Pinks
Sanderson, H.	Pas de Deux
Santlofer, J.	Beyond the Forest
Santlofer, J.	Burning Bush
Sigler, H.	If She Could Free Her Heart...
Tàpies, A.	Impressions of Hands
Warshaw, H.	Hands
Wesselmann, T.	Smoker
Wirsum, K.	Hand Print
Wirsum, K.	Whats the Coinfusion...
Youngblood, J.	Primary Head #4

Hangmen *see* Execution and Executioners

Harbors *see also* Boats, Coves

Beerman, J.	Stones Silent Witness
Drewes, W.	Calm Morning
Frasconi, A.	Monterey Fisherman

Harvest

Deines, E.H.	Joy on Kaw Valley Loam
Huntoon, M.	Kansas Harvest

Hats *see also* Caps, Head Coverings

Ash, R.	Pinocchio Series, The Financier
DeMatties, N.	Conversation
Hammond, J.	Untitled #17
Hockney, D.	Celia with Green Hat
Jones, L.	Hamlet
Jones, L.	Hat for Tamara Toumanova
Lasansky, L.	Orientalia
Lasansky, L.	Tomás
Lindner, R.	Fun City
Lockwood, D.	Hats and Boots
Myers, F.	Saint Teresa's Seventh Mansion
Myers, M.	Fox in Costume
Myers, V.	Self Portrait with Hat
Oldenburg, C.	Three Hats
Paschke, E.	Hat
Paschke, E.	Hubert
Paschke, E.	Klaus
Paschke, E.	Kontato
Paschke, E.	Tudor
Rocca, S.	Rings
Scholder, F.	Indian at the Bar
Sultan, D.	Sailor Hats, March 21, 1979
Sultan, D.	Water under the Bridge
Walters, S.	Summer Self-Portrait
Wiley, W.	Pilgrim Repair
Wirsum, K.	Chris Mist Cowboy
Wirsum, K.	Santa Hat
Wirsum, K.	Tex Tour

Hawaii

Childs, B.	Images from Hawaiian Legends...
Feldman, A.	Hawaiian Memory [Kauai]

Hawks

| Oliveira, N. | Acoma Hawk I |
| Oliveira, N. | Acoma Hawk V |

Haystacks

Goulet, C.	Bales of Hay
Huntoon, M.	Kansas Harvest
Lucioni, L.	Big Haystack

Head Coverings *see also* Caps, Crowns, Dunce Caps, Hair, Hats, Headdresse
 Swimming Caps, Veils

Ash, R.	Pinocchio Series, The Financier
Baskin, L.	Crazy Horse
Beal, J.	Self-Portrait
Corrigan, D.	Queen Victoria Troubled by Flies
Francis, M.	Shattered King
Hanson, P.	Veiled Head I
Hanson, P.	Veiled Head II
Hanson, P.	Veiled Head III
Hanson, P.	Veiled Head IV
Hockney, D.	Celia with Green Hat
Katz, A.	Anne
Katz, A.	Green Cap
Kennedy, W.	Memories, Dreams…
Lasansky, L.	Young Nahua Dancer
Lindner, R.	Miss American Indian
Myers, F.	Saint Teresa's Seventh Mansion
Myers, M.	Fox in Costume
Oldenburg, C.	Three Hats
Reder, B.	Lady with Veil
Scholder, F.	Indian with Butterfly
Sessler, A.	Red Wig
Walters, S.	Summer Self-Portrait
White, C.	Exodus II
Wirsum, K.	BAD BLUE Boys Make Good!
Wirsum, K.	Before you Go with the Glow…
Wirsum, K.	Blue Boys SPLIT the Difference
Wirsum, K.	Chalk it off to Tex perience
Wirsum, K.	Inner "E" Stare Bonnet
Wirsum, K.	Lets Split Fountain the Difference

Dine, J.	Girl and Her Dog
Dine, J.	Heart 1983
Dine, J.	Heart and the Wall
Dine, J.	My Nights in Santa Monica
Dine, J.	Sovereign Nights
Hanson, P.	Heart Variations
Nutt, J.	Gatherer of Wool
Ritchie, B.H., Jr.	Canceled Artist's Last Love Letter
Ritchie, B.H., Jr.	Locus and Sea Squares
Ritchie, B.H., Jr.	Video Target Head
Rocca, S.	Heart Head [*2 States*]
Wiley, W.	Who the Alien?
Wirsum, K.	Transplant: Famous Heart-Tits...
Wright, D.	Untitled
Zakanitch, R.	Hearts of Swan (Red)

Heaven

| Allen, T. | Pinto to Paradise |
| Lomas-Garza, C. | Heaven and Hell |

Helicopters

| Lee, D. | Helicopter |

Hell

Lomas-Garza, C.	Heaven and Hell
Kohn, M.	Season in Hell
Rauschenberg, R.	Spot

Helmets

| Fenton, J. | Open Road |

Heroes

| Nutt, J. | [title=drawing of two fingers] |

Hexagons (Shapes)

| Zammit, N. | Untitled |

Highways *see* Roads

Hijackings
Rosenquist, J. Cold Light

Hills *see also* Mountains
Bodger, L. English Summer Night
Capps, C. Into the Hills
Capps, C. Taos
Dasburg, A. Ranchos Valley I
Goulet, C. Rolling Fields
Hoover, E. Untitled [Taos Pueblo]
McAfee, I. Small Ranch ["At Evening Time"]
Reed, D. Adobe and Wild Plum
Taylor, P. Towards Santa Fe
Thiebaud, W. Apartment Hill
Welliver, N. Si's Hill

Historical Figures and Themes *see also* Civil War, Portraits
Baskin, L. Crazy Horse
Beck, H. St. Francis
Brown, Roger Family Tree Mourning Print
Colescott, W. Attack and Defense at Little...
Colescott, W. History of Printmaking: Goya...
Colescott, W. Raft of the Titanic
Colescott, W. Triumph of St. Valentine
Cumming, R. Alexandria
Gorny, A-P. Queen's Autumn...
Hamilton, R. Kent State
Hanley, J. Plague-Doctor
Izquierdo, M. Pierrot's Tapestry
Kardon, D. Revolutionary Cleanser
Meeker, D. Genghis Khan
Peterdi, G. Alexander
Rauschenberg, R. Signs
Rivers, L. Last Civil War Veteran
Rivers, L. Last Civil War Veteran II
Shahn, B. Sacco and Vanzetti
Summers, C. Dark Vision of Xerxes
Thomas, L. Forgotten Moments in History #4
Thomas, L. No Kid of Mine Works for Peanuts
Tilson, J. Letter from Ché

Warhol, A. Birmingham Race Riots
Warhol, A. Mao Tse-Tung
Warhol, A. Plate 11 (*from* Flash...)
Wiley, W. Pilgrim Repair

Holes
Schuselka, E. Untitled
Siler, P. Bug Comes Out

Hollywood
Ruscha, E. Hollywood

Homosexuality
Hockney, D. Two Boys Aged 23 or 24

Hoops
Prochaska, T. Maybe

Hope
Carnwath, S. We All Want to Believe
Mersky, D. Cuttings

Horns (Animal)
Feddersen, J. Veiled Memory
Kimball, W. Properly Mounted Texas Longhorn
Palmore, T. Bevo with Birds

Horseback Riding and Riders
De Lamonica, R. Untitled [1984]
Frank, M. Astronomy
Frasconi, A. Self-Portrait with Don Quixote
Ikeda, M. Sphinx of the Woods
Kohn, M. Death Rides a Dark Horse
Lasansky, M. España
Meeker, D. Don Quixote
Moy, S. Classical Horse and Rider
O'Hara, J.F. Riders
Peterdi, G. Alexander
Scholder, F. Indian on Galloping Horse...

Nutt, J. toe tapping Nose
Sullivan, D. Asymmetry

Hospitals *see* Medicine

Hotels
Hockney, D. Hotel Acatlán: First Day
Hockney, D. Hotel Acatlán: Second Day
Hockney, D. Hotel Acatlán: Two Weeks Later
Hockney, D. Views of Hotel Well I
Hockney, D. Views of Hotel Well II
Hockney, D. Views of Hotel Well III

Houses and Housing
Autry, C. Relationship of Things (Belief XV)
Barnet, W. Waiting
Bartlett, J. Rhapsody: House, Mountain, ...
Brants, C. Deserted House
Brown, Roger Rolling Meadows
Capps, C. Into the Hills
Capps, C. Taos
Capps, C. Trees at Questa
Carsman, J. Asbury Reflection
Crane, P. Neo-Colorado
Cumming, R. Burning Box
Cunningham, E.C. Beach House with Claw
Cunningham, E.C. Fried Egg House
Dennis, D. Two Towers
Goldman, J. Summer Nights
Goldman, J. To the Garden
Haas, R. Great Hall, Kip Riker Mansion
Hamilton, R. Interior
Indiana, R. ERR
Kerslake, K. Magic House: Reverie
Kerslake, K. Magic House: Tear
Kerslake, K. Sense of Place
Kondos, G. River Mansions, Sacramento River
Kondos, G. River Reflection, Sacramento River
Lehrer, L. Terrace
Levine, M. Pardee House (West View)...

Mazur, M.	Three Beds, No. 14
McNeil, G.	Oblique Figure
Mills, L.	I Do
Morales, A.	Dos Ciclistas [Two Cyclists]
Morris, K.	King's Day
Motherwell, R.	Personnage
Moy, S.	Classical Horse and Rider
Murray, E.	Her Story
Nebeker, R.	Jacob's Ladder
Nelson, Richard	How Fate Works
Nevelson, L.	Ancient Garden
Nevelson, L.	In the Land Where the Trees Talk
Noah, B.	Pioneer
Nutt, J.	[title=drawing of two fingers]
Nutt, J.	"your so coarse" (tish tish)
O'Hara, J.F.	Comanche Gap IV
Oliviera, N.	Man
Osorio, J.H.	In the N.Y. Sub
Paolozzi, E.	Silken World of Michelangelo
Paris, H.	Untitled
Paschke, E.	Tudor
Phillips, M.	Figures with Golden Bowl
Phillips, M.	Large Reader #2
Pokorny, E.	My Life
Ponce de Leon, M.	Man is the Measure...
Prentice, M.	Constructing Layers of Time...
Prentice, M.	Another Flying Dream
Prentice, M.	Implications of Sound, I
Prentice, M.	Implications of Sound, II
Prentice, M.	Primal Time I, II, III
Ramberg, C.	Back to Back
Ramberg, C.	Untitled [1968]
Ramberg, C.	Veiled Person
Rathbun, R.K.	Leap of Faith
Rathbun, R.K.	Living in Deliberate Optimism
Rathbun, R.K.	Opportunity and Distraction
Ringgold, F.	Woman, Power, Poverty and Love
Rivers, L.	US
Rocca, S.	Rings
Romano, C.	Figure and Hills

Wirsum, K.	Lets Split Fountain the Difference
Wirsum, K.	She was Impressive
Wirsum, K.	Wade "N" C Policy
Wirsum, K.	Wake Up Yer Scalp with Chicago
Wirsum, K.	We Got Nuthun to Hyde!...
Wood, T.	Some Beasts Will Eat Anything
Youngblood, J.	Primary Head #4
Yunkers, A.	Big Kiss
Yunkers, A.	Miss Ever-Ready
Yunkers, A.	Succubae

Human Organs

Hockenhull, J.	Inheritors
Kaneshiro, R.	Untitled
Smith, Kiki	Lungs

Hunters and Hunting

| Hoke, S. | Waiting for the Freight |
| O'Hara, J.F. | Riders |

Hygiene

| Nutt, J. | seams straight! |

Ice Cream Bars

| Maryan, M. | Untitled |
| Oldenburg, C. | System of Iconography: Plug... |

Ice Cream Cones

| Thiebaud, W. | Delights |

Ice Skating

| Poster, M. | Rockefeller Center |

Icebergs

| Wilson, R. | Untitled #5 |

Idleness

| Beckmann, M. | King and Demagogue |

Illness *see* Medicine

Ruscha, E.	Swarm of Red Ants
Schleeter, H.	Glow Bugs
Siler, P.	Bug Comes Out
Woehrman, R.	Attacus Edwards ii

Insolence *see also* Disrespect, Mockery
Arneson, R. Hollow Gesture

Insults *see* Insolence

Interiors (Houses, Buildings) *see also* Alcoves, Bathrooms,
 Dining Rooms, Kitchens

Albright, I.	Into the World There Came a Soul Called Ida
Albright, I.	Self-Portrait at 55 Division Street
Anderson, W.T.	Great Indian War Series No. 26
Artschwager, R.	Interior
Artschwager, R.	Interior (Woodgrain) #2
Autry, C.	Relationship of Things (Belief XV)
Avery, E.	Summer Boogie Woogie
Barrera, A.	Untitled
Blackburn, R.	Girl in Red
Brady, R.	Tiger Lilies
Brown, Roger	Untitled [1968-69]
Bush, S.	Memories—Cornucopia...
Cadmus, P.	Rehearsal
Cooper, R.	Tri-Axial Rotation of a Floating...
Corrigan, D.	President Nixon Hiding...
Cunningham, E.C.	Beach House with Claw
Cunningham, E.C.	Fried Egg House
Dallman, D.	Bath
Dennis, D.	Deep Station: View from the Track
Estes, R.	Urban Landscapes No. 2
Fischl, E.	Untitled (*from* Floating Islands)
Fuentes, M.	Solstsmoon
Goldman, J.	Breezeway #7
Goldman, J.	Sun Porch
Green, Art	Kitchen Still Life
Guston, P.	Studio Corner
Haas, R.	Great Hall, Kip Riker Mansion
Hamilton, R.	Interior

Pond, C. Kitchen in My Studio...
Prentice, M. Implications of Sound, I
Price, G. Table
Price, K. Lizard Cup
Rasmussen, K. House—Savannah Beach
Renda, M. Untitled
Rodriguez, J. Sagrado Corazon
Rosofsky, S. Untitled II
Ryan, A. In a Room
Samaras, L. Clenched Couple
Sandlin, D. Living Room with Four Death...
Shaffer, R. Platform
Sigler, H. Where Daughters Fear...
Smith, A. Untitled
Solien, T.L. Memoir Den
Stock, M. Keys
Summer, E. Dream from a Majestic Past III
Walker, T. Untitled [*p. 123*]
Walters, S. Potato Low
Warhol, A. Electric Chair
Wengenroth, S. Meeting House
Werger, A. By Force
Wesselmann, T. Nude Print
Williams, M.K. House of Somnus
Wolff, E. Trailers

Irises (Flowers)
Baynard, E. Quarter Moon
Esaki, Y. Fourth Iris
Goldman, J. Mid-Summer Light
Goldstein, D. Evening Iris
Grosch, L. Iris on Bokhara
Worley, T. Interweave

Ironing *see* Laundry

Islands
Crutchfield, W. Zeppelin Island

Isolation
Bourgeois, L. "In the mountains of central..."
Solien, T. Night Watchman

Istanbul
Delaney, B. Untitled [Istanbul, Turkey]

Italy *see also* Florence (Italy), Rome, Venice
Berman, Eugene Pisan Fantasy
Castellon, F. Roman Urchins
Christo Wrapped Monument to Leonardo
Olsen, D. Pentimento XXII
Pozzatti, R. Venetian Sun
Yunkers, A. Skies of Venice VIII

Jackets
Esaki, Y. Jacket

Jacqueline Kennedy Onassis *see* Onassis, Jacqueline Kennedy

Jacks (Playing)
Goodman, J. Un Ange Passe

James, Henry
Milton, P. Jolly Corner III: 7

Japan
Byron, M. Untitled
Farnsworth, D. Counterpoint Series/Quatrefoil
Hiratsuka, Y. Cacnus
Hiratsuka, Y. Judgment
Hiratsuka, Y. Morning Glory Sigh
Ikegawa, S. Issa
Kohn, M. Kabuki Samurai
Nebeker, R. Still I Don't Know

Jars
Davis, R.T. Bottles
Fish, J. Preserved Peaches
Freilicher, J. Poppies and Peonies

Jeans
Segal, G. Three Figures in Red Shirts...

Jellyfish
McCoy, A. Meduse
Utter, B. Foo Dog and Jellyfish

Jesus Christ
Corita, Sr.M. This Beginning of Miracles
Cremean, R. Fourteen Stations of the Cross
Driesbach, D. St. Luke Paints the Madonna
Eckart, C. Cimabue Restoration Project
Jones, A.R. La Sagrada Familia
La Roux, L.J. Icon #2
Lebrun, R. Grünewald Study
Nilsson, G. Christ in the Garden
Sánchez, J. Para Don Pedro
Schnabel, J. Raft [Dream]
Wayne, J. Shine Here to Us...

Jewelry *see also* Rings
Close, C. Janet
Kushner, R. Rhoda VIII 3
Kushner, R. Rhonda VII
Rocca, S. Rings

Jockeys
Ruscha, E. Jockey

Joy
Lomas-Garza, C. Heaven and Hell

Judaism *see also* Biblical Figures and Themes
Avery, E. Massacre of Innocents
Chase, L. Red Sea
Chicago, J. Creation
Hodgell, R. Burning Bush
Lasansky, M. For an Eye an Eye, III
Schnabel, J. Raft [Dream]

Solomon, B. Song of Songs

Jugglers and Juggling
Levers, R. Terrorist Juggling Plates
Stussy, J. Family of Acrobatic Jugglers
von Wicht, J. Juggler

Jukeboxes
Frank, R. Black Juke

Kangaroos
Boxer, S. Kangaroos

Kansas
Huntoon, M. Kansas Harvest

Kauai
Feldman, A. Hawaiian Memory [Kauai]

Keyholes
Reeder, D. Abstract Keyhole

Keys
Bosman, R. Backdoor
Rauschenberg, R. Breakthrough I
Rauschenberg, R. Breakthrough II

Kings
Beckmann, M. King and Demagogue
Henry, J. King in His Counting House
Morris, K. King's Day
Nutt, J. Christmas Card
Peterdi, G. Alexander

Kissing
Fritzius, H. Untitled [1985]
Hayes, S. Days of Love
Warhol, A. Kiss

Kitchens
Green, Art Kitchen Still Life
Hickey, C. A-Chair
Pond, C. Kitchen in My Studio...

Kneeling
Kent, R. Europe
Weisberg, R. Before the Bath

Knives *see also* Eating Utensils *or* Weapons
Hanson, P. Room with...Flowers and Knives
Nutt, J. oh Dat Sally

Laboratories
Lichtenstein, R. Peace Through Chemistry IV

Ladders
Gonzalez-Tornero, S. Stepladder
Machinist, L. Ascension III
Nebeker, R. Jacob's Ladder
Rathbun, R.K. Leap of Faith
Rossi, B. Footnotes on Portraiture

Lakes and Ponds
Freilicher, J. Untitled
Gornik, A. Equinox
Kondos, G. River Mansions, Sacramento River
Mortensen, G. Summer Pond
Schrag, K. Pond in a Forest
Wilson, R. Untitled #5
Wirsum, K. Surplus Slop from...the Windy...
Zimmerman, L. Mt. Shuksan

Lamps *see* Light (Fixtures)

Lampshades
Caulfield, P. Lampshade

Landscapes *see also* Mountains, Trees
Alechinsky, P. Around the Falls

Freilicher, J.	Poppies and Peonies
Freilicher, J.	Still Life and Landscape
Freilicher, J.	Untitled
Friese, N.	Homage to Constable
Gardner, S.	Missing Person's Reports
Gelb, J.	Oahu Sunrise
Gellis, S.	Dusk: Lake Rowland
Gilkey, G.	Oregon Coast
Gordy, R.	Figure in Landscape
Gornik, A.	Equinox
Goulet, C.	Bales of Hay
Goulet, C.	Rolling Fields
Goulet, C.	Wide Cornfields #571
Grebinar, K.	Triptych
Green, Art	Roger Brown/Art Green [1973]
Gwyn, W.	Interstate
Hall, S.	Morning Glory
Hamilton, R.	Sunset
Hansen, A.	Flower Landscape
Hansen, A.	Winter 1977
Helfensteller, V.	Untitled [Landscape with Animals]
Henle, M.	In the Clouds
Hewitt, C.	Summer Night
High, T.G.	rebel earth—Maranatha
High, T.G.	rebel earth—Ramath lehi
Hildebrand, J.	Eagle's Nest—Gore Range
Hoover, E.	Untitled [Taos Pueblo]
Huntoon, M.	Kansas Harvest
Jacquette, Y.	Brooklyn-Atlantic Avenue I
Jonson, R.	Sanctuario
Kelly, E.	Saint Martin Landscape
Kernan, C.	Traversal I
Kernan, C.	Traversal II
Kerslake, K.	Sense of Place
Kirk, M.	It's Been a Long Time... Since
Kohn, M.	Sleeping Soldier
Kondos, G.	River Mansions, Sacramento River
Kondos, G.	River Reflection, Sacramento River
Kozloff, J.	Harvard Litho
Kuopus, C.	Mustard Fields

Peak, E.	Morning
Peterdi, G.	Cathedral
Pfaff, J.	Yoyogi [*State I*]
Pokorny, E.	In the Ravine
Porter, F.	Isle au Haut
Pozzatti, R.	Cosmorama
Price, K.	Untitled
Rasmussen, K.	Greyfield Ghosts
Rasmussen, K.	House—Savannah Beach
Rathbun, R.K.	Living in Deliberate Optimism
Reed, D.	Adobe and Wild Plum
Richter, G.	Canary Islands Landscape
Rivers, L.	Elephants
Romano, C.	Figure and Hills
Romano, C.	Night Canyon
Romano, C.	River Canyon
Romano, C.	Silver Canyon
Rosenquist, J.	Cold Light
Ruble, R.	Dying Rhino
Ruscha, E.	Hollywood
Sallick, L.	View from the Deck in Maine, IV
Santlofer, J.	Beyond the Forest
Schooley, E.	Ravens Feeding in a Field
Schultheiss, C.	Pastoral II
Schuselka, E.	Untitled
Sewards, M.	Rain
Shatter, S.	Canyon Rose
Shatter, S.	Rock Face/Zion Canyon
Shatter, S.	Vertigo
Siegel, I.	Sunset
Sigler, H.	"Dance of Life"
Sigler, H.	Every Chance She Gets…
Skinner, A.	Lost Train
Smith, D.G.	Prickly Pear Cactus
Smith, Moishe	Four Seasons—Winter
Stasik, A.	Still Life Landscape, No. 5
Steinberg, S.	Untitled
Stock, M.	Air Whale
Stone, C.	In February
Sultan, A.	Red Roofs, North Island, …

Johns, J. Light Bulb
Kruger, B. Untitled ["Printed Matter Matters"]
Lichtenstein, R. Lamp

Lighthouses
Hansell, F. Untitled
Moskowitz, R. Eddystone

Lightning
Anderson, Laurie Mt. Daly/US IV
Bell, C. Thunder Smash
Brown, Roger Indian Lightning
Brown, Roger Three Lightning Bolts
Hanson, P. Pavilion Park
Scarlett, R. Nature's Catalyst

Lights *see* Light (Beam, Fixtures, *or* Sunlight), Lightbulbs,
 Neon Lighting, Streetlights, Traffic Signals or Traffic Lights

Lightswitch
Lichtenstein, R. On

Lilies
Baynard, E. Lilies
Goldman, J. Mid-Summer Light
Nesbitt, L. Lily [*State I*]

Lily Pads *see* Waterlilies

Limes
Antreasian, G. Limes, Leaves, and Flowers

Lines and Bars
Albers, J. Ascension
Albers, J. Multiplex A
Andrade, E. Black Cisoide
Antreasian, G. Bebek II
Antreasian, G. Untitled [1980]
Antreasian, G. Untitled 72-121
Anuszkiewicz, R. Diamond Chroma

Hazel, S.	Biloxi Beach Liner
Heizer, M.	45°, 90°, 180°
Hofmann, G.	Temtie
Hofmann, G.	Untitled
Holland, T.	Ryder
Johns, J.	Between the Clock and the Bed
Johns, J.	Corpse and Mirror
Johns, J.	Plate No. 6 after Untitled
Johns, J.	Scent
Johns, J.	Untitled [1983]
Judd, D.	6-L
Judd, D.	Untitled (*one of 6*)
Kmetko, A.	La Bajada
LeWitt, S.	Composite Series
LeWitt, S.	Lines from corners, sides and the...
LeWitt, S.	Lines from Sides, Corners and...
LeWitt, S.	Lines in Color from Corners, ...
LeWitt, S.	Squares with a Different Line...
LeWitt, S.	Untitled [1971]
LeWitt, S.	Untitled [1972]
Longo, V.	ABCD
Longo, V.	First Cut, Second Cut, Third Cut
Martin, A.	On a Clear Day
Mason, A.T.	Inverse
McCulloch, F.	79.5
Moses, E.	Broken Wedge Series No. 6
Nesbitt, L.	Barriers
Noland, K.	Blush
Noland, K.	Winds 82-34
Nushawg, M.	(Dové Te) Destiny Kinnel
Paschke, E.	Untitled [c1960]
Pearson, H.	Red and Blue
Phillips, J.	Melrose
Rabel, K.	Dobro
Sandback, F.	Twenty-Two Constructions...
Sandback, F.	Untitled [1975]
Saret, A.	#AS83-103
Sato, N.	Video Sunrise II: Zoom In
Scott, A.	17!
Scully, S.	Desire

Lips *see also* Mouth

Indiana, R.	Sex Anyone?
Katz, A.	Red Coat
Nauman, B.	Studies for Holograms
Noah, B.	Ooh
Rosenquist, J.	Flowers and Females
Rosenquist, J.	Shriek
Rosenquist, J.	Sister Shrieks
Warhol, A.	Marilyn Monroe I Love Your...
Wesselmann, T.	Smoker

Lipstick

Acconci, V.	Kiss-Off
Oldenburg, C.	System of Iconography: Plug...

Literary Figures and Themes

Brown, Roger	Shit to Gold
Frasconi, A.	Don Quixote and Rocinantes
Frasconi, A.	Self Portrait with Don Quixote
Jones, L.	Hamlet
Jones, L.	Hat for Tamara Toumanova
Landau, J.	Violent Against Themselves...
Meeker, D.	Don Quixote
Meeker, D.	Trojan Horse
Smith, David	Don Quixote

Lizards

Daupert, B.	Written in the Body...
Woehrman, R.	Henrietta

Lobsters

Anaya, S.	Kuraje

Logos (Symbols)

Rosenquist, J.	Circles of Confusion I
Thomas, L.	No Kid of Mine Works for Peanuts

Lollipops

Nanao, K.	Dream Over the Hills

Nanao, K. Further Variations on a Sucker
Nice, D. Tootsie Pops

London
Kitaj, R.B. London By Night—Life and Art...
Kitaj, R.B. Outlying London Districts I

Lovers *see also* Fornication, Homosexuality, Men and Women
Applebroog, I. "I will go before thee..."
Hayes, S. Days of Love
Hockney, D. Two Boys Aged 23 or 24
Katz, A. Eric, Anni
Katz, A. Jennifer, Eric
Katz, A. Peter, Linda
Nutt, J. toe tapping Nose
Prentice, M. Waiting in the Garden
Warhol, A. Kiss
Wayne, J. Shine Here to Us...
Woodruff, H. Prominade

Luxembourg
Altman, H. Luxembourg November
De Kooning, E. Jardin du Luxembourg I

Lynchings
Catlett, E. My Reward has been bars...

Machines and Machinery *see also* Factories and Factory
 Workers, Workshops
Detamore, R.C. Secret Letters and Private Numbers
Frank, R. Black Juke
Hanson, P. Flying Machine
Hanson, P. Machines
Hanson, P. Smoke Machine
Hanson, P. Telescoping Machine
Lee, D. Helicopter
Leithauser, M. Horological Fascination
Weege, W. Dance of Death
Yates, S. Quartet EPC, I

Magazines
Khalil, M.O. Mr. Goodbar
Kitaj, R.B. London By Night—Life and Art...
Kitaj, R.B. Partisan Review
Nutt, J. Untitled [1970]

Magic and Magicians
Hanson, P. Magician

Mailboxes
Stock, M. Keys

Maine
Drewes, W. Cliffs on Monhegan Island
Drewes, W. Maine Sunset
Katz, A. Maine Landscape
Sallick, L. View from the Deck in Maine, IV

Manhole Covers
Powell, R.J. Richard Wright Series #7: Cerebrus

Maps
Atkinson, T. Map of Thirty-Six Square Mile...
Baldwin, M. Map of Thirty-Six Square Mile...
Chryssa Weather Map
Cunningham, E.C. Road Work
Dennis, C. Cross-Reference
Henderson, V. Isle of California
Johns, J. Two Maps I
Johns, J. Two Maps II
Morris, R. Steam (*from* Earth Projects)
Oldenburg, C. Chicago Stuffed with Numbers
Ritchie, B.H., Jr. Locus and Sea Squares
Schnabel, J. Mother
Schoonhoven, T. Isle of California
Walmsley, W. Ding Dong Daddy Whew
Wiley, W. Coast Reverse (Diptych)

Mardi Gras
Piene, O. Sky Art [*plate*]

Wirsum, K. Street Corner Santa
Wood, T. Young Icarus

Matchbooks
Thiebaud, W. Rainbow Grill

Matches
Rayo, O. Last Night in Marienbad
Thiebaud, W. Rainbow Grill

Mathematics
Berger, P. Mathematics #57
Berger, P. Mathguy
Chesebro, E. Eight Generation Shape...
Chesebro, E. Random Chair #4
Jensen, A. Pythagorean Notebook [*plate*]
Robertson, B. Miao

Maws (Animal Mouths)
Edwards, C. Untitled
Stanuga, T. Killer
Wirsum, K. Museum...: Bull Dog and Bone

Mazes
Nadler, H. Grey Labyrinth

Meadows *see* Fields

Medicine
Hanley, J. Plague-Doctor
Laroche, C. Medicine Bowl
Wirsum, K. Dr. Chicago

Memory and Memories
Bothwell, D. Memory Machine
Feddersen, J. Veiled Memory
Hara, K. Hagoromo
Hockenhull, J. Silver and Gold, Edged in Black
Kennedy, W. Memories, Dreams...
Milton, P. Julia Passing

Boyd, J.D.	Portrait of Magritte
Boyd, J.D.	Portrait of van Gogh
Bravo, C.	Fur Coat Front and Back
Brown, Roger	Male Legs
Byard, C.M.	Thoughts: May Your...
Cadmus, P.	Going South [Bicycle Riders]
Catlett, E.	My Reward has been bars...
Catlett, E.	Portrait in Black
Chafetz, S.	Freud
Chafetz, S.	Mio, Milhaud
Chagoya, E.	Life Is a Dream, Then...
Clemente, F.	I
Clemente, F.	Self-Portrait #2 [Teeth]
Clemente, F.	Self-Portrait #3 [Pincers]
Close, C.	Keith
Close, C.	Phil
Close, C.	Self Portrait
Colescott, W.	Birdbrain
Colescott, W.	Life and Times of Prof. Dr. S....
Conner, A.	Silverado
Cunningham, D.	Pesca Cabeza #7
Damer, R.W.	1973 Birdnest, Rose, and Capital
Damer, R.W.	I Bombed the Taj Mahal...
Dass, D.	Within—Without
De Mauro, D.	Trapeze Figures
Dine, J.	Self Portrait as a Negative
Ehlbeck, M.	Untitled
Eichenberg, F.	Dame Folly Speaks
Ellison, M.E.	International Boulevard
Escher, F.	Pissin' in the Wind
Falconer, J.	Hairy Who (*poster for 1ˢᵗ...*)
Falconer, J.	Hairy Who (cat-a-log)
Fearing, K.	Fishermen
Feigin, M.	Farrier
Feigin, M.	Tennis
Fink, A.	Blue Smoker
Fink, A.	Portrait I
Fischl, E.	Untitled (*from* Floating Islands)
Francis, M.	Shattered King
Frank, M.	Man in the Water

Oliveira, N.	Homage to Carrière
Oliviera, N.	Man
Parker, Robert	Chester Johnson and Myself...
Paschke, E.	Budget Floors
Paschke, E.	Dayton Ohio
Paschke, E.	Execo
Paschke, E.	Hubert
Paschke, E.	Klaus
Paschke, E.	Kontato
Paschke, E.	Mask Man
Paschke, E.	Open Karate
Paschke, E.	Untitled [1970]
Passmore, G.	Dark Shadows
Pearlstein, P.	Nude Lying on Black and Red...
Peterdi, G.	Alexander
Powell, R.J.	Richard Wright Series #7: Cerebrus
Proersch, G.	Dark Shadows
Raetz, M.	Untitled (*plate from untitled...*)
Rainer, A.	Self-Portrait
Rauschenberg, R.	Bellini #5
Rauschenberg, R.	Breakthrough II
Rauschenberg, R.	Preview
Rauschenberg, R.	Sling-Shots Lit #8
Rauschenberg, R.	Spot
Rauschenberg, R.	Trilogy from the Bellini Series
Reeder, F.B.	Dragon and Saint George
Rivers, L.	Last Civil War Veteran
Rocca, S.	Hairy Who (*poster for 1ˢᵗ...*)
Rocca, S.	Hairy Who (cat-a-log)
Rosenquist, J.	See-Saw, Class Systems
Rossi, B.	Footnotes on Portraiture [1971]
Rossi, B.	Footnotes on Portraiture [1971-72]
Rothenberg, S.	Breath-man
Rowan, D.	Encore
Ruble, R.	Dying Rhino
Sánchez, J.	Para Don Pedro
Scholder, F.	Indian on Galloping Horse...
Schrag, K.	Portrait of Bernard Malamud
Segal, G.	Walter
Sessler, A.	Red Wig

Wirsum, K.	Lets Split Fountain the Difference
Wirsum, K.	Self Portrait
Wirsum, K.	Tex Tour
Wujcik, T.	Larry Bell, John Altoon, Ed Moses
Yarde, R.	Falls
Zirker, J.	Wrestling, Graeco-Roman...

Men and Women

Alexander, J.	Queen for a Day
Applebroog, I.	Executive Tower, West Plaza
Applebroog, I.	"I will go before thee..."
Avery, E.	Blue Bath
Becker, D.	Tremble in the Air
Becker, D.	Union Grove Picnic
Biggers, J.T.	Untitled
Bishop, I.	Encounter
Blackburn, L.	Escape
Bosman, R.	Rescue
Brown, Roger	Introduction to an out-of-town girl
Brown, Roger	short introduction
Brown, Roger	short Introduction to a lady...
Brown, Roger	Tree in Sunderland
Brown, Roger	Untitled [1968]
Cadmus, P.	Rehearsal
Clark, C.	Boogie Woogie
Cobitz, J.	Couple
Colescott, W.	S. W. Hayter Discovers...
Crane, P.	Stranger in a Strange Land
Deines, E.H.	Joy on Kaw Valley Loam
Freed, E.	Battle of the Sexes
Fritzius, H.	Untitled [1985]
Gongora, L.	Transformation of Samson &...
Hamilton, R.	Just What Is It That Makes...?
Hayes, S.	Days of Love
High, T.G.	Days the Locust Have Eaten
Hockney, D.	Johnny and Lindsey
Jimenez, L.	Baile con la Talaca
Jimenez, L.	Snake and Eagle
Katz, A.	Ada, Alex
Katz, A.	Ando, Dino

Ponce de Leon, M.	Man is the Measure...
Prentice, M.	Waiting in the Garden
Prochaska, T.	Den Armen Duval
Prochaska, T.	Oh Yes
Samaras, L.	Clenched Couple
Schapiro, M.	Adam and Eve
Siegel, I.	Twin Beds, I Presume
Soyer, R.	Artist's Parents
Warhol, A.	Portraits of the Artists
Weege, W.	He----in Chicago
Werger, A.	Violation
Wirsum, K.	Hare Toddy Kong Tamari
Woodruff, H.	Prominade

Menstruation *see* Ovulation

Mesas

McNeil, G.	Acoma Mesa I

Mice

McSheehy, C.	Dedication for Manus Pinkwater
Nelson, Robert	Cat and Mice
Nelson, Robert	Prince of Atlantis
Paolozzi, E.	Silken World of Michelangelo
Wirsum, K.	Mouse Meow

Michigan

Dennis, C.	Cross-Reference

Microscopes

Lichtenstein, R.	Peace Through Chemistry IV

Military *see also* War

Bolton, R.	Strong Arm
Paschke, E.	Kontato
Rauschenberg, R.	Pledge
Rauschenberg, R.	Spot
Thiebaud, W.	Jan Palach

Minneapolis
Jacquette, Y. Mississippi Night Lights...

Minnesota *see* Minneapolis

Mirrors
Brown, Roger False Image II
D'Arcangelo, A. Side View Mirror
Dube, E. False Image II
Fenton, J. Open Road
Hanson, P. False Image II
Hanson, P. Woman at Swan Vanity
Hara, K. Heart
Johns, J. High School Days
Milton, P. Daylilies
Pearlstein, P. Models with Mirror
Ramberg, C. False Image II
Rifka, J. Portrait of Dracula
Rowan, D. Encore
Sigler, H. Where Daughters Fear...

Missions *see also* Churches, Temples
Capps, C. Mission at Trampas

Mittens
Fish, J. Pears and Mittens

Mockery *see also* Disrespect, Insolence
Becker, D. In A Dark Time

Molecular Structures *see also* DNA
Bolton, R. Berry Pickers
Shahn, B. Scientist

Money
Crane, P. Stranger in a Strange Land
Day, G. Fishing is Another 9-to-5 Job
Green, Art One Dollar
Hockney, D. Receiving the Inheritance
Koppelman, C. Retired Napoleons

Rivers, L. Double French Money
Steinberg, S. Sam's Art
Wirsum, K. Whats the Coinfusion…

Monkeys
Mitchell, Jeffry No Title
Parker, Robert Squirrel Monkey
Rocca, S. Monkey and Flower

Monroe, Marilyn
Hamilton, R. My Marilyn
Warhol, A. Marilyn Monroe
Warhol, A. Marilyn Monroe Diptych
Warhol, A. Marilyn Monroe I Love Your…

Monuments *see also* Arc de Triomphe, Eiffel Tower, Statue of Liberty
Berman, Eugene Pisan Fantasy
Brown, Roger Liberty inviting artists…
Brown, Roger Obelisk
Christo Wrapped Monument to Leonardo
Nagatani, P. Trinitite Tempest
Rauschenberg, R. Front Roll

Moon
Boyle, M. Wan Was Wax
Buck, J. Les Grande Eclipse
Clemente, F. Tondo
Francis, M. Shattered King
Graves, N. Fra Mauro Region of the Moon
Katz, A. Luna Park
Lundeberg, H. Moonrise
Margo, B. Sea
Rathbun, R.K. Living in Deliberate Optimism
Rosenquist, J. Cold Light
Wiley, W. Moon Mullings

Moose
Hoke, S. Waiting for the Freight

Mornings

Drewes, W.	Calm Morning
Feinberg, E.	Dawn
Hall, S.	Morning Glory
Mazur, M.	Wakeby Storm III [Morning Rain]
Peak, E.	Morning
Plotkin, L.	Morning Light

Moses

Hodgell, R.	Burning Bush

Mothers

Burgess, C.	Temptations

Mothers and Children *see also* Daughters, Sons

Brown, Roger	Mother and Child
Dickson, J.	Mother and Child
Seligmann, K.	Marriage
Snyder, J.	Things Have Tears...
Wayne, J.	Shine Here to Us...

Mothers and Fathers *see* Parents

Moths

O'Rourke, J.	Lovers
Woehrman, R.	Attacus Edwards ii

Motion

Bury, P.	Circle and Ten Triangles...
Celmins, V.	Concentric Bearings D
Clark, C.	Boogie Woogie
De Kooning, E.	Torchlight Cave Drawings
Dunham, C.	Untitled [1984-85]
Guston, P.	Street
Lebrun, R.	Rabbit
Mock, R.	Racing Beauty
Moy, S.	Dancer in Motion
Murray, E.	Inside Story
Nutt, J.	oh! my goodness (NO NO)
Rauschenberg, R.	Test Stone #7

Sorman, S.	Trees Blowing and Blowing...
Stussy, J.	Family of Acrobatic Jugglers
Yamazaki, K.	House Wife
Youngblood, J.	Primary Head #4

Motorcycles
Green, Art Murray Simon's Motorcycle

Mountains *see also* Hills

Anderson, Laurie	Mt. Daly/US IV
Bartlett, J.	Rhapsody: House, Mountain, ...
Brach, P.	Sandia
Brokl, R.	Weeping Willow
Davis, R.T.	Outcrop
Drewes, W.	Cliffs on Monhegan Island
Feldman, A.	Hawaiian Memory [Kauai]
Ferrer, R.	Amanecer Sobre el Cabo
Ferrer, R.	azul
Gelb, J.	Oahu Sunrise
Gornik, A.	Rolling Clouds
Henle, M.	In the Clouds
Humphrey, D.	Nocturne
Landacre, P.	Smoke Tree
Mangold, S.	View of Schumnemunk Mt.
Myers, F.	Monte Alban II
Porter, F.	Isle au Haut
Rocca, S.	Mountain and Ring
Shatter, S.	Rock Face/Zion Canyon
Sigler, H.	Every Chance She Gets...
Sultan, A.	Red Roofs, North Island, ...
Summers, C.	Mezzogiorno
Weege, W.	Dance of Death
Wolff, D.I.	Untitled
Zakanitch, R.	Double Geese Mountain
Zimmerman, L.	Mt. Shuksan

Mouth *see also* Lips, Maws (Animal Mouths)

Bontecou, L.	Fourth Stone
Boynton, J.	Plate VIII
Lichtenstein, R.	American Indian Theme III

Nauman, B. Studies for Holograms
Nauman, B. Untitled (*from* Studies for ...)
Paschke, E. Fem-Rouge
Reeder, D. Mazy
Rossi, B. Footnotes on Portraiture [1971]
Rossi, B. Footnotes on Portraiture [1971-72]
Tilson, J. Software Chart Questionnaire
Wirsum, K. Inner "E" Stare Bonnet

Movie Cameras
Oldenburg, C. Mickey Mouse

Movie Theaters *see also* Drive-In (Movie Theater)
Cottingham, R. Fox

Murder *see also* Slaughter
Avery, E. Massacre of Innocents
Bosman, R. Mutiny
Colescott, W. Triumph of St. Valentine
Kardon, D. Revolutionary Cleanser
Longo, R. Frank

Muscles
Bolton, R. Strong Arm

Muses (Inspirational)
Nilsson, G. Holes with a Muse

Museums
Broodthaers, M. Museum
Christo MOMA (Rear)
Christo Whitney Museum Wrapped...
Hamilton, R. Solomon R. Guggenheim
Steinberg, S. Museum

Mushrooms
Albee, G. Fly Agaric

Musical Instruments *see also* String Bass, Pianos
Bearden, R. Vampin' [Piney Brown Blues]

Boxer, S.	Pianist
Cuevas, J.L.	"Music Is a Higher Revelation…"
Greenwald, B.	Creole Jazz Band III
Johnson, Lucas	Homage to Tamayo
Lichtenstein, R.	Still Life with Crystal Bowl
Paschke, E.	Untitled [2 *states*]

Musicians and Music *see also* Singers and Singing

Bearden, R.	Vampin' [Piney Brown Blues]
Boxer, S.	Pianist
Chafetz, S.	Mio, Milhaud
Cuevas, J.L.	"Music Is a Higher Revelation…"
Gloeckler, R.	Hornblower
Greenwald, B.	Creole Jazz Band III
Jules, M.	Folksinger
Mabe, J.	Blessed Elvis Prayer Rug
Paschke, E.	Untitled [2 *states*]
Phillips, M.	Serenade
Warhol, A.	Mick Jagger
Warhol, A.	Print #8

Mythological Figures and Themes (Greek and Roman)
 see also Biblical Figures and Themes, Legends, Literary Figures
 and Themes

Anderson, A.	Trilogy
Avery, E.	False Bacchus
Baskin, L.	Icarus
Bratt, B.	Gaia and Uranus
Colescott, W.	Tremble Sin City (San Andreas Fault)
Crull, F.	Prophet
Cuilty, L.	Untitled [Daphne]
Daupert, B.	Written in the Body…
Nelson, K.	Myth of Changmai
Rice, A.	Untitled [1985]
Scheier, S.	Leda
Seligmann, K.	Acteon
Seligmann, K.	Marriage
Spafford, M.	Battle of Lapiths and Centaurs
Spafford, M.	Origin of Pegasus #2
Spafford, M.	Split Laocoön

Neckties *see* Ties (Clothing)

Needlework
Freckelton, S. Openwork

Neon Lighting
Cottingham, R. Fox
Cottingham, R. Hot

Nets *see* Fishing Nets, Tennis Nets

New Mexico *see also* Taos (New Mexico)
Blumenschein, H. Untitled [Ranchos de Taos]
Brach, P. Sandia
Capps, C. Taos
Dasburg, A. Ranchos Valley I
Ellis, R. Rio Grande Gorge #16
McNeil, G. Acoma Mesa I
Nagatani, P. Trinitite Tempest
Pearlstein, P. Ruins at Gran Quivira
Taylor, P. Towards Santa Fe

New York City
Brown, Roger Liberty inviting artists...
Christo MOMA (Rear)
Christo Whitney Museum Wrapped
Cunningham, E.C. From Poughkeepsie...
DeWoody, J. 55th Street at Madison Avenue
Diamond, M. Manhattan Suite
Feininger, L. Manhattan (Stone 2)
Gilkey, G. Theme Center, New York...
Haas, R. Flatiron Building
Jacquette, Y. Aerial View of 33rd Street
Jacquette, Y. Brooklyn-Atlantic Avenue I
Jacquette, Y. Northwest View from the...
Jacquette, Y. Times Square (Motion Picture)
Kelly, E. Four Blacks and Whites: Upper...
Landeck, A. Rooftops—14th Street
Lazzell, B. Little Church, New York City
Lichtenstein, R. Untitled

Notebooks
Plotkin, L. Still Life with Tangerine

Nudes and Nudity
Abdalla, N. Nude in Red Kimono
Anderson, A. Trilogy
Attie, D. Exile
Avery, E. Blue Bath
Avery, E. Massacre of Innocents
Avery, Milton Nude Recumbent (Nude Asleep)
Avery, Milton Nude with Long Torso
Avery, Milton Sailboat
Bartlett, J. In the Garden #116
Baskin, L. Eve
Becker, D. In A Dark Time
Becker, D. Union Grove Picnic
Billops, C. I Am Black, I Am Black...
Bishop, I. Little Nude
Boxer, S. Amissinamist
Boxer, S. Argumentofnoavail
Boxer, S. Askanceglancelongingly
Boxer, S. Cleavedsummerautumnalglance
Boxer, S. Conventionofslydiscussants
Boxer, S. Curioustalking
Boxer, S. Feybowlofplay
Boxer, S. Gatheringforsomereason
Boxer, S. Obliquequestionofaturtle
Boxer, S. Oddconversationatnoon
Boxer, S. Pauseofnoconcern
Boxer, S. Ring of Dust in Bloom [Title Page]
Boxer, S. Spawnofcloverwithcuriousoccupants
Boxer, S. Strangetalkwithfriend
Brown, Roger Purple Passion in the South Sea
Buck, J. Les Grande Eclipse
Burgess, C. Beast Series: Untitled
Cadmus, P. Rehearsal
Clemente, F. Tondo
Cobitz, J. Couple
Colescott, W. Tremble Sin City (San Andreas Fault)

Izquierdo, M.	Grand Rodeo
Jimenez, L.	Snake and Eagle
Kardon, D.	Charlotte's Gaze
Kelly, E.	Saint Martin Landscape
Kerslake, K.	Magic House: Reverie
Kushner, R.	Bibelot
Lane, L.	Untitled [1990]
Lasansky, M.	For an Eye an Eye, III
Lichtenstein, R.	Nude
Lichtenstein, R.	Reclining Nude
Lindner, R.	Miss American Indian
Markovitz, S.	Ovulation II
Martin, P.	Fall of St. Mar #1
Meeker, D.	Joseph's Coat
Milton, P.	Collecting with Rudi
Milton, P.	Daylilies
Milton, P.	Jolly Corner III: 7
Morales, A.	Dos Ciclistas [Two Cyclists]
Nadler, S.	Untitled
Nebeker, R.	Dream
Nebeker, R.	Still I Don't Know
Nilsson, G.	Holes with a Muse
Nilsson, G.	Masked Eunuch
Nilsson, G.	Nudes at Water
Nilsson, G.	Plate Dancing in Carbondale
Nilsson, G.	Problematical Tripdickery
Nilsson, G.	Self-Portrait as White Rock Lady
Nilsson, G.	Untitled [1963, 3 5/8 x 5 3/32]
Nilsson, G.	Untitled [1963, 5 1/8 x 5 1/8]
Nilsson, G.	Untitled [1963, 5 11/16 x 4 1/4]
Nilsson, G.	Untitled [1963, 6 1/2 x 5 11/16]
Nutt, J.	[title=drawing of adhesive...]
Nutt, J.	Don't do it
Nutt, J.	I have been waiting!
Nutt, J.	Look snay
Nutt, J.	Nacktes Weib
Nutt, J.	Now! Hairy Who Makes You...
Nutt, J.	oh Dat Sally
Nutt, J.	oh! my goodness (NO NO)
Nutt, J.	SMack SMack

Schwartz, C.	Heirloom 4
Soyer, R.	Toward the Light
Spafford, M.	Split Laocoön
Spero, Nancy	Ballade von der Judenhure...
Stevens, M.	Big Daddy Paper Doll
Sultan, D.	Female Series, April 1988
Thomas, T.	Dream Lover
Thompson, Mildred	Love for Sale
Ting, W.	Miss U.S.A.
Walmsley, W.	Ding Dong Daddy #8.2
Walmsley, W.	Ding Dong Daddy #11 Never
Wayne, J.	Adam en Attente
Wayne, J.	Eve Tentee
Wayne, J.	Tower of Babel A
Wayne, J.	Travellers
Weege, W.	Dance of Death
Weege, W.	He----in Chicago
Wesselmann, T.	Great American Nude
Wesselmann, T.	Nude
Wesselmann, T.	Nude (for SEDFRE)
Wesselmann, T.	Nude Print
Wesselmann, T.	Untitled
Yunkers, A.	Succubae
Zirker, J.	Wrestling, Graeco-Roman...

Numbers (Numerals)

Albers, J.	Gouache Study for Mitered Squares
Borofsky, J.	Stick Man
Diebenkorn, R.	IV 4-13-75
Diebenkorn, R.	V 4-13-75
Dine, J.	Eleven Part Self Portrait
Everts, C.	Romabrite
Fried, R.	Dylan's Drifter
Hamilton, K.	Sellin'
Hara, K.	Heart
Indiana, R.	Numbers
Indiana, R.	Polygons #4
Jensen, A.	Pythagorean Notebook [plate]
Johns, J.	0
Johns, J.	0-9

Oil Drums *see* Barrels

Olives
Ruscha, E. Cheese Mold Standard with Olive

Onassis, Jacqueline Kennedy
Warhol, A. Jackie I
Warhol, A. Jackie III

Onions
Freckelton, S. Drawingroom Still Life

Orange (Color)
Anuszkiewicz, R. Inward Eye [*Plate 6*]
Frankenthaler, H. Cedar Hill
Frankenthaler, H. East and Beyond
Frankenthaler, H. Harvest
Green, Art Untitled [1962 or 1963]
Hanson, P. Dancing Couple III
Hanson, P. Singer
Kelly, E. Red-Orange/Yellow/Blue
Kelly, E. Red-Orange over Black
Kuopus, C. Downwind
LaRoux, L. Keystone
Nutt, J. Nacktes Weib
Stella, F. Butcher Came and Slew the Ox

Oranges
Rauschenberg, R. Banner

Orchids
Baynard, E. Dragonfly Vase
Baynard, E. Still Life with Orchid

Oregon *see also* Portland (Oregon)
Gilkey, G. Oregon Coast
Johanson, G. Night Games #5
McGarrell, J. Portland I

Ovulation
Markovitz, S. Ovulation II

Owls
Childs, B. Images from Hawaiian Legends...

Oysters
Beal, J. Oysters with White Wine and...

Pain *see* Agony

Paint
Dine, J. Colored Palette
Dine, J. Double Apple Palette...

Paintbrushes
Dine, J. Five Paint Brushes
Dine, J. Five Paintbrushes
Dine, J. Girl and Her Dog
Johns, J. Savarin
Johns, J. Savarin [1977-81]
Johns, J. Savarin [1978]
Johns, J. Savarin Monotype
Mazur, M. Palette Still Life #53
Rosenquist, J. Horse Blinders (East)

Painters
Staley, E. Self 1
Staley, E. Self 3
Stevens, M. Big Daddy Paper Doll

Paintings *see also* Art
Huntoon, M. Girl with Sand Painting
Johns, J. Figure 7
Lichtenstein, R. Two Paintings: Dagwood
Lichtenstein, R. Two Paintings: Sleeping Muse

Pajamas
Wirsum, K. Bird in the Hand is Worth Two...

Parents
Burgess, C. Temptations
Herman, R. Fatherland, Mothertongue
Soyer, R. Artist's Parents

Paris *see also* Arc de Triomphe, Eiffel Tower
Manns, S. Paris

Parks *see also* Amusement Parks, Gardens, New York City
Altman, H. Luxembourg November
Altman, H. Park with Seven Figures in 1969
Milton, P. Julia Passing

Parrots
Morley, M. Parrots

Passion (Religious)
Myers, F. Saint Teresa's Seventh Mansion

Pastries *see* Cakes and Pastries

Paths
Folsom, K. K
Margo, B. Pathway
Schooley, E. Garden Walk

Patience
Pierce, D. In the Fields

Peace *see* Tranquility

Peaches
Fish, J. Preserved Peaches

Pears
Fish, J. Pears and Autumn Leaves
Fish, J. Pears and Mittens
Helfensteller, V. Untitled [Pears]
Wolf, S. Stripes and Pear

Nutt, J.	"your so coarse" (tish tish)
Paschke, E.	Bistro
Poster, M.	Rockefeller Center
Rauschenberg, R.	Signs
Seawell, T.	Variation on Themes of Callot-V
Thomas, L.	Forgotten Moments in History #4
Werger, A.	Cloudburst
Werger, A.	Neighborhood Watch
Wirsum, K.	Moming
Wolff, E.	Terminal

Perambulators *see* Strollers (Baby)

Performers and Performances *see also* Musicians, Singers

Boxer, S.	Pianist
Gordy, R.	Sister Act
Green, Art	Indecent Composure
Hanson, P.	Magician
Hanson, P.	Singer
Nilsson, G.	Hoofers and Tootsies
Nutt, J.	Untitled [1975]
Paschke, E.	Untitled [1970]
Prochaska, T.	Maybe

Phone Booths

Torlakson, J.	19th Avenue Booth, 1:00 AM

Phonographs

Weege, W.	Record Trout
Wirsum, K.	Cracked Record

Photographs

Acconci, V.	Kiss-Off
Crane, P.	Outside In
Gardner, A.	American Air Tourist—1940's…
Gongora, L.	Transformation of Samson &…
Green, Art	Art Green
Rauschenberg, R.	Soviet/American Array
Rosenquist, J.	Certificate
Rossi, B.	Poor Self Trait #1: Dog Girl

Pilots *see* Airplane Pilots

Pinball
Bell, C. Thunder Smash
Indiana, R. American Dream

Pincers
Clemente, F. Self-Portrait #3 [Pincers]

Pink (Color)
Frankenthaler, H. Bay Area Sunday VI
Frankenthaler, H. Dream Walk
Frankenthaler, H. Red Sea
Moses, E. Broken Wedge 5
Olitski, J. Untitled [1968]

Pisa
Berman, Eugene Pisan Fantasy

Pitchers
Baynard, E. Tulip Pitcher
Freckelton, S. Drawingroom Still Life
Johns, J. Ventriloquist
Lichtenstein, R. Picture and Pitcher
Ryan, A. In a Room

Pits *see* Abysses

Pizza
Oldenburg, C. Flying Pizza

Planes *see* Airplanes

Planets
Barrera, A. Untitled
Bratt, B. Gaia and Uranus
Rosenquist, J. Space Dust

Plants (Nonflowering) *see also* Cacti, Flowers, Grass,
Palm Trees, Still Life, Trees

Rosenquist, J.	Spaghetti and Grass
Schooley, E.	Garden Walk
Sommers, J.	Wold [Ambiance]
Thomas, T.	Last Date
Thompson, R.	Vessel Study-Lily
Turner, J.	Frightened Jack Rabbit Hiding

Plates

Diebenkorn, R.	Cup and Saucer
Freckelton, S.	Souvenir
Johns, J.	Souvenir
Levers, R.	Terrorist Juggling Plates
Plotkin, L.	Morning Light
Stock, M.	Keys
Warhol, A.	Fiesta Pig
Wolf, S.	Cup Collection

Plays *see* Dramatic Productions

Plowing *see also* Farms and Farming

| Pierce, D. | In the Fields |
| Weege, W. | Dance of Death |

Plugs (Electrical)

| Oldenburg, C. | Floating Three-Way Plug |
| Oldenburg, C. | System of Iconography: Plug... |

Plumbing

| Rosenquist, J. | Where the Water Goes |

Plums

| Freckelton, S. | Plums and Gloriosa Daisies |

Poetry

Kline, F.	Untitled
Motherwell, R.	Poem (*from* El Negro)
Motherwell, R.	Quarrel
Murray, E.	Her Story
Oldenburg, C.	Untitled

Shahn, B.	Three Friends
Spero, Nancy	Ballade von der Judenhure...
Thiebaud, W.	Jan Palach
Tilson, J.	Is This Ché Guevara?
Tilson, J.	Letter from Ché
Warhol, A.	Chairman Mao
Warhol, A.	Mao Tse-Tung
Warhol, A.	Plate 11 (*from* Flash...)
Wiley, W.	Seasonall Gate

Pollution
| Weege, W. | Dance of Death |

Ponds *see* Lakes and Ponds

Pools (Swimming) *see also* Fountains
Evergood, P.	Cool Doll in Pool
Hockney, D.	Afternoon Swimming
Hockney, D.	Lithograph of Water... [*all*]
Hockney, D.	Lithographic Water... [*all*]
Hockney, D.	Pool made with paper and blue...

Poppies
| Freilicher, J. | Poppies and Peonies |
| Peterdi, G. | Poppies of Csobanka I |

Portland (Oregon)
| Johanson, G. | Night Games #5 |
| McGarrell, J. | Portland I |

Portraits *see also* Self-Portraits, individual names
Albright, I.	Fleeting Time Thou Hast Left Me Old
Albright, I.	Into the World There Came a Soul Called Ida
Avery, E.	Watson and the Shark
Baskin, L.	Crazy Horse
Baskin, L.	Jean-Louis André Théodore...
Baskin, L.	Mantegna at Eremitani
Beck, H.	St. Francis
Boyd, J.D.	Homage to Picasso
Boyd, J.D.	Homage to Rembrandt

Tilson, J.	Letter from Ché
Warhol, A.	Cagney
Warhol, A.	Chairman Mao
Warhol, A.	Jackie I
Warhol, A.	Jackie III
Warhol, A.	Liz
Warhol, A.	Mao Tse-Tung
Warhol, A.	Marilyn Monroe
Warhol, A.	Marilyn Monroe Diptych
Warhol, A.	Mick Jagger
Warhol, A.	Plate 11 (*from* Flash...)
Warhol, A.	Portrait of Jane Fonda
Warhol, A.	Portraits of the Artists
Warhol, A.	Print #8
Warhol, A.	"Rebel Without a Cause"
White, C.	Frederick Douglas
Wirsum, K.	Draw Dick Tracy the Hard Way
Woehrman, R.	Henrietta
Wujcik, T.	Larry Bell, John Altoon, Ed Moses
Wujcik, T.	Portrait of June Wayne

Portugal

Rabel, K.	São Tomé

Postage Stamps

Ritchie, B.H., Jr.	Canceled Artist's Last Love Letter
Rizzie, D.	Red Cross
Wiley, W.	Pilgrim Repair

Postcards

Brown, Roger	False Image (*poster/invitation*...)
Brown, Roger	False Image Postcards
Crane, P.	Greetings from Green River
Crane, P.	Stranger in a Strange Land
Dube, E.	False Image (*poster/invitation*...)
Dube, E.	False Image Postcards
Hanson, P.	False Image (*poster/invitation*...)
Hanson, P.	False Image Postcards
Ramberg, C.	False Image (*poster/invitation*...)
Ramberg, C.	False Image Postcards

Posters *see* Advertisements and Advertising, Signs and Signage

Potatoes
Kreneck, L. Great Moments in Food Law...
Walters, S. Potato Low

Poughkeepsie (New York)
Cunningham, E.C. From Poughkeepsie...

Prayers
Carnwath, S. We All Want to Believe

Prehistoric Art and Artifacts
De Kooning, E. Lascaux #3
De Kooning, E. Lascaux #4
De Kooning, E. Torchlight Cave Drawings

Prehistory
Prentice, M. Constructing Layers of Time...
Prentice, M. Primal Time I, II, III
Vida Avebury by Air

Presidents (American)
Corrigan, D. President Nixon Hiding...
Dine, J. Drag—Johnson and Mao
Paschke, E. Ben Hur

Presley, Elvis *see* Elvis Presley

Primping
Hanson, P. Woman at Swan Vanity
Nutt, J. seams straight!

Printmaking
Colescott, W. S. W. Hayter Discovers...

Prisons and Prisoners
Paschke, E. Dayton Ohio

Profiles

Ash, R.	Pinocchio Series, The Financier
Castellon, F.	Mimi as Florentine
Kushner, R.	Rhonda VII
Lasansky, M.	La Jimena
Lindner, R.	Profile
Nilsson, G.	Young Girls 1963
Trova, E.	F. M. Manscapes

Prospectors

Conner, A.	Silverado

Prostitutes and Prostitution

Spero, Nancy	Ballade von der Judenhure...
Thompson, Mildred	Love for Sale

Psychology

Chafetz, S.	Freud
Colescott, W.	Life and Times of Prof. Dr. S....

Puddles

Brown, Roger	Magic
Brown, Roger	Rain Print
Brown, Roger	Splashes

Pumpkins

Wirsum, K.	Pumpkin Mask (H)
Wirsum, K.	Pumpkin Mask (V)

Puppetmakers

Eichenberg, F.	Dame Folly Speaks

Puppets

Eichenberg, F.	Dame Folly Speaks
Wirsum, K.	Dancing Hare Toddy/Dancing Kong...

Purple (Color)

Conover, R.	Tree
Francis, S.	Lover Loved Loved Lover
Francis, S.	Serpent on the Stone

Frankenthaler, H. Dream Walk
Hanson, P. Dancing Couple I
Hanson, P. Purple
Hanson, P. Stage with Lights
Hanson, P. Stage with Staircase
Hanson, P. Veiled Head II
Reeder, D. Eidelon
Uchima, A. Flight

Pyramids (Shapes)
Chilla, B. Plan and Form
Denes, A. Probability Pyramid
di Suervo, M. Tetra
Lichtenstein, R. Pyramid
McGowan, M. Untitled [1978]
Rabkin, L. Thumbprint Print
Steinberg, S. Sam's Art
Wong, P. Winds and Moods

Quadriplegics
De Mauro, D. Trapeze Figures

Queens
Corrigan, D. Queen Victoria Troubled by Flies
Gorny, A-P. Queen's Autumn…
Hartigan, G. Elizabeth Etched
Richter, G. Elisabeth II

Quills (Writing Implements)
Kozloff, J. Homage to Robert Adam

Quilts
Freckelton, S. Begonia with Quilt
Freckelton, S. Drawingroom Still Life
Freckelton, S. Souvenir
Mersky, D. Boat Quilt
Mersky, D. Cuttings
Treaster, R. Vermeer and Times

Rabbits
Boxer, S.	Askanceglancelongingly
Hanson, P.	Birds
Henning, R.	Still Life with Beetle
Mock, R.	Crossing Fate's Boundaries
Thiebaud, W.	Rabbit
Turner, J.	Frightened Jack Rabbit Hiding
Wirsum, K.	Dancing Hare Toddy/Dancing...

Racism
Catlett, E.	My Reward has been bars...
Warhol, A.	Birmingham Race Riots

Racquets *see* Tennis

Radar
Hanson, P.	Radar Pavilion

Radios
Hockney, D.	Bedlam

Rafts
Bolton, R.	Boat of Holes
Colescott, W.	Raft of the Titanic
Hockney, D.	Afternoon Swimming

Railroads and Railroad Stations
Crutchfield, W.	Trestle Trains
Herman, R.	Woman on the Railroad Tracks
Hoke, S.	Waiting for the Freight

Rain *see also* Storms
Brown, Roger	Rain Print
Chase, L.	Squall
Hambleton, R.	Figure [Monsoon]
Hockney, D.	Mist
Mazur, M.	Wakeby Storm III [Morning Rain]
Ming-Dao, D.	Rain Basin
Summers, C.	Monsoon
Wengenroth, S.	Untamed

Werger, A. Cloudburst

Rainbows
Dine, J. Scissors and Rainbow

Rajasthan
Summers, C. Rajasthan

Ranches
Snidow, G. Baby Sitter

Rats
Hockenhull, J. Everlovin' Light
Hockenhull, J. Inheritors
Nelson, Robert Light Load

Ravens
Pletka, P. Raven
Schooley, E. Ravens Feeding in a Field

Ravines *see also* Canyons, Chasm
Pokorny, E. In the Ravine

Records *see* Phonographs

Rectangles (Shapes)
Albers, J. Variant 4
Albers, J. Variant IX
Albers, J. W.E.G., I
Alps, G. Moon Sequence
App, T. Untitled
Azuma, N. Image of a City
Bass, J. Horizontals-C
Berman, Eleanore Dos Lados de la Mañana
Bjorklund, M. Void V/VI
Bochner, M. First Quartet
Bochner, M. Fourth Quartet
Bochner, M. Rules of Inference
Bochner, M. Second Quartet
Bochner, M. Third Quartet

Bolotowsky, I.	Rectangle Red, Yellow
Bolotowsky, I.	Red Tondo
Davis, R.W.	Arc Arch
Davis, R.W.	Bent Beam
Davis, R.W.	Big Open Box
Davis, R.W.	Invert Span
Davis, R.W.	Twin Wave
Davis, R.W.	Upright Slab
Davis, R.W.	Wide Wave
Dehner, D.	Lunar Series
DeLap, T.	Karnak I
Diebenkorn, R.	Blue
Dowell, J.	Free Form for Ten
Formicola, J.	Meditation
Glarner, F.	Color Drawing for Relational...
Glarner, F.	Untitled
Halley, P.	Tour of the Monuments of...
Hamilton, K.	Sellin'
Hammersley, F.	Clout
Hanson, P.	Structure
Haynes, N.	Untitled [GT/NH 6-90 W-7]
Heizer, M.	Levitated Mass
Johns, J.	Usuyuki
Judd, D.	Untitled (*one of 3 portfolios...*)
Kelly, E.	Conques
Kelly, E.	Dark Gray and White
Kelly, E.	Red-Orange over Black
Kernan, C.	Traversal I
Kernan, C.	Traversal II
Kraver, R.	Untitled
LeWitt, S.	Composite Series
LeWitt, S.	Squares with a Different Line...
LeWitt, S.	Untitled (*from series of 16*)
Longo, V.	Untitled
Lutz, W.	Night Edged Reversal
Marden, B.	Five Plates [*plate*]
Marden, B.	Gulf
Marden, B.	Untitled (*from portfolio* Five...)
Marden, B.	Untitled (*from* Ten Days)
Marden, B.	Untitled [Two Vertical Rectangles]

Chase, L.	Chasm
Childs, B.	Eyeball of the Sun
Clemente, F.	Tondo
Davis, S.	Detail Study for Cliché
De Lamonica, R.	Untitled [1984]
Dine, J.	Red Bathrobe
di Suervo, M.	Afterstudy for Marianne Moore
di Suervo, M.	Centering
Erskine, E.	Firebird
Fink, A.	Portrait I
Francis, S.	Hurrah for the Red, White and Blue
Francis, S.	Lover Loved Loved Lover
Francis, S.	Serpent on the Stone
Frankenthaler, H.	Bay Area Tuesday IV
Frankenthaler, H.	Red Sea
Frankenthaler, H.	Savage Breeze
Frankenthaler, H.	Slice of the Stone Itself
Freckelton, S.	Red Chair
Golub, L.	Wounded Warrior
Gottlieb, A.	Untitled [1969]
Green, Art	Untitled [1962 or 1963]
Hammersley, F.	Clout
Hanson, P.	Singer
Herman, R.	Van Gogh in Red
Hockney, D.	Red Celia
Jenkins, P.	Four Winds (I)
Johns, J.	Periscope
Johns, J.	Plate No. 6 after Untitled
Kakas, C.	Juneway Edge
Kelly, E.	Blue and Red-Orange
Kelly, E.	Red Blue
Kelly, E.	Red-Orange/Yellow/Blue
Krushenick, N.	Untitled [1965]
Kuopus, C.	Downwind
Lewis, T.R.	Death of a Conscious Called…
Liberman, A.	Untitled [1961]
Lichtenstein, R.	Brushstrokes
Longo, V.	Untitled
Mason, E.	Soft the Sun
Motherwell, R.	Burning Sun

Myers, F. Saint Teresa's Seventh Mansion
Schnabel, J. Raft [Dream]
Sessler, A. Thorny Crown

Reproduction (of life)
Hockenhull, J. Inheritors

Reproductions (of other works of art)
Avery, E. False Bacchus
Damer, J. Fog Mourn II
De Kooning, E. Lascaux #3
De Kooning, E. Lascaux #4
Duchamp, M. L.H.O.O.Q. Shaved
Gorny, A-P. Queen's Autumn...
Johanson, G. George Beach
Johns, J. Figure 7
Kirk, P. Sleeping Saquaro...
Kreneck, L. Every Artist Has an Attic
Kreneck, L. From the Sketchbook of...
Lichtenstein, R. Cathedral #4
Lichtenstein, R. Cathedral #5
Oliveira, N. Tauromaquia 6.20.73 III
Oliveira, N. Tauromaquia 6.21.73 III
Oliveira, N. Tauromaquia 6.21.73 IV
Paolozzi, E. Silken World of Michelangelo
Rauschenberg, R. Bellini #4
Rauschenberg, R. Bellini #5
Rauschenberg, R. Centennial Certificate M.M.A.
Rauschenberg, R. Trilogy from the Bellini Series
Schapiro, M. Frida and Me
Seawell, T. Variation on Themes of Callot-V
Steinberg, S. Millet
Treaster, R. Vermeer and Times
Wayne, J. Tower of Babel A

Reptiles *see* Alligators, Lizards, Snakes, Turtles

Rescues (by Water)
Bosman, R. Rescue
Solien, T.L. Boatman's Rescue

Roads

Brown, Roger	Roads
Capps, C.	Into the Hills
Capps, C.	Taos
Cunningham, E.C.	Road Work
D'Arcangelo, A.	Side View Mirror
Fenton, J.	Open Road
Francis, M.	Shattered King
Friese, N.	Homage to Constable
Gardner, S.	Missing Person's Reports
Gordy, R.	Wanderer
Goulet, C.	Rolling Fields
Gwyn, W.	Interstate
Henderson, V.	Isle of California
Kirk, M.	It's Been a Long Time... Since
McCombs, B.	Bridge
Rheingold, L.	Country Road
Schoonhoven, T.	Isle of California
Summers, C.	Mezzogiorno
Summers, C.	Road to Ketchikan
Taylor, P.	Towards Santa Fe

Robes *see also* Cloaks, Coats

Brice, W.	Striped Robe
Dine, J.	Bathrobe
Dine, J.	Black and White Robe
Dine, J.	Eleven Part Self Portrait
Dine, J.	Fourteen Color Woodcut Bathrobe
Dine, J.	Painted Self-Portrait
Dine, J.	Photographs and Etchings...
Dine, J.	Red Bathrobe
Dine, J.	Self-portrait in zinc and acid
Dine, J.	Self-Portrait: The Landscape
Fink, A.	Blue Smoker
Pearlstein, P.	Model in Green Kimono [*all*]
White, C.	Exodus II

Rockets

Rauschenberg, R.	Sky Garden

Rosenquist, J. Horse Blinders

Roses
Baynard, E. Dark Pot with Roses
Baynard, E. Roses
Rosenquist, J. Dusting Off Roses
Rosenquist, J. Sight Seeing
Wesselmann, T. Great American Nude
Wesselmann, T. Nude

Rugs *see also* Blankets, Tapestries, Weaving and Weaves
Grosch, L. Gloxinia on an Oriental Rug
Grosch, L. Iris on Bokhara
Mabe, J. Blessed Elvis Prayer Rug
Menard, L. Aries Prayer Rug
Menard, L. Fragments from Eastern Turkestan...
Mullen, P. ADI Blue
Pearlstein, P. Girl on Orange and Black...
Pearlstein, P. Untitled

Ruins
Huse, M. Ruins—Tours, France
Oliveira, N. Ryan Site 86
Pearlstein, P. Ruins at Gran Quivira
Stroh, E. Mesa Verde

Rulers (Measuring Sticks)
Hara, K. Heart
Johns, J. Untitled (Ruler) I

Runners and Running
Applebroog, I. Just Watch and See
Borofsky, J. People Running
Bosman, R. Survivor
Lasansky, M. Eye for an Eye IV
Lebrun, R. Rabbit
Sonneman, E. Deep Runners

Russia
Acconci, V. Three Flags for One Space...

Saucers *see* Plates

Saxophones
Anderson, Laurie Mt. Daly/US IV
Prentice, M. Implications of Sound, I

Scales (Weighing)
Nelson, Robert Bombs of Barsoom

Scarecrows
Wiley, W. Scarecrow

Scarves
Baynard, E. Print Scarf
Dine, J. Picture of Dorian Gray

Scientists and Science *see also* Chemistry, DNA, Molecular Structures
Shahn, B. Scientist

Scissors
Dine, J. Scissors and Rainbow
Freckelton, S. Blue Chenille
Wright, D. Untitled

Screws
Oldenburg, C. Double Screwarch Bridge

Scrolls
Detamore, R.C. Secret Letters and Private Numbers

Sea Creatures *see* Sea Life

Sea Life *see also* Clams, Coral, Jellyfish, Lobsters, Sharks, Squid
Anaya, S. Kuraje
Landers, B. Life Under the Sea
McCoy, A. Night Sea

Seas
Anaya, S. Kuraje

Drewes, W. Calm Morning
DuBasky, V. Heron Cove
Ferrer, R. Amanecer Sobre el Cabo
Ferrer, R. azul
Fischl, E. Year of the Drowned Dog
Gilkey, G. Oregon Coast
Grace, C. Key Limes Marigot Harbour
Hamilton, R. Sunset
Hockney, D. Bora Bora
Jules, M. Cove
Katz, A. Luna Park
Kunc, K. Two Waters
Lichtenstein, R. View from the Window
Mock, R. Bird of Paradise
Morley, M. Beach Scene
Phillips, M. Among the Waves
Ritchie, B.H., Jr. Locus and Sea Squares
Rocca, S. Palm Tree
Steir, P. At Sea #13 (Dread)
Trotter, M. Sea Change

Seashells
Brady, R. Tiger Lilies
Cuilty, L. Shells
Hanson, P. Room with Shells and Vases

Seasons *see also* individual seasons
Johns, J. Fall
Johns, J. Seasons
Johns, J. Spring
Johns, J. Summer
Johns, J. Winter

Seeds
Peterdi, G. Germination I

Self-Portraits *see also* Artists
Acconci, V. Kiss-Off
Adams, R. Profile in Blue
Albright, I. Self-Portrait at 55 Division Street

Nilsson, G. Self-Portrait as White Rock Lady
Nilsson, G. Thats Me: Gladys Nilsson
Nishimura, N. Self-Portrait
Nutt, J. Jim Nutt [1964]
Nutt, J. Selbst Bildnis
Nutt, J. Self-Portrait
Rainer, A. Self-Portrait
Rauschenberg, R. Booster
Rossi, B. Poor Self Trait #1: Dog Girl
Rossi, B. Poor Self Trait #2: Shep
Rossi, B. Poor Self Trait #3: Curls
Rowan, D. Encore
Shapiro, D. Kala
Solien, T.L. Memoir Den
Solien, T.L. Three Sailors
Staley, E. Self 1
Staley, E. Self 3
Steir, P. Self Drawn as though...
Steir, P. Self-Portrait after Rembrandt...
Walmsley, W. Walmsley in 2288
Walters, S. Summer Self-Portrait
Warhol, A. Portraits of the Artists
Warhol, A. Self Portrait
Wirsum, K. Self Portrait

Semi-Circles (Shapes)
Bengston, B.A. Mecca Dracula
Boyle, M. Triptych: Conundrum I...
Hanson, P. Structure
Johns, J. Device
Lowney, B. Flower
Rabkin, L. Thumbprint Print
Shapiro, D. Kala

Sewing
Freckelton, S. Openwork
Lanyon, E. Thimblebox
Shields, A. Houston Oil

Sex *see* Fornication

Adams, C.	Strata
Adams, C.	Window Series [*Plate III*]
Albers, A.	Triangulated Intaglio II
Albers, A.	Triangulated Intaglio V
Albers, J.	Ascension
Albers, J.	Day and Night [*Plate I*]
Albers, J.	Embossed Linear Construction, ...
Albers, J.	Gouache Study for Mitered Squares
Albers, J.	Gray Instrumentation I (*Ia-II...*)
Albers, J.	Gray Instrumentation I, Plus I
Albers, J.	Gray Instrumentation II (*IIa-III...*)
Albers, J.	Gray Instrumentation II, Plus II
Albers, J.	Homage to the Square: Midnight...
Albers, J.	Mitered Squares (*a-l...*)
Albers, J.	Mitered Squares f
Albers, J.	Mitered Squares, Plus II
Albers, J.	Multiplex A
Albers, J.	Never Before (*a-l from portfolio*)
Albers, J.	Never Before (Variation IX)
Albers, J.	Never Before f
Albers, J.	Variant 4
Albers, J.	Variant IX
Albers, J.	W.E.G. 1
Alps, G.	Moon Sequence
Alps, G.	White Square
Anderson, C.	History of the Square...
Andrade, E.	Black Cisoide
Antonakos, S.	Book
Antreasian, G.	Bebek II
Antreasian, G.	Quantum Suite [*Plate VII*]
Antreasian, G.	Untitled [1980]
Anuszkiewicz, R.	Eternity
Anuszkiewicz, R.	Inward Eye [*Plate 3*]
Anuszkiewicz, R.	Largo
App, T.	Untitled
Artschwager, R.	Locations
Ausby, E.	Space Odyssey #5
Azuma, N.	Image of a City
Bartlett, J.	Day and Night
Bartlett, J.	Graceland Mansions

D'Arcangelo, A.	Constellation
Damer, J.	Main Line
David, M.	Blue
David, M.	Red
David, M.	White
Davis, R.W.	Arc Arch
Davis, R.W.	Arch
Davis, R.W.	Bent Beam
Davis, R.W.	Big Open Box
Davis, R.W.	Invert Span
Davis, R.W.	Pinwheel, Diamond, and Stripe
Davis, R.W.	Twin Wave
Davis, R.W.	Upright Slab
Davis, R.W.	Wide Wave
De Lamonica, R.	Who
Dehner, D.	Lunar Series
DeLap, T.	Karnak I
Denes, A.	Probability Pyramid
Diebenkorn, R.	Black Club
Diebenkorn, R.	Blue
Diebenkorn, R.	Blue Surround
Diebenkorn, R.	Six Soft-ground Etchings [#4]
Diebenkorn, R.	Untitled (from 5 Aquatints...)
Dine, J.	Heart 1983
Dine, J.	Picture of Dorian Gray
di Suervo, M.	Jak
di Suervo, M.	Tetra
Drewes, W.	Spectre [Two Monsters]
Drewes, W.	Untitled
Eckart, C.	Cimabue Restoration Project
Edwards, C.	Untitled
Feddersen, J.	Changer II
Feddersen, J.	Plateau Geometric #71
Francis, S.	Hurrah for the Red, White and Blue
Francis, S.	Untitled [1963]
Frankenthaler, H.	Bay Area Sunday VI
Glarner, F.	Recollection
Glarner, F.	Untitled
Goode, J.	Untitled
Gottlieb, A.	Black and Gray

Johns, J.	Device
Johns, J.	Gray Alphabets
Johns, J.	Painting with Two Balls
Johns, J.	Target
Johns, J.	Usuyuki
Jones, J.P.	Boundary
Judd, D.	6-L
Judd, D.	Untitled (*one of 3 portfolios...*)
Kelly, E.	Black/White/Black
Kelly, E.	Colors on a Grid
Kelly, E.	Colors on a Grid
Kelly, E.	Dark Gray and White
Kelly, E.	Green Curve with Radius of 20...
Kelly, E.	Nine Squares
Kelly, E.	Red-Orange/Yellow/Blue
Kelly, E.	Red-Orange over Black
Kelly, E.	Wall
Kelly, E.	Yellow/Black
Kepets, H.	Astor
Kepets, H.	Lenox
Kepets, H.	Tilden
Kernan, C.	Traversal I
Kernan, C.	Traversal II
Kounelis, J.	Untitled [1979]
Kozloff, J.	Cochiti
Kozloff, J.	Homage to Robert Adam
Kozloff, J.	Is It Still High Art?
Kozloff, J.	Longing
Kraver, R.	Untitled
Kunc, K.	Drama of Source
Kunc, K.	In Spiral Drama
Kunc, K.	Mirrored Touchpoints
Kunc, K.	Unbound Above
LaRoux, L.	Keystone
Lasuchin, M.	Trans
Lasuchin, M.	Triad
Lichtenstein, R.	Pyramid
Longo, V.	ABCD
Longo, V.	First Cut, Second Cut, Third Cut
Longo, V.	Temenos

Pusey, M.	Operation
Quaytman, H.	Untitled
Rabel, K.	School Crossing
Richardson, S.	Through the Greened Into
Riisaburo, K.	City No. 115
Riley, B.	Print A
Rizzie, D.	Untitled
Rockburne, D.	Locus No. 1
Rockburne, D.	Locus No. 4
Rockburne, D.	Melencolia
Rockburne, D.	Radiance
Rose, M.A.	Untitled
Rosenquist, J.	Bunraku
Rosenquist, J.	Circles of Confusion I
Salemme, A.	One Against Many
Sandback, F.	Twenty-Two Constructions...
Sanders, B.	Symbiotic Shapes
Sanderson, H.	Bed Rest
Saret, A.	#AS83-103
Savelli, A.	Lotus
Secunda, A.	Road to Arles
Serra, R.	Circuit
Shannon, B.	Untitled
Shapiro, D.	Birnham Wood
Shapiro, D.	Kala
Shapiro, J.	Untitled [1988]
Shapiro, J.	Untitled [1989]
Shedletsky, S.	Seven Gardens for Matisse No. 5
Shields, A.	Ahmadabad Silk
Shields, A.	Alice in Grayland
Shields, A.	Armie's Tough Course
Shields, A.	Box Sweet Jane's Egg...Moose Set
Shields, A.	Chicago Tenement
Shields, A.	Color Radar Smile A
Shields, A.	Color Radar Smile B
Shields, A.	Color Radar Smile C
Shields, A.	Equatorial Route
Shields, A.	Fire Escape Plan
Shields, A.	Fran Tarkington's Tie
Shields, A.	Guardian Mole

Stella, F.	Star of Persia II
Stella, F.	Talladega Three II
Stewart, N.	Harbinger
Stewart, N.	Hi-Flyer
Strunck, J.	STS-6
Strunck, J.	STS-15
Sugarman, G.	T.1340
Summers, C.	Rajasthan
Taylor, A.	Untitled [Double Spiral]
Thorn, R.	160 Lines
Thorn, R.	It's All the Same
Toner, R.	Fishermen
Toner, R.	Sailmaker
Twombly, C.	Note I
Twombly, C.	Note II
Twombly, C.	Untitled I
Twombly, C.	Untitled II
Tworkov, J.	KTL #1
Tworkov, J.	L.P. #3 Q3-75
Van Houten, K.	Passage I
Vasarely, V.	Homage to the Hexagon
Vital, N.	Snowblind
Wayne, J.	Travellers
Wiley, W.	Ecnud
Wiley, W.	Who the Alien?
Williams, D.	Study: Temples and Monuments
Winters, T.	Morula II
Winters, T.	Primer
Wirsum, K.	Single Signed
Woodman, G.	Algebraic Pattern
Wong, P.	Sites for Three Sunken Trapezoids
Wong, P.	Winds and Moods
Youkeles, A.	Shining Darkly
Zammit, N.	Untitled
Zebrun, C.	Triangle Landscape

Sharks

| Avery, E. | Watson and the Shark |

Nutt, J. Don't do it
Nutt, J. Untitled [1969, *13 3/8 x 10 7/16*]
Paschke, E. Hairy Shoes
Rosenquist, J. Expo 67 Mural—Firepole 33'x17'
Shapiro, J. Untitled [1975]
Solman, J. High Button Shoes
Stasik, A. Moment I
Wirsum, K. Correspondence

Shrouds (Death)
Becker, D. In A Dark Time

Shrubbery
Beerman, J. Two Bushes at Twilight
Folsom, K. K
Forrester, P.T. Won't You Come into My Parlor?
Hodgell, R. Burning Bush
Lowney, B. Gateway
Santlofer, J. Burning Bush

Sidewalks
McCombs, B. Street Corners
Nilsson, G. Street Scene
Powell, R.J. Richard Wright Series #7: Cerebrus
Werger, A. Cloudburst
Wolff, E. Terminal

Siestas *see* Sleeping

Sign Language
Kruger, B. Untitled [We Will No Longer…]

Signs and Signage
Baeder, J. Empire Diner
Brown, Roger False Image II
Cottingham, R. Fox
Cottingham, R. Hot
D'Arcangelo, A. Landscape No. 3
Dickson, J. White Haired Girl
Dube, E. False Image II

Seawell, T.	Around Town
Seawell, T.	Mercury [St. Louis]
Torlakson, J.	Rio
Warhol, A.	Paris Review Poster
Wirsum, K.	Dr. Chicago
Wirsum, K.	Hairy Who (*poster for 1st...*)
Wirsum, K.	Hairy Who (*poster for 2nd...*)
Wirsum, K.	Hare Toddy Kong Tamari
Wirsum, K.	Moming Masked Ball
Wirsum, K.	Santi-Cloth
Wirsum, K.	Surplus Slop from...the Windy...
Wirsum, K.	Transplant: Famous Heart-Tits...
Wirsum, K.	Wake Up Yer Scalp with Chicago
Wirsum, K.	Weasel While You Work (#1)
Wirsum, K.	Worse Sum Show

Silhouettes *see also* Profiles

Boyd, J.D.	Portrait of Magritte
DeMatties, N.	Conversation
Dixon, K.	Wildflowers of Texas: LBJ &...
Hambleton, R.	Figure [Monsoon]
Koppelman, C.	Retired Napoleons
Marisol	Phnom Penh I
Ramberg, C.	Head
Ruscha, E.	Standard Station
Westermann, H.C.	See America First [*Plate 17*]
Wright, D.	Untitled
Youngblood, J.	Primary Head #4

Silverware *see* Eating Utensils

Singers and Singing

Hamilton, R.	I'm Dreaming of a White...
Hanson, P.	Masked Chorus
Hanson, P.	Singer
Jules, M.	Folksinger
Lichtenstein, R.	Reverie
Mabe, J.	Blessed Elvis Prayer Rug
Paschke, E.	Untitled [1970]
Warhol, A.	Print #8

Tarnower, J. Marta Black

Skating Rinks *see* Ice Skating

Skeletons *see also* Bones and Skulls
Alexander, J. Queen for a Day
Allen, T. Palabras Malo
Baskin, L. Hydrogen Man
Biddle, M. Untitled
Colangelo, C. Trophies
Daupert, B. Metamorphosis
Dine, J. Youth and the Maiden
Everts, C. Execution
Fichter, R. Bones Alone Has Looked on Beauty...
Frank, M. Dinosaur
Frank, M. Skeletal Figure
Hansmann, G. Ancestor
Hockenhull, J. Silver and Gold, Edged in Black
Jimenez, L. Baile con la Talaca
Lebrun, R. Man and Armor
Miller, M. Ablaze
Rauschenberg, R. Booster
Rice, A. Untitled [1985]
Rich, J. Woman I
Seligmann, K. Acteon
Skelley, R. War

Skies *see also* Outer Space
Bartlett, J. Rhapsody: House, Mountain, ...
Beerman, J. Stones Silent Witness
Beerman, J. Two Bushes at Twilight
Bodger, L. English Summer Night
Brown, Roger Cathedrals of Space
Brown, Roger Little Nimbus
Brown, Roger Which Way Is Up?
Celmins, V. Alliance
Celmins, V. Concentric Bearings B
Celmins, V. Strata
Celmins, V. Untitled [1975]
Celmins, V. Untitled Galaxy

Skiing and Skiers

Skirts

Skulls *see* Bones and Skulls

Skyscrapers

Brown, Roger	Introduction to an out-of-town girl
Brown, Roger	Standing While All Around Are...
Brown, Roger	Untitled [1968]
Colescott, W.	Tremble Sin City (San Andreas Fault)
Diamond, M.	Manhattan Suite
Di Cerbo, M.	Untitled [77A]
Di Cerbo, M.	Untitled [78C]
Feininger, L.	Manhattan [Stone 2]
Feldman, A.	Midday
Han, H.N.	On the Circle Line No. 1
Jacquette, Y.	Brooklyn-Atlantic Avenue I
Jacquette, Y.	Northwest View from the...
Kelly, E.	Four Blacks and Whites: Upper...
Lichtenstein, R.	This Must Be the Place
McCombs, B.	Bridge
Myers, F.	Gotham
Myslowski, T.	I New York City
Rizzi, J.	It's So Hard to Be a Saint...
Ruscha, E.	Standard Station
Sheeler, C.	Delmonico Building
Thiebaud, W.	N.Y. Decals 1&2
Thiebaud, W.	Rainbow Grill
Thomas, T.	Dream Lover
Werger, A.	Other Side

Slaughter

Stella, F.	Butcher Came and Slew the Ox

Sleeping

Avery, E.	Summer Boogie Woogie
Blaine, N.	Sleeping Girl
High, T.G.	Madame Butterfly
Kirk, P.	Sleeping Saquaro...
Kohn, M.	Sleeping Soldier
Lichtenstein, R.	Two Paintings: Sleeping Muse
Mazur, M.	Three Beds, No. 14
Van Hoesen, B.	Nap
Wayne, J.	Shine Here to Us...
Werger, A.	Violation

Rathbun, R.K.	Leap of Faith
Rauschenberg, R.	Trilogy from the Bellini Series
Schapiro, M.	Adam and Eve
Stackhouse, R.	Naja
Wirsum, K.	Correspondence

Snow

Altman, H.	Luxembourg November
Barrett, L.	Untitled [Horses in Winter]
Bolton, R.	Winter Storm
Bosman, R.	Snowman
Burkert, R.	December Woods
Grooms, R.	Downhill Skier
Hansen, A.	Winter 1977
Johns, J.	Winter
Lozowick, L.	Central Park
Prince, R.	Property Owner
Seawell, T.	Snow
Smith, Moishe	Four Seasons—Winter
Tobey, M.	Winter
Westermann, H.C.	See America First [*Plate 16*]

Snowmen

Solien, T.L.	Boatman's Rescue

Socks

Nevelson, M.	Two Pair Black Night

Sodas *see* Soft Drinks

Soft Drinks *see also* Beverages

Lichtenstein, R.	Sandwich and Soda

Solar System *see also* Outer Space, Planets

Barrera, A.	Untitled

Soldiers *see also* Warriors

Avery, E.	Massacre of Innocents
Kohn, M.	Sleeping Soldier
Rivers, L.	Last Civil War Veteran

Spaghetti
Rosenquist, J. Spaghetti
Rosenquist, J. Spaghetti and Grass

Spain
Castellon, F. Spanish Landscape
Frasconi, A. Franco I
Izquierdo, M. Grand Rodeo
Lasansky, M. España

Sparkplugs
Ramos, M. A. C. Annic

Speeches
Gloeckler, R. Eeny Meeny Miney Moe

Spheres (Shapes)
Bell, C. Thunder Smash
Capobianco, D. B.A.L.L.&S.
Celmins, V. View
Dine, J. Black and White Blossom
Lifa, S. Untitled
Rizzie, D. Untitled

Spiderwebs
Rockman, A. Macrocosmos

Spirals (Shapes)
Denes, A. Map Projection
Ponce De Leon, M. Succubus
Taylor, A. Untitled [Double Spiral]

Spirits *see also* Apparitions
Miller, M. Ablaze
Seligmann, K. Marriage
Smith, Lee Dog Spirits

Spitting
Nutt, J. pitui

Sports *see* individual names of sports

Spotlights *see* Light (Beam)

Spray Cans
Lichtenstein, R. Fresh Air

Spring (Season)
Johns, J. Seasons
Johns, J. Spring

Squares (Shapes)
Adams, C. Window Series [*Plate III*]
Albers, J. Day and Night [*Plate I*]
Albers, J. Gouache Study for Mitered Squares
Albers, J. Gray Instrumentation I (*Ia-II...*)
Albers, J. Gray Instrumentation I, Plus I
Albers, J. Gray Instrumentation II (*IIa-III...*)
Albers, J. Gray Instrumentation II, Plus II
Albers, J. Homage to the Square: Midnight...
Albers, J. Mitered Squares (*a-l...*)
Albers, J. Mitered Squares f
Albers, J. Mitered Squares, Plus II
Albers, J. Untitled [Midnight and Noon III]
Albers, J. Untitled [Midnight and Noon V]
Albers, J. Untitled [Midnight and Noon VI]
Albers, J. W.E.G. 1
Alps, G. White Square
Anderson, C. History of the Square...
Andre, C. Xerox Book
Antreasian, G. Untitled [1980]
Anuszkiewicz, R. Eternity
Azuma, N. Image of a City
Bartlett, J. Day and Night
Bengston, B.A. Mecca Dracula
Bochner, M. Rules of Inference
Cortese, D. "Take-Mado" Bamboo Curtain
Crile, S. Palio
Cumming, R. Burning Box
Cunningham, B. Texas High Line/Low Line

D'Arcangelo, A.	Constellation
David, M.	Blue
David, M.	Red
David, M.	White
Davis, R.W.	Arch
Davis, R.W.	Invert Span
Davis, R.W.	Twin Wave
Diebenkorn, R.	Blue Surround
Diebenkorn, R.	Six Soft-ground Etchings [#4]
Downes, V.	Diminuer
Edwards, C.	Untitled
Feddersen, J.	Plateau Geometric #71
Francis, S.	Untitled [1978]
Goode, J.	Untitled
Green, Alan	Center to Edge—Neutral to Black
Guastella, C.D.	Patching
Guastella, C.D.	Timepiece
Guzak, K.	Geometrics: Circle, Cross...
Halley, P.	Tour of the Monuments of...
Hammersley, F.	Clout
Hanson, P.	Grid of Squiggles
Hanson, P.	Squiggles
Harrison, T.	Untitled #7
Harrison, T.	Untitled #13
Heilmann, M.	Rincon, House, Whitewater
Heizer, M.	Levitated Mass
Hockney, D.	Picture of a Pointless Abstraction...
Indiana, R.	Polygons #4
Jacklin, B.	Moody Rocker
Jacklin, B.	Rocking and Rubbing
Jacklin, B.	Rocking my Blues Away
Jensen, A.	[Growth of 4x5 Rectangle]
Jensen, A.	Pythagorean Notebook [plate]
Johns, J.	Gray Alphabets
Judd, D.	Untitled (one of 3 portfolios...)
Kakas, C.	Juneway Edge
Kauffman, C.	Untitled
Kelly, E.	Colors on a Grid
Kelly, E.	Colors on a Grid
Kelly, E.	Nine Squares

Shields, A.	Fire Escape Plan
Shields, A.	Fran Tarkington's Tie
Shields, A.	Jason's Rabbit Holler...
Shields, A.	Plastic Bucket
Shields, A.	Polar Route
Shields, A.	Santa's Collar
Shields, A.	Two Birds, Woodcock I
Shields, A.	Two Birds, Woodcock II
Shields, A.	Two Four Too
Smith, R.	Russian I
Sorman, S.	What's This, What's That
Sparling, C.	Peony Series I
Steir, P.	Abstraction, Belief, Desire
Steir, P.	Kyoto Chrysanthemum
Steir, P.	Tree After Hiroshige
Steir, P.	Wish #3—Transformation
Stella, F.	Arundel Castle
Stella, F.	Double Gray Scramble
Stella, F.	Jasper's Dilemma
Strunck, J.	STS-6
Strunck, J.	STS-15
Thorn, R.	It's All the Same
Twombly, C.	Note I
Tworkov, J.	KTL #1
Tworkov, J.	L.P. #3 Q3-75
Vasarely, V.	Homage to the Hexagon
Vital, N.	Snowblind
Youkeles, A.	Shining Darkly

Squid

Anaya, S.	Kuraje
McCoy, A.	Night Sea

Squirrels

Rockman, A.	Untitled [Squirrel & Amaryllis]

St. Louis (Missouri)

Seawell, T.	Mercury [St. Louis]

Freckelton, S.	All Over Red
Freckelton, S.	Begonia with Quilt
Freckelton, S.	Blue Chenille
Freckelton, S.	Drawingroom Still Life
Freckelton, S.	Openwork
Freckelton, S.	Plums and Gloriosa Daisies
Freckelton, S.	Red Chair
Freckelton, S.	Souvenir
Freckelton, S.	Tulips
Freilicher, J.	Still Life and Landscape
Goldman, J.	Dallas Reflections #15
Goldman, J.	Ellen's Window
Goldman, J.	Grassmere Lane
Goldman, J.	Mid-Summer Light
Goldman, J.	November
Goldman, J.	Summer Nights
Goldman, J.	Sun Porch
Goldyne, J.	Narcissus
Goode, J.	Glass Middle Left—Spoon...
Green, Art	Kitchen Still Life
Grosch, L.	Gloxinia on an Oriental Rug
Grosch, L.	Iris on Bokhara
Hahn, B.	Botanical Layout: Peony
Hamilton, R.	Flower-Piece B
Hanson, P.	Bouquet
Hanson, P.	Flower Presentation
Hanson, P.	Room with Vases and Flowers
Helfensteller, V.	Untitled [Pears]
Henning, R.	Still Life with Beetle
Hockney, D.	Amaryllis in Vase
Hockney, D.	Black Tulips
Hockney, D.	Hollywood Collection
Hockney, D.	Potted Daffodils
Hockney, D.	Walking Past Two Chairs
Johanson, G.	Skulls
Kimball, W.	Longhorn in Sheep's Clothing
Kimball, W.	Properly Mounted Texas Longhorn
Lanyon, E.	Thimblebox
Lichtenstein, R.	Picture and Pitcher
Lichtenstein, R.	Sandwich and Soda

Lebrun, R.	Rain of Ashes
Mazur, M.	Wakeby Storm III [Morning Rain]
McGarrell, J.	Quotation with Twister
Nagatani, P.	Trinitite Tempest
Schrag, K.	Silence Above the Storm
Sewards, M.	Rain
Summers, C.	Dark Vision of Xerxes
Summers, C.	Monsoon
Taylor, P.	Towards Santa Fe
Van Vliet, C.	Horbylunde Storm
Wengenroth, S.	Untamed
Zimmerman, L.	Storm Over the Cascades

Stoves

| Renda, M. | Untitled |

Streetlights

| Jacquette, Y. | Mississippi Night Lights... |
| Wengenroth, S. | Quiet Hour |

Streets

Baczek, P.	Duboce Street
Baczek, P.	Lombard Street Triptych
Colescott, W.	Tremble Sin City (San Andreas Fault)
Davis, S.	Sixth Avenue El
DeWoody, J.	55th Street at Madison Avenue
Estes, R.	Untitled [1974-75]
Friedlander, I.	East Side
Goldman, J.	Norris Court #4
Gray, N.	El at Myrtle Avenue
Grooms, R.	AARRRRRRHH
Guston, P.	Street
Haines, R.	Bus Stop
Hockney, D.	Picture of Melrose Avenue...
Jacquette, Y.	Aerial View of 33rd Street
Jacquette, Y.	Brooklyn-Atlantic Avenue I
Jacquette, Y.	Northwest View from the...
Jacquette, Y.	Times Square (Motion Picture)
McCombs, B.	Street Corners
Montenegro, E.	Woman on a Crosswalk

Suits (Business)
Foote, H. In by Nine, Out by Five

Summer
Johns, J. Seasons
Johns, J. Summer
Mortensen, G. Summer Pond

Sun
Childs, B. Eyeball of the Sun
McLean, J. Flight over Busch Gardens
Summers, C. Chinese Landscape
Wayne, J. Shine Here to Us...

Sun Visors (Caps)
Beal, J. Self-Portrait

Sunflowers
Baynard, E. Sunflower

Sunglasses
Rosenquist, J. Iris Lake

Sunlight *see* Light (Sunlight)

Sunrise and Sunset
Beerman, J. Two Bushes at Twilight
Brown, Roger Tree in Sunderland
Drewes, W. Maine Sunset
Ferrer, R. Amanecer Sobre el Cabo
Gelb, J. Oahu Sunrise
Lichtenstein, R. Sunrise
Pozzatti, R. Venetian Sun
Siegel, I. Sunset
Westermann, H.C. See America First [*Plate 17*]
Yang, J. Sunset: Hanalei

Superheroes
Myers, F. Martyrdom

Twombly, C. Untitled II

Swords
Surls, J. Through It All

Syrup
Kreneck, L. Great Moments in Domestic...

Tables (Furniture)
Brown, Roger Magic
Goldman, J. Sun Porch
Lee, M.J. Untitled [Woman at Table]
Lichtenstein, R. Picture and Pitcher
Mazur, M. Smoke
Miyauchi, H. In the Sunrise
Plotkin, L. Morning Light
Porter, F. Table
Price, G. Table
Price, K. Coffee Shop at the Chicago Art...

Tailors *see* Sewing

Taj Mahal
Damer, R.W. I Bombed the Taj Mahal...

Talons
Nutt, J. soft touch me

Tan Lines
Dallman, D. Sunbather

Tanks
Biddle, M. Untitled
Bolton, R. Strong Arm

Taos (New Mexico)
Blumenschein, H. Untitled [Ranchos de Taos]
Capps, C. Taos
Hoover, E. Untitled [Taos Pueblo]

Tape (Adhesive)
Crane, P. Outside In

Tapestries *see also* Rugs, Weaving and Weaves
Izquierdo, M. Pierrot's Tapestry
Mullen, P. ADI Blue

Targets
Johns, J. Target
Ritchie, B.H., Jr. Locus and Sea Squares
Ritchie, B.H., Jr. Video Target Head

Taste (Gustatory Sense)
Bolton, R. Berry Pickers

Tattoos
Falconer, J. Hairy Who (*poster for 1*st...)
Green, Art Hairy Who (*poster for 1*st...)
Nilsson, G. Hairy Who (*poster for 1*st...)
Nutt, J. Hairy Who (*poster for 1*st...)
Rocca, S. Hairy Who (*poster for 1*st...)
Wirsum, K. Hairy Who (*poster for 1*st...)

Tea Bags
Oldenburg, C. Tea Bag

Teapots
Oldenburg, C. Teapot
Scheier, S. Tea Party
Treaster, R. Vermeer and Times

Tears *see* Crying

Technology
Weege, W. Dance of Death

Teddy Bears
Baldessari, J. Object (with Flaw)

Teenagers *see* Youth

Teepees
Lichtenstein, R. Figure with Teepee
Lichtenstein, R. Two Figures with Teepee

Teeth
Andell, N. Picnic at Crane's Beach
Bontecou, L. Fourth Stone
Clemente, F. Self-Portrait #2 [Teeth]
Nauman, B. Untitled (*from* Studies for ...)
Rosenquist, J. Shriek
Rosenquist, J. Sister Shrieks
Warhol, A. Marilyn Monroe I Love Your...

Telescopes
Hanson, P. Telescoping Machine

Television
Anderson, Laurie Mt. Daly/US IV
Fischl, E. Untitled (*from* Floating Islands)
Hockenhull, J. Everlovin' Light
Levine, L. Iris Print-out Portrait
Nutt, J. ummmph....
Tilson, J. Software Chart Questionnaire
Wesselmann, T. T.V. Still Life

Temples *see also* Cathedrals, Churches, Missions
Myers, F. Monte Alban II

Temptation
Nutt, J. Untitled [1970]
Schapiro, M. Adam and Eve

Tennis
Feigin, M. Tennis

Tennis Nets
Feigin, M. Tennis
Northington, T. Encroaching on the Continent

Thailand
Nelson, K. Myth of Changmai

Theater *see* Dramatic Productions

Theft
Werger, A. Violation

Thimbles
Lanyon, E. Thimblebox

Throats *see* Necks

Thrones
Beckmann, M. King and Demagogue

Ties (Clothing)
Dine, J. Five Layers of Metal Ties
Dine, J. Informal Tie
Dine, J. Tie
Johnson, R. Correspondence
Nelson, Robert Bombs of Barsoom
Wirsum, K. Correspondence

Tigers
Humphrey, M. Lady and the Tiger
Markovitz, S. Tiger Chase
Morley, M. Parrots

Time
Applebroog, I. Executive Tower, West Plaza
Chan, J. Time Series, No. 3
Milton, P. Daylilies
Pfanschmidt, M.J. Turning
Thompson, Margot Leaf Wheel, Forest Song
Wolf, S. Persistence

Tissue
Rosenquist, J. Campaign

Tomatoes
Dine, J. Tomato and Pliers

Tools
Boyd, J.D. Homage to Rembrandt
Bratt, B. Random Order
Brown, Roger Visions/Painting and Sculpture...
Crane, P. Neo-Colorado
Dine, J. Colored Palette
Dine, J. Double Apple Palette...
Dine, J. Five Paint Brushes
Dine, J. Five Paintbrushes
Dine, J. Flesh Palette in a Landscape
Dine, J. Four C Clamps
Dine, J. Piranesi's 24 colored marks
Dine, J. Tomato and Pliers
Johns, J. 1st Etchings
Johns, J. Savarin
Johns, J. Savarin [1977-81]
Johns, J. Savarin [1978]
Johns, J. Savarin Monotype
Kitaj, R.B. Photo-eye (El Lissitzky)
Mazur, M. Palette Still Life #53
Nelson, Robert Light Load
Nutt, J. ummmph....
Rosenquist, J. Horse Blinders (East)
Ross, R. Printed Printer's Palette
Sanderson, H. Pas de Deux
Wright, D. Untitled

Toothbrushes
Johns, J. Critic Smiles

Topography
Ritchie, B.H., Jr. Locus and Sea Squares

Torment
Baskin, L. Torment
Myers, M. St. Anthony

Traffic Signals or Traffic Lights
Jacquette, Y. Traffic Light Close Up
Jacquette, Y. Traffic Signal
Plotkin, L. Intersection
Seawell, T. Mercury [St. Louis]

Trailers
Wolff, E. Trailers

Trains
Crutchfield, W. Burial at Sea
Crutchfield, W. Cubie Smoke
Crutchfield, W. Diamond Express
Crutchfield, W. Elevated Smoke
Crutchfield, W. Trestle Trains
Gray, N. El at Myrtle Avenue
Hall, S. Morning Glory
Humphrey, D. Nocturne
Parker, Robert Chester Johnson and Myself...
Savinar, T. I Want
Seawell, T. Around Town
Skinner, A. Lost Train

Transportation
Seawell, T. Around Town

Tranquility
Prentice, M. Implications of Sound, I

Transform
Nilsson, G. Untitled [1964, *2 5/8 x 13 29/32*]

Trapeze
De Mauro, D. Trapeze Figures

Trapezoids (Shapes)
Wong, P. Sites for Three Sunken Trapezoids

Trash *see* Garbage

Forrester, P.T.	Great Palm
Freilicher, J.	Flowering Cherry
Friese, N.	Homage to Constable
Garet, J.	Night Boy
Gellis, S.	Dusk: Lake Rowland
Gornik, A.	Equinox
Hansen, A.	Winter 1977
Hnizdovsky, J.	Pinoak Trees
Hockney, D.	Bora Bora
Hockney, D.	Pacific Mutual Life Building...
Ikeda, M.	Sphinx of the Woods
Katz, A.	Luna Park
Katz, A.	Maine Landscape
Kay, B.	Crowhill [State 3]
Kimball, W.	Longhorn in Sheep's Clothing
Kondos, G.	River Reflection, Sacramento River
Kozloff, J.	Harvard Litho
Landacre, P.	Smoke Tree
Leithauser, M.	Migration
Livesay, W.T.	Large Oak Tree
Lozowick, L.	Central Park
Lucioni, L.	Big Haystack
Lundeberg, H.	Moonrise
MacDougall, A.	Mongo Fongo I
Magennis, B.	Partial Construction of...
Mangold, S.	Nut Trees (Red)
Mangold, S.	Pin Oak
Mark, W.	Cry to Me I
Mark, W.	Cry to Me II
Marsh, G.	Natura Naturata
Milton, P.	Julia Passing
Mortensen, G.	Summer Pond
Nilsson, G.	Gladys Nilsson
Nilsson, G.	Jim Nutt: Paintings...
O'Rourke, J.	Brazilian Rain Forest #2
Peak, E.	Morning
Peak, E.	View of a City
Price, K.	Japanese Tree Frog Cup
Rasmussen, K.	Greyfield Ghosts
Rocca, S.	Nine Palm Trees

Triangles (Shapes)

Green, Art	Second Etching
Guzak, K.	Jewels for Taj
Haksar, M.	Letter Series #55
Hamilton, K.	Sellin'
Hanson, P.	Squiggles
Hashimi, Z.	Seed
Heizer, M.	Scrap Metal Drypoint #2
Held, A.	Stone Ridge IV
Hirtzel, S.	Grace
Hirtzel, S.	Infinity Dance
Kelly, E.	Dark Gray and White
Kelly, E.	Green Curve with Radius of 20…
Kunc, K.	Mirrored Touchpoints
Kunc, K.	Unbound Above
Lasuchin, M.	Trans
Lasuchin, M.	Triad
LeWitt, S.	Squares with a Different Line…
LeWitt, S.	Untitled (*from series of 16*)
Lichtenstein, R.	Imperfect 58" x 92 3/8"
Lichtenstein, R.	Imperfect 63 3/8" x 88 7/8"
Longo, V.	ABCD
Longo, V.	First Cut, Second Cut, Third Cut
Longo, V.	Temenos
McGowan, M.	Untitled [1978]
Nevelson, L.	By the Lake
Noland, K.	Echo
Noland, K.	Winds 82-34
Palermo, B.	4 Prototypes
Pfanschmidt, M.J.	Heart House
Rabel, K.	School Crossing
Rabkin, L.	Thumbprint Print
Rockburne, D.	Melencolia
Rockburne, D.	Radiance
Salemme, A.	One Against Many
Secunda, A.	Road to Arles
Shields, A.	c.b.a.r.l.a.a.(old)y.(odd)o.
Sihvonen, O.	Block Print IV
Smith, C.W.	Red and Green Discs
Smith, Kimber	Untitled
Smith, Leon	Untitled [1968]

Piene, O. Sky Art [*plate*]

T.V. *see* Television

Twins
Catlett, E. Lovey Twice

Umbrellas
Anderson, Laurie Mt. Daly/US IV
Feigin, M. Woman, Child, Umbrella
Morley, M. Beach Scene
Nagatani, P. Trinitite Tempest
Weege, W. Dance of Death
Werger, A. Cloudburst

Underwear
Nutt, J. Eddy Wonder

Undressing
Bishop, I. Little Nude
Ramberg, C. Untitled [1968]

Unease
Baskin, L. Frightened Boy and His Dog
Baskin, L. Icarus
Gordy, R. Male Head
Hodgell, R. Burning Bush
Mock, R. Crossing Fate's Boundaries
Turner, J. Frightened Jack Rabbit Hiding

Uniforms (Military)
Rivers, L. Last Civil War Veteran

United States *see* America

Universe *see* Outer Space

Urination
Escher, F. Pissin' in the Wind

Hanson, P.	Veiled Head II
Hanson, P.	Veiled Head III
Hanson, P.	Veiled Head IV
Ramberg, C.	Veiled Person

Venice
Pozzatti, R.	Venetian Domes
Pozzatti, R.	Venetian Sun
Yunkers, A.	Skies of Venice VIII

Vials *see* Flasks

Villages
Capps, C.	Taos
Castellon, F.	Spanish Landscape
Dasburg, A.	Ranchos Valley I
Hoover, E.	Untitled [Taos Pueblo]
Pearlstein, P.	Ruins at Gran Quivira
Reed, D.	Adobe and Wild Plum
Stroh, E.	Mesa Verde
Woodruff, H.	Prominade

Violence
Bosman, R.	Forced Entry
Colescott, W.	Attack and Defense at Little...
Freed, E.	Battle of the Sexes
Landau, J.	Violent Against Themselves...
Lasansky, M.	For an Eye an Eye, III
Lichtenstein, R.	CRAK!
Lichtenstein, R.	Sweet Dreams, Baby!
Skelley, R.	War
Warhol, A.	Birmingham Race Riots
Werger, A.	By Force
Werger, A.	Neighborhood Watch

Visions *see* Dreams and Visions

Visors *see* Sun Visors (Caps)

Volcanoes
Arnoldi, C. Untitled [1983]
Noah, B. Big

Wading
Frank, M. Man in the Water

Waffles
Kreneck, L. Great Moments in Domestic...

Wagons
Solien, T.L. Handle and Tow

Waiting
Barnet, W. Waiting
Haines, R. Bus Stop
Itchkawich, D. Awaiting the Results...

Walkers or Walking
Bosman, R. Snowman
Hammond, J. Untitled #17
Morgan, N. Tired Traveler
Nilsson, G. Problematical Tripdickery
Nilsson, G. Street Scene
Nutt, J. Sally Slips Bye-Bye
Nutt, J. Untitled #1
Resnick, M. Stage Spirits II
Walker, T. Untitled [*p. 121*]

Walking Cane
Rauschenberg, R. Post Rally

Walking Stick
Walker, T. Untitled [*p. 121*]

Walkway *see* Paths

Wallpaper
Rizzie, D. Red Cross

Walls

Acconci, V.	Stones for a Wall No. 7
Anderson, W.T.	Great Indian War Series No. 26
Askin, W.	Bruegel-Brittania
Frasconi, A.	Franco I
Fried, R.	Dylan's Drifter
Levy, P.	Commonwealth of…
McLarty, J.	Wall City
Raetz, M.	Untitled (*plate from untitled…*)

War *see also* Military

Arneson, R.	Nuclear War Head
Baskin, L.	Hydrogen Man
Baskin, L.	Mantegna at Eremitani
Biddle, M.	Untitled
Brown, Roger	Family Tree Mourning Print
Colescott, W.	History of Printmaking: Goya…
Gloeckler, R.	Eeny Meeny Miney Moe
Johanson, G.	Night Games #5
Johns, J.	Souvenir
Morris, R.	Crater with Smoke
Morris, R.	Infantry Archive—To Be…
Nauman, B.	Raw-War
Rivers, L.	Last Civil War Veteran
Scheier, S.	Tea Party
Skelley, R.	War
Spafford, M.	Battle of Lapiths and Centaurs
Thiebaud, W.	Jan Palach
Torres, F.	Northern Guernica
Weege, W.	Dance of Death

Warriors

Frasconi, A.	Don Quixote and Rocinantes
Frasconi, A.	Franco I
Golub, L.	Wounded Warrior
Herman, R.	Fatherland, Mothertongue
Kohn, M.	Kabuki Samurai
Lasansky, M.	Quetzalcoatl
Lebrun, R.	Man and Armor
Lichtenstein, R.	To Battle

Gornik, A.	Equinox
Hall, S.	Secret Journey
Hanson, P.	Fountain
Hockney, D.	Afternoon Swimming
Hockney, D.	Lithograph of Water... [all]
Hockney, D.	Lithographic Water... [all]
Hockney, D.	Pool made with paper and blue...
Hopkins, D.	Somewhere Near the Border
Jules, M.	Cove
Kessler, D.	Shadow Line
Kessler, D.	Surface Disturbance
Lichtenstein, R.	Goldfish Bowl
Macko, N.	Gyotaku IV
Mazur, M.	Wakeby Night
McMillan, S.	Reflections and Carp
Mortensen, G.	Summer Pond
Moses, F.	Landscape, Rocks, Water
Motherwell, R.	Wave
Nawara, L.P.	Bash Bish Falls
Nilsson, G.	Nudes at Water
Noah, B.	Ooh
Overton, J.	Blue Zone
Patterson, C.	Black Beauty
Prentice, M.	Another Flying Dream
Raffael, J.	Flow and Snow
Ritchie, B.H., Jr.	Locus and Sea Squares
Romano, C.	Big Falls
Romano, C.	Deep Falls
Romano, C.	Mammoth Falls
Rosenquist, J.	Welcome to the Water Planet
Schrag, K.	Pond in a Forest
Solien, T.L.	Sunken Treasure
Welliver, N.	Brown Trout
Wilson, R.	Untitled #5
Wirsum, K.	Surplus Slop from...the Windy...
Zimmerman, L.	Mt. Shuksan
Zimmerman, L.	Storm Over the Cascades

Water Fountains

Bolton, J.	Two Girls

Wells

Hockney, D.	Hotel Acatlán: Second Day
Hockney, D.	Views of Hotel Well I
Hockney, D.	Views of Hotel Well II
Hockney, D.	Views of Hotel Well III

West *see* Western United States

Western United States

Lichtenstein, R.	American Indian Theme III
Lockwood, D.	Hats and Boots
Westermann, H.C.	See America First [*Plate 17*]
Wiley, W.	Seasonall Gate

Whales

Eichenberg, R.	Book of Jonah
Weege, W.	Dance of Death

Wheelchairs

Andrews, B.	Pusher

Wheels

Green, Art	Untitled [c.1973]
Oldenburg, C.	Profile Airflow—Test Model...
Rauschenberg, R.	Test Stone #7

Whirlpools

Weege, W.	Dance of Death

Wigs

Rocca, S.	Wiglet

Wildlife *see* Animals

Wind

Brown, Roger	i of the storm
Burchfield, C.	Autumn Wind

Windows

Applebroog, I.	Executive Tower, West Plaza

Walters, S. Summer Self-Portrait
Wilson, R. Golden Windows
Yamazaki, K. House Wife

Wine
Beal, J. Oysters with White Wine and…
Erlebacher, M. Homage to Bacchus

Winter *see also* Snow
Altman, H. Luxembourg November
Avery, Milton Birds and Sea
Barrett, L. Untitled [Horses in Winter]
Bolton, R. Winter Storm
Bosman, R. Snowman
Burkert, R. December Woods
Grooms, R. Downhill Skier
Hansen, A. Winter 1977
Johns, J. Seasons
Johns, J. Winter
Lozowick, L. Central Park
Seawell, T. Snow
Smith, Moishe Four Seasons—Winter
Tobey, M. Winter

Wires (Electrical)
Lozowick, L. Design in Wire
Rosenquist, J. Area Code

Wisconsin
Greenbaum, M. Bklyn local in Weege Wisconsin

Women *see also* Mothers, Nudes and Nudity
Abdalla, N. Nude in Red Kimono
Albright, I. Into the World There Came a Soul Called Ida
Amen, I. Dreamer Amid Flowers
Amos, E. Diver
Amos, E. Dream Girl
Applebroog, I. Just Watch and See
Attie, D. Exile
Avery, E. Massacre of Innocents

De Lamonica, R.	Who
Dehn, A.	Mayan Queen
Dickson, J.	White Haired Girl
Diebenkorn, R.	41 Etchings and Drypoints
Diebenkorn, R.	Seated Woman Drinking...
Dine, J.	Black and White Cubist Venus
Dine, J.	French Watercolor Venus
Dine, J.	Nurse
Dine, J.	Swimmer
Dine, J.	Youth and the Maiden
Drewes, W.	Nausikaa (no. 149)
Duchamp, M.	L.H.O.O.Q. Shaved
Ellison, M.E.	International Boulevard
Erskine, E.	Icarus
Erskine, E.	Vertical Edge
Evergood, P.	Cool Doll in Pool
Farley, K.	Rotary Circuit
Fearing, K.	Collector
Feigin, M.	Woman, Child, Umbrella
Fischl, E.	Digging Kids
Forbis, S.	Sharing Traditions
Forrester, P.T.	Daughters
Frank, M.	Astronomy
Gelman, A.	Self-Portrait II
Goetz, J.R.	Untitled Abstract
Gordy, R.	Sister Act
Gorny, A-P.	Queen's Autumn
Green, Art	Indecent Composure
Green, Art	Third Etching
Grooms, R.	Gertrude
Hall, S.	Secret Journey
Hamilton, R.	Fashion Plate
Hamilton, R.	Interior
Hamilton, R.	My Marilyn
Hanson, P.	Fiesta
Hanson, P.	Masked Head
Hanson, P.	Veiled Head I
Hanson, P.	Veiled Head IV
Hanson, P.	Woman at Swan Vanity
Harrington, S.	Untitled

Kushner, R. Bibelot
Kushner, R. National Treasure
Kushner, R. Rhoda VIII 3
Kushner, R. Rhonda VII
Lane, L. Untitled [1990]
La Roux, L.J. Icon #4
Laurence, S. Bay Woman
Lee, M.J. Untitled [Woman at Table]
Leech, R. Gregor Samsa's Family
Lichtenstein, R. CRAK!
Lichtenstein, R. Fresh Air
Lichtenstein, R. Reclining Nude
Lichtenstein, R. Reverie
Lindner, R. Hit
Lindner, R. Miss American Indian
Longo, R. Jules, Gretchen, Mark
Lovell, W. Nanny
Markovitz, S. Ovulation II
McGarrell, J. Portland I
McSheehy, C. Dedication for Manus Pinkwater
Meeker, D. Lisa
Milton, P. Jolly Corner III: 7
Milton, P. Passage II
Montenegro, E. Woman on a Crosswalk
Morales, A. Dos Ciclistas [Two Cyclists]
Myers, F. Martyrdom
Myers, F. Saint Teresa's Seventh Mansion
Myers, V. Self Portrait with Hat
Nadler, S. Untitled
Nebeker, R. Dream
Nebeker, R. Still I Don't Know
Nefertiti Getting Fixed to Look Pretty
Nilsson, G. Europa and the Bull
Nilsson, G. Group of Three Figures 1963
Nilsson, G. Holes with a Muse
Nilsson, G. Hoofers and Tootsies
Nilsson, G. Nudes at Water
Nilsson, G. Plate Dancing in Carbondale
Nilsson, G. Problematical Tripdickery
Nilsson, G. Self-Portrait as White Rock Lady

Pearlstein, P.	Nude in Hammock
Pearlstein, P.	Nude on Mexican Blanket
Pearlstein, P.	Reclining Nude on Green Couch
Pearlstein, P.	Two Nudes
Pearlstein, P.	Untitled
Phillips, M.	Figures with Golden Bowl
Pogue, S.	Arabesque
Ponce de Leon, M.	Recycling of Gran'ma
Powell, R.J.	Richard Wright Series #7: Cerebrus
Pozzatti, R.	Etruscan Lady
Ramos, M.	A. C. Annic
Ramos, M.	Miss Comfort Creme
Rauschenberg, R.	Bellini #4
Rauschenberg, R.	Breakthrough II
Rauschenberg, R.	Sling-Shots Lit #8
Rauschenberg, R.	Trilogy from the Bellini Series
Reder, B.	Lady with Veil
Resnick, M.	Entrance
Resnick, M.	Stage Spirits II
Rice, A.	Untitled [1985]
Rich, J.	Woman I
Ringgold, F.	Woman, Power, Poverty and Love
Rivers, L.	Diane Raised III
Rocca, S.	Ring Girl
Romano, C.	Figure and Hills
Rosenquist, J.	Electrical Nymphs...
Rosenquist, J.	Flowers and Females
Rosenquist, J.	Shriek
Rosenquist, J.	Sister Shrieks
Ross, R.	Printed Printer's Palette
Ruble, R.	She Who Controls Dreams
Ryan, A.	Two Women
Salle, D.	Until Photographs Could Be...
Schapiro, M.	Frida and Me
Schapiro, M.	Homage
Scheier, S.	Leda
Schwartz, C.	Heirloom 2
Schwartz, C.	Heirloom 4
Segal, G.	Helen III
Sessler, A.	Morning Forum

Wirsum, K. Wake Up Yer Scalp with Chicago
Wirsum, K. We Got Nuthun to Hyde!…
Wirsum, K. Woman and Birds
Wirsum, K. Woman's Head
Wirsum, K. Women with Birds and Flowers
Woehrman, R. Henrietta
Wujcik, T. Portrait of June Wayne
Yunkers, A. Miss Ever-Ready
Yunkers, A. Succubae

Wood
Noah, B. Big

Woods *see* Forests

Words *see* Writing

Work and Workers *see also* Artists' Studios, Construction (Sites,
 Equipment, etc.), Cooks and Cooking, Factories and Factory
 Workers, Farmers, Farms and Farming, Fishermen and Fishing
Applebroog, I. Executive Tower, West Plaza
Biggers, J.T. Untitled
Golub, L. Workers
Lozowick, L. Design in Wire
Weege, W. Dance of Death
Wolff, E. Bean Soup

Workshops
Leithauser, M. Horological Fascination

World's Fair
Gilkey, G. Theme Center, New York…

Wrappers and Wrapping
Christo Allied Chemical Tower, Rear
Christo Whitney Museum Wrapped…
Christo Wrapped Monument to Leonardo
Hanson, P. Room with Covered Vase

Chesebro, E.	Eight Generation Shape...
Colangelo, C.	Trophies
Cortese, D.	Grigenti Scroll
Cottingham, R.	Fox
Cottingham, R.	Hot
Darboven, H.	Diary NYC February 15 Until...
De Kooning, W.	Untitled [1987]
De Saint Phalle, N.	Zoo with You
Diao, D.	Untitled [China in Russian]
Dine, J.	Car Crash I-V
Dine, J.	End of the Crash
Dine, J.	Five Layers of Metal Ties
Dine, J.	Scissors and Rainbow
Everts, C.	Romabrite
Falconer, J.	Hairy Who (*poster for 1st...*)
Falconer, J.	Hairy Who (*poster for 2nd...*)
Förg, G.	Reason Why I Work...
Glarner, F.	Recollection
Green, Art	Hairy Who (*poster for 1st...*)
Green, Art	Hairy Who (*poster for 2nd...*)
Green, Art	Salvatory Solution
Green, Art	Untitled [c.1973]
Grooms, R.	Stamped Indelibly [*Plate 2*]
Hansell, F.	Untitled
Hanson, P.	Chicago Imagist Art
Hanson, P.	McGovern and Shriver
Hara, K.	Topophilia #7
Heizer, M.	45°, 90°, 180°
Heizer, M.	Dragged Mass
Heizer, M.	Levitated Mass
High, T.G.	Madame Butterfly
Holzer, J.	Truisms
Ikegawa, S.	Issa
Indiana, R.	American Dream
Indiana, R.	LOVE
Indiana, R.	LOVE Wall
Indiana, R.	Numbers
Indiana, R.	Polygons #4
Indiana, R.	Sex Anyone?
Johns, J.	Critic Sees

Motherwell, R.	Black Banners
Motherwell, R.	Black Lament
Motherwell, R.	Black Wall of Spain
Motherwell, R.	El Negro (*front endleaf*)
Motherwell, R.	El Negro (*half title page*)
Motherwell, R.	El Negro [Preface]
Motherwell, R.	El Negro [Title Page]
Motherwell, R.	Forever Black
Motherwell, R.	Hermitage
Motherwell, R.	Mourning
Motherwell, R.	Poem
Motherwell, R.	Quarrel
Motherwell, R.	Through Black Emerge Purified
Motherwell, R.	Untitled, A
Motherwell, R.	Untitled, B
Motherwell, R.	Untitled, C
Nauman, B.	Earth-World
Nauman, B.	M. Ampere
Nauman, B.	Normal Desires
Nauman, B.	No-State
Nauman, B.	Raw-War
Nebeker, R.	Dream
Nilsson, G.	Gladys Nilsson: Paintings…
Nilsson, G.	Hairy Who (*poster for 1st…*)
Nilsson, G.	Hairy Who (*poster for 2nd…*)
Nilsson, G.	Thats Me: Gladys Nilsson
Nilsson, G.	Women (*announcement*)
Nilsson, G.	Women (*poster*)
Nutt, J.	[title=drawing of two fingers]
Nutt, J.	Advertisement for Nutt's Frames
Nutt, J.	Christmas Card
Nutt, J.	Gay Nurse
Nutt, J.	Hairy Who (*poster for 1st…*)
Nutt, J.	Hairy Who (*poster for 2nd…*)
Nutt, J.	Hairy Who (*poster for group…*)
Nutt, J.	Now! Hairy Who Makes You…
Nutt, J.	Nutt's Frames
Nutt, J.	Selbst-Explanatory
Oldenburg, C.	Orpheum Sign
Oldenburg, C.	Store Poster

Yo-Yo's
Thiebaud, W. Yo-Yo's

Youth
Eichenberg, F. Bestiarium Juvenille

Zeppelins
Crutchfield, W. Zeppelin Island
Murray, J. Graf Zeppelin at Lakehurst 1929
Stock, M. Air Whale

Zoos *see also* Animals
De Saint Phalle, N. Zoo with You

AUTHOR/TITLE INDEX

A

Q

R

About the Author

Betty Kelly Bryce (B.A. Hollins College, Virginia; M.A. New York University Fine Arts Institute; M.L.S. University of Alabama) is Reference Librarian/Associate Professor and Fine Arts Selector at the University of Alabama Libraries, Tuscaloosa, Alabama. She is active in national and state library associations. As a member of the American Library Association's College and Research Libraries Division, she has edited the national newsletter of the Arts Section and chaired the Arts Section Publications Committee. She collects post-World War II American prints.